VIGÉE-LEBRUN
1755-1842

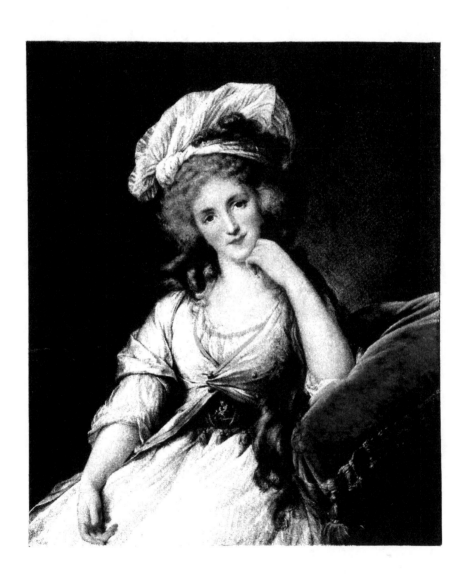

VIGÉE-LEBRUN
1755-1842

HER LIFE, WORKS, AND FRIENDSHIPS

BY

W. H. HELM

AUTHOR OF
"JANE AUSTEN AND HER COUNTRY-HOUSE COMEDY"
"ASPECTS OF BALZAC," "CHARLES DICKENS"

WITH A CATALOGUE RAISONNÉ
OF THE ARTIST'S PICTURES

WITH A FRONTISPIECE IN COLOURS
40 PHOTOGRAVURE PLATES
AND OTHER ILLUSTRATIONS

BOSTON
SMALL, MAYNARD AND COMPANY
1915

AUTHOR'S NOTE

IN preparing this account of Madame Lebrun and the catalogue of her works, the author has been helped with information and advice by many to whom he here gives sincere thanks, especially to Messrs. Christie, Manson and Woods, Mr. Algernon Graves, F.S.A., Mr. James Greig, Mr. Daniel O'Connor, Mr. W. Romaine Paterson, Mr. W. Roberts, Lady Sackville, and Mr. T. H. Thomas.

For permission to reproduce pictures or copyright plates, and in several cases for other assistance, he is much indebted to Messrs. Thomas Agnew and Sons, The Marquis of Bristol, Messrs. Duveen Brothers, M. Féral, Mr. Otto Gutekunst, Mr. Adolph Hirsch, Mr. E. M. Hodgkins, Mr. William McKay, The Dowager Countess of Portarlington, the family of the late Comtesse E. de Pourtalès, The Earl of Radnor, Baron Edmond de Rothschild, Lord Sackville, M. Charles Sedelmeyer, M. Wildenstein, and to Dr. G. C. Williamson and the executors of the late Mr. J. Pierpont Morgan.

Among many published sources of information, his chief authority, apart from Madame Lebrun's own *Souvenirs*, has been the admirable volume by M. Pierre de Nolhac, Keeper of the Art Galleries at Versailles, to which is appended a valuable descriptive list by M. Pannier, compiled from the sale catalogues of such of the artist's works as were sold in public from 1778 up to the year (1908) in which the book was issued. In M. Jacques Doucet's noble library in Paris he was able to see many original manuscripts and other documents relating to his subject.

With regard to the catalogue given at the end of the present book, the author is well aware that it must inevitably contain many errors, as it obviously leaves many pictures either entirely unidentified or insufficiently described. He will be greatly obliged for any corrections or additions which may be sent to him.

CONTENTS

CHAPTER I

EARLY YEARS

The influence of courts on art—Childhood of Elisabeth Vigée—At the convent school—Her father's eccentric behaviour—His untimely death—Elisabeth's friends—Rosalie Bocquet—Lessons in the Louvre—The Paris art galleries—Good commissions for the child-painter—A grasping step-father—A terrible public disaster—Evil omen for the Dauphin and his Austrian bride pp. 1–8

CHAPTER II

THE GIRL-ARTIST

A propitious time for Elisabeth Vigée—The vogue of " prettiness "—The attractions of Elisabeth's studio—Disappointed admirers—Insulting proposals—A skirmish with the law—First public display of her works—Some of her sitters—Social success—Notable acquaintances—" Pleasures " of the country—First meeting with Queen Marie Antoinette—Elisabeth's gifts to the French Academy—A visit from D'Alembert . . pp. 9–15

CHAPTER III

MARRIAGE

M. Lebrun as lover—He marries Elisabeth Vigée—Reason for a secret wedding—Scandalous talk—Invoking the police—Want of money—An art school that failed—Scheme for a judicial separation—The plan abandoned—Habits of M. Lebrun—Art dealing—A valuable customer—The vanity of riches—An influential friend pp. 16–23

CHAPTER IV

MARIE ANTOINETTE

State of society amid which Vigée-Lebrun rose into fame—The frivolous crowd at Versailles—Less love and more gallantry—Outward decorum and light morality—Louis XVI and Marie Antoinette—The Queen's bad advisers—Ties of sympathy between Vigée-Lebrun and her royal patroness pp. 24–28

ix

CHAPTER V

THE QUEEN'S PORTRAITS

CHAPTER VI

ACADEMICIAN

CHAPTER VII

SOCIAL LIFE

CHAPTER VIII

BOOKS AND THEATRES

CONTENTS

CHAPTER IX

COUNTRY-HOUSES

CHAPTER X

CALONNE

CHAPTER XI

REPLIES TO DEFAMERS

CHAPTER XII

MADAME DU BARRY

CHAPTER XIII

THE COMING REVOLUTION

CHAPTER XXII

IN ENGLAND, 1802-5

CHAPTER XXIII

ENGLISH FRIENDS

CHAPTER XXIV

PARIS AGAIN, 1805

CHAPTER XXV

VISIT TO SWITZERLAND, 1808

CHAPTER XXVI

THE RESTORATION

CHAPTER XXVII

AUTUMN AND WINTER

LIST OF ILLUSTRATIONS

The names in brackets (except in the case of public galleries) are those of the owners of copyright pictures or photographs who have permitted their reproduction in this book.

VIGÉE-LEBRUN

1755—1842

CHAPTER I

EARLY YEARS

The influence of courts on art—Childhood of Elisabeth Vigée—At the convent school—Her father's eccentric behaviour—His untimely death—Elisabeth's friends—Rosalie Bocquet —Lessons in the Louvre—The Paris art galleries—Good commissions for the child-painter —A grasping step-father—A terrible public disaster—Evil omen for the Dauphin and his Austrian bride

IN the history of royal patronage no chapter is more generally creditable than that concerned with the arts. The atmosphere of courts may have been ruinous to countless gifted beings, but not, as a rule, to artists. Indeed, but for the means formerly provided by national wealth in passing through the bottomless pockets of autocrats, we should be without a large proportion of the finest of existing treasures. Court painters have been as diverse in merit as poets-laureate: Rubens, Velasquez, Vandyck, Kneller, Lely, Vigée-Lebrun, for examples, offered styles various enough to please every taste until the advent of those originals whose " futurisms," old almost before they are new in the enervating atmosphere wherein such things are made, seem to have as much effect on art as have " freak " dinners on the social habits of sober people. Madame Vigée-Lebrun was not, of course, " in the same studio " with Rubens and Vandyck and Velasquez, but she is distinguished among famous court painters, not merely as the one woman in the list, but as the possessor of gifts which, apart from the historical associations that lend a peculiar attraction to many of her works, would ensure for her best pictures prominent places in any general collection of fine art.

In a house near the corner where the Rue Coq-Héron joins the Rue

I

Coquillière, close to the Place des Victoires in Paris, Jeanne, the beautiful
wife of the artist Louis Vigée, gave to him, on April 16, 1755, the daughter
who was to ensure the preservation of his name. The child was called
Marie Elisabeth Louise. When she reached years of discretion, she
dropped the first name, and reversed the order of the other two. Many
other notable people, for the sake either of euphony or convenience, have
chosen to make such alterations.

Of her earliest infancy we know as much as of most earliest infancies,
and that is all that we need. She was no doubt submitted to the risk
of permanent paralysis from the tight swaddling which, though soon to
become less common, persisted in France until our own time. According
to the general practice of well-to-do families, abroad as in England, at
that period, she was sent, soon after birth, to live with a wet-nurse in the
country. After a few months with this foster-mother she was transferred
to another " good woman " who lived at Epernon. The woman's husband
worked on the land, and the home was a poor one, but the baby was so
well treated that, eighty years later, Madame Lebrun attributed the
generally good if never robust health she had so long possessed to the
five years spent at that cottage amidst the wooded hills of one of
the pleasantest regions of France.

Among her oldest distinct memories was that of her last day at
Epernon, when she was jolted in a panier on her nurse's donkey to the
high road, where her father's cabriolet was waiting to convey her to
Paris.

After a few days at home, this child of five was taken to the Convent
of La Trinité, in the suburb beyond the Bastille. Her life was less agreeable
with the nuns than with the peasants. The discipline was far more strict,
and the food much less to her taste. But her troubles were mitigated
by the frequency with which her parents, seeing that she was not very
happy or very well, fetched her home for two or three days at a time.

It was at this period that her talent for drawing began to show itself.
She scrawled charcoal sketches on the walls of the dormitory and the
passages of the convent, and covered her writing-books with heads of
nuns and of schoolgirls. When convicted of these crimes she was properly
punished, but unhappily another child, in whose books she had found extra
space for drawing, was punished also, in the erroneous belief of the Mother-
superior that there were two infant artists at work. To the end of her days
the guilty culprit reproached herself when she remembered the affair.

At the age of eleven, Elisabeth made her first communion. That event ended her school life, and she thenceforth stayed at home, to play with her tiny brother Etienne, and to develop her now recognised inheritance of her father's artistic sense.

Vigée gave his daughter the free run of his studio, where he worked, with moderate success, in pastels and in oils, painting such people as would pay him for their portraits, and pleasing himself by producing imaginative compositions more or less after the manner of Watteau.

Apart from his domestic concerns his mind was chiefly taken up by two loves—for his art and for the lasses. So intensely was he preoccupied at times by the first that, his thoughts full of the picture he was painting, he was known to go out to a dinner-party with a nightcap on his head instead of a wig. As for the other obsession, it was absurdly displayed on successive New Year's Days, when he would hurry all over Paris in order that he might kiss the young girls he met in the streets, on the pretext of wishing them the Compliments of the Season !

Madame Vigée, who, amid the temptations of Paris, had retained the austere morality and piety of the simple peasants of Lorraine from whom she came, was grievously distressed by her husband's amatory antics, but she was compelled to be satisfied with the fact that, if he gave her little marital devotion, he regarded her always with a respect that hardly fell short of adoration.

While M. Vigée showered promiscuous fondness on other people's children on the opening day, he had abundant affection left for his own during the rest of the year. Between father and daughter, in any case, there was a strong attachment—the strongest mutual love, indeed, in which Elisabeth was ever to share. The mother was disposed to spoil the boy and to be hard on the girl, partly, as Madame Lebrun afterwards thought, because she was gawky, and even rather ugly in childhood, as is frequently the case with those who become good-looking in adolescence.

Her life while her father lived was in every respect adapted to encourage her instinctive leaning towards his profession. During the day she worked in his studio, or in that of the struggling artist Davesne, who taught her to prepare her palette. In the evenings several painters, as well as some writers and men of various occupations, were accustomed to come to the Vigées' rooms for conversation. Among the more important of such visitors was M. Gabriel Doyen, the painter of a then much-esteemed picture of " The Death of Virginia " (which had gained him admission into

the Academy), and of other compositions quite foreign to Elisabeth's own art at any period, unless her " Apotheosis of Marie Antoinette," painted in the decadence of her powers, may be regarded as an example of that " pictorial " school.

In these closing years of her father's life, and still more notably later on, Doyen was indeed the chief friend of the girl among the " grown-ups " of her acquaintance. He was a man of over forty, almost paternally interested in the development of the clever daughter of his old comrade in art.

Doyen had high principles, as might be gathered from his own story of the origin of Fragonard's " Swing " picture. It appears that just about the time when he was most earnestly encouraging the budding talent of Elisabeth Vigée, he was asked by the Baron de Saint-Julien to paint such a scene as is represented in " The Swing " (L'Escarpolette). He was rather shocked by the proposal, but after a moment to collect his wits he replied, " Ah ! Monsieur, one would have to add to your idea for a picture by making the lady's shoes fly in the air and be caught by cupids." More seriously, not being at all willing to do work so far outside his usual field, he recommended the frivolous courtier to apply to Fragonard, with the result that the famous picture now in the Wallace Gallery came into being.

When Elisabeth was thirteen years old, she suffered her first serious loss. Her father died of blood-poisoning, after an operation for the removal of a fishbone which he had swallowed. The operating surgeon was the ablest man in Paris. This was Jean Cosme, whose father and grandfather had been surgeons of repute before him, but who had decided to end the succession, having become, quite early in life, a member of a religious order which allowed him to practise surgery as well as spiritual healing. However capable the operator might be in those days before Pasteur or Lister, the chances of survival after a big operation were small, and the combination of surgeon and clergyman must often have been sadly convenient.

Elisabeth was strongly encouraged by Doyen to find consolation, as a child of thirteen naturally might, in applying herself assiduously to her favourite occupation. She became still more engrossed in the study of what she called " Nature," by which she implied heads of people and what is absurdly known as " still life," and not at all the " nature " of woods and streams.

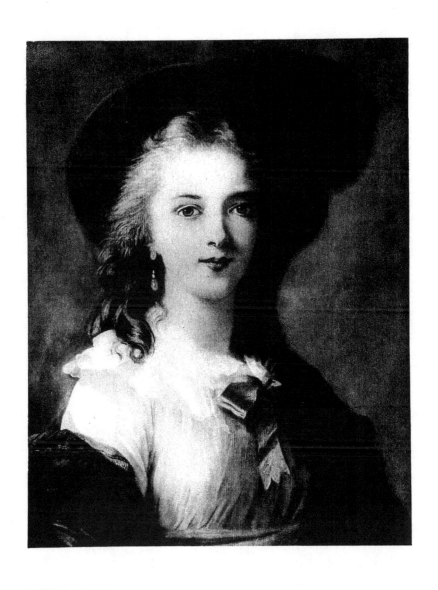

Fortunately, she had a friend, only a year older than herself, Rosalie Bocquet by name, who shared her talent and her tastes. By the time Elisabeth was fourteen, the two girls went very often together to the Louvre to study under the historical painter, Gabriel Briard, who gave them his criticism on their copies of his own sketches and their drawings of antique busts. The Louvre in those days was not only a museum, but a home for certain artists who, usually as members of the Academy, had been granted rooms and studios. Briard, whose art was of that grandiose, half-classical, half-symbolical style which expands itself most freely on palace ceilings, drew better than he painted. Although these two children benefited by his help, they could not join his school, which was only for boys and young men, the idea of "mixed" classes being in those times regarded as impossible for decently brought-up pupils, even if the "subject" were a bust of Pericles. Rosalie and Elisabeth used to spend whole days in the Louvre, taking their dinners with them in little baskets. Sometimes they would indulge in the added luxury of slices of beef à la mode supplied by the concierge, which seemed so good that, in old age, Madame Lebrun (who had known the finest cookery of the Brillat-Savarin period) still declared she had never tasted anything more delicious.

The elder of the two girl-students was pretty, and so indeed, by this time, was the younger. Elisabeth's cheeks had filled out, her complexion was clearer, her figure had become well proportioned, and her movements had lost the gracelessness of early youth.

The good looks of either of the girls, in Paris at any period, would have been sufficient reason for a chaperon in the evenings, and at that time the "Ville Lumière" was even worse lighted than it is at present. With the exception of the great thoroughfares, few streets in that city can now be said to be illuminated, but such rare lamps as project from the walls are usually gas or electric, and far more powerful than the oil-lamps of the eighteenth century.

Elisabeth went frequently to the Bocquets' in the evenings, to draw and paint with Rosalie, and Madame Vigée went with her, then, and up to the time of Elisabeth's marriage, taking great care of the daughter of whose attractions, physical and other, she had at length become even more proud than of her own beauty.

Madame Vigée frequently took her daughter to see the great permanent collections of pictures, both public and private. In those days the Luxembourg contained the Henri Quatre series of paintings designed by

Rubens for Marie de Médicis, which nowadays fills a spacious gallery in the Louvre.

The exhibition which gave the girl most pleasure was that at the Palais-Royal, originally brought together by the Regent Orléans. It was rich in fine examples of Italian and Flemish art, many of which, by the way, are now in English collections, having been bought for this country when the art treasures of the Bourbons were sold off at the Revolution. At the time when Elisabeth Vigée was, as she said, "feeding like a bee" on these glories of old art, the restorers had recently been doing irreparable damage to some of them. Horace Walpole declared that they had been "varnished so thick that you may see your face in them, and some of them transported from board to cloth bit by bit, and the seams filled up with colour."

Elisabeth not only fed with her eyes on such masterpieces of Rubens, Vandyck, and Rembrandt, and the great Italians as were open to her inspection ; she copied assiduously. It is worth noting that the fanciful heads of her elderly friend Greuze (who, by this time, had devoted his talents to the reigning taste for prettiness, abandoning the elaborate moralities which had once delighted Diderot) helped her even more than the splendid paintings of Vandyck to understand those delicate half-tones which mean so much in her own work. From a close study of the dainty cream-and-rose complexions of the Greuze girls she chiefly gained her early knowledge of the production and effect of varying degrees of light on the salient parts of a face.

Aided by her studies in the great galleries, her lessons from Briard, and her evenings with Rosalie Bocquet, added to the counsels of Doyen and Joseph Vernet—another of the early admirers of her powers— Elisabeth advanced rapidly in her art. Doyen was old-fashioned, while Vernet, the elder of the two, was sufficiently modern to be afraid of Academic teaching. "Whatever you do, my child," he said to her, "don't follow any particular system. Study only the works of the great Italian and Flemish masters ; but above all, study Nature as much as possible. She is the first of all masters, and if you study her carefully you will not fall into any kind of mannerism." Except for the substitution of indoor "nature" for the open-air kind that Vernet himself delighted in, and for the addition of Greuze to the masters whom she studied—very considerable exceptions—Elisabeth, as we have seen, followed Vernet's advice. It was well that she had so soon developed her powers sufficiently to earn

money by their exercise, for her father had left his family very poorly off. Already she was paid quite good prices for portraits, and could help her mother by providing for the needs of her brother Etienne. She could not, however, keep up the home in the Rue de Cléry, whither they had some time ago removed, and, in these circumstances, Madame Vigée, after a brief widowhood, decided to accept an offer of marriage from a prosperous jeweller, considerably younger than herself. Some one wrote the name of this man very badly, and so it has happened that he is variously called Le Sèvre, Le Lèvre, and Le Fèvre, in printed books. His step-daughter herself either forgot, in her old age, what his name really was, or found it unmentionable, calling him by such titles as "my villainous stepfather," or simply "that man." Le Fèvre seems to have been the real name.

Elisabeth went to live with the newly-wedded pair in the Rue Saint Honoré, close to the Palais-Royal. From the first she detested her step-father, who was miserly and generally disagreeable, and who specially disgusted her by wearing her father's old clothes, not even going to the expense of having them altered to suit his very different figure. He took all the girl's earnings, to the indignation of her friends. Vernet, for instance, was intensely angry, and advised her to pay a stipulated sum for her board and lodging, and to keep the rest of her money for herself. She feared, however, that "with such a Harpagon" as Le Fèvre, her mother would have paid in unhappiness for any such change, and so nothing was done to carry out Vernet's wish. Madame Le Fèvre was not allowed much freedom, her suspicious husband being jealous of her good looks. He usually objected to the mother and daughter going out together, unless he was with them, so that they often missed their airings to the Tuileries, the Luxembourg, or the Palais-Royal.

But the young and charming step-daughter was not imprisoned under the roof-tree of the money-grubbing step-father. She received many invitations to dinner—then served at what is "tea-time" nowadays—and met many people who were useful in describing her attractions and talents elsewhere. The first time she dined "in town," as she says, was with Le Moine, the sculptor, and it was in his house, where two daughters "did the honours," that she met Le Kain, the tragedian, who frightened her by his gloomy air and his notorious ugliness. "He did not talk, but he made an enormous dinner." Grétry, the composer whose portrait she was afterwards to paint, and Latour, the pastellist, often dined at Le Moine's, and there was plenty of fun and of music after dinner, and some-

times a little misery for the more nervous of the young girls present, who were made to sing in their turns.

One of the memories of this period which Elisabeth was never likely to forget was of the great firework display in the Place Louis XV (now the Place de la Concorde) on May 31, 1770, to celebrate the marriage of The Dauphin (afterwards Louis XVI) with Marie Antoinette. She went with her mother and step-father, and, thanks to the chance which made them take the route by the Tuileries on their way home instead of returning by the Rue Royale, they were not numbered among the victims of the disaster which then occurred. The tragic event is described as follows by M. Paul Lacroix in a chapter on the " Fêtes and Pleasures of Paris in the Eighteenth Century " : " After the firework display, which had been a complete success, the crowd, in going away by the Rue Royale, then in course of construction, came across another crowd which was approaching from the other end of the street by the Madeleine, on its way to see the illuminations in the Champs-Elysées. The place where these crowds met was packed with carriages. A terrific crush resulted, with fearful shrieks ; the hoardings of the unfinished houses were broken down by the pressure, and many unhappy people, precipitated into the excavations made for the new buildings, were crushed against the stones, suffocated, rolled over, and trodden underfoot. On the morrow a hundred and thirty-three bodies were found at that spot, while the total number of victims reached to more than three hundred, and that of the wounded to over a thousand."

The young painter had no thought, as she went across the Place Louis XV, on that evening of disaster, that before she was forty years old not only the Prince and Princess in whose honour the display of fire-works had been given, but many of her own friends, and scores of her acquaintances would have been killed on the ground over which she was treading. Yet at the time of that accident of 1770 the people naturally regarded so miserable an ending to the marriage festivities as of evil augury for the future of the newly-wedded Louis and Marie Antoinette. For once popular superstition was justified in the long event.

CHAPTER II

THE GIRL-ARTIST

A propitious time for Elisabeth Vigée—The vogue of " prettiness "—The attractions of Elisabeth's studio—Disappointed admirers—Insulting proposals—A skirmish with the law—First public display of her works—Some of her sitters—Social success—Notable acquaintances—" Pleasures " of the country—First meeting with Queen Marie Antoinette —Elisabeth's gifts to the French Academy—A visit from D'Alembert

MADEMOISELLE VIGÉE came before the world in a propitious hour. Boucher (who, after gratifying the courtiers of Louis XV by his voluptuous pictures, had become so fixed in his mannerisms that his best customers were getting tired of his pink nymphs) died in 1770, just when Elisabeth Vigée was beginning to be remarked as a precocious and attractive painter, and when portraiture was becoming more fashionable than the artificialities of Greuze. There was still no demand for the highest art ; and it is certain that few of the ladies of Paris would have cared to be represented on canvas by the veracious brush of a Velasquez or a Rembrandt. Prettiness, as a caustic observer of that time remarked, was the idol of Paris ; in faces, in gardens, in furniture, in dress, in paintings, in prints, verses, and tales it was the " pretty " rather than the noble which delighted. Elisabeth Vigée fitted with delicate precision into that idolatry, and improved its tone. She preferred pretty women above all other sitters ; but, lovely or plain, very few could look unpleasant on her canvas. That was unquestionably one of the main causes of her immense vogue. The women of her time knew that they could safely entrust their personal appearance to the young artist, who would almost certainly make them at least a shade better-looking than nature or their maids had done, and would dress them in a manner that showed off their charms to much better advantage than the hoops and false hair which disfigured them in their daily life.

Not only did she so present the faces and figures of other women, but, quite impartially, she meted out the same indulgent justice to herself.

As befitted a priestess in the temple of the reigning divinity, she was a pretty woman. A careful comparison among her various portraits of herself will convince any one, not actually in love with her, that she was not quite (if very nearly) as pretty as in the charming " straw hat " picture in Trafalgar Square, or the " Grecian " picture at the Louvre.

Like Rembrandt, she was much given to painting her own portrait, and the subject was certainly attractive. There is more of the Narcissus feeling about her self-representations than about those of the Dutch Master, who used his own reflection as a model as much from want of ready money, or temporary dearth of paying sitters, as for any other reason.

We have no early portraits of her by other artists in which we can place much confidence. If we want to see how her appearance impressed other painters, we may study the portrait by David in the Museum at Rouen, and the miniature by François Dumont in the Wallace Collection. The first of these was almost certainly painted in the Empire period, though possibly from sketches made before the Revolution. It is in the highest degree improbable that she would, after her return to France, have given sittings to so bitter a Republican as David, and in the slightly sardonic mouth which she has in his picture there may be another illustration of that enmity towards his old friend which she believed him to have shown very cruelly on several occasions. At any rate David was not at all likely to flatter her. The fact that, in the Rouen portrait, in spite of some bad drawing about the neck and head, she is shown in middle age as the possessor of notable personal attractions, not only of face, but of hair, figure, arms, and hands, justifies a considerable measure of confidence in her representations of herself. A miniature by Ritt, painted about 1796, is even more favourable.

For written testimony to the veracity of one, at least, of her best-known self-portraits we may turn to the Princess Natalie Kourakin, who (when she visited Florence in 1818, just after seeing a great deal of her old friend Madame Lebrun in Paris) wrote of the Uffizi picture : " How pretty she must have been, and indeed, how much she still resembles that portrait."

Elisabeth Vigée's successful portraits of friends and acquaintances, bourgeois or artistic, had come, in a short time, to the notice of " people of quality," and when she had painted the young Marquis de Choiseul, the Comte and Comtesse de la Blache, Madame d'Aguesseau (" with her dog "), and other persons of social influence, who were pleased with her renderings

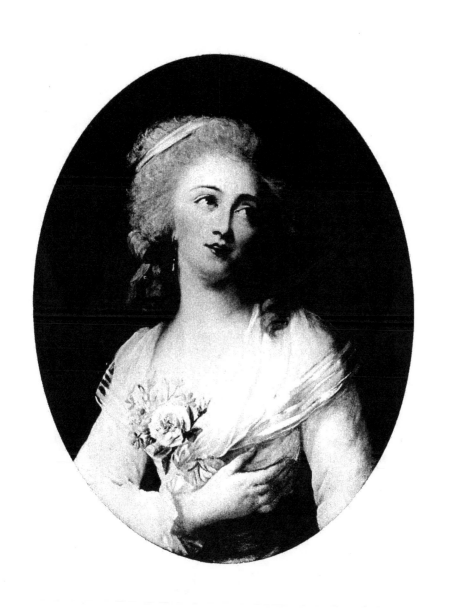

of their appearance, a career was open to her, and she became " fashionable." If the women were drawn to her studio because they longed to have their charms rendered with the fullest appreciation on canvas, the men often sat in order to make love to the artist. " Several amateurs of my face," she tells us, " desired me to paint their own faces, in the hope of making a favourable impression on me, but I was so engrossed by my art that they could not manage to distract me. . . . Whenever I saw that they were trying to look tenderly at me, I painted them as if they were lost in thought, which makes it impossible for the sitter to look at the artist. Then, at the least movement of their gaze in my direction, I said ' I am doing your eyes ' ; that vexed them a little, and my mother, who was always in my studio on such occasions, and whom I had taken into my confidence, laughed to herself."

Among these " amateurs " were, it would seem, the Comte du Barry (brother-in-law of the celebrated lady with whom Mademoiselle Vigée was to become well acquainted in later years) and the Comte de Brie. The attentions of this last gallant were worse than a nuisance ; he insulted the artist by trying to buy her affection for cash. At the time of her marriage, as we shall see later, he revenged himself for her refusal of his " protection" by inventing and spreading scandalous stories against her virtue.

It must not be supposed that Elisabeth Vigée was insensible to admiration. She well knew that she was attractive, and she took every reasonable care to look as nice as possible on all occasions. Her taste in dress was simple, and she was one of the first women of any " fashion " to see the folly of elaborately artificial hair-dressing, and of disguising the natural figure by hoops and tight-lacing. How much she valued good opinions on her personal appearance may be estimated from her own little story of an incident at the Coliseum, a sort of gaudy " Ranelagh " of plaster and gilt in the Champs Elysées. When darkness set in, the company at this resort used to leave the surrounding garden for the Rotunda, where an excellent concert was provided. On the conclusion of the entertainment, the women, as they went out through the portico, had to listen to the audible criticism of the " elegants." One evening, as Mademoiselle Vigée was coming down the steps with her mother, the Duc de Chartres (the Philippe Egalité of the Revolution), who was lounging there with his equally disreputable friend the Marquis de Genlis (both uttering offensive sarcasms on the women who passed before them), said out loud to his

companion, as Elisabeth Vigée appeared: " Ah! there is nothing to say about this one."

In recalling the incident sixty years afterwards, " This one " said : " The remark, which many people besides myself heard, gave me so keen a satisfaction that I remember it still with a certain pleasure."

It was about this time that Elisabeth had her first conflict with the law. The guild or corporation system was so strongly established, among artists as well as artisans and tradesmen, that it was illegal to paint portraits for money unless one was either a member or apprenticed to a member of some recognised Academy of Art. Elisabeth had never taken this regulation seriously into account, and was unpleasantly astonished one day by the appearance of a bailiff charged to seize the contents of her studio. The way out of this difficulty which naturally presented itself to her was to apply for admission to the Academy of Saint Luke, in which her father had been a teacher, and of which several of her friends were members. After showing some of her pictures at the rooms in the Rue Saint Merri, where this Academy had its exhibitions, she was admitted, as a " Master-painter," on October 25, 1774.

It is a curious fact that of the pictures attributed to her in the catalogue of the Academy of Saint Luke not one appears in her own list of her works. Eight were specified particularly, including portraits of M. Dumesnil, rector of the Academy (this served as her diploma picture), M. Fournier, counsellor of the same Academy, and several other persons, men or women, and also imaginative representations of women representing " Painting," " Poetry," and " Music." Most of these works were done in oil, but there was an oval picture in pastel, of an unnamed lady.

It is worth noting that at this exhibition Elisabeth Vigée for the first time found herself in rivalry with the artist (six years her senior) who was destined to be her chief competitor—Madame Adelaide Labille-Guiard. It was the first public exhibition of works by either of these gifted young people. The work of Elisabeth's friend and fellow-student, Rosalie Bocquet, was also represented on this occasion.

Mademoiselle Vigée's pictures, thus shown to the public, had a considerable success with the amateurs of budding talent, and commissions came in more rapidly, so that the invocation of the Law of Corporations against her had really hastened her arrival as a successful portrait-painter. In her twenty-first year, according to her own list, she painted no less than thirty-three original portraits. Some of these were pastels, and some,

perhaps, mere sketches, but in any case it is clear that she already worked very hard, and that she had plenty of willing sitters.

Among them were Madame Dénis (Voltaire's niece), the Prince de Rohan-Rochefort, Mademoiselle Julie Carreau (afterwards the wife of Talma the tragedian), and Count Schouvaloff, formerly Grand Chamberlain at the Russian Court. Of this last sitter the artist tells us that he " united good-hearted politeness with perfect manners, and, being more-over a capital fellow, he was cordially welcomed in the best society." The Count was a friend of Voltaire, and gave him much assistance towards his " History of Peter the Great."

At the house of the Prince and Princess de Rohan-Rochefort, where she was sometimes invited to dine or to sup, Mademoiselle Vigóo became acquainted with many notable persons—none, perhaps, more worthy of esteem than the Duc de Choiseul. After twenty years of hard work in the reorganisation of the army and the navy, and the watchful care of his country's interests, this patriotic public servant had been turned out of power partly because of the influence of the Jesuits, whose expulsion he had helped to secure, and partly because he refused to pay court to Madame du Barry, the successor of the Pompadour in the very mundane affections of Louis XV.

The most entertaining of the company was Armand, Duc de Lauzun. In her whole life the girl was not destined to meet any one who seemed to her more lively and witty. At that time he was under thirty, and was a fine flower of a period when scamps flourished in a rich and well-rotted soil. " He charmed us all," she says, at those suppers where the contest was as to who should be the most entertaining talker. " I only listened, and although too young to appreciate entirely the charm of that conversation, it gave me a distaste for many others."

If the Duc de Lauzun was about the brightest, and the Duc de Choiseul the most creditable member of the circle in which Elisabeth found herself when she was patronised by the Princess de Rohan-Rochefort, no one to be seen and heard at those dinners was more disreputable than " Prince Louis" de Rohan. This man, the epitome of all that was bad in the old régime, was in 1774 (at forty years old) removed from his post as ambassador at Vienna largely on account of his disgraceful way of life. Ten years later he was to achieve immortality by his credulous folly and wickedness in that business of a necklace which had so disastrous an influence on the position of Marie Antoinette.

The sculptor Suzanne and his wife, very kindly people, were the means of giving Elisabeth Vigée her first taste of the real pleasures of the country since she had left Epernon as an infant, and also, indirectly, of bringing her for the first time under the direct notice of the Queen, whose patronage was to be the most important influence on her life.

Most of her week-ends were spent at Chaillot, where M. Le Fèvre had taken what his step-daughter calls "a small hovel." He called it "the country"; "but imagine," she asks, "a tiny garden without a tree, and with no other shade than a small arbour round which he had planted haricot beans and nasturtiums which never grew up. And even then we only had a quarter of this charming garden; it was divided into four parts by little fences, and the other three were let to shop-assistants who came every Sunday to amuse themselves by shooting at the birds. The perpetual noise of their guns drove me nearly wild, and not only that, but I was in constant dread lest I should be killed by these clumsy youths, who couldn't aim straight." From some of the worst hours of these week-ends at the "hovel" Elisabeth was to be relieved by the Suzannes, who, after dining there one Sunday, were moved by pity for her, and took her out for long excursions when the peculiar habits of the sculptor allowed. Two days out of three, he would shut himself up in his room and refuse to see any one, even his wife, or to take any meals. Mademoiselle Vigée naturally regarded this as a "singular malady." It is likely that it was some kind of neurasthenia. On the other hand, the evidence is consistent with the idea that he was an early adherent to the starvation cure for indigestion, and that he was bored by the "chatter and blast," as Emerson calls it, of ordinary conversation. Anyhow, the two days of seclusion were followed by a day when he was full of life and fun. The difficulty was to make his good days coincide with Sunday excursions to such pleasant places as Sceaux, to the south of Paris, and Marly to the west. It was on one of her visits to Marly that Elisabeth, strolling in the park within sight of her mother, came upon the Queen and her attendant ladies "all dressed in white, and so young, so pretty, that they seemed like a vision" to the girl, who was moving out of the way when Marie Antoinette called her back, and told her to walk wherever she liked.

In 1775 Mademoiselle Vigée gained the goodwill of the French Academy by sending to that august body portraits of Cardinal de Fleury and of La Bruyère, done from old prints, having ascertained that these former members were not represented in the series of portraits belonging

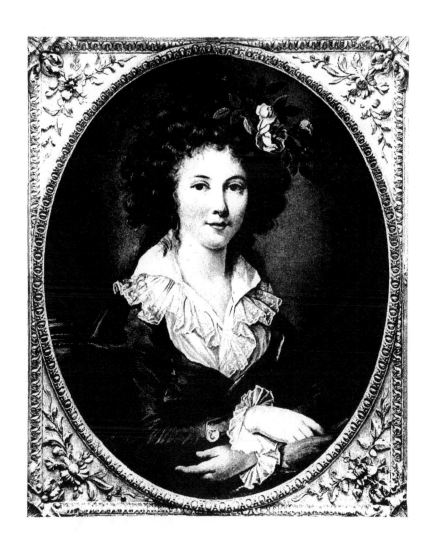

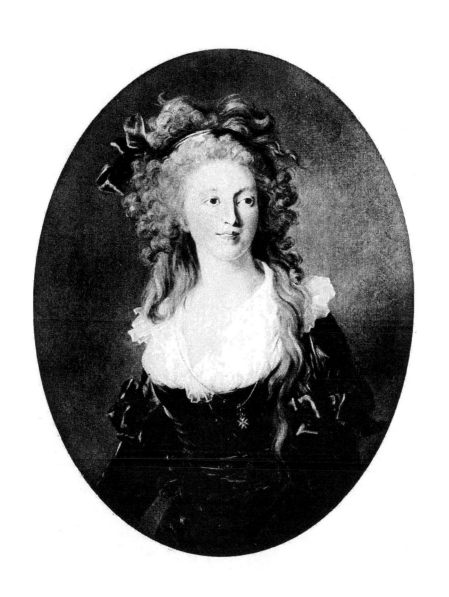

to the Academy. This gift was especially pleasing to the Perpetual Secretary, d'Alembert, who had written the lives of all the Academicians who had died between 1700 and 1772. She received from this highly distinguished savant a letter which would have given pleasure to anybody, and which must have been a source of intense delight to a girl of twenty. Not only, he wrote, had the portraits filled gaps which the Academicians had long deplored, but they would always remind them of their debt to her. " Moreover, Mademoiselle, they will, in their eyes, be a lasting monument of your exceptional talents, which were known by common report, and which were enhanced in your case by intelligence, grace, and the most charming modesty." On behalf of the Academy he begged her to accept a permanent invitation to all its public meetings, and on his own behalf he added that he was glad of the opportunity of assuring her of the high esteem in which he had long held her on account of her talents and her personality, an esteem in which he was supported by everybody of good taste and judgment.

D'Alembert soon followed up his official letter with a personal call. He was then fifty-eight years old, rather frigid, but extremely polite. He remained a long while in Mademoiselle Vigée's studio, saying many flattering things. When he had gone, a lady of high rank, who happened to be present, asked Mademoiselle if she had painted the portraits of La Bruyère and Cardinal Fleury, of which M. D'Alembert had been speaking, from life ? As one of the subjects of these pictures had been dead for eighty years, and the other for thirty, we may almost pardon Elisabeth Vigée the laugh with which she replied, " I am a little too young for that."

CHAPTER III

MARRIAGE

M. Lebrun as lover—He marries Elisabeth Vigée—Reason for a secret wedding—Scandalous talk—Invoking the police—Want of money—An art school that failed—Scheme for a judicial separation—The plan abandoned—Habits of M. Lebrun—Art dealing—A valuable customer—The vanity of riches—An influential friend

HOWEVER "sage," as her countrymen say, Mademoiselle Vigée may have been towards unprincipled men who were attracted by her charms without desiring to marry her, she failed lamentably in sagacity when she came to choose a husband.

M. Le Fèvre had taken his wife and step-daughter to live once more in the Rue de Cléry, in a house opposite to that which they had inhabited at the time when he offered himself to Madame Vigée as a husband. In the same house—" flats " were almost as common in Paris then as they are now, in proportion to the population—lived a dissolute young man about seven years older than Elisabeth, Jean Baptiste Pierre Lebrun by name, the son of a dealer in antiques, and himself a dealer in " old masters " and other pictures, as well as an artist of some slight pretensions. Being an astute and lightly-principled person, Lebrun, after thinking the matter over, arrived at the conclusion that " there was money " in a marriage with so promising and already so successful a portrait-painter as his neighbour's step-daughter. No doubt her charms of person and manner counted for something, even if he regarded her more favourably as a source of wealth than of sweetly conjugal happiness.

Jean Baptiste was not ill-looking, he had a good figure, he was lively, attentive, and entertaining in an airy sort of way. Moreover, he was clever enough to write favourable little criticisms on Elisabeth's work, to get them printed, and, of course, brought to her notice. Then, when he thought the ground had been sufficiently prepared, he made her an offer of his hand, his affection and his ostensible riches. Those who are familiar with the scene in *Arms and the Man* in which the " hero " outbids his

Servian rival for the hand of the " heroine," will have no difficulty in understanding how a dealer in expensive pictures and ornaments could make a false impression of solid wealth on so simple a soul as Madame Le Fèvre, and so inexperienced a person in matters of money and property as her daughter of twenty-one. His rooms, which, handsomely furnished and richly decorated, satisfied the mother, were hung with pictures which were a delight to the eyes of the daughter whom he desired for his wife. Both women seem to have ignored the fact that his " flat " was really a shop, and his " riches " his stock-in-trade, much of which was not his own.

Bluntschli, the Swiss hotel-keeper's son, in Mr. Shaw's play, overpowered the Petkoff family by his assertion that, while Saranoff could only claim twenty horses, three carriages, and so on in proportion, he himself possessed two hundred horses, seventy carriages, nine thousand six hundred sheets and blankets, and two thousand four hundred eider-down quilts. Lebrun, showing his scores of fine pictures, and his beautiful inlaid tables, was even more easily able, by ocular demonstration, to impress the only two women who needed to be influenced. Le Fèvre must have known something of the truth, if not all of it, but he seems to have been glad enough to get his step-daughter married and out of his way, in spite of the fact that she was more than able to pay for her keep in his too economical establishment.

But for the fact that Lebrun was already more than half engaged to another girl, he probably would not have succeeded in drawing Elisabeth Vigée into his trap. It fell out in this way. He was at the time carrying out a big " deal " in pictures with a Dutchman, and, in order to facilitate business, the Frenchman had persuaded the Dutchman that he was anxious to marry his daughter. If it now appeared that he was on the point of marrying some one else's daughter, his immediate business would be seriously hindered, and very likely lost altogether. So the marriage with Mademoiselle Vigée was privately celebrated, without the publication of banns, in the church of Saint Eustache, on January 11, 1776. She was not very keen to marry Lebrun then, but her mother was anxious to see her settled, and she herself was tired of her disagreeable step-father. " I felt so little incentive to give up my freedom," she writes, " that on the way to the church I still asked myself : shall I ? shall I not ? Alas, I said yes, and I exchanged one set of troubles for another."

The necessity for concealment still remained until the Dutch affair was concluded. The result of such secrecy was an early trial for the bride.

2

Her friends, seeing her constantly in Lebrun's company, expressed their alarm lest she intended to take the very step she had already taken. It was just the situation of which Victorien Sardou made the finest scene in his melodrama *Dora* (known in the popular English version as *Diplomacy*), save that in the play it is the new and innocent husband who is warned, instead of the wife. Among others, Aubert, the court jeweller, quite plainly told Elisabeth that she would be wiser to tie a stone to her neck and jump into the Seine than to marry Lebrun. This was bad for a newly wedded wife to hear, but as she still believed in her husband's respectability and was herself the victim of scandalous lies, she was not yet to be enlightened as to the selfishness of his "affection."

The scandals about herself at this trying time were the work of the scoundrelly Comte de Brie, to whom reference has already been made. Lebrun denounced him to the police for spreading reports damaging to Madame Lebrun's good name, and particularly for writing anonymous letters in which it was asserted that she was a young woman of the lowest morals, several men being actually named as belonging to her crowd of lovers. The complaint to the Commissary of Police in the Saint-Eustache quarter seems to have stopped the lying of the Comte, and for a time the Lebruns were tolerably happy together. They were none too well off in real and personal property, but she was rich in prospects. They had bought on the instalment system the house in the Rue de Cléry wherein they lived ; Lebrun's pictures and furniture were valued at about £4,000 sterling. He owed about £1,200, and he was owed £240. His wife brought a dowry of about £600, half inherited from her father and half saved from her earnings, with some furniture, jewels, and the usual outfit of linen. As money went about three times as far in those days, in its purchasing power, as it does to-day, they ought to have made a good start had all their estimated means been tangible.

From the day of his marriage till she left him for Italy, thirteen years later, Lebrun took possession of his wife's earnings and fixed the charges for her portraits. As she was not at that time a very good business-woman, this might have been a satisfactory arrangement, had he regarded her interests as much as his own.

In order to exploit his wife's powers as fully as possible, Lebrun suggested that she should take pupils, like some other successful painters. She agreed to try, and her time was soon much occupied by several girls whose instruction in the elements of painting not only interfered sadly

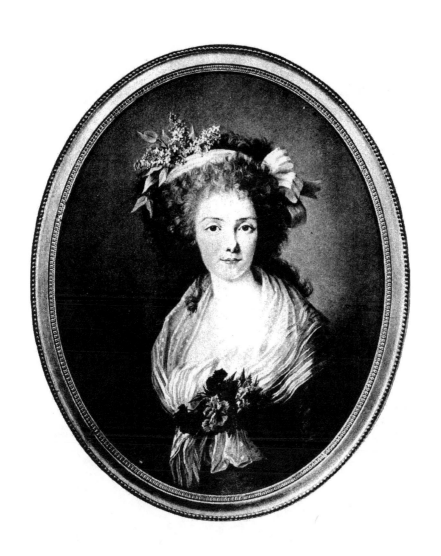

with her usual work, but bored her terribly. Most of these pupils were older than their teacher, and she found it very hard to maintain discipline. " I had set up this school in an old loft, across the ceiling of which there were some very thick beams. One morning I went up and found that my pupils had tied a cord to one of the beams, and were trying who could swing the highest. I pulled a serious face, I scowled, I talked finely about the waste of time—and then, I couldn't resist having a swing, and enjoyed it more than all the others." Who can wonder that the school was soon closed ! She had pupils after this time who worked in her studio, among them Mademoiselle Emilie Laville-Leroux (Madame Benoist) of whom Vigée-Lebrun was the first teacher.

The " rainy days " came, but the young couple were not flooded out, though at one time they were very near to a public exposure of their difficulties.

Possibly at the instigation of Lebrun (who, as a debtor, may have thought it convenient to have no attachable share in his wife's earnings), a petition for a separation of goods between husband and wife was drawn up in her name for presentation to the proper legal authorities. This document set out that Madame Lebrun had been " cruelly deceived " as to her prospects of easy circumstances in marriage. Her husband, by bad investments, had lost so much money that he was pursued by creditors, and she (in the language of the petition) "finds herself at the moment liable to be reduced to the last degree of poverty ; and sees no other means of preventing the complete loss of her fortune than to take such action as the law provides—that is to say, by the separation of goods."

Such petitions were as common in the Paris of that age as petitions of divorce are to-day—indeed, they were relatively more numerous. Divorce itself was not yet possible by any process of law open to the general public, but considerable pressure could be brought to bear on a wearisome or too-fickle husband by the wife's proposal to dissolve the partnership in worldly goods, if not actually to end his claim on her society, which, in such cases as the Lebruns', he did not usually value so highly as his power to spend her money.

Nothing came of the petition, and, indeed, the picture-dealer soon found his business much improved. He was able, out of his wife's earnings, to build a large gallery in the courtyard of their house, where he could show and sell his " old masters " and whatever other examples of art he might have in stock. In his opinion his wife owed a good deal of her

success to the cultivation of her taste and talent by contemplation of these masterpieces, and no doubt it was of some help to be able to gaze at will on examples by Italian and Dutch masters. The building of this big room was one of the most sensible things Lebrun ever did with Elisabeth's money, much of which he spent, as he did his own, in gambling hells and on other women.

In spite of all his faults of commission and of omission she has a good word to say for him. He was a smooth-tempered person, ready to do little services for her or any one else, and never interfering with her social pleasures, in which he himself had a very small part. She could stay in country-houses, go out to any number of evening parties, to the theatre or to the opera, without having to consider how he was to get on without her. That question never gave him any anxiety, and she does not seem to have bothered herself about it either. He was never rough to her, or abusive ; he did not spy on her, nor behave in the ordinary way of evil-disposed husbands towards pretty wives who have found them less desirable after experience of married life. He merely behaved as if he were a bachelor, and, like her step-father before him, regarded her industry as his own.

There is little doubt that, had he been a person of orderly character, Lebrun would have done very well indeed in his business of art-dealer, wherein, even in the days when the many American millionaires of our own time were represented in advance by a comparative handful of Fermiers-Généraux and other financiers, profits much beyond those of ordinary shopkeeping were to be made by an acute and experienced man. A spendthrift and gambler is not the kind of person to succeed in such a business, where a large balance at the bank is often essential to a successful venture. Ready money, indeed, was much more needful in those days, when the banking system, and the whole machinery of credit, had been so much less elaborately developed. As it was, Lebrun was at times prosperous. He usually had plenty of business ; the trouble was, that he would spend his money—and hers—almost as fast as it came in. About the best thing we ever hear of M. Lebrun was that, in 1793, when monuments and works of art connected with royalty were being ruthlessly destroyed, he managed to save some fine bronzes. These included the bas-reliefs from the pedestal of the statue of Louis XIV. in the Place des Victoires, five of which found their way into the house of George III. at Kew, and were given back to France by King George V. when he visited

Paris in April 1914. Lebrun was a member of a committee chosen to select such objects for preservation, and he was the only member who kept the appointment, so that he selected what he liked for the State.

An example of the customers desired of art-dealers in the eighteenth century, and particularly of the period with which we are at the moment concerned, may be found in M. Nicolas Beaujon, best remembered in the Paris of to-day as the munificent founder of the great hospital which bears his name. As banker of the court, and later on as Receiver-General of finance in Normandy, he made a very large fortune, much of which he expended for the public benefit, or in private charity. At the time when, about eight years after her marriage, Madame Lebrun painted his portrait, he was living in the Elysée Palace, formerly the Paris home of Madame de Pompadour, and nowadays of the President of the Republic.

M. Beaujon was of precisely the kind of capitalist that makes the fortunes of dealers, as we may gather from Madame Lebrun's account of her visit to him at the Elysée. " The first salon one entered was hung with rather showy pictures, none of remarkable merit—so easy is it for amateurs to be deceived, whatever value they may attach to their acquisitions. The next salon was a music-room : pianos great and small, all kinds of musical instruments, nothing was missing from the collection. Other rooms, such as the boudoirs and the studies, were most elegantly furnished. The bath-room was especially charming : a couch, and the bath itself, were covered with beautiful muslin (of which the design represented little branches of flowers) lined with pink, and the walls were hung with the same materials. The suites of rooms on the first floor were equally well furnished. In the middle of one room, the ceiling of which was supported by columns, stood an enormous gilt basket, surrounded by flowers, and containing a bed wherein no one had ever lain."

The contrast between this display of luxury and the life of the master of the house was so sharp that it is worth while to quote further from Madame Vigée-Lebrun's account. " It was impossible for me to move about in that delightful house without heaving a sigh of pity for its wealthy proprietor, and without remembering an anecdote I had heard a few days before. An Englishman, anxious to see everything that was considered remarkable in Paris, successfully sought permission from M. de Beaujon to visit his fine house. When he was shown into the dining-room, he found the big table laid, as I had found it myself, and, turning to the footman who was showing him round, he said : ' Your master evidently

enjoys a good dinner?' 'Alas! sir,' answered the man, 'my master
never comes to the table; his only dinner is a dish of vegetables.' The
Englishman going then into the drawing-room said, as he looked at the
pictures, 'Here at least he can feast his eyes.' 'Alas! sir,' replied
the servant, 'my master is nearly blind.' 'Ah!' said the Englishman,
as he entered the music-room, 'he is compensated, I hope, by listening
to good music?' 'Alas! sir, my master has never heard music here; he
goes to bed too early for that, hoping to obtain a few moments of sleep.'
The Englishman, looking out of the window at the fine garden, said then:
'At any rate your master is able to enjoy the pleasure of strolling there.'
'Alas! sir, he is no longer able to walk.' At that moment the guests
invited to dinner passed within sight, among them being some handsome
women. 'In any case,' said the Englishman finally, 'here I see more
than one beauty who can make him pass some very agreeable moments.'
The servant only replied by saying, 'Alas!' twice over, without adding
another word."

In truth, M. Beaujon was so crippled by disease that he could not
use either his hands or his legs. Madame Lebrun relates how he would
sit in his wheel-chair at the side of the dining-room, while thirty or forty
guests were dining, including some ladies, " all well-born and very good
company, who were known as the *berceuses* (cradle-rockers) of M. de
Beaujon. They gave orders to his household, and had the free use of
his establishment, including his horses and carriages, giving in return for
these advantages the few short hours of conversation that they afforded
to the poor cripple, weary of living alone." Could any moralist desire a
much more effective illustration of the vanity of riches?

M. Lebrun did, undoubtedly, receive a good deal of money from such
customers as M. Beaujon, and others of smaller "worth" from the financial
point of view. But money, as we have seen, was not comfortable in his
coffers or his pockets. If he did not, like Charles Lamb's friend, " literally
toss and hurl it violently from him," he at any rate " made use of it while
it was fresh "; and had not her sound (if delicate) constitution, strengthened
by a wholesome infancy at Epernon, enabled his wife to work almost inces-
santly from morning until evening, the contents of the house in the Rue
de Cléry might very soon have been distributed among brokers who would
have given Lebrun no share in their " knock-out."

There was no lack of custom for her painting. Courtiers, ambassadors,
wealthy merchants, with their wives and daughters, were already glad to

sit to so accomplished and charming a painter. One of her most useful
friends was the Duc de Cossé (who was to become Duc de Brissac on the
death of his father in 1784), the acknowledged lover of Madame du Barry.
He employed the young artist to copy a portrait of his mistress, as well
as to paint an original portrait of himself, and he álso purchased several of
her early studies. His position as a distinguished leader in social affairs
enabled him to advertise her talents very fruitfully.

CHAPTER IV

MARIE ANTOINETTE

NOW that we have seen Elisabeth Vigée unhappily married, but started on a career which, in spite of some fearful experiences and great obstacles, was to continue almost unchecked for thirty years, and to run out in as many years of leisured prosperity, we may cast a glance over the social conditions amid which she gained a firm position as a professional portrait painter, and on the external aspects of which at least she exercised some degree of influence.

The motives and actions of a person cannot be properly appreciated without regard to the general trend of thought and social conditions in which that person grew up and played a part in the drama of experience. In the case of Vigée-Lebrun these factors are of even special importance, because she lived at one of those rare epochs in which evolution gives place to convulsion, and the division between past and future is marked by a cleft, instead of by a mere shifting of another bead on the endless rosary of Time.

As every reader who is likely to trouble about Paris history is well aware, the French Revolution did not begin in July 1789, when the Bastille was destroyed by the mob. The spirit of popular revolt against the old order, the determination on the part of the manual makers of wealth to have some share in its advantages, had long been spreading not only below, but upon the surface of society in Western Europe. As far back as 1766 an insurrection in Madrid, largely brought about by the excessive taxation of bread and oil, had been marked by incidents between the Spanish Court and people which, in the light of after years, seem like dress rehearsals for the days when the women of the Paris slums marched to Versailles,

and when the French King and his family fled, with such disastrous results, to Varennes. In that same year of the Madrid revolt there were serious outbreaks in France, which, for the time being, the Government was strong enough to suppress. Sixteen years earlier Lord Chesterfield had noted that the " germ of reason " which Du Clos, the historian, had about that time declared to be developing itself in France, must prove fatal to the monarchy and the church as they then existed. Every warning, however, was lost on the people whose manner of life was a principal source of discontent. Had the whole nation shared in hardships that were borne for the common welfare, the suffering of the toilers could more easily have been endured. Most of the army of courtiers, sons and grandsons of those whom, for reasons of policy, Louis XIV had compelled to spend their time at Versailles, lived in idle luxury.

The nobility was as distinct from the people without the particle " de," as the officers of a big ship are distinct from the crew. A nobleman was treated as a being set apart by Providence to enjoy the Court and its pleasures ; the rest of the people were born into the world to produce the food and raiment and other wealth which he and his class required, or to minister to his needs by keeping shops or lending money.

Between the nobles and the shopkeepers came a vaguely defined class, largely made up of men of letters and artists, whose powers of entertaining or otherwise pleasing made them welcome in the houses of the courtiers and even attracted the courtiers into their dwellings.

If everything was *roturier* to the noble outside his own class, the typical bourgeois, or plain citizen possessed of substantial means, was often more antipathetic to the working-class than were the nobles themselves. He had no " Divine Right," and his airs of superiority were harder to excuse than those from which they were imitated. Yet it was chiefly through the advance in political influence of the wealthy middle-class that the nobles were losing power in the state, wherein the position, both of themselves and (parodoxically as it may at first sight seem) of their supplanters who were not " noble," was rapidly becoming untenable.

All this is the commonplace of history. Yet, in the days when Madame Vigée-Lebrun was painting the belles of Paris and Versailles, scarcely a fear troubled their minds, or hers, save that of scandalous tittle-tattle.

Sincere love, which at most periods of recorded history has been one of the chief social forces at work, was never less powerful in any civilised

society than among the courtiers and their parasites in the thirty years
preceding the Revolution. The human butterflies that fluttered in the
bowers and coppices of Versailles and Marly had no longer that
capacity for ardent passion which had existed among their grandparents.
Galanterie had indeed usurped the place of *L'Amour*, and fidelity to
one lover at a time was somewhat out of fashion. It must in fairness be
recognised that, so far as we may judge from the memoirs of the age, there
was a good deal of platonic affection left, and that it was not always less
possible in Paris than in Edinburgh for "affairs of the heart" to run such
a painful course as that which is displayed for our analysis in the letters
of "Clarinda" MacLehose and "Sylvander" Burns. It was, however,
much more improbable, seeing how widely the example of Versailles and
the Court during many years had spread. Men and women "of fashion"
certainly took their pleasures gaily in the Paris of Madame Lebrun's youth,
and for the most part acted strictly in accordance with the Roman poet's
advice: "Carpe diem," of which the best-known and very free rendering
is "Gather ye rosebuds while ye may."

There were plenty of sober-minded people to be met with among
the middle classes, not excepting the artists and authors; but artists and
authors lived then, as they must in most cases, by producing what was
agreeable to the people with money to spend. All of them had not even
so much self-respect as Doyen, whose refusal to paint an undignified
picture was recalled on an earlier page, and the frivolity and superficiality
which ruled in the Court often ruled also in the studio, the library and
the shop.

In their morals, the frivolous class—which unhappily included most
of those, bourgeois as well as noble, who came to high office in the state—
were in some ways much less careless than their forbears. They were
usually careful in keeping up appearances, and it required the habits of a
Paul Pry, or even the cunning of a clever detective, to find out any of
the truth about half the scandals of the day. To display a *liaison* was an
offence against etiquette; people who behaved after the candid fashions of
the Restoration in England or the Regency in France would, until chaos had
established its power at Versailles, have been sent to their country houses
very speedily. Outwardly, therefore, there was little, so far as morals were
in question, to offend the most honest prude. Nothing in this respect had
changed much since Walpole, in a letter to his old friend Gray (the author
of the *Elegy*), wrote in 1766 from Paris: "It requires the greatest curiosity,

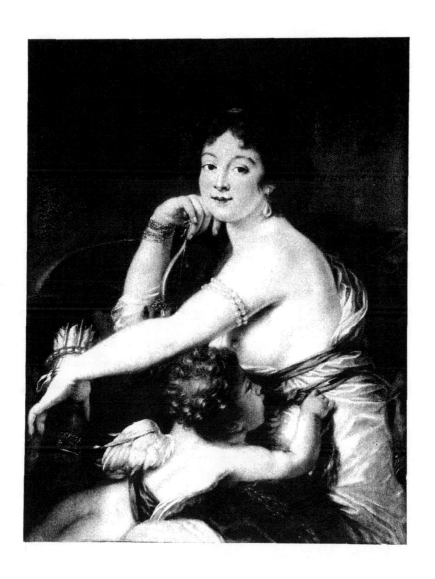

or the greatest habitude, to discover the smallest connection between the sexes here. No familiarity, but under the veil of friendship, is permitted, and love's dictionary is as much prohibited as at first sight one should think his ritual was."

The writer of this letter at the same time warned Gray not to believe a syllable of what he read in French novels about love affairs, or to suppose that *amie* necessarily implied anything more than a " decent friend."

These impressions of social life in Paris, by a man who had the best opportunities of going behind the scenes that any foreigner could obtain, were written just before Elisabeth Vigée left her convent school, but they have a considerable bearing on her experiences of the world when she had come into notice as a portrait-painter who happened also to be a pretty woman.

Had the society which centred in Versailles and the Tuileries been altogether frivolous, it would have come to its death even more quickly than it did. Not a few of the nobles had, indeed, followed the motto attributed to the Ducs de Broglie : " Love your wives and your châteaux," and had taken away their first objects of affection to rusticate in the second. But all that we learn from Madame Lebrun of the conversation and habits of the people whose portraits she painted, who attended her " evenings," and to whose dinners or suppers she went, bears out the general impression which most students of eighteenth-century France have necessarily formed. There was plenty of light morality in England too, but with that we have nothing to do here.

Paris has never been an index to France, either socially or politically, and at no time has the capital less closely resembled the country in its ways of life and thought than in the eighteenth century.

The politic measures of Louis XIV in dealing with the nobility had so concentrated the wealth and culture of the leisured class in and about the Court that very many of the large estates in the provinces, and many of the small estates also, were almost entirely neglected by their owners. La Bruyère's terrible description of the peasantry towards the end of the seventeenth century, when the system of Louis XIV was already fully established, is one of the most famous passages of his series of incisive character-studies illustrating the manners and thoughts of his time.

A hundred years of abandonment to agents and bailiffs, whose constantly repeated instructions from their employers at Versailles were to

get more money out of the estates by hook or by crook, had done nothing
to brighten the picture.

Louis XVI (the opening of whose reign in 1774 synchronised closely
with the commencement of Elisabeth Vigée's career) was indeed, as was
well said, " separated from the people by his faults, and from the nobles by
his virtues," and was so far from being a spendthrift on his own pleasures
that his moral integrity was one of his gravest defects in the opinion of
his entourage, who could not understand a man voluntarily preferring
lock-making to love-making.

Years before the thundercloud burst over Paris, Marie Antoinette had
become the object of the vilest efforts of scandal-mongers. The story of
the campaign to destroy her reputation is one of the most sickening that
has ever been told, and the fact that she figures in history as a thought-
less pleasure-seeker, not as a really vicious woman, is a triumph for her
over her calumniators. Had she, brought at fifteen as a stranger from
the most pompous to the most depraved of courts, become as bad as her
enemies, there would have been more cause for pity than surprise.

During the early years of her life in France she was feather-headed,
and often very foolish in her conduct. After she became a mother,
she was much more careful and dignified, and had she been under the
influence of honest and prudent people, she would have been spared many
of her worst mistakes.

Unhappily, the set—sometimes divided against itself—of courtiers
who surrounded her, and had her ear at all times, was in most of its
members, its aims and its methods, everything that it ought not to have
been from the point of view of the Queen's happiness. These people got
riches for themselves by obtaining sinecures and properties through her
assistance ; they worked their friends into high positions, even against
her real wishes. But for this "set," Calonne, for instance, would never
have been Controller-General.

Not only was Elisabeth Vigée born in the same year as Marie Antoi-
nette, not only did she owe her fame and fortune chiefly to the favour of
that unfortunate Queen, but she was subjected, in the less degree that
matched her difference of position, to the aspersions of some of the same
tribe of calumniators that attacked her kindly patroness.

CHAPTER V

THE QUEEN'S PORTRAITS

A first sitting from the Queen—Marie Antoinette described by the artist—Were Vigée-Lebrun's portraits good likenesses ?—What Maria Theresa said of her daughter's portrait—Grand toilettes and simple dresses—The Queen sings duets with the artist—The Prince de Bauffremont's picture of the Queen by Vigée-Lebrun : how was it painted ?—The birth of Vigée-Lebrun's child—Madame de Verdun the " friend in need "—The Queen's considerate conduct—Vigée-Lebrun paints all the Royal Family except one—Scores of sitters waiting their turns

FROM her own record, and from other sources, it is known that Madame Lebrun had painted several portraits of the Queen before she was accorded the favour of a sitting. These were either exact copies of other people's original drawings or paintings, or else variations based on such works. She was willing to do them at low prices—from 240 to 480 francs apiece—seeing that they were in the nature of "command" commissions, and were likely to lead to something better. Small as the prices were, it was not easy to get paid. For the money due on two pictures that were painted and delivered in 1777, costing 720 francs together, she was obliged to write, two years later, evidently at the dictation of Lebrun, a letter to the Controller-General of the *Menus Plaisirs* of the King, in which she says : " You will do me the greatest service if you will give me a special order which will enable me to obtain that trifling amount. No service would be more highly appreciated by my husband, at a moment when he is owed a considerable sum."

Little worries of this kind were of no consequence in face of the happiness which came to her when, according to her *Souvenirs*, in that same year (1779) she was for the first time given sittings by the Queen. At the first sitting, the imposing air which Marie Antoinette always affected when strangers were present frightened the young artist " prodigiously," but the Queen spoke so kindly to her that her fears were speedily removed. From that moment Madame Lebrun was so permanent a devotee of her royal patroness that her description must be accepted with

a little reserve. On the whole, it is as clear an account of Marie Antoinette at the height of her good looks as history possesses. She was, as we hear from her favourite artist, " tall, with an admirable figure, rather plump, but not too much so. Her arms were superb, her hands small and perfectly formed, her feet were charming. She walked better than any other woman in France, carrying her head very erect, with a majesty which made the Sovereign recognisable in the midst of all her court, without detracting from the sweetness and benevolence of her aspect. It is really very difficult to convey to those who have never seen the Queen any idea of the union of so many graces and so much nobility. Her features were not regular ; she inherited the long and narrow oval face peculiar to her Austrian nationality. Her eyes were rather small, their colour was nearly blue ; her expression was intelligent and gentle. Her nose was small and pretty, and her mouth was not too big, although the lips were rather thick. But the most remarkable thing about her face was the brilliance of her complexion. I have never seen another to equal it, and brilliant is the right word to use ; for her skin was so transparent that it did not take a shadow (*elle ne prenait point d'ombre*). I could not render it to my satisfaction : the colours were wanting that could paint that freshness, those tints so fine which belonged only to that charming face and which I have never found again on any other woman."

It is a not uncommon criticism of Madame Lebrun's portraits of Marie Antoinette that they are not really " portraits " at all, but flatteries. After examining representations of the Queen by other hands, and noting where they agree with or differ from the portraits by Madame Vigée-Lebrun, or among themselves, I am convinced that most of those done by Madame Lebrun from life are no more unlike their human original than the works of Romney, of Gainsborough, or of Lawrence are unlike the people (especially the ladies) who sat for them. Let us compare, for example, the portraits of Mrs. Robinson, by Gainsborough and by Romney (Wallace Gallery), or those of Mrs. Siddons, by Lawrence and by Gainsborough (National Gallery), and decide what those ladies really were to the eye.

Not only are all Vigée-Lebrun's portraits of Marie Antoinette at Versailles (with the possible exception of that first one of 1779) consistent with each other, and with others from her hand in various collections, but they are consistent with the charming bust of the Queen in early youth by Augustin Pajou (the elder), also at Versailles, and with portraits by other artists. As for engravings, the Queen's face was, with the possible exception of

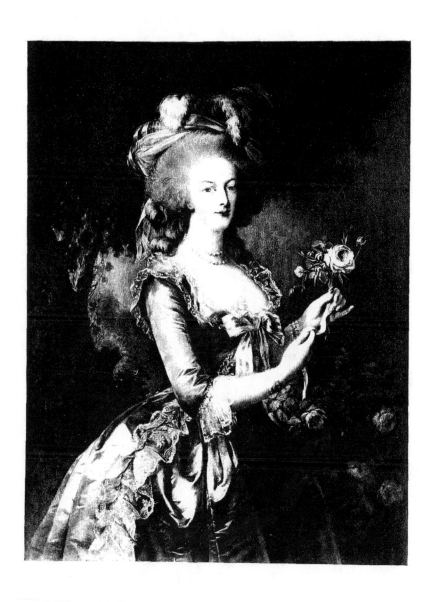

Voltaire's, the subject of more prints than any that ever gazed out upon the world; and, widely as they may differ among themselves, there are those among them which go to show that Madame Lebrun, if she has often somewhat "improved" on what nature had done for Marie Antoinette, still enables us to form a true idea of the Queen's appearance in the days before ruin had fallen upon her. The softening treatment used by Millais, in his rendering of the faces of Mr. Gladstone and Disraeli, was no more or less legitimate than the fining off of some defects in Marie Antoinette's face by Madame Lebrun.

The first of the portraits distinctly declared to be from life is not, as already suggested, as consistent as might be expected with those that followed. Evidently it gave great satisfaction to the Queen, for whom the artist made two replicas. Two more were made for other people. Of these four replicas, two are at Versailles. They differ from the original in that the necklace has disappeared. The young Queen is dressed in the monstrous hoops and paniers which, about that period, made the ladies of the French court as uncomfortable, and as unnatural to view, as were the ladies of the Spanish court in the days of Velasquez. Regarded in the light of present-day fashions, the costume is hideous, but ugliness in woman's dress seems to be a question not of taste, but of convention, and no doubt Marie Antoinette thought herself beautifully dressed as she stood up in this fortress of frameworks and furbelows. Her hair is arranged in an unbecoming fashion, and her pose is stiff—it could not be otherwise in such clothing.

The original of this portrait is in the Hofburg at Vienna, whither it was sent as a present from the young Queen of France to her mother, the Empress Maria Theresa, whose letter acknowledging its reception contains the phrase: " Your big portrait has delighted me. Ligne has found some resemblance, but it is enough for me that it represents you." This Prince de Ligne, who was as much at home at Versailles as at Vienna, ought to have been a good critic of the portrait, and if he could only find "some" likeness, which apparently was rather more than the Empress herself could do, it is evident that on this first occasion Madame Lebrun's success was not by any means complete.

An engraving of this portrait had a great success after the return of the Bourbons, and on that reproduction the original picture was attributed to the Swedish artist Alexandre Roslin, several excellent works by whom, notably a portrait of Boucher, are to be seen at Versailles.

Rather strangely, there is nothing to show that Madame Lebrun made any objection to this false attribution.

Whether the likeness was a good one or not, it is certain that the picture was not altogether a pleasing object to the artist. One must travel far afield to find another in which all her ideas on the subject of dress were so grievously abused.

If she did not originate the fancy for simple costumes of the " shepherdess " and " milk-girl " type, which indeed Watteau and Greuze had painted long before, she made them the mode in portraiture.

The Queen was attracted by the artist, whose timidity speedily gave place to confidence as she found how gentle and considerate Marie Antoinette really was. Something almost of friendship sprang up between these two young women. The Queen was told by some one that the artist could sing well, and afterwards there were few " sittings " which did not include duets sung by the artist and the sitter, for Marie Antoinette was very fond indeed of music, though she had not a very good voice. " As to her conversation," says Madame Lebrun, " it would be difficult for me to describe all its grace and kindliness; I do not believe that Queen Marie Antoinette ever missed an opportunity of saying something agreeable to those who had the honour of approaching her, and the goodwill she has always shown towards myself is one of my sweetest memories."

We have seen that, according to her own narrative, Madame Lebrun first painted the Queen " from life " in 1779, and that the portrait was a " panier " one, showing Marie Antoinette in monstrous hoops and yards upon yards of flouncings and furbelows. There is, however, a charming portrait signed and dated the previous year (1778), which has all the appearance of an original work. In her own lists of pictures—compiled, no doubt, from rough memoranda, and abounding in errors—the artist says that in 1778 she painted two " copies " of portraits of Marie Antoinette, mentioning no original portrait of the Queen. The question to be decided, therefore, is this: was Madame Lebrun doubly incorrect in saying that the first sittings were in 1779 and that only copies were painted in the previous year, or is this fine picture of 1778 the earliest portrait of the Queen " from life " by the artist ?

In the letter to Prince Théodore de Bauffremont, of which a facsimile is given in this book, Madame Lebrun, in May 1837, when she was eighty-two years of age, states that she made the portrait in 1778, and the following

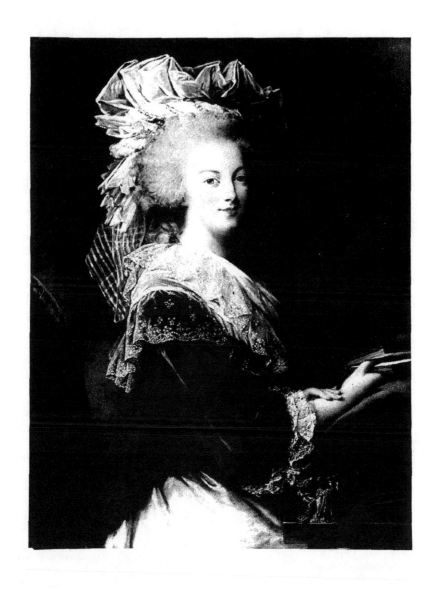

note attached to the picture, dated 6 Oct., 1837, and signed by the Prince, seems to prove that in this statement she was correct.

"This portrait of the Queen," writes the Prince, "is by Madame Lebrun. I have had it re-backed (*fait rentoiler*) because of a hole which I believe to have been a bayonet thrust made during the first Revolution of 1789. She has signed it at the bottom with the point of a penknife, as she always did. The Queen is painted in 1778, when my dear and beloved wife and myself bought (back) (*rachetâmes*) this portrait from the estate of my aunt, Madame La Comtesse de Choiseul. I had it shown to Madame Lebrun, who wrote to me the letter which accompanies this. The portrait is in the salon of my dear Laurence."

No one, I think, who sees this portrait (of which a reproduction is here given, and of which an almost exact twin, in the collection of the Baron Edouard de Rothschild, was reproduced in M. de Nolhac's book) will deny that it is a very fine example of her work.

She does not state that she painted it "from life." We know that in the painting of portraits based on other people's works she was an adept, and I am strongly of opinion, from a frequent comparison of some of her portraits of herself with her portraits of other persons, that she sometimes sat for other figures than her own. That she drew and painted from her reflexion in a mirror with great ease, we cannot doubt, and, as she made the statement to the Prince de Bauffremont just about the time when she was bringing out her *Souvenirs* (wherein she tells us of the "copies" of portraits of the Queen which she produced in 1778, and of no original portrait) is it unreasonable to suggest that the youthful face was painted from somebody else's picture of the Queen, lent to Madame Lebrun for the purpose, and that the rest of the "portrait" was a representation of her own pleasing figure? She was the same age as the Queen, and her contours were no less graceful than those which she professed to be reproducing.

Elsewhere in these pages I have referred to the frequent reappearance of particular hats or scarves in Vigée-Lebrun's pictures. There are other things besides draperies. In the portrait at Versailles of the unhappy wife of Philippe Egalité, she is wearing at the waist a medallion showing a disconsolate woman, with dishevelled hair, seated beneath a willow, with a dog, no doubt signifying fidelity, looking up at her. The word *Amitié* appears on a sculptured urn near by. The special appropriateness of this medallion to the circumstances of the Duchess in 1789, when the portrait was painted, has often been felt. It is therefore specially

3

remarkable that in a portrait of Madame de Laborde, now in the Morgan collection, that lady is seen wearing the same medallion, and is posed very much as the Duchesse d'Orléans is represented in the portrait at Versailles.

The eldest child of the King and Queen, "Madame Royale," as this Princess Marie Thérèse was formally called, had been born in 1778, a year before Madame Lebrun became the Queen's painter; and in the year after the "panier" portrait of the Queen from life was produced, the painter herself gave birth (February 1780) to a daughter, who was to be a source of great pleasure to her at first, and afterwards of great disappointment. This event interfered very little with her work. "Madame de Verdun, my oldest friend, came to see me in the morning. She foresaw that I should be brought to bed during the day, and, as she knew my carelessness, she asked if I was prepared with all that would be wanted; to which I replied, with an air of surprise, that I did not know what was needful! 'That is just like you,' she said; ' you are a regular garçon. I warn you that it will happen this evening.' 'No! no!' said I, 'I have a sitting to-morrow, and I do not wish it to happen to-day.' Without replying, Madame de Verdun left me for a moment to send for an accoucheur, who arrived almost immediately. I sent him away, but he hid in my house until the evening, and at ten o'clock my daughter arrived in the world. I shall not attempt to describe the joy which I felt when I heard my child cry; every mother knows it."

Of the infancy of Julie (Jeanne Julie Louise) we know less than of her mother's, and we only begin to learn anything particular about her when we come to the time of exile from France.

Madame Lebrun had one other child, also a daughter, who followed the first after a few years, and lived but a very short time.

One day, not long before the birth of this second child, Vigée-Lebrun found herself too unwell to go to Versailles, where the Queen had arranged to give her a sitting. In those times, when the horse was the quickest means of communication, it was impossible to send a message over a distance of twelve miles in time to prevent the sitter from getting ready for the painter.

On the next morning, having sufficiently recovered, she hastened to Versailles to explain her apparent lèse-Majesté. The Queen's carriage was at the door, and when the artist arrived, one of the gentlemen-in-waiting (Campan) said to her in an angry manner, "It was yesterday,

Madame, that Her Majesty expected you, and as she is now going out she will certainly not give you a sitting to-day." Madame Lebrun remarked that she only came to take Her Majesty's orders. She was sent for to the Queen's dressing-room, and having explained her non-appearance of the day before, and asked to know the Queen's pleasure, Marie Antoinette countermanded her carriage and at once began a " sitting." The end of this reminiscence reminds us of several anecdotes of royal personages and their painters—of Charles V and Titian, of Philip IV and Velasquez for examples. " I remember," says Madame Lebrun, " that in my eagerness to respond to such kindness I snatched up my paint-box so hastily that I upset it ; my brushes, my pencils fell on to the floor. I stooped to repair my clumsiness. ' Stop, stop!' said the Queen: ' you must not stoop ;' and, in spite of my protests, she picked everything up herself." This kindly act on the part of Marie Antoinette was such as any woman of decent feeling would naturally perform for another whose condition was that of Madame Lebrun at the time. Surely it is a strange perversion of respect which would give to acts of sympathy or courtesy on the part of a Prince, a merit which would not be allowed to them in the case of a commoner. High as was the painter's admiration for the Queen, she does not enlarge further on this example of womanly sympathy.

The patronage of the Queen, however ill-respected that Queen may have been by those who surrounded her, brought many commissions to the painter. As she herself has recorded, she painted in turn every member of the Royal Family except the Comte d'Artois, younger brother of the King. The Comte de Provence (afterwards Louis XVIII) relieved his tedium as a sitter by singing vulgar songs. " How do you think I sing?" he asked the painter. " Like a prince, Monsieur," she tells us was her reply. Scores of ladies and gentlemen of the Court—particularly ladies— were soon waiting their turns to "sit." Almost any Court painter can get plenty of commissions, but when that painter is able to diminish wrinkles, to straighten crooked mouths a little, to fine down noses and to brighten eyes without spoiling the likeness, it is natural that there should be some difficulty in getting an appointment for " sittings " in that painter's studio.

CHAPTER VI

ACADEMICIAN

Devotion to work—The artist goes to Belgium with her husband—Combining business and pleasure—The charming Prince de Ligne—Mutual attraction—From Brussels to París for the opera—Express travelling in the eighteenth century—The Flemish and Dutch painters —Vigée-Lebrun's imitation of Rubens—Her " chapeau de paille "—Return to Paris—She is proposed for election to the Academy of Arts—Difficulties in the way—The Queen's influence forces the doors—Ingenious " reasons " for breaking the rules—Vigée-Lebrun's portrait of the Queen *en gaulle*—Its withdrawal from exhibition—A joyful evening at the theatre—Convention *versus* fashion

THE gospel of work has rarely had a better exemplar than Vigée-Lebrun. She usually worked all the morning and all the afternoon; deciding, very early in her career, to decline those frequent dinner invitations which, as people dined between three and five, broke up her day and seriously disturbed her digestion. She scarcely ever tired of her work, however much her body might at times get weary of exertion. After three years and more of almost continual painting, she took, in 1782, a little holiday which had a considerable influence on her art. A famous collection of pictures, formed by a princely house, was to be dispersed in Brussels, and M. Lebrun hoped to do some profitable business at the sale. For some reason or other he took his wife with him, though in so doing he was interfering with her money-making. The reason almost certainly was that her prestige as the favourite artist of the Queen of France might be of value to himself. Whether he benefited much by her presence we do not know, but in any case she had a pleasant time. The Duchesse d'Arenberg, whom she had often met in Paris, welcomed her in that famous old house above the Petit Sablon Square in which, until a few years ago, a great collection was almost as easy of access to art-lovers as in a public gallery.

The Prince de Ligne—he who had discovered a likeness in her " panier " portrait of Marie Antoinette, but with whom she was not till now personally acquainted—showed the visitors round his own gallery, chiefly notable

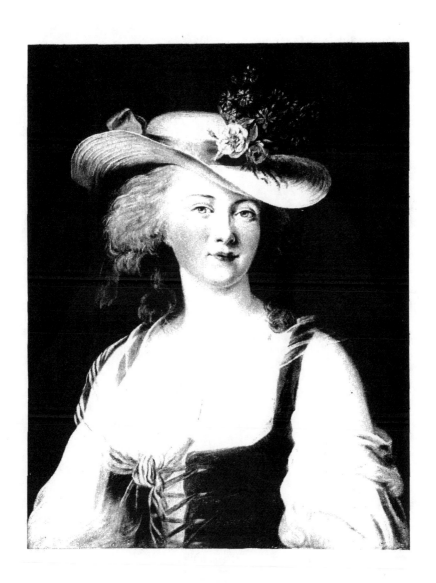

for portraits by Rubens and Vandyck. He also invited them to his
country house, where his charming manners and lively wit seem to have
put him, in the opinion of Madame, at least on a level with the Duc de
Lauzun.

If she was attracted by the grace and wit of the Prince, he on his side
was impressed by her beauty and intelligence, and from that time onwards
she had no more faithful adherent than this influential cosmopolitan, who,
wherever he went, praised the quality of her paintings and the charms of
her appearance and social gifts.

A remark made by Madame Lebrun apropos of this new friend throws
a strong light on the zeal for pleasure which characterised the "high life"
of those days as much as it does the plutocracy of to-day. She tells us
that "a good many friends of the Prince de Ligne sometimes left Brussels
after breakfast, arrived at the Opera in Paris just as the curtain went up,
and, after the representation, returned at once to Brussels, travelling
all night"; and "that is what they call loving the Opera!" she adds.
Evidently the road from "the little Paris" to the big one was better than
the English roads of that period. The distance from Brussels to Paris in
a bee line (or a crow line, whichever is straighter) is at least 160 miles,
so that if the opera-goers travelled at an average speed of twelve miles
an hour they would have taken from seven in the morning till eight in
the evening to cover the distance. The descendants of these music-lovers
find their big motor-cars preferable to their great-grandmothers' chaises
for such one-day trips to Paris, about the nearest equivalents to which
in these days are such excursions as village choirs in the Eastern Counties
take to Blackpool and back "in one day."

On leaving the Flemish capital and its social delights, the Lebruns
made a tour in Holland, and Madame was particularly struck by the good
looks of the women of the North, and by their extreme shyness of strangers,
which caused them to run away as soon as a traveller came in sight.

At Amsterdam, one of the pictures by Van der Helst (whom she calls
"Wanols," in her easy manner with names) at the Hôtel de Ville evidently
gave her more pleasure than all the Rembrandts. "I don't believe," she
says, "that there is a more beautiful or truer painting in existence. It is
nature itself. The burgomasters are dressed in black; the heads, the hands,
the draperies, all are inimitably beautiful: these men live—one believes
oneself in their presence. I am certain that picture is the finest of its kind;
I could with difficulty leave it, and the impression it made on me renders

it even now present to my eyes." This is the greatest praise that, in her
Souvenirs, she ever gave to a picture, and it affords strong evidence of
her taste in the particular branch of art to which she was called. Sir
Joshua Reynolds, speaking of another of the Amsterdam groups by Van
der Helst, had said: "This is perhaps the finest picture of portraits in
the world; comprehending more of those qualities which make a perfect
portrait than any other I have seen; they are correctly drawn, both heads
and figures, and have great variety of action, characters, and countenances,
and those so lively, and truly expressing what they are about, that
the spectator has nothing to wish for." Had she not specified the black
dresses, we might have believed that Vigée-Lebrun was referring to the
same work ("Meeting of Officers of a Train-band") which the English
artist so highly praised.

A sensible remark which she makes as to some of the best pictures of
Rubens, seen on her way back through Flanders, is that they were much
better placed in the Flemish churches than in the Luxembourg or the
Louvre in Paris.

It was in a private collection at Antwerp that she saw the portrait
by Rubens which most directly influenced her own art of all those seen
during this first experience of foreign travel—this kind of belated honey-
moon with a husband with whom she was never to go far from home in
future. The picture in question was the celebrated "Chapeau de Paille"
—so called on the *lucus a non lucendo* principle, because the hat is not
straw, but beaver-felt (*poil*). She supposed the picture to represent one
of the wives of Rubens, but she is on surer ground when she says
that "its force lies in the two different lights—those of the direct rays
of the sun, and of the reflected sunlight. The 'clears' are in full
sunlight, and what, for want of a better word, must be called the
shadows, are reflected light. Perhaps one must be a painter in order to
appreciate all the power here displayed by Rubens. The picture delighted
and inspired me to such an extent that while at Brussels I did a portrait of
myself in which I strove after the same effect." This picture by Rubens,
and an excellent replica or copy of the picture by Vigée-Lebrun which
it inspired, hang in our own National Gallery to-day, and we can learn
much of the powers of either artist, the Flemish giant or the French sylph,
by studying the two works in the same visit.

Apropos of Madame's charming imitation of the art of Rubens and of
her own face and figure, a curiously misleading rendering of its qualities

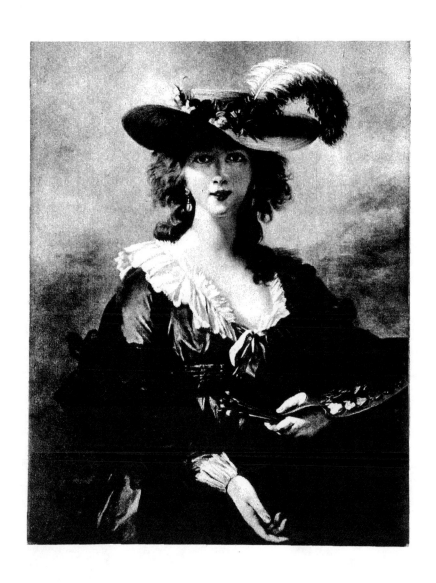

is given in an engraving done by J. G. Muller in 1785, wherein the chief purpose of the picture is so entirely ignored that the whites of the eyes give a nigger-like expression by their intense contrast to the heavily shaded parts of the face. The Baron Portalis, in some remarks based on this engraving, draws attention to the manner in which "this violent clashing between the black and the white accentuates very happily the piquancy of that very expressive countenance." Thus the engraver conveys to the critic exactly the opposite impression to that which the painter had striven, with a large measure of success, to produce—of the contrast, not between light and deep shade, but between a lesser and a greater light derived from the sun directly and by reflexion. Madame Lebrun herself, in referring to Muller's print, justly observes that the black shadows of the engraving take away all the effect of a picture of that kind.

In this same year which saw the making of one of Vigée-Lebrun's most notable self-portraits, her husband also was at work at his easel, and made his first appearance at the Salon with a painting representing a subject which must have appealed much more to him than to her. It was called "A Toper embracing a Maid-servant." No doubt it was painted under the influence of Teniers and Ostade.

Soon after the Lebruns had returned to Paris, and largely on account of the admiration aroused by the portrait after the manner of Rubens' picture, Joseph Vernet decided to propose Vigée-Lebrun for election to the Royal Academy of Painting. It was no light task which he had taken upon himself, if he meant to see her elected, and but for the outside pressure which was brought to bear on the members present at the election it seems almost certain that she would have been rejected.

In the first place, the "director" of this Academy, M. Pierre, who was also "First Painter to the King," was strongly opposed to the admission of women; and in the second place, it was the general opinion among the Academicians that if any more women were to be admitted the claims of Adelaide Labille-Guiard ought first to be recognised. There were already three women Academicians (Madame Roslin, the pastellist, Madame Coster, a flower-painter, and Madame Vien, a miniaturist and painter of "still life"), and that, thought M. Pierre and his friends, was already three too many.

These adversaries began a campaign against Madame Lebrun's candidature, in which the weapons employed were partly legitimate and partly slanderous. The chief legitimate objection was that, her husband

being a picture-dealer, she was ruled out by a clause in the statutes of the Academy which declared that no member must be engaged in trade. It is true that she herself was not a dealer, but it might with some show of reason be held that a wife must be a partner of her husband in more than the merely conjugal sense.

The other weapon employed was the accusation that her best pictures were touched up by François Ménageot. This most amiable historical-painter, who had a flat in the Lebruns' house, was always a friend of hers, and gave her plenty of advice—which, on the evidence of her work, we may suppose that she did not take. The story of his helping her was little heard again after the public had the opportunity of seeing both his work and hers hung on the same wall at the Salon. In any case, she was admitted as a member of the Academy on the last day of May, 1783. In recording this fact, she says : " M. Pierre spread about that I was elected by order of the Court. I believe that, as a matter of fact, the King and Queen had been good enough to wish to see me enter the Academy, but that is all." It is " all " that Madame Lebrun chooses to remember. Let us see what actually happened, as shown in the original documents bearing on the part taken by the King and Queen, which are textually reproduced in M. de Nolhac's account of the business.

The Comte d'Angiviller, who held the comprehensive position of " Director-General of Royal Buildings, Gardens, Manufactures and Acade-mies," was several times consulted by Marie Antoinette as to the chances of her favourite painter being admitted to the Academy. At last, the Queen having shown the strongest interest in the matter, M. d'Angiviller took anxious thought, and proceeded to draw up the following ingenious statement for presentation to the King :

" In the statutes given by Louis XIV to the Academy of Painting, it is forbidden to every artist to deal in pictures, either directly or indirectly. This regulation has been confirmed by Your Majesty in the clearest manner ; it is of the highest importance to maintain a law which contributes to the glory of the arts and, what is still more important, sustains them in a country where they are so useful and so necessary for commerce with foreign countries.

" Madame Lebrun, the wife of a picture-dealer, has very great talent, and would certainly have been an Academician long ago but for her husband's business. It is said, and I believe truly, that she has nothing

to do with that business, but in France a woman has no other standing than that of her husband. The Queen honours by her kindness Madame Lebrun, who merits it, not only by her talents, but also by her conduct. Her Majesty has done me the honour of asking me if there is not some means, without breaking the statute, and while preserving all its force, to gain admittance for Madame Lebrun into that body, which it is well to sustain in all the exactitude and the rigour of the statutes, above all, since Your Majesty has granted freedom to the arts. I have had the honour to reply that the protection with which Her Majesty honoured Madame Lebrun fell upon a subject sufficiently distinguished to make an exception in her favour rather a confirmation than an infraction of the law, if it were based upon that honourable protection, and that Your Majesty would be able to authorise it by a formal act.

" I therefore beg Your Majesty to give me directions, and to order that in future the number of women who can be admitted into the Academy shall be restricted to four. That number is sufficient to recognise talent, women never being able to assist the progress of the arts, because the modesty of their sex makes it impossible for them ever to study from nature and in the public school established and founded by Your Majesty."

The composer of this document must surely have written with a smile on his lips. It is one of the finest examples of " special pleading " ever seen, not surpassed by the reasoning of the learned brother concerning the father's will, in *A Tale of a Tub*. Because the statute was so excellent, it was to be safeguarded by being flagrantly disregarded. There were already three women members, and as four was the exact number that ought to represent feminine talent, Madame Lebrun ought at once to be let in.

In the last lines of M. d'Angiviller's petition, " nature," which meant still-life and fully-dressed friends when Elisabeth Vigée and Rosalie Bocquet worked together as children, evidently implies the nude model, unless the " and " after nature is a slip, and the impossibility was merely that of men and women studying together.

The tortuous reasoning of M. d'Angiviller convinced the King, who was glad to do anything he could to please his wife, and in the minutes of the Academy of Painting for the meeting of May 3I the swallowing of the royal pill by that body is thus recorded : " The Academy, executing with profound respect the orders of its sovereign, has received the demoiselle

Vigée, wife of the sire Lebrun, as a member, upon the reputation of her
talents, and invites Madame Lebrun to send some of her works to the
next meeting." Madame Labille-Guiard was, however, also admitted, the
taint of commerce not being attached to her. As the Academy in its
minutes refers to the terms of the new statutes which the King had author-
ised M. d'Angiviller to draw up, including the limitation to four women
members in future, some jugglery must have been necessary to cover the
fact that the two new members brought the number up to five—unless,
indeed, one of the three ladies already mentioned as members of the
Academy had died in the interval. Apparently it was arranged that while
Madame Labille-Guiard was elected in the ordinary way, her rival should
be regarded as being thrust in by royal " dispensation."

In any case she brought more distinction in the end to the Academy
than she received from it. At the moment, as her response to the
demand for a diploma picture, she sent in the allegorical work " La Paix
ramenant L'Abondance," which hangs to-day in Gallery XVI of the
Louvre.

The enemies of women were furious at the admission of the two
most distinguished women-painters of the day to the Academy, and the
versifiers were speedily employed in writing unpleasant lines about them.
Madame Labille-Guiard fared the worse, her character as well as her art
being attacked, whereas in the case of Madame Lebrun it was only her
alleged pride that was assailed, in addition to her talents. She was told
not to be stuck up because she had a fine carriage-and-horses, and that her
pride was as impertinent as the colouring in her pictures was bad. The
high praises she received made up for any such pin-pricks, and her fame,
till then chiefly confined to the Court, now spread throughout the public
generally.

Their arrival together in the Academy, their common experience of
hostile criticism did not serve to make the two new *Académiciennes* friendly
to one another. It is significant that Madame Lebrun never refers to
her rival by name, though she probably has her in mind when, on one
occasion, she speaks of women artists who are jealous of her because they
are more ugly than herself !

In that same year she was to have another snub, followed by another
triumph, in connection with a picture which soon became famous all over
Europe. At the Salon which opened shortly after her admission to the
Academy she was represented by quite a number of pictures, among them

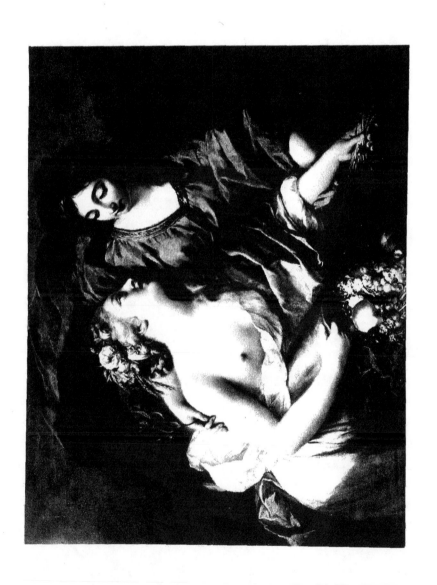

being the diploma work already mentioned (for which, by the way, the models were two young friends of her own) ; the "Chapeau de Paille" portrait of herself, and portraits of the Queen and of the King's sister-in-law the Comtesse de Provence, both these princesses wearing the simple white muslin dresses known as "gaulles." Such a fuss was made about the "impropriety" and "indecency" of representing the Queen in this indoor costume—which some of the most old-fashioned or of the most disagreeable people described as a "chemise"—that the picture was withdrawn from the Salon a few days after the opening. It is certain that already, apart from the machinations of her enemies, the Queen gave great dissatisfaction to a large section of the public by just such a disregard of the conventions of royalty as this incident illustrates. Indeed, while at Court she was disliked on account of the exclusiveness of her friendships, in the town she was severely criticised for her lack of dignity and neglect of etiquette.

Partly, no doubt, in consequence of the profit made out of this portrait by the enemies of the Queen, it had a great success, and Madame Lebrun recalls with special satisfaction an incident at the Vaudeville Theatre late in the season of that same year, when a species of *revue* called by some such name as *La Réunion des Arts* was produced. Her friend Brongniart (an architect of repute) and his wife, who were in the confidence of the management, took her to a box on the first night. Let her tell the rest of the story : " As I had not the least inkling of the surprise in store for me, you can imagine my emotion when the actress representing ' Painting ' came on the stage, and I saw that she was surprisingly well got up to look like myself, at work on my portrait of the Queen. At the same moment all the people in the stalls and boxes looked towards me and applauded enthusiastically : I do not think any one could ever be more touched, or more grateful than I was that evening."

The unpleasant reception given to the Queen's portrait at the Salon by a section of the public was quite neutralised for the artist by this pleasing episode, and was followed by no loss of favour at Court, nor did the Queen cease to dress herself as a peasant when she engaged in the pleasure of dairying at her village near the Little Trianon, making the mistake of supposing, as an historian has well said, "that in those days a Queen of France could live for herself."

It was not till some years after the much abused "portrait en chemise" was exhibited that women of the richer classes could appear in public

simply dressed without the risk of insult or contempt. They still had to balance themselves on their high, pointed heels, and to surround themselves with hooped petticoats. Such insignia of the old order existed after the new ideas planted by Rousseau and the philosophers of the *Encyclopædia* had become deeply rooted and fruitful. Marie Antoinette tried to live in the two worlds, the old and the new—a thing impossible for any one in such a position as she occupied in France. Possibly a French princess might have done all that she did and become all the more popular with a large section of the public. For a foreigner it was hopeless.

CHAPTER VII

SOCIAL LIFE

Vigée-Lebrun in society—Her intimate friends—The Marquise de Grollier—Wit without malice
—The over-polite Madame d'Angiviller—A passion for verdure indoors—Benjamin Franklin
—His silence and his popularity—A Parisian who knew everything—Strange way of dis-
covering a lost wife—The Abbé Delille—Inconvenience of being "fond of everybody "—
The "Snakes" and "Crabtrees" of Paris—Vigée-Lebrun's "evenings "—M. Doyen's
opinion of geniuses—Music at home—Garat's lovely voice—The fascinations of the Comte
de Vaudreuil—Afternoon rest and no dinner-parties

THE social life of Madame Vigée-Lebrun was necessarily restricted by
her passion for work, at the same time that her fame as a painter
brought her many opportunities of visiting houses frequented by
people who were specially worth meeting. One of these houses, where she
had been welcome even before she became famous, was that of Madame
Grimod de la Reynière, a lady of a noble but impoverished family, who, in
marrying the son of one of the wealthiest of the farmers-general of taxes,
had made that exchange of rank for wealth which was not yet so frequent
a bargain as it was to become in the nineteenth century. Her husband
was as much celebrated for his dinners as for his money, and, among his
intimates, for his absurd delusions that he could paint and that he had a
fine voice. He was dreadfully afraid of thunder, and, whenever a storm
began, he retired to a thickly-curtained room in the basement, where he
made one of his men-servants beat a big drum as loudly as possible until
the thunder had ceased.

His wife was always "upon her dignity," apropos of which fact
Doyen once said, when asked what he thought of her : "She 'receives'
very well, but I think she has an attack of loftiness" (*Je la crois attaquée
de noblesse*).

From the early days of her married life there was no house in which
Madame Lebrun was more happy than that of the Marquise de Grollier,
where a few chosen friends were accustomed to come in the evening, and
where now and then the young artist enjoyed the special pleasure of a

45

long *tête-à-tête* with the "grande dame," her elder by some thirteen years.
"Her conversation, always lively, was rich in ideas, full of happy
touches, and for all that one could not recall, among all the witty things
that constantly fell from her lips, a single word which was soiled by
scandal. The fact is all the more remarkable since that very superior
woman owed to her tact, to the extreme clearness of her understanding, a
perfect knowledge of men, and that she was a bit of a misanthrope, as
her talk more than once showed me. . . . One day, when we were
talking of the attachment and fidelity of our two little dogs, I said: ' I
wish that dogs could speak—they would tell us such pretty things ! '
' If they spoke, my dear,' she replied, ' they would also understand,
and they would soon be corrupted.' "

At one or other of the dinners or supper-tables which she frequented,
Vigée-Lebrun frequently met with the Comtesse d'Angiviller (formerly
Madame Marchais), the wife of that " Director-General of Royal Buildings,
Gardens, Manufactures and Academies" who was so helpful in the matter
of the Academy " election." She was an exceedingly gushing person, who
never, as Dr. Johnson said to a woman of her type, " considered what
her flattery was worth before applying it so freely." Madame Lebrun
could stand compliments pretty well, but some of Madame d'Angiviller's
passed the limit which divides the agreeable from the ridiculous, and at
times were embarrassing both to the recipient and to the rest of the
company. For example, she cordially greeted a man of quite exceptional
ugliness with the remark, " Why, really, Monsieur, you have grown quite
handsome ! "

Madame Lebrun's description of this too polite lady recalls an unusual
form of nature-worship. "Although I have often seen Madame d'Angiviller,
and have frequently sat next to her at table, I cannot say whether she was
ugly or pretty. Her face was always covered by a veil, which she did
not take off even at dinner. That veil not only covered her face, but also
an immense bouquet, which she constantly carried at her side, made of
sprigs from green trees. . . . When I went into her bedroom, I was still
more surprised to see it adorned by stands always covered with every
kind of foliage, not even taken away at night."

Vigée-Lebrun frequently saw Benjamin Franklin. The first time was
at the Court, when he was received, with the other foreign ambassadors,
by the King. In his Quaker-like costume, among the magnificent nobles
from the great European States, he must have afforded an even more

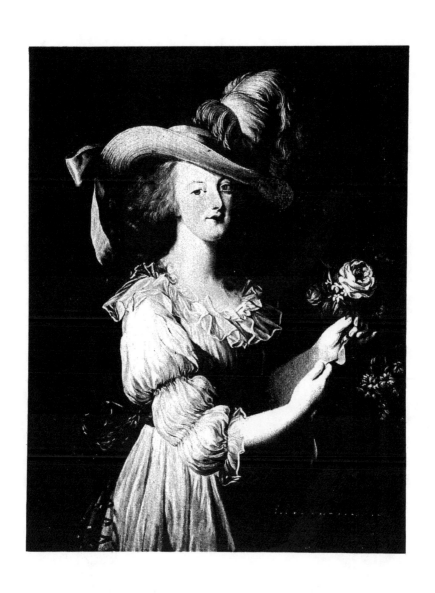

striking contrast than Castlereagh was to offer when he attended the Congress of Vienna in a plain suit, without wearing his orders. Any one more out of place, one might think, in the Paris society of that time, could hardly have been found than Dr. Franklin, and at the house of her friends the Brions, where Vigée-Lebrun often met him, he would sit without saying a word, so that she was "tempted to believe that he had made a vow of silence." But, however dull might be his conversation and his costume, "No man was more the fashion in Paris, or more sought after. The crowd ran after him on the promenades and in other public places ; hats, walking-sticks, snuff-boxes, everything was *à la Franklin*."

One of Madame Lebrun's acquaintances, whose name is not among the famous in history, but who was a highly remarkable specimen of a type which still exists, was the Comte d'Espinchal. His whole pleasure and business was to find out everything that was going to happen in Paris before the rest of the world could know. An engagement to marry, a love intrigue, a death, the acceptance or refusal of a new play or picture—such incidents were generally old news to him when they were still fresh to others. He knew an enormous number of people of every class, from the great nobles to the call-boys at theatres, from duchesses to grisettes. He knew to whom every box at the Opera or the Comédie Française belonged, and, most astonishing fact of all, he knew the identity of almost every woman at the masked balls of the Opera, however closely their faces might be covered; and though at that time these balls were much more "select" than they were afterwards to become, this was a marvellous gift. Naturally enough, he was not popular on these occasions. But once he was able, by *not* knowing one woman at such a ball, to relieve the great anxiety of a stranger. He noticed a man whom he had never seen before, rushing hither and thither, with every sign of distress, going up to every woman who wore a blue domino, and running off again with an air of desperation. "You seem to be in trouble, sir," said the Count. "If I can be of any good, I shall be delighted to serve you." "Ah! sir," replied the stranger, "I am the most unhappy of men. Imagine that this morning I arrived from Orleans with my wife, who gave me no rest until I would bring her to a ball at the Opera. In this crowd I have lost her, and the poor little woman doesn't know the name of the hotel, or even the name of the street where we have put up." "Don't worry yourself," said the Count,—"I will take you to her. Your wife is sitting at the second window in the *foyer*." There, indeed, she was. Her husband,

almost beside himself with joy, could not sufficiently express his thanks.
"But how on earth, sir," he asked, " did you know this was my wife?"
"Nothing is simpler," was the reply; "Madame being the only woman
at the ball whom I do not know, I had already made up my mind that
she had very recently come up from the country."

The gayest, most irresponsible creature among the intellectual people
of that time was the Abbé Delille, who represented almost at its best that
strange type of quite unclerical "clergy" which had no official functions
except to draw incomes from benefices which rarely or never saw their
" occupiers." He had come into notice by a verse translation of the
Georgics, became an Academician in 1774, and was made Professor of
Latin Poetry at the Collège de France, about which time he obtained a
rich endowment of church property through the influence of the Comte
d'Artois. Voltaire regarded him as one of the highest ornaments of French
literature. Madame Lebrun's impression of him was that he had never
grown up. He was in her eyes " the most charming, the best, the most
intelligent child one could possibly see. He was known as *chose légère*,
and I have always been struck by the aptness of that description, for no
man has ever skimmed over the surface of life more lightly than he
did, without forming a strong attachment to anything in the world.
. . . His fine wit, his natural gaiety, lent an indescribable charm to his
conversation. No one could tell a story better than he; he delighted
every circle he frequented by innumerable tales and anecdotes, without
ever being bitter or satirical ; one could say that everybody was fond
of him, and also that he was fond of everybody." This last characteristi:
was a weakness which caused some trouble among his friends, as he was
always liable to be captured by the last comer. When reproached with
this tendency he would admit it, and defend himself by saying, " I per-
suade myself that the person who comes to seek me wants me more than
that other who is waiting for me."

It will have been noticed how highly Vigée-Lebrun reckons good-
nature among the qualities of her acquaintances. It was not commonly
regarded as a social virtue in those days, when backbiting flourished as
perhaps never before or since, on either side of the Channel. It was the
period of the *School for Scandal*, a play which the critic of the *Morning Post*,
on the morrow of its first performance, justly described as one wherein
a group of characters " are ever ready, at the call of scandal, to sacrifice
the reputations even of their dearest friends at the too fashionable shrine

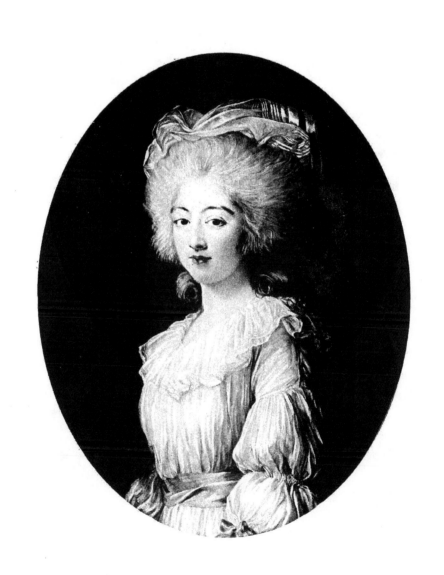

of calumny." If calumny could not be more "fashionable" in Paris than in London, it was assuredly more virulent, the licence allowed to the malicious tongues and pens exceeding anything that Sheridan even suggests.

Slander had become so prevalent in the pleasure-seeking society of that age that no one could be safe from its effects. Elsinore, when Hamlet told Ophelia : "Be thou as chaste as ice, as pure as snow, thou shalt not escape calumny," was a place full of charity and veracity compared with the Paris of the eighteenth century, especially of the latter half. The zest for slander had its origin in frivolity. As Mercier wrote concerning the "proverbs" played in certain drawing-rooms : "Simple slander would not hit the victim sufficiently hard ; what was wanted was that she should expire from wounds made by the sharpest possible arrows, and all this merely for amusement." How openly slanders were published in those days when, as a rule, the freedom of the press, outside politics, was tempered only by fear of personal chastisement or private influence, we shall see in the life-story of Vigée-Lebrun herself.

Several of the Parisian varieties of Snake and Crabtree are recalled by Madame Lebrun, the most detestable in her sight being Chamfort, who must have been odious indeed if she could abhor him, seeing that he was a protégé of her favourite the Comte de Vaudreuil. She allows that his talk was very clever, but it was so acrid and so malicious that it had no attraction for her, even if his coarseness and cynicism had not absolutely disgusted her.

If she was, during the decade which preceded the outbreak of the Revolution, a social favourite, much invited, she invited many in her turn, and it was quite "the right thing" to pass an hour or two with the Queen's favourite painter. The rooms of her house in the Rue de Cléry were simply furnished, though of course the big gallery adjoining, in which her husband did his business, was richly appointed, and hung with pictures of price. Her enemies spread about that she lived in extravagant luxury, and that her hangings, her couches, her candelabra, her plate and everything else were after the style of Versailles. One man in particular, the young and vicious Chevalier de Champcenetz, whose hostility she believed to be due to his step-mother or his mother-in-law (we cannot say which, for we only know it was his *belle-mère*) being jealous of her, declared that her ceilings and walls were richly adorned with gilt mouldings, and that she burnt only the expensive wood of aloes for her fires !

According to Madame Lebrun's account, the origin of all these stories

4

of her luxurious dwelling and habits, and of the jealousy of the *belle-mère* of Champcenetz, was that the company who came to her "evenings" in her "modest rooms" was specially select! Men and women of high social position, authors and artists of the first consideration, filled her bedroom (the walls of which were papered to match the chintz curtains and hangings of the bed), where, according to a custom still not extinct in Paris, she "received" her guests. She used to say in her old age that in those days in the Rue de Cléry there was sometimes such a crowd of distinguished persons present that, for want of enough sofas or chairs, people sat on the floor, and that "Marshal de Noiailles, very fat and very old, had one evening the greatest difficulty to get up again." He was only about seventy at the time, it is true, but that was regarded as *very* old in those unhygienic times.

Foremost among the artists who came were, as might be supposed, Ménageot (who lived upstairs), Brongniart, Hubert Robert, and Vernet, the last two having been among her best friends from her childhood. The Abbé Delille headed the literary set, with the poet Ecouchard Lebrun (no relative of her husband), and its tail, in the opinion of the hostess, was that poet's friend, Pierre Ginguené, critic then, and historian after the Revolution, whom she disliked excessively, and who struck a discordant note whenever he appeared. She was an enthusiastic admirer of Ecouchard Lebrun's poetry. Like some more famous poets, he did not at all think that his name was writ in water. One day he read out an ode to himself in which he had written :

> " Comme un cèdre aux vastes ombrages,
> Mon nom, croissant avec les âges,
> Règne sur la postérité.
> Siècles, vous êtes ma conquête ;
> Et la palme qui ceint ma tête
> Rayonne d'immortalité."

No one smiled or had a word to say except " It is magnificent! It is true."

Madame Vigée-Lebrun's admiration for her namesake's work was so high that she had become friendly with the man himself, and, remembering the horrid things that people sometimes said about her, she defended him warmly against those who spoke evil of him. As it happened, the man was a blackguard—a fact she realised at the Revolution, when he turned on those who had been his chief benefactors and published foul verses concerning the very people he had formerly beslavered. On one

occasion the wise Doyen, always her prudent friend, found her alone and in tears after she had been defending the poet against some of his detractors. "What is the matter, my child?" he asked. "I could not stand those men," she replied: "they calumniate Lebrun in a horrible way." When she had repeated what they had been saying (among other things that the poet had sold his wife to the Prince di Conti) Doyen smiled, and said, "I do not assert that all they have been saying is true; but you are too young, my dear friend, to know that most wits have everything at their country house and nothing at their town house, in other words, everything in the head and nothing in the heart."

In one of the long letters addressed to the Princess Natalie Kourakin, Madame Lebrun describes the manner in which she entertained her guests on these occasions. She does not flatter herself that "all these great personages" come to see her. They come to see one another, and to enjoy "the best music that could then be heard in Paris." The leading composers of the day, Grétry (composer of *Aucassin et Nicolette* and *Richard Cœur-de-lion*), Sacchini (who came to Paris from England in 1782), and Martini (really named Schwartzendorf, who was Superintendent of Music to Louis XVI) often treated the company in the Rue de Cléry to some of the numbers from their operas before those works had been publicly produced. In Sacchini's case, those compositions probably met with a better reception after Madame Lebrun's simple and appetising suppers than they did at the Opera-house, unless his biographers have been unkind. The instrumentalists included the violinist Viotti, and the pianist Cramer, and sometimes Prince Henry of Prussia, brother of Frederick the Great. Of the singers, the most remarkable was Jean Pierre Garat, in those days hardly more than a boy, the possessor of one of the most lovely voices ever heard; and Madame Todi, who sang comic songs and serious ballads equally well, though it would be libellous, perhaps, to describe her as a serio-comique. The hostess herself did not fear to sing occasionally. She had never had time to take any lessons, but, she writes, "my voice was rather pleasing: that amiable Grétry declared that I had some silvery notes."

Of all her guests, men or women, nobles or financiers, artists, authors, or musicians, the one whose presence at her soirées gave her the greatest pleasure was the Comte de Vaudreuil, of whom she never speaks without kindness. Like nearly all those, men or women, with whom she made friendships after she had been called to Versailles—though she had met

him before that time—he was a member of the set of which the actual sovereign was that Duchesse de Polignac who, as the closest personal friend of Marie Antoinette, was, with numerous helpers, the cause of many of the Queen's most foolish acts and of much of her unpopularity.

Madame Lebrun assures us that her dear Comte de Vaudreuil possessed " every quality and grace which can render a man attractive. He was tall, well made, and bore himself with remarkable nobility and elegance. His expression was agreeable and refined, his countenance as mobile as his ideas, and his kindly smile prejudiced one in his favour at first sight. He was very intelligent and witty, but you were tempted to think that he never opened his mouth except to make your remarks appear more excellent, so amiable and graceful was his way of listening to what you said. Whether the conversation were serious or not, he would adapt himself to every turn and *nuance*, for he was as well-informed as he was lively ; he was an admirable *raconteur*. Some of his verses were praised by the most exacting critics, but they were only read by his friends. He was all the less desirous of their being more widely circulated, in that he had in some of them employed both the spirit and the manner of epigram. It was indeed necessary, when he indulged in epigrams, that some bad action had revolted his pure and noble soul, and one can say that, if he showed small pity for what was evil, he was enthusiastic for everything that was good. . . . The only contradiction noticeable in that character so wholesome and so straightforward, is that M. de Vaudreuil very often complained that he had to live at Court, when all his friends knew that he would not have been happy anywhere else. After reflecting over this odd idea of his, I satisfied myself as to the explanation. He was, from his charming disposition, a child of nature, which he loved, and from which he got much too little enjoyment ; his rank kept him away too often from a world towards which the soundness of his understanding and his taste for the arts attracted him incessantly. On another side he was undoubtedly pleased to occupy so distinguished a position at Court, and one which he owed to his personal merit, his frank and loyal character. Besides, he adored his prince, Monseigneur the Comte d'Artois, whom he never flattered and whom he never left in his time of trouble. It is rarely that such a friendship is established between two men of whom one is so near a throne ; for this friendship was mutual. . . ." At the end of her long eulogy of her idol among nobles, she quotes some lines in which, amid much other

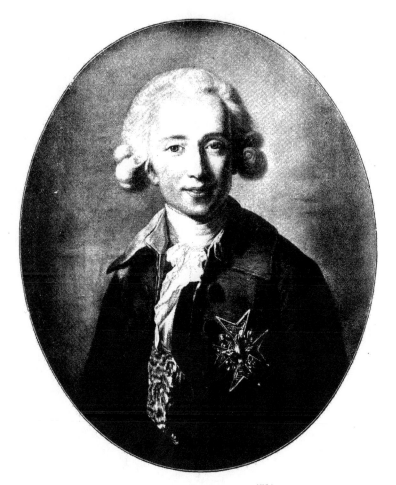

THE COMTE DE VAUDREUIL, 1784

flattery of the Comte de Vaudreuil, Ecouchard Lebrun declares that he "always joins good words to good actions."

Apart from her own "evenings," and her visits to the houses of some of the *grandes dames* whose portraits she had painted, Madame Lebrun found recreation after her long hours of work in going out to supper with her intimate friends, especially to houses where she heard some more good music, or where there were pleasant little dances—though she much preferred singing to dancing.

Often giving three sittings a day, and returning to her studio directly after dinner, she wore herself out so much that her friends became alarmed to see her getting thinner every month. At length they persuaded her doctor—who must have been a poor kind of doctor to need such persuasion—to order her a nap every afternoon. At first she found it difficult to get to sleep at that time, but by keeping shut up in her bedroom, with the curtains drawn, she at last got into the way of it, and derived such benefit that for the rest of her life she could rarely be induced to give up what she called her "*calme.*"

She gives another reason for her resolution to refrain from accepting invitations to dinner, but we may regard it as of little account in comparison with loss of health and of precious daylight hours, though it may well have been the immediate suggestion for the actual break with her dining-out past.

Being dressed in readiness for a dinner-party at the Princesse de Rohan-Rochefort's, and while waiting for her carriage, she went into her studio to look at a portrait commenced that morning. "I was wearing a white satin dress, which I had put on for the first time. I sat down on a chair which was standing opposite my easel, without noticing that my palette was lying upon it. You can imagine that my dress was in such a state that I had to stay at home, and from that moment I took the resolution never to accept any invitations except for suppers."

CHAPTER VIII

BOOKS AND THEATRES

HER *"calme"* was the only physical and mental repose that Madame Lebrun allowed herself between morning and night. There was not so much sitting quietly in armchairs before the fire in those days, nor in hammock-chairs in the garden—such comfortable things were not yet familiar, and the garden seats of Versailles or of Marly were generally of stone. In any case, to enjoy a book in peaceful solitude was not a favourite occupation of the kind of people among whom she lived, and she was not much of a reader at any time, if we may judge from the extreme rarity of references in her letters and *Souvenirs* to books that she herself knew. She declares that until after her marriage she read nothing but religious books, among them " *La Morale des Saints Pères*, of which I did not get tired, for everything is there," and some schoolbooks of her brother. Had she been familiar with the novels of her youth she might have found it more difficult, as she afterwards thought, to have resisted those " amateurs of her face " of whom we have heard already, and she attributes the preservation of her virtue at that time chiefly to the moral and religious principles instilled into her by her mother.

When she did feel that, as a married woman, she was free to eat the hitherto forbidden fruit of romance, the first novel she read was a translation of *Clarissa Harlowe*. That immense novel of Richardson had an extraordinary success in France. Indeed, it probably had more influence on French fiction and French ideas than any other English book ever published. The Abbé Prévost, who himself in *Manon Lescaut* (written in England) had struck a new note in imaginative literature, honoured

54

Richardson by translating his work, and another notable translation was that by Pierre Letourneur. It was no doubt either Prévost's or Letourneur's version of *Clarissa* in which Elisabeth Vigée made her first acquaintance with English literature, and with secular fiction. She could not have fallen in with a better book at that time than this curiously intimate study of a woman's character by a man, the power of which was so strongly felt by Balzac, seventy years after its publication, that its effect is to be recognised again and again throughout the *Comédie Humaine*.

The ten volumes of *Clarisse Harlowe* filled a large part in Madame Lebrun's reading. In her social world new novels, new poems, and new plays were still read in part or in whole by their authors in ladies' drawing-rooms, before they were seen in print, and an intelligent person could often be better informed as to the literature of the day than in our own time is possible, even to the most constant student of the " New Books " columns in the best newspapers.

It was, therefore, at evening parties that she obtained most of her knowledge of what was going on in the world of Polite Literature (and of rather impolite literature too, sometimes), as also of the movement of thought in the arts, in politics, and in manners and ideas generally, and certainly the Goddess of Folly did not hold undisputed sway in her large circle of friends.

When she did not go out to parties, or entertain in her own rooms, she frequently went to the theatre, being very fond of plays, and acquainted with most of the leading players of the time. Le Kain was the chief figure among the actors in her early days—that impressive tragedian who, discovered and instructed by Voltaire, overcame the physical disadvantages of ugliness of face and of voice by the sheer power of his acting. Brizard (we recall the players by their stage names, and not as Cain, or Boitard, or whatever names their fathers bore) was highly successful in " heavy father " parts, and made so great an impression in the versions of *King Lear* and *Œdipus* by Ducis, that this most independent of playwrights himself attributed part of his own success to Brizard's acting.

Sophie Arnould's best acting days were over about the time when Madame Lebrun saw her in *Castor and Pollux* at the Opera. " I was little capable," she tells us, " to judge of her talent as an actress. . . . As to her talent as a singer, the music of that time bored me so horribly that I did not attend sufficiently to be able to speak about it. Mademoiselle Arnould was not pretty, her mouth being very ugly indeed, and her eyes

alone gave full expression to the remarkable *esprit* which made her so famous." In this case Vigée-Lebrun may not be altogether fair to Mademoiselle Arnould, whose sarcasms concerning a certain picture by her critic will be recalled on another page.

The most famous French actress of the eighteenth century, Mademoiselle Clairon, had retired, smarting under a sense of injustice, in 1765, at forty-three years of age, so that Madame Lebrun never saw her act. But she was specially invited to meet La Clairon at the house of Larive (Le Kain's successor), who owed a great deal to the influence of that actress. "I had imagined her very tall, but she was, on the contrary, very short, and very thin. She held her head very straight, which added dignity to her appearance. I never heard any one else speak with so much emphasis ; for she always retained the tragic tone and the airs of a princess ; but she seemed to me well-informed and intelligent. I sat beside her at dinner, and she talked to me a good deal. Larive paid her the greatest respect ; the deference he had for her showed at once his admiration and his gratitude."

Mademoiselle Dumesnil—from whom Peg Woffington took lessons in Paris, of whom Garrick declared that she became for him the actual character that she represented, whatever it might be, and who had actually made an audience recoil in terror during one of her tragic scenes—retired from the stage in the year of Vigée-Lebrun's marriage, so that the painter's memories of the actress were few, and appear, indeed, to be based rather on common knowledge than on personal reminiscence. Her reference to this notoriously unequal player ends with the information, derived from some unnamed person, that Mademoiselle Dumesnil " drank a bottle of wine before going on, and had another bottle kept ready for her in the wings." Judging from many similar stories of public characters and their stimulants, we are justified in believing that the "bottles" were not much bigger than the two tiny phials of egg-flip which Mr. Gladstone used to empty, in full view of the House of Commons, during any one of his great oratorical efforts.

In comedy there was no one to equal Préville, who, for many beside Madame Lebrun, was the perfect comedian. Dugazon (who stepped into Préville's shoes on the retirement of that greater actor in 1786) was too farcical to please her, but for his sometime wife she had a great liking, both as a spectator and as a friend. Madame Dugazon had a huge success in the emotional play *Nina, ou la Folle par Amour*, in which she played

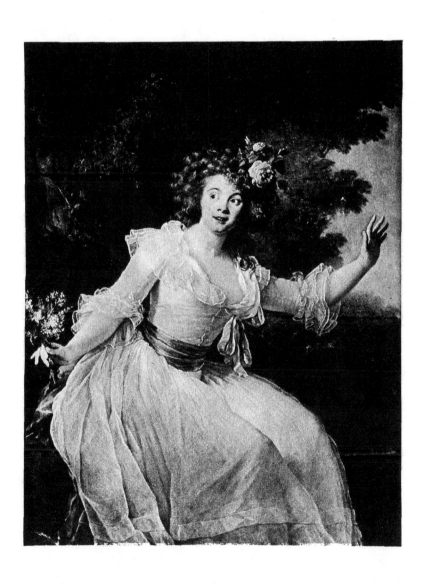

the title rôle, and Vigée-Lebrun went about twenty times to see the piece, being more affected each time by the pathetic performance of the principal actress. She writes : " I was too great an admirer of Madame Dugazon not to ask her often to come to supper with me. We used to notice that, when she had been playing Nina, her eyes were still a little haggard—in a word, that she remained Nina all the evening. It was assuredly to that faculty of profoundly entering into her rôle that she owed the astonishing perfection of her talent." The artist made an admirable picture of the actress in the character of Nina, and several other artists represented La Dugazon in the same scene of the play, wherein she fancies she can hear her lover's voice in the garden.

At the Théâtre Français Molé was highly successful in comedy parts, but was a failure in tragedy, whereas his rival Monvel was admirable both in tragedy and comedy. Vigée-Lebrun declares that on one occasion when, in the course of his part, Monvel had to bow to the other characters on the stage, she got up in her box and returned his bow, much to the amusement of her companions! Monvel's far more famous daughter, whose stage name was Mademoiselle Mars, was only ten years old when Madame Lebrun left Paris for her long exile in Italy and Russia. But it may conveniently be added here that some forty years afterwards she wrote to the Princess Natalie Kourakin, who had seen Mars in Paris in the days of Louis XVIII : " You will certainly not have forgotten her pretty face, her charming figure, and her angelic voice. Happily that face, that figure, that enchanting voice are so perfectly preserved, that Mademoiselle Mars has no age, nor do I believe she ever will have ; and every evening the public by its enthusiasm shows that it is of my opinion."

The most brilliant stage début that Madame Lebrun ever witnessed during her long life occurred when she was seventeen. It was that of Mademoiselle Raucourt as Dido. The débutante was about nineteen, and "the beauty of her face, her figure, her voice, and" (one better than La Mars) " her diction, everything gave promise of a perfect actress. She joined to so many advantages a remarkably modest air and a reputation for austere morality which made her very much sought after in the highest society ; people gave her jewels, stage costumes, and money for herself and her father, who never left her. Later on, she changed her behaviour very considerably. . . . If Mademoiselle Raucourt did not remain *sage*, she remained a great tragic actress ; but her voice became so rough and hard that, when you shut your eyes, you might fancy a man was speaking."

At the Opera, Madame Saint-Huberti so fascinated Madame Lebrun
that for this one member of the audience the rest of the performers were
merely people who interfered with her pleasure. In the ballets at that
time the men were often more regarded than the women. Gardel and the
elder Vestris were, in Vigée-Lebrun's girlhood, the principal male dancers,
and the most notable *première danseuse* was the rather notorious Madeleine
Guimard. On seeing a dance wherein the two men had to pursue the
danseuse, who was small and thin, some wag said it looked like two big
dogs quarrelling over a bone !

Gardel is partly remembered as the man who finally banished from
the stage the masks formerly worn by dancers ; it was the elder Vestris
who said, "There are only three great men in Europe—the King of Prussia,
Voltaire, and I."

Of his son, who succeeded him at the Opera in 1781, and whom
Madame Lebrun calls "the most wonderful dancer that could ever be
seen," so light and graceful was his pirouetting, old Vestris declared that
if he touched the ground at all, "it was only out of consideration for
his comrades ! "

CHAPTER IX

COUNTRY-HOUSES

THE days when Elisabeth Vigée had to depend for her enjoyment of the country upon occasional Sunday excursions to Marly or Chantilly with the Suzannes were over as soon as she became a welcome guest in wealthy houses. While still in her teens, she was the friend of Madame de Verdun, the wife of one of those powerful farmers of the taxes who, under the system then weighing heavily in France, were authorised to make large fortunes in the process of extracting money out of an impoverished people. M. de Verdun appears to have been a kind-hearted tax-gatherer, who gave away a good deal in charity. He was also a source of considerable profit to artists and art-dealers. His country seat was the historic château of Colombes, about five miles from Paris, between Asnières and Argenteuil. It had once been the home, after her flight from England, of Queen Henrietta Maria, in whose time the wall-paintings by Simon Vouet, Court painter to Louis XIII, were still fresh. The dampness of the Seine valley had now badly damaged them, but M. de Verdun had them thoroughly " repaired," and made them, from the point of view of that period, " as good as new." At Colombes, Elisabeth Vigée, both as maiden and as married woman, was a frequent guest, and used sometimes to stay there, when she could keep away from her studio, for days together. There she found many of her Paris friends, artists, writers, and wits, and took part in amateur theatricals, a favourite amusement at that time, in which she thought herself rather a good performer, as she probably was, being lively of mind and graceful of figure.

Genevilliers, about three miles to the west of Colombes, within the

same loop of the Seine, was a place to which invitations were specially welcome. It was not particularly pretty, and the house itself was not picturesque. But it was the seat of the Comte de Vaudreuil, who had bought it and furnished it " plainly "—according to the ideas of the age —and " in the best taste." As it had a little theatre, theatricals could there be enjoyed with unusual advantage. Eminent professionals 'used to assist, and comic-operas were performed in which Madame Dugazon, the honey-voiced Garat, and the retired actors Cailleau and Laruette (superb in parts of the " father " and " guardian " kind) shared the rôles with Madame Vigée-Lebrun, her brother Etienne and his charming wife, and that wife's brother M. de Rivière.

The Comte d'Artois (afterwards Charles X) and his followers were often among the audience on these occasions, and the first time they unexpectedly entered the theatre Madame Lebrun was so nervous that, but for the confusion such a withdrawal must have caused, she would have thrown up her part. However, " our excellent Prince " with his " usual grace " came behind the scenes after the first piece " to encourage us with every imaginable compliment," and all was well. Lebrun, by the way, the artist's husband, was custodian of the Comte d'Artois' collection of pictures.

Early in 1780, Madame Lebrun stayed for some time at Raincy, in the forest of Bondy, where the Duc d'Orléans (grandson of the Regent) had a country place. This veteran soldier was more devoted to intellectual society than most of his race. He had been a keen amateur actor in his time, but he did not " return to the stage " when the clever young artist was staying with him and his morganatic wife, Madame de Montesson. Had he done so, Madame Lebrun would have been less bored. As it was, the only amusement she found at Raincy, apart from the society of the amiable Madame Bertholet, " who played very well on the harp," was in watching the meets and runs of the ducal buckhounds. " I there discovered," she writes, " why it is that there are men, and especially princes, who become passionately fond of hunting, for that exercise, where a large number take part in it, certainly provides a grand spectacle. The general movement, joined to the sound of the horns, has truly something of a warlike effect."

How truly an artist she here shows herself ! It is not the zest of the chase, the exhilaration of the exercise on horseback in the open air, that, in her opinion, make men go out hunting. It is the fine picture which

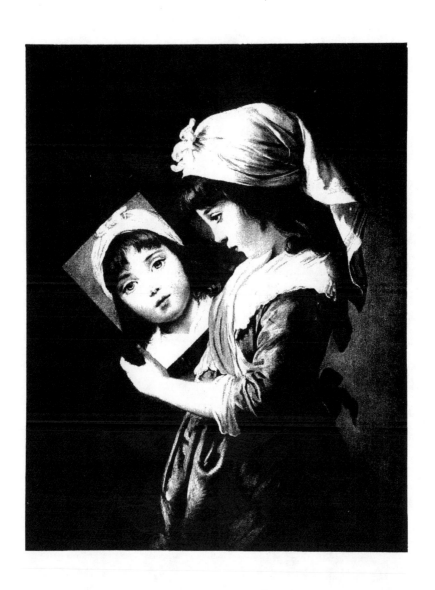

is shown, to the accompaniment of martial music ! But she was not at Raincy to enjoy herself ; she was there on business, having been commissioned by the Duke to paint his own portrait and his wife's. The artist was at that time expecting the birth of her first-born, and was rather scandalised one day, when she was painting Madame de Montesson's portrait, by the conduct of the old Princesse de Conti, who (having called to see the artist) persisted in addressing her as " Mademoiselle." That fashion of marking the inferiority of the wives of bourgeois and " roturiers " to the great people who so addressed them—Molière's wife, for instance, was commonly called " Mademoiselle Molière,"—had gone out with the reign of Louis XV.

Maupertuis, the seat of the Marquis and Marquise de Montesquiou, was one of the houses to which Madame Lebrun specially liked to be invited. She first went there, it would seem, to paint the portraits of her host and hostess and their daughter-in-law, a girl of fifteen, of whom she made a charming picture. The Marquis, who was equerry to the King's brother, the Comte de Provence, lived in great state at Maupertuis, where not only magnificence was regarded, but good order. From his own wealth he was able to entertain large house-parties in great luxury, thirty or forty guests being usually there whenever the family were at home, and by his office at court he was able to make free use of the horses and carriages of his royal master. In Paris, Madame Lebrun found the Marquis de Montesquiou stiff and inclined to pick faults, but at Maupertuis he was a different creature, agreeable both in what he said and in his way of saying it. One may describe him as a pessimist in town and an optimist in the country. One evening when he was at Maupertuis, there was, for a change, only a small number of guests. The Marquis drew the horoscope of each in turn. For Madame Lebrun he predicted long life, and that she would be a pleasant old woman, " because she was not a coquette."

A strong contrast to Maupertuis was afforded by Mortefontaine, eighteen miles north-east of Paris, where, in the château surrounded by a beautiful park (with a lake which was to form the subject of one of Corot's finest pictures), lived Monsieur Le Pelletier " of Morfontaine "—as the name of his territory was usually pronounced, and as Madame Lebrun followed a common practice in spelling it. Though he was fond of improving his intelligent mind and his park, he kept his house very badly. Indeed, Madame Lebrun could not remember that she had ever seen

such an untidy interior. He was, in everything, the most desultory and ridiculous of beings. One of his habits was to take notes at the time, in a little pocket-book, of everything that was said in his hearing which seemed remarkable. "I have often tried," says Madame Lebrun, "to read over his shoulder, but although his writing was very big, it was so formless that I could not make out a word, and I defy his heirs to make use of any reminiscences he may have left behind him."

He was tall and gaunt ; he wore an immense pointed wig, like a sugarloaf, with curls at the sides ; and, at fifty-five, he was for ever boasting of his irresistible powers of fascinating women. Order and ceremony were alike banished from Mortefontaine, and everybody behaved as if he was in his own home, only with more disregard for the peace of other people. The Comte de Vaudreuil, the Chevalier de Coigny (another of the Trianon courtiers), Ecouchard Lebrun, Brongniart, Hubert Robert, Etienne Vigée and Rivière used to amuse themselves and the rest of the company with charades, which they made up in the night, and whenever one of them thought of a good word for a charade he would knock up all the guests to tell them this important piece of news. "This mad fun shows what liberty one had in that beautiful place," says the artist who records it ; and it undoubtedly seems pretty good evidence that the Château de Mortefontaine was more of an "Hôtel Tohu-bohu" (to borrow the name of a modern French farce) than of a quiet country-house.

In illustration of her host's unjustifiable conceit concerning his personal charm, Madame Lebrun tells a story which was told to her by the Chevalier de Coigny. One morning when the Chevalier called upon Le Pelletier, he found this rather nauseous boaster lying on a couch, beside a table covered with bottles, pots of ointment, scent-sachets, and other such aids to lady-killing, and so pale, not having yet put on his rouge, that he looked as if he were dying. "Ah! my dear Chevalier," he cried, "how delighted am I to see you! You can give me your excellent advice on a matter which occupies a great deal of my attention. You must know that I have just broken off all my love affairs ; I am free, absolutely free; and you, who know the prettiest women at court, will tell me to which of them you would advise me to pay my addresses." The Chevalier, who enjoyed "roasting" this absurd fop, named all the greatest beauties of Versailles, but each one he mentioned had some defect in the eyes of M. Le Pelletier. At length the Chevalier, getting rather bored, no doubt, by the unexpected duration of the talk, burst out laughing and said : "My dear sir, since

you are so hard to please, I advise you to follow the example of Narcissus, and to fall in love with yourself."

Madame Lebrun gives yet another example of Le Pelletier's absurdities, which will remind George Meredith's readers of the Martin Tinman in *The House on the Beach*, who, after having once appeared at Buckingham Palace, used to put on his court suit every day at home. On some public occasion with which, as Prévôt des Marchands, M. Le Pelletier was officially concerned, the King gave him the *cordon bleu* (ribbon of an order of knighthood), and the man's head was turned by its possession. He wore it always. "I almost believe he must have put it on over his dressing-gown," his friend, who was herself entirely proof against his charms, declares. " One day I saw him climbing about the rocks which border the lake at Mortefontaine, dressed according to his custom as though he were about to start for Versailles. I cried out to him from below, where I was walking, deep in my rural reveries, that his blue ribbon was quite absurd in that beautiful bit of nature. He was not in the least annoyed with me for having thus made him conscious of his eccentricity, for after all it must be said that this poor M. Le Pelletier was the best man in the world."

One of her country visits was to Villette, the hostess of which was the charming " Belle-et-Bonne," as Voltaire named her, the delight of that old philosopher's closing years, who, with his full consent, had married the blasé Marquis de Villette in November 1777, six months before Voltaire's death. Madame de Villette, remembering the trials of her own girlhood, from which the kindness of Madame Denis and Voltaire had saved her, looked after the welfare of the young girls in the village, and took a personal share in their education.

Vigée-Lebrun herself saw Voltaire at the Théâtre Français on the evening of his " Triumph," but she never was presented to him. However, she had a memory of his last days which gave her great and natural satisfaction. Voltaire was staying at the town residence of the Villettes, that house (still standing) on the left bank where he was shortly to die, and Madame Lebrun was very anxious to visit him, but having heard that he was greatly fatigued by the number of visitors, she gave up the idea. It happened, however, that Hall, the Swedish artist, who had just finished a miniature of her, showed it to Voltaire, and " The famous old man, after having gazed at it for some time, kissed it again and again." She was, of course, much flattered, and was grateful to her friend Hall, whose

handsome daughters, two or three years later, sat for the figures in her picture of *La Paix ramenant L'Abondance*, Lucie being the "Plenty" and Adèle the "Peace."

On the occasion of Madame's visit to the Villettes in the country, the Marquis, who had taken quite seriously the name of "The French Tibullus" which Voltaire had given him, greeted her with some verses in which he called her "Sublime Lebrun, the pride of France," and declared that the glory which accompanied her made his little château seem great, and restored the country to life, and that she herself made the sunlight more beautiful, and realised for him his castles in Spain! Women (and men too) could stand a good deal of that kind of gush in the eighteenth century, and Madame Lebrun had a fairly good appetite for such literary sweets, with which her namesake, Lebrun "Pindar," as he liked to be called, and her brother Etienne, kept her well supplied. As a brief example of "Pindar's" flattery, here are some lines from a poem in which the nightingales of Mortefontaine are made to say concerning the artist:

> "Nous l'avons vue errer sur ce rivage
> Et l'embellir par ses appas,
> D'un seul de ses regards, dans ce petit bocage,
> Mille Amours sont nés à la fois ;
> Et nous, sous le même feuillage,
> Nous étions déjà nés des accents de sa voix."

Madame Lebrun enjoyed one of the privileges of Royal princes, in that she nearly always found herself in her own little coterie of intimates wherever she went to visit or to dine. At Mortefontaine, at Colombes, at Genevilliers, at Tivoli on the slopes of Montmartre, where she was almost a weekly guest of the financier Boutin, her special court, Vaudreuil her lord-in-waiting, Ecouchard Lebrun her poet-laureate, Brongniart and Delille gentlemen in attendance (one can scarcely call Delille her chaplain, for the church had little place in her circle) must have received many an extra invitation because her hosts knew that she would like to find them wherever she went.

Montmartre was almost rural in those days, at least as rural as Bellevue to-day ; and more restful still for the hard-working artist was Moulin-Joli, the delightful home, on an island in the Seine, of M. Watelet, a wealthy Receiver-General, who not only loved to surround himself with authors and painters, but was himself a man of letters and an artist of distinction, a member both of the Académie Française and of the Académie de Peinture.

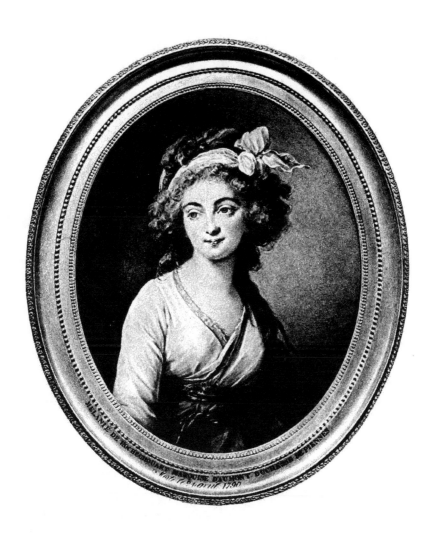

The life at Moulin-Joli in summer was rather like that of some large villa on the Thames above Richmond in our day. " Ah," wrote Madame Lebrun to the Princess Natalie in after years, " how I should have loved to stroll with you through those woods of Moulin-Joli ! Here, indeed, was one of those spots that one can never forget ; so beautiful, so varied, so picturesque, so Elysian, so wild—in fact so ravishing altogether ! Imagine a big island, covered with woods, gardens, and orchards, cut in two by the Seine. One went from one bank to the other by a bridge of boats, adorned on either side by flowers planted in boxes, and whereon seats, placed at equal distances, allowed one to enjoy at one's ease the perfumed air and the lovely views. Seen from a little way off, that bridge, with its reflexion in the water, produced a charming effect. Forest trees, of noble growth, bordered the river on the right, while on the left the bank was covered with immense poplars and weeping-willows, the boughs of which made arbours with their leafy branches. One of these willows formed a huge canopy, beneath which one could rest, and dream pleasant dreams. The Prince de Ligne, in his memoirs, speaks of that superb willow. I cannot tell you how happy I was in that lovely place, of which, to my mind, I have never seen the equal."

It was a great disappointment to Madame Lebrun that, after her return from Russia in 1802, she missed a chance of buying Moulin-Joli, owing to the non-arrival of her savings from St. Petersburg. The estate was sold for about £3,000 to a coppersmith, who turned the beautiful trees into fuel.

CHAPTER X

CALONNE

A famous balloon-ascent—The *ménage* Lebrun—Lovely women and pretty costumes—Vigée-Lebrun's portrait of Calonne—Sophie Arnould's malicious *mot*—Gossip about Calonne and Vigée-Lebrun—The artist described as the Aspasia of Calonne's reign—Lebrun's belated defence of his wife's reputation—Banknotes in a snuff-box—Character of Calonne— Persistence of the scandal—The bogus " Comte de " Rivarol a possible enemy of the artist—A coat-turning poet

DAYS and nights, or merely afternoon visits, at one or other of the pleasant places we have been recalling, helped to preserve the health and increase the happiness of the busy portrait-painter. Sometimes, of course, she would leave her easel even on her working-days, as when, one summer afternoon, she went to the Tuileries Gardens to see the ascent of MM. Robert and Charles in a balloon. A huge crowd had collected, for the first balloons were as attractive as the first aeroplanes; and when the cords were cut and the balloon rose majestically to so great a height that it went out of sight, many people, from mingled admiration and anxiety for the aeronauts, had tears in their eyes. Among them was Madame Lebrun.

Such thrilling extra-excitements were, however, rare in the life of one of the most industrious of women, industrious in a period when very few women of her class and associations did any work beyond their household duties. She was making a large income, according to the standard of a time when a thousand francs was considered a very good price for a big picture by a distinguished artist, and when few but those who dipped in the coffers of the state were rich in the modern meaning of the term. Two thousand to eight thousand francs were about the prices she generally got (or rather her husband got) for her pictures. He gave her very little cash, but as she had excellent credit, a carriage and horses, and plenty of prosperous friends, she never felt the want of ready-money very seriously

for herself, at that time. The real objection to Lebrun's conduct of her affairs was that he spent everything, putting nothing out at interest for the future, and that she had little or no spare money for charitable purposes.

However, up to 1785, at any rate, she lived, on the whole, as happy a life as any woman married to such a man could expect to live. He troubled her much less than he might have done, his principle being that so long as she did not interfere with him, she herself could go where she liked, and do what she liked. Her work was usually to her taste, her sitters being women or men of the Court or of the plutocracy, with an occasional artist or actress. Among her most successful portraits were those of the Duchesse de Gramont-Caderousse, painted in 1784, and of the Baronne de Crussol in the following year, both exhibited at the Salon of 1785. Marie Gabrielle de Sinéty, Duchesse de Gramont-Caderousse, as she appears in Vigée-Lebrun's picture, is a delightful example of feminine charm in the fullness of youthful happiness. Here is the artist's little story of this portrait, which attracted so much public attention on its first exhibition, and excited the enthusiasm of critics expressed both in prose and in verse: " As I could not endure powdered hair, I induced the beautiful Duchess not to wear any powder when she came to be painted. Her hair was of ebony black ; I separated it upon the forehead, and arranged it in irregular curls. After my sitting, which ended at dinner-time, the Duchess left her hair just as it was and went in that state to the play. So pretty a woman as she was, can set the fashion ; that mode took lightly at first, and at length became general."

The Baronne de Crussol appears to be older than the Duchesse de Gramont-Caderousse and is not so pretty. But she is very handsome, with her fine eyes and that coquettish mouth which is as common to the women of Vigée-Lebrun as is the enlarged thyroid gland in the necks of the women painted by Rossetti. Portraits of the Comtesse de Chatenay, a blonde with big eyes, and the Comtesse de Clermont-Tonnerre, with a turban on her head, were exhibited that year, and also the fine portrait of Grétry, now at Versailles, and that of the Controller-General of the Finances, Charles Alexandre de Calonne. This last portrait provided an opportunity for the worst attack from malicious pens to which Madame Lebrun was ever subjected. That one of the critics should refer to the portraits of Calonne and the four beautiful women as suggesting a sultan in his seraglio was more unpleasant for these ladies than for the Minister or the artist.

But when another " critic " said of Calonne's picture " it is here that the greatest number of difficulties have been overcome by the painter, and that she has the most completely proved herself to be *mistress* of her subject," it was a more serious matter for the object of this equivocal praise.

The story thus plainly stated in a *jeu de mots* was common gossip in the boudoirs of that time. When Sophie Arnould saw at the Salon this portrait of the Controller-General, in which he is shown seated, the lower part of the legs being unseen, she said : " Madame Lebrun has cut off his legs, so that he must stay where he is, and remain faithful."

In all her life, nothing angered Vigée-Lebrun so much as the common talk that she had shared in the ample pickings which Calonne was publicly accused of having taken from the coffers of the State. At the time when the portrait was painted he had only lately been appointed to his great position. It was said that the payments made to the artist by the Minister were far beyond the price she would have received for such a picture from any other quarter, and that this extreme generosity, from a man who had been heavily in debt when he took office, was due to a liaison between the artist and her sitter. Before finally considering the merits or demerits of a question so frequently brought up in her own correspond-ence and memoirs, let us see the kind of way in which the affair was mentioned by her contemporaries at the time when she and Calonne were acquainted.

In the letters (the originals of which are preserved in the Imperial Library of St. Petersburg) from some one closely in touch with the Court life at Versailles to some one in Poland, which were published in Paris during the Second Empire under the title *Correspondance Secrète inédite sur Louis XVI, Marie Antoinette, La Cour et la Ville de 1777 à 1792,* there are several references to this Calonne-Lebrun business. In January 1786 the writer says : " M. de Calonne, who displays grandeur and magnificence in all his acts, has given New Year's presents to Madame Lebrun. First of all, he offered her a handful of pistachio-nuts, wrapped in paper-twists, and while she amused herself in unwrapping them, he laughed and said, ' Take care not to tear the mottoes ! ' What was the astonishment of Madame Lebrun ! Each bonbon was wrapped in a bank-note for 300 francs. After jesting about such a pleasing kind of paper-wrappings, M. de Calonne took from his pocket a superb gold box which he presented to that amiable artist, saying as he did so, ' Here is some-thing to keep your sweets in ! ' Madame Lebrun, wishing to put the

MARIE, DUCHESSE DE GRAMONT-CADEROUSSE
(Dr. Williamson, for the Executors of the late
J. Pierpont Morgan, Esq.)

From a miniature by Villers after the portrait by Vigée-Lebrun

MADAME VIGÉE-LEBRUN AND HER DAUGHTER
(Dr. Williamson, for the Executors of the late
J. Pierpont Morgan, Esq.)

From a miniature by Janvier

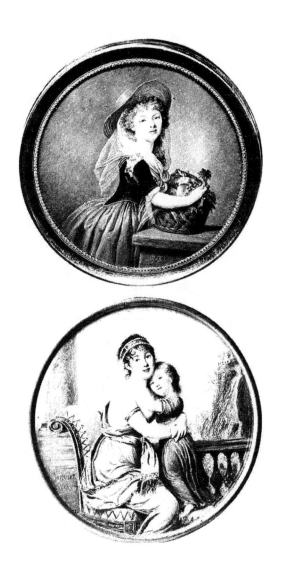

bank-notes in this box, found that it was already filled with new twenty-franc pieces, each wrapped in a bank-note of the same value as the others."

In the early spring of 1787, after the dismissal of Calonne from his place as Controller-General (in which he had only succeeded in bringing the finances into a more desperate state than they were in before), the same correspondent writes, again from Versailles: "It is positively declared that, since his disgrace, M. de Calonne has given a splendid set of carriage-horses to Madame Lebrun. He so little expected to be sent far away from Paris that, a few minutes before he received the order to go into exile, he had asked the Jacobin Monks in the Rue Saint-Dominique, near the house to which he had retired on leaving the Ministry of Finance, to find him a place where he could store a thousand casks of wine and five hundred loads of wood," a statement which has an air of exaggeration, to say the least. At the following Christmas-time the writer has a last, and double shot at the reputation of the artist, when he tells his distant correspondent that: "The celebrated Aspasia of the reign of M. de Calonne, Madame Lebrun, has departed for Italy, to rejoin de Vaudreuil." This last statement was certainly untrue. The Comte de Vaudreuil had gone to Italy, but it was not until they met in Vienna, six years later, that Madame Lebrun saw him again.

Although not written till several years later, the defence of his wife which M. Lebrun printed in 1793 chiefly refers to the time of which we are speaking. It was, in reality, published (gratis) by its author to shield himself from the unpleasant attentions of Jacobins who suggested that, as Madame Lebrun was notoriously an ardent Royalist and had helped Calonne to waste the national wealth, her husband was probably equally guilty of attachment to the *ancien régime*, and might well be sent to prison, if not to the guillotine. In her girlhood, wrote this now much-worried man, the conduct of the Citoyenne Lebrun, sage and modest, gave no opening to ill-nature. As a wife, she was everything she ought to be. Enemies asserted that Calonne had given her pastilles wrapped in bank-notes, pensions on the Treasury ("formerly Royal"), interests in the finances, and so on, but it was a tissue of falsehoods. Calonne came to the house before he was a Minister of State. When he had been appointed Controller-General of the Finances, people pestered the Citoyenne Lebrun to use her influence with him on their behalf. He had sent her, in payment for his portrait, bank-notes to the total amount of 3,600 francs, enclosed in a snuff-box worth about 1,200 francs. "She had never seen

Calonne again ; he came no more to see her ; he had paid for his picture."
Where, asks Lebrun, are the people who benefited by the Citoyenne's
interest with Calonne ? It had been spread about that the Controller-
General had paid for a house which the Lebruns had built in the Rue
du Gros-Chenet, where the Citoyen Lebrun was now residing. So far was
this from being true, that a good part of the bills for that house had not
yet been settled. In any case, it, and the other house in the Rue de Cléry,
were the only property his wife possessed, though she had long been earning
plenty of money—as much, indeed, as five-and-twenty thousand francs
(£1,000) a year, while he also had made a good deal by "a very active and
very extensive" trade in works of art.

He did not say that the plenty of money his wife had earned had
largely been expended in his own pleasures, in which she had no share.
And it may also be noted again, in passing on, that a thousand a year then
meant very much more than it would mean at the present day. Even
Gainsborough, as Mr. James Greig shows in his admirable monograph on
Madame Lebrun's great contemporary, did not expect to have more than
a thousand a year to spend when, at forty-seven years of age, and in high
repute as a portrait-painter, he left Bath for London.

The naturally anxious Citoyen Lebrun further stated, in proof of his
wife's innocence of dipping in the public Treasury, that there had been no
lavish expenditure in his house—that at most four servants (three women
and one man) had been kept, and asked why it was so difficult to believe
that he and his wife had enough money for so modest a household, and for
building another house, if they desired so to invest their savings ?

It is not to be supposed that Calonne, intelligent, agreeable, and
unprincipled, would have had any more scruples in making love to the
charming woman who was painting his portrait than did the Choiseuls
and Bries of fifteen years earlier ; when, as we know from herself, adven-
turous young men used to "sit" to her with the deliberate intention of
seducing her. In those days of her maidenhood her mother acted as
chaperon ; now the artist was a married woman with no affection for her
husband. She was a protégée of the Queen, and it was to the Queen's
influence with the King that Calonne himself—said the foes of Marie
Antoinette—owed his appointment to the control of the Finances, so that
in devotion, chiefly selfish on his part, to the cause of the Queen, artist
and sitter had a certain kind of sympathy at the outset. It may be illogical
to say that a man who is dishonest in money matters would be unscrupulous

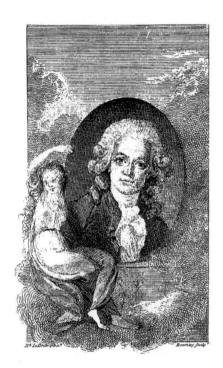

M. DE CALONE.

Publish'd by J.Sewell 32 Cornhill May 1789

CHARLES ALEXANDRE DE CALONNE

After the portrait of Vigée-Lebrun From the *European Magazine*, 1789

in love, but there is no doubt that as a financier Calonne had very loose principles. No sooner had he obtained his appointment as Controller-General than he had the audacity to go to the King and say : " Sir, I owe two hundred thousand francs. Another man would conceal the fact from you, and pay his debts out of the funds entrusted to him ; I prefer to acknowledge them ! " King Louis, a simple soul, who was much impressed by this candid avowal, went to his desk, and took out some securities to the amount stated, which, without saying a word, he handed to the new Minister. Calonne kept the shares, and paid his debts in some other way.

His governing principles in financial operations were that a man who wishes to borrow must appear to be rich, and that in order to seem rich he must make a great display. Economy, he said, is doubly disastrous ; it warns the men with money not to lend to an embarrassed Treasury, and it makes the arts languish as much as prodigality keeps them alive. The application of these principles, in his case, was itself " doubly disastrous." It sent him, half ruined, into exile, and it hastened the coming of the Revolution.

Calonne, who gave away freely what did not belong to him, could have had no difficulty with his conscience in spending the money wrung from the tradespeople and peasantry on his own pleasures, but there is not the smallest substantial evidence that he gave Madame Lebrun more than a fair price for his portrait. Had he done so, the money would soon have got into the hands of her rascally husband ; it was not suggested that she received it secretly.

The story of the extravagance in which she lived, at the immediate expense of Calonne, was repeated round and round, with just such variations as this kind of gossip always takes. Some jester in 1789, at a time when Calonne was in London and Madame Lebrun still in the Rue de Cléry, published a letter in which she is supposed to write to the ex-Minister from that address, beginning with " My dear love," and ending with the hope that " the beauties of Covent Garden will not make you forget your faithful V. Lebrun." This bogus letter assures the exile that France owes its regeneration to him in the same way in which London owed its magnificence to the person who started the great conflagration of 1666. It was the coal-fires of England that had made Calonne so pensive as he now seemed to be. " When you burnt rosewood in my grate," says the letter, "and lit my candle with bank-notes such ideas had not entered your head."

In the *Galerie des Dames Françaises*, published in London in 1790,
some one—probably that self-styled " Comte de " Rivarol who was so
prolific a source of such literature—gives a " character sketch " of Madame
Vigée-Lebrun, in which she is called "Charites." This lady, it is said,
" had devoted her brilliant artistic talents (*traits*) to a being worthy of
that homage. He began the great work which occupies our attention ;
calumny fell foul of him, wishing to give the first blow to the Colossus
who to-day lies low. . . He was struck by the blow, and destroyed by
it, and a priest, now also a fugitive, raised himself upon his ruin, whilst
his adversary hastened away to breathe under a free and peaceful sky."

" The great work which occupies our attention " was presumably the
Revolution, then rapidly advancing on its course ; and the credit given
to Calonne for " beginning " it was partly his due, whether we take it as
satirically or seriously intended. If seriously, it might well refer to the
fact that part of the hopeless mixture of ideas which he had proposed as a
remedy for the bankruptcy of the Treasury was the extension of taxation
to the privileged classes.

There is some reason to think that Rivarol was an active, though
unavowed enemy of Madame Lebrun, though the only offence that, so far
as we know, she had given to him personally was that when her brother
brought him to her studio, in order that she might make his acquaintance,
she was too busy to listen to the flow of amusing talk for which he was
celebrated. " I was putting what we call ' harmony ' to several pictures
which were otherwise finished. One knows that this last process does not
allow any inattention, so that in spite of the wish I had always had to hear
M. de Rivarol talk, I enjoyed very little of the charm of his conversation,
being so much preoccupied. Besides, he talked with such volubility that
I was almost bewildered by it. I observed, however, that he had a hand-
some face and an exceedingly elegant figure ; none the less he found me
so dull that he never came to my house again. It is true there might be
another reason for his not returning there. He passed his life with the
Marquis de Champcenetz, who was always exceedingly ill-natured towards
me." It was Champcenetz, as we have already seen, who spread about
that she lived extravagantly in a gilded palace.

Lebrun's " defence " of his wife, the gist of which has been given,
was occupied rather in denying that she had been enriched by Calonne
than that she had been the mistress of that highly unpopular Minister.
As to a pension which she was declared to have received from Calonne,

it is not unlikely that the origin of this particular clause in the variable indictment against her may be found in the fact that he had given a pension of two thousand francs to " Pindar " Lebrun, the poet who was said to write for him the verses which he claimed as his own compositions. One day, when Calonne read one of these bits of poetry to Rivarol, and asked him, with a self-satisfied air, whether he thought the lines " *sentaient le collège*," his visitor replied, " *Oh! non, Monseigneur, mais quelque peu la pension.*"

In further return for Calonne's pecuniary favours "Pindar" Lebrun compared the incompetent Minister of Louis XVI to Sully, the incomparable Minister of Henri IV! It may be added that at the Revolution he turned round and poured abuse on the Court and its Ministers; later on he eulogised Napoleon (who gave him a pension three times as great as the first), and had he not died before the return of the Bourbons, there is no reason to doubt that he would have written an ode to the glory of Louis XVIII. The history of courtly poets is less pleasing than that of Court painters.

CHAPTER XI

REPLIES TO DEFAMERS

Madame Vigée-Lebrun's reply to her calumniators—Her simple tastes—Why her carriage was in Calonne's courtyard at night—The Minister's periwig as evidence of her innocence——A point in her favour—Her husband's consolatory promise—The benefit of the doubt

WHAT was Madame Vigée-Lebrun's own reply to the oft-recurring statement that she had received large presents of money and money's-worth from the Controller-General of Finance, and that she had been his mistress?

In the first place, she asserts that she cared very little for money—which, though she liked the comforts and pleasures that money may buy, is true. Her husband, as we know already, took all that she got for her work, leaving her often with no more than six francs in her pocket—women had pockets in those days—and refusing to let her have fifty francs when she asked for that amount. He seems to have paid her bills, however, more or less regularly. But "I spent very little indeed on my clothes," she writes. "I was even accused of negligence, because I only wore white frocks of muslin or linen, and never had trimmed dresses except when I went to paint portraits at Versailles. The dressing of my hair cost me nothing, for I did it myself, and usually I twisted in it a muslin kerchief, as you may see in all my portraits of myself, with the exception of that in which I am wearing a Grecian costume." All this is not of much consequence either for or against her virtue, though it supports her denial of extravagance. "Though I think," says this much-abused lady, "that I was the most harmless creature that ever existed, I had enemies; not only were there women who had a spite against me for being less ugly than themselves, but a good many others could not forgive me for being successful, and securing higher prices for my portraits than they could get; the consequence was that a thousand things were said against me, one of which, above all the rest, gave me intense pain. Shortly before the

74

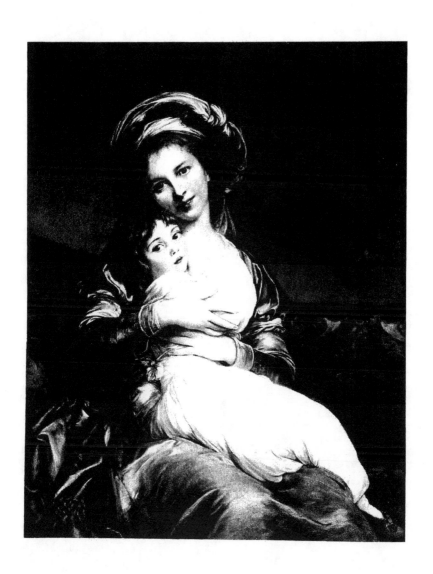

Revolution I painted a portrait of M. de Calonne, and I exhibited it at the Salon of 1785. . . I was subjected to the most odious calumnies on that occasion; first of all a thousand absurdities were circulated concerning the payments I had received for the portrait. It was said that the Controller-General had given me a large number of bonbons wrapped in bank-notes, also that I had been given, in a *pâté*, a sum of money large enough to empty the Treasury. . . . The truth is, that M. de Calonne had sent me four thousand francs in bank-notes, in a box which has been valued at twenty louis. Some of those who were present when I received that box are still alive, and can bear witness to what I say. They were even surprised at the smallness of the payment, for, a little while before, M. de Beaujon had sent me eight thousand francs for a portrait of the same size, and no one thought I was overpaid." She goes on to the specific accusation that she had been over-intimate with M. de Calonne. Apart from mere inventions by her enemies, the tale was founded, according to her account, on the fact that, just at that time, her husband had built the house in the Rue du Gros-Chenet (not fully paid for till she returned from Russia in 1801), and that one night her carriage had been seen waiting in the small hours outside the Ministry of Finance. She asserts that on the evening in question she had lent her carriage to a lady who actually had a liaison with Calonne, and who had taken advantage of Madame Lebrun's kindness to save her own reputation at the expense of the owner of the carriage. Putting all questions of morality on one side, it is certainly in the highest degree unlikely that so intelligent a woman as Madame Lebrun would have allowed her coachman to drive up and down, or wait in the courtyard of Calonne's official residence while she spent the night there. She was not a fool.

Her own strongest "proof" of innocence in respect of Calonne, however, was not a matter of evidence, but of taste. After emphasising her extreme simplicity in personal adornment she clinches her "defence" in the following words : "Assuredly it was not such a woman as that who was likely to be seduced by the title of a Receiver-General of Finance, and in all other respects Monsieur de Calonne always seemed to me little seductive ; for he wore the periwig of a Treasurer (*une perruque fiscale*). A periwig ! you can imagine how, with my love of the picturesque, I should have been able to get used to a periwig ! I have always detested them, even to the point of refusing to marry a wealthy suitor because he wore a periwig; and I much disliked having to paint the portraits of men with such things on their heads."

Were it not that she was a very old woman when she put forward this final reply to the Calonne calumny, which still vexed her, we might almost regard it as evidence that there really was some ground for the story so persistently repeated between 1785 and 1793. Wigs of any sort were certainly becoming unfashionable in the days when Calonne was in power, and Parisians in general were allowing their hair to grow long, to be powdered and tied with a bow at the back. But the periwig for great officers of state and church still held its own in France up to the Revolution, as it did in England till long after, our Bishops retaining their wigs into the Victorian era, our judges and barristers and the Speaker of our House of Commons wearing them officially at the present day.

Proverbs, according to a famous Englishman of the eighteenth century, Lord Chesterfield, are not to be used in polite conversation, but it is impossible not to be reminded of the familiar saying as to one man being allowed to steal a horse whilst another may not look over the wall, when we read Madame Lebrun's remarks on M. de Calonne's periwig, and re-member that only a year before his portrait was exhibited she had shown two of the Comte de Vaudreuil, in which that perfect friend is seen wearing a wig which only differs from the Controller-General's in being less abundantly curled.

If a charming woman of our own time, accustomed to the society of people of refined taste and of the latest fashion, were accused by busy-bodies of being too friendly with an unscrupulous public man, and she were to ask : " Is it likely that I, who dress in the quietest fashion, and do my hair as simply as possible, should allow a man who still wears a frock-coat and mutton-chop whiskers to make love to me ? " it would probably be held to be very unlikely indeed. When, however, it was realised that this man who was so behind in the fashions had been placed in one of the highest positions in the state through the wire-pulling of a clique to which, if the lady herself did not actually belong, she was very closely attached by interest and long personal friendships, that he was a lively person of rather engaging manners and conversation, and that the lady's husband had ceased to interest her heart, her question might appear not quite so easy to answer in the negative without some further evidence of the extreme improbability that she wished her hearers to recognise.

This business about Calonne is a source of difficulty to any one who wants to find out all that is to be known as to the nature and experiences of Vigée-Lebrun. If she said in so many words, " the thing is an absolute

lie," we at the present day could readily accept her disclaimer. But that is just what she does not say, the gist of her remarks on the subject illustrating the ancient method of begging the question with that other question, " Is it likely ? "

So far as her *public* reputation was concerned, the scandal mainly confined itself to the presents she was said to have received from the Finance Minister, who was known to be scattering money right and left while, in spite of excessive taxation, the deficit in the national balance-sheet was constantly growing. Only a few great families which kept aloof from the Court would have thought it very wrong of Madame Lebrun to have one lover or more, so long as the loving was unobtrusively conducted. To all but his own party, which by no means included the whole Trianon set, Calonne was as odious as was Strafford—no comparison is suggested between the characters of the two men—to the Parliamentary party in England.

Evident factors in favour of Madame Lebrun's innocence are that she was too keen on her work to have much time or inclination for gallivanting, and that had she been disposed towards lightness of conduct, there were several men of her acquaintance who would certainly have had a far better chance of winning her affection than the lover assigned to her.

What did her husband do at the time to defend his wife's reputation ? She was for ever saying to him, " You see what infamous things are being spread about," but although she declares that he showed a *sainte colère* his words are more suggestive of a holy calm. " Let them say what they like : when you are dead I will raise in my garden a pyramid reaching to the sky, and I will have a list of your pictures engraved on it ; people will then know very well where your fortune came from."

His efforts at a later period to persuade the Jacobin world that she had not taken public money from an unjust steward of the public property effected its object, if he was really in serious danger, for he survived the Terror, and if his nerves were for a time horribly shaken by justifiable dread of arrest, he retained his freedom and his stock-in-trade. It may be added that some Jacobin official, into whose hands a letter from Madame Lebrun to Madame du Barry fell, was so unkind as to endorse it as being written by the wife of the citizen Lebrun, and " Mistress of Calonne."

It has been necessary to devote numerous pages to the Calonne episode in Vigée-Lebrun's life, both because it held so large a place in her own

thoughts, and because, unless the main facts were, as far as might be, recalled, the reader would be left with no means of deciding for himself whether there was or was not any foundation whatever for the taunts so persistently and spitefully thrown at her by the enemies of herself and of her patrons.

On a consideration of the persons, the circumstances and motives in this matter, so far as they are known or may reasonably be assumed, many readers will agree that if the case were left to a fair-minded and intelligent jury of to-day in the familiar form of questions: (1) Did Madame Lebrun receive an excessive payment for Calonne's portrait? and (2) Was Madame Lebrun the mistress of Calonne? the "benefit of the doubt" would probably commend itself to the twelve citizens who at the moment represented "the palladium of our liberties."

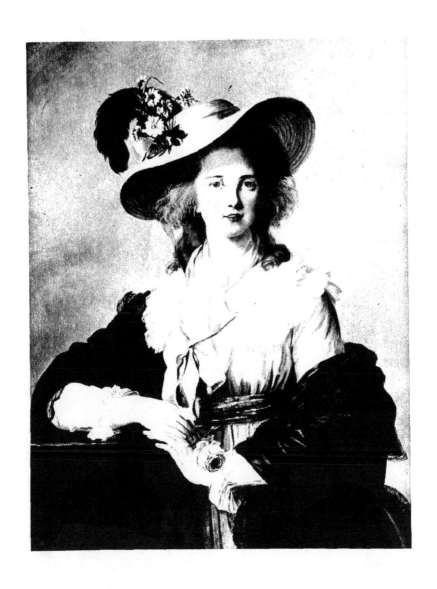

CHAPTER XII

MADAME DU BARRY

A visit to Madame du Barry—Louveciennes then and now—The waterworks of Marly—The Pavilion above the Seine—Spoils of a king's mistress—The Duc de Brissac—Madame du Barry as Lady Bountiful—The envoys of Tippoo-Sahib—Dinner on the floor—Trouble about a portrait—Indian presents for Madame du Barry

IN 1786 Madame Lebrun was asked to stay at Madame du Barry's country home, and to paint a portrait from life of that notorious adventuress, who, from being a dressmaker's assistant, had become, for about five years, as Mistress of Louis XV, the most powerful person in France. After the death of that king she had retired, amply endowed, to the beautiful place that he had given her at Louveciennes (or Luciennes as it was commonly written in those days), on the hill above the left bank of the Seine, between Bougival and Marly.

As this village was also to be the country home of Madame Lebrun herself during the last thirty years of her life, where she experienced a great deal of happiness and some brief but intense anxieties; and as her dust now lies in the little cemetery at the top of the hill, it will not be out of place to describe a spot which is still much as it was in her lifetime, even in those years just before the Revolution when she passed such peaceful days in the luxurious château of " The Du Barry."

Villadom, which has made the wooded valley of the Seine below Paris so speckled with white and red in many parts, has largely spared Louveciennes, and as you walk up the village street, or down the wide lane that leads past the gardens of Madame du Barry's home, you may, if you have a little imagination, forget for a while the passing of time and fancy yourself in the Louveciennes of long ago. In springtime, when the wild cherry is in bloom in the copses, and the celandine covers the roadsides with its yellow stars, while the ferns and the little toad-flax are pushing out their young shoots from the crevices of the ancient walls of stone and plaster,

the long lanes of Louveciennes are delightful to the senses. The scent
of blossom and moss and of the freshly turned earth of the gardens is
in the air, and even the very roofs of some of the old cottages are gardens
of wild flowers, planted by the wind and the birds.

There is a link between past and present which, to any one familiar
with the *Souvenirs* of Vigée-Lebrun, gives a startling reality to his
thoughts of her presence as he wanders in her paths above the valley of
the Seine. On more than one occasion she speaks of the noise made by
the " machine " which pumps the water up from the river to the great
aqueduct built, under Louis XIV. for supplying the fountains of Marly
and Versailles. Once she complains that her rest is disturbed by the
incessant roaring of this example of clever engineering. It is roaring still.
As you begin to descend the hill you hear it, getting louder and louder.
Then, as you come within sight of the river, you see the great dam over
which the water falls, to turn the machinery by which the reservoirs of
Versailles are partly fed—machinery very different from that which made
the water go uphill to please the Bourbons as it gushed from the mouths
of Tritons and lions at the other end of the pipes, but quite capable of
keeping people awake when they first come to stay within sound of its
working.

The former mistress of a king of France, and actual mistress of a duke,
Marie Jeanne Vaubernier, Comtesse Du Barry, was forty years old, or a
little more, when Madame Lebrun came down to Louveciennes to paint
her portrait. It was the first time these two women, each so typical of
certain aspects of their period, had met one another, and the artist was
" extremely curious " to see the courtesan. She found her " tall, without
being too much so ; she was plump, her neck and shoulders a little large,
but very beautiful ; she still looked charming, her features were regular
and pleasing, her hair was fair and curly like a child's, her com-
plexion alone was beginning to lose its freshness. She received me very
kindly, and seemed to have very good manners. But I found her more
at ease in her mind than in her manners. Her expression was that of a
coquette, for her long eyes were never fully opened, and there was some-
thing childish about her pronunciation which was unsuitable to her
years."

The visitor was given a suite of rooms on the side of the Château
looking over the river, and within full sound of the " machine " of which
" the mournful noise " so distressed her nerves. Below her rooms was a

gallery (badly in want of spring cleaning) wherein vases, busts, marble statues, and many other art treasures were jumbled together, so that " one might have fancied that one was staying with the mistress of several sovereigns, all of whom had enriched her by their presents." Nearer the river than the Château is the famous " pavilion " built under Madame Du Barry's own directions; the doors, chimneypieces, and fittings, the furniture and bric-à-brac of which, in those far-off days, were of the most expensive and, according to the taste of the time, most " elegant " character. The windows of this luxurious house overlooked what Madame Lebrun calls " the most beautiful view in the world".—rather an exaggeration, perhaps, even in those days, from a woman who had been through Italy and Switzerland, and had seen many of the glories of English scenery, but excusable as the impression of any one under the immediate influence of the Seine valley at that spot.

The hostess herself was much more simply adorned than her rooms. At all seasons of the year she wore " nothing but loose gowns of cambric or white muslin; and every day, whatever the weather, she went for a walk in her park or beyond it, without any untoward results, so robust had her life in the country made her." We may reasonably suppose, without indelicacy, that Madame du Barry's *dessous* were thicker on days of frost than on days of broiling sunshine.

Fresh from Paris, where she spent most of the evenings in friendly crowds, or from country-houses where the hostesses spent much of their time in welcoming arriving and speeding departing guests, Madame Lebrun found the Château of Louveciennes very quiet. She declares that only two ladies called whilst she was there—a great contrast, no doubt, to the days when Madame du Barry was first installed in her gorgeous and beautifully situated nest.

But, as Madame Lebrun reflects, " it was no longer Louis XV who lounged upon these fine sofas, it was the Duc de Brissac; and we often left him alone there, because he liked to take a siesta." He came frequently, and lived in that house as if he were at home, but nothing, in his behaviour or in that of Madame du Barry, could lead one to suspect that he was more than " the friend of the mistress of the château," though " it was easy to see that a tender attachment united these two people." On most evenings the two women were alone, and the guest evidently found the society of the hostess a little dull. Madame Lebrun, indeed, rather naïvely remarks that Madame du Barry avoided all details about Louis XV and his court;

6

"it was even evident that she preferred to keep off that subject of talk, *en sorte qu'habituellement sa conversation était assez nulle.*"

The Châtelaine of Louveciennes was the Lady Bountiful of the village, where "all the poor were relieved by her. We often went together to visit some one who was in distress, and I remember the righteous anger she showed one day, when she found a poor woman, just delivered of a child, and with nothing provided for her wants. 'What!' said Madame du Barry, 'you have not linen, or wine, or beef-tea!' 'Alas! nothing, Madame.' As soon as we got back to the château, Madame du Barry sent for her housekeeper and some other servants who had not carried out her orders. I cannot tell you" (this is part of a letter addressed to the Princess Kourakin) "how furious she was with them, while she made them do up a bundle of linen that she sent them off with, at once, with some beef-tea and a bottle of red wine for the poor invalid."

Tippoo Sahib, the ruthless Sultan of Mysore, whose resolute opposition, feebly aided by the French army, caused so much trouble to Cornwallis, had determined, in 1787, on a great effort to drive the English out of India with the aid of the French. With this idea he sent two envoys, Mahomet Dervisch Khan and Mahomet Usman Khan, to France, to ask for the help of his former allies in achieving so magnificent an object. Madame Lebrun saw these dusky strangers at the Opera, and was so struck by the sight of their "superb heads" and brilliant costumes that she asked the Queen to ask the King to ask the envoys—a lot of asking—to sit for their portraits, she having ascertained that nothing but a direct request from His Majesty would induce them to be painted. No doubt their religion, as good followers of their great namesake who founded it, made them so particular in this respect.

On receiving the royal request they agreed to sit at the house where they were quartered. When the artist came into the room, Usman Khan fetched some rose-water and threw it over her hands, and Dervisch Khan then posed for his portrait. She painted him standing up, holding a dagger, and found him an excellent model. When he got tired, she put the canvas to dry in another room, and began the portrait of the elder ambassador, whom she represented sitting down, with his son at his side.

Evidently these distinguished Orientals took a fancy to the charming lady who, unveiled, had stood so long in their presence, for they invited her to come to dinner one day, and allowed her to bring her beautiful friend, Madame de Bonneuil. "We accepted out of pure curiosity. On entering

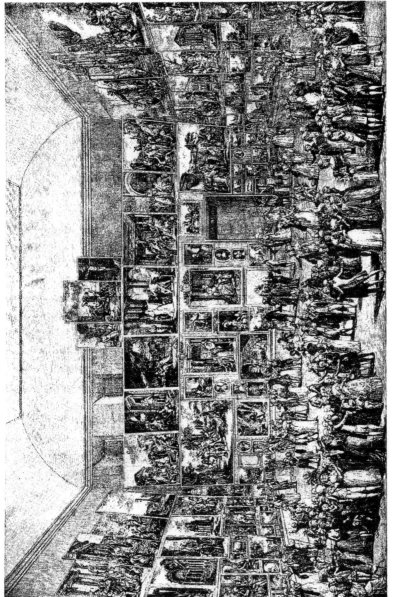

EXHIBITION OF THE PARIS SALON (1787) AT THE LOUVRE

Vigée-Lebrun's portraits of Marie Antoinette and her children, of Julie Lebrun "with a mirror," and of Madame de Méon can be seen to the left of the door

82]

the dining-room we were a little surprised to find the dinner laid on the
floor, so that we were obliged to recline, as they did, round the board.
They helped us with their own hands from the two dishes, one of which
contained a fricassée of sheep's trotters with highly spiced white sauce,
and the other some kind of ragoût. You can imagine we made a sorry
meal; it quite took away our appetites to see their bronzed hands used
as spoons." Dervisch Khan, when his portrait was finished, hid it behind
his bed and would not give it up, declaring that " it had no soul," and it
was only with the aid of the ambassador's body-servant that the artist
could get it. When his master found that his servant had given up the
portrait, he would have killed him, had not the interpreter, with great
difficulty, made him understand that you could not do that sort of thing
in Paris, and assured him—quite untruthfully—that the King of France
had sent for the picture. If the records of Oriental visitors to European
capitals were published we should probably find that interpreters have not
always been equally successful in preventing such ancient customs of the
East from being illustrated in the West.

For some reason or other the Mysorean envoys believed it their duty
to go all the way out to Louveciennes to call on Madame du Barry, carrying
handsome presents to that lady. Their master, Tippoo Sahib, had learnt
the French art of war from some officers in the army of Louis XV. and it
is very likely that the Sultan of Mysore knew from his instructors that
the King's " second wife " had been the real power in the state in those
days. Among the gifts they brought from the East were some pieces of
muslin richly embroidered with gold thread. Madame du Barry gave
one of these pieces, adorned with large coloured flowers, as well as with
gold, to Madame Lebrun, who valued it for the rest of her life.

We must not leave these Indian envoys without mentioning their
end, which was tragically in keeping with events that were happening in
France at the time when they arrived in Mysore. The Sultan was so enraged
at the failure of their mission to his French " brother " that he had their
heads cut off, a welcome home for which they probably were well prepared,
from their knowledge of the customs of their country, the character of their
master, and of what they would have done to any servants of their own
who had failed in an even less important business.

CHAPTER XIII

THE COMING REVOLUTION

I N 1788 the Abbé Barthélemy published his celebrated work *The Travels
of Young Anacharsis in Greece*, one of the most learned achievements
of that period, and by no means the least entertaining, as to which
Robert Burns wrote to Mrs. Riddel, " I never met with a book that be-
witched me so much." In the course of his book Barthélemy describes
an ancient Greek banquet. Such descriptions were once rather popular.
Smollett, for example, had already introduced a comical supper after the
manner of the Romans in *Peregrine Pickle*. One afternoon, whilst Madame
Vigée-Lebrun was taking her usual siesta (her *calme*), she was tempted to
listen to her brother reading some pages from Barthélemy's book, which
was already in great demand at the libraries. When Etienne Vigée had
read the passage where, in describing the Greek dinner, the author gives
recipes for making several kinds of sauce, he had a brilliant inspiration.
" We must taste some of these sauces this very evening," he said. His
sister thought this a capital idea, and sent at once for the cook, who, after
hearing what the sauces contained, undertook to make one kind for a
chicken and another kind for an eel. Some " very pretty women " were
expected to come to supper that night, and Madame Lebrun thought it
would be great fun if she and they were to dress up in Greek style, as a
surprise for M. de Vaudreuil and M. Boutin, who were expected to arrive
about ten o'clock. She had a large assortment of suitable costumes in
her studio ; and a neighbour, the Comte de Parois, who had rooms in the
building, would certainly lend some of his splendid Etruscan cups and
vases. A mahogany table was laid for the supper, without a cloth, the

Etruscan pottery being placed upon it, and behind the chairs Madame
Lebrun put a huge screen, covered with some draperies, which were dis-
posed "as one sees them in Poussin's pictures." When the ladies arrived
—Joseph Vernet's daughter the "charming Madame Chalgrin," the lovely
Madame de Bonneuil, and Etienne Vigée's wife, who, "without being so
pretty, had the most beautiful eyes in the world,"—they were soon turned
into alluring Athenian women. Lebrun, the master of the house, was not
present, but "Pindar" Lebrun came in, and made no objection to having
his curls straightened out, being crowned with laurel, robed in purple,
and called Anacreon for the occasion. Several other men who came
were turned into Greeks almost before they had time to know why, one
of them, the Marquis de Cubières, sending to his house to fetch a guitar
that bore some resemblance to a gilt lyre. Julie Lebrun, the daughter of
the house, then eight years old, and Madame de Bonneuil's little girl were
attired as Greek slaves, in long tunics. The hostess herself, having dressed
all the others, merely added a thin veil and a wreath of flowers to her
ordinary costume—a white tunic (or blouse) and skirt—and thought she
was quite near enough to her Greek ideal. The chairs having been covered
with draperies, to look something like the couches of classical antiquity,
the company at half-past nine sat round the table, and amused themselves
by looking at one another until, at about ten, Messieurs de Vaudreuil and
Boutin were heard arriving. They found the company singing an appro-
priate chorus by Gluck, his "God of Paphos and of Cnidus," accompanied
by M. de Cubières with his lyre-guitar. "In all my life," says the hostess
of that evening, "I have never seen two faces look so astonished as theirs.
They were so surprised and delighted, that they stood looking at us for
ever so long, before they could bring themselves to take the places we
had kept for them."

As for the feast itself, it consisted, besides the chicken and the eel
with their spicy sauces, of figs, olives, a cake made of honey and currants,
and some real Cypriote wine which the two little "slaves" poured from
antique vases.

These innocent Greek revivalists sat long at table, though they did
not do much revelling save in wit and anecdote, the consumption of wine
being limited, as the hostess declared, to one bottle of the wine of Cyprus.
Let us hope it was a big one (if the wine was pleasant), for there were
at least four men and four women to drink it, and probably the little
girls who served it were allowed a sip or two from their mothers' glasses.

" Anacreon " made up, it seems, for the scarcity of material stimulant by reciting several odes which he had translated into French from the Greek of his Ionian original. Altogether Madame Lebrun thought it was the most amusing evening she ever spent.

It was indeed, to quote Theodore de Banville, " Un beau souper, ruisselant de surprises," but unhappily it was to prove a too excellent illustration of the ancient truth expressed in the familiar lines :

> " Men laugh and sing until the feast is o'er,
> Then comes the reckoning, and they laugh no more."

The reckoning, in this case of Madame Lebrun's supper after the manner of the ancient Greeks, was to be paid in mental suffering. Some of those who had been present, particularly M. de Vaudreuil and M. Boutin, talked about its delights wherever they went, and some ladies of the court begged her to give another entertainment of the same kind. She refused, partly, as one of her friends said in after years, because she did not wish to do " in cold comedy " what had been originally done on the spur of an inspiration. Some of the people who wished they had been there, some others who never lost a chance of saying unkindly things about anybody, and above all, some who were glad of an opportunity of injuring Madame Lebrun, spread about far and wide that the Greek supper had been one of the costliest entertainments of the season. The King heard that twenty thousand francs had been spent on it, and he expressed his vexation to M. de Cubières, who had played his guitar on the occasion, and was therefore able to deny the truth from personal knowledge. But the story once started was beyond denial, as such stories almost invariably are. At Rome, a year or two later, Madame Lebrun heard that she had spent forty thousand francs on that fantasy ; at Vienna she was told that the sum was sixty thousand, and at St. Petersburg that it was eighty thousand. She herself estimated the cash expenses of that night at about fifteen francs.

The poison in the sting of this flying gossip was, of course, the suggestion, more or less openly made, that the money for this Grecian festival came, through Calonne's hands, from the cruelly-taxed public.

In this same year she was invited, " with her family," to spend a month at her once much beloved Moulin-Joli, which, after the death of M. Watelet in 1786, had passed into the possession of a new and very different owner, M. Gaudran, a wealthy man of business. M. Gaudran had no sense of the picturesque, and he had already spoilt some parts of the beautiful haven

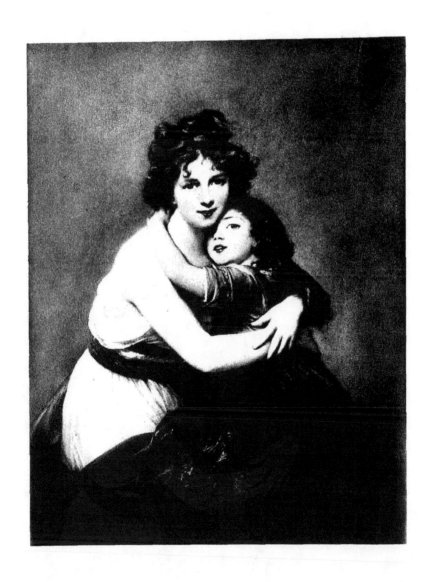

of rest. However, he had not had time to destroy the chief charms of the gardens and woods. Hubert Robert was now a fellow guest, and it was during this time that Madame Lebrun painted his portrait. She describes it as "one of my best portraits," an opinion with which most people who have paid attention to her work would agree. "Lebrun-Pindar" was at Moulin-Joli at the same time, writing verse, and so was Etienne Vigée. We may assume that this brother of Madame Lebrun's, and her daughter Julie, represented "her family" Her husband, as usual, is really "conspicuous by his absence."

In her Paris studio there were several pictures, finished or unfinished, intended for the Salon of the next year. On July 14, 1789, the Bastille fell, and the King's remark, that before *The Marriage of Figaro* could be produced that fortress would have to be pulled down, was in great part justified, though the order of the two events was changed.

In August the Salon opened its doors as usual, and among the pictures of the year were two at least of Madame Lebrun's finest works—the portraits of Hubert Robert and the Duchesse d'Orléans. The first, now in the Louvre, was begun, as we have seen, at Moulin-Joli. It shows the landscape painter leaning on a balustrade, with his strong, intelligent face looking up. He was one of the men for whom Madame Lebrun had a real regard, though she was rather a severe critic of his work in general, which was marred, in her view, by excess of facility. "He painted a picture as quickly as he wrote a letter ; but when he could control that facility, his works were often perfect." He was a great "diner-out," though theatres, balls, and picnics were all a delight to one who was "amateur of every pleasure." His constant brightness of disposition made him very popular, and, in a rather degenerate society, his physical "fitness" made him remarkable on all occasions when any bodily exercises were part of the programme. "When he was over sixty," Madame Lebrun tells us, "although he had become very bulky, he was still so brisk that he ran better than any one else in a game of rounders, played at tennis and at football, and delighted us all by schoolboy feats which made us laugh until we cried."

The subject of the other portrait, the Duchesse d'Orléans, is one of the most pathetic figures among those members of the Royal family who survived the Revolution. Perhaps it is because we know her history that we seem almost to read it in her pictured face, with its blue eyes full of a gentle melancholy. Married in 1769, at sixteen years of age, to the Duc

de Chartres (afterwards Duc d'Orléans and " Philippe Egalité ") who was six years older than herself, her great fortune as heiress of the Duc de Bourbon-Penthièvre was largely dissipated by her disgraceful husband, whose notions of pleasure were very much those of his forerunner at the Palais-Royal, the Regent Orleans. We have met him before in these pages, when, not long after his marriage to a virtuous and lovable girl, he was staring the women out of countenance, and jeering at their appearance, on the steps of the Coliseum. Every one of decent character sympathised with this ill-married princess, and the pity of thousands, long years after her death in 1821, has been quickened for the mother of Louis Philippe by this picture from Madame Vigée-Lebrun's brush.

The portraits of the Mysorean envoys, one of the Dauphin, and one of the young Prince Henri Lubomirski (holding the particular crown of myrtle and laurel which Lebrun-Pindare wore at the Greek supper) were also among the pictures exhibited by her in the Salon of 1789.

By this time, Madame Lebrun had begun to realise the possibility that she might have to leave France. Already some of her friends, notably the Polignacs and the Comte de Vaudreuil, had thought it wiser to be out of the country. The ship of the old Régime was obviously sinking, to the eyes of intelligent members of the crew, and, rather than go to the bottom with it, they preferred to imitate the proverbial rats.

In the preceding year Madame Lebrun had noticed with alarm, during country walks in the environs of Paris, that the labourers no longer took off their hats to her and her companions, and even at times became insolent and threatening in their attitude. At Marly, where she was staying in the midsummer of 1789 with her friend Madame Auguier (a beautiful lady of the Court, sister of the more celebrated Madame Campan), an incident occurred which would have been a direful warning, even to an optimist adherent of monarchy. We will hear what happened from Madame Lebrun herself. " One day when we were at a window which looked into the courtyard, which courtyard opened on to the high road, we saw a drunken man come in, and fall down on the ground. Madame Auguier, with her usual kindliness, called a valet, and told him to help the unhappy man, to lead him to the kitchen and take care of him. A few minutes later the valet came back. ' Truly,' he said, ' Madame is too good : that man is a wretch ! Look here at the papers which fell out of his pocket.' And he handed to us several note-books, one of which began : ' Down with the Royal Family ! down with the nobles ! down with the priests ! ' followed

by the revolutionary litanies and a thousand atrocious predictions, written in language which made one's hair stand on end. Madame Auguier sent for the mounted police, to whom the safeguarding of the villages was then confided. Four of these gendarmes (militaires) arrived ; they were charged to remove the man and to make inquiries about him. They took him off ; but the valet, having followed them at a distance without being noticed, saw them, as soon as they had turned the corner, walk arm-in-arm with their prisoner, leaping and singing with him, on the best of terms."

This little story has more than one significant feature. We see the kind-hearted aristocrat from Versailles ready, out of her abundant wealth, to relieve the necessities of any drunken tramp who stumbles into her courtyard, without any attempt to discover whether he is in need of other assistance than a bucket of water over his head. (This species of largesse, scattered promiscuously, was apparently much practised by wealthy courtiers of that period, though of course there were sensible philanthropists among them.) The police who have been summoned, and who (so far) have not shown any disposition to shirk their duty, are not left to act on their own responsibility as guardians of the peace, but are " charged " by the lady of the house or her servants (*enjoindre* is the verb used) as to their business with the man. They were at the orders of every person of position, while the bounty of nobles was free to any scoundrel who chose to present himself.

Madame Auguier took the papers seized on the drunken wretch to the Queen (they ought to have been taken away by the police, one would suppose), and as Marie Antoinette read them she said : " They are impossible things ; I shall never believe that they meditate such atrocities."

On another afternoon in that anxious summer-time Madame Lebrun went to dine at Malmaison, where among the guests she found the famous Abbé Sieyès " and several amateurs of the Revolution." One of them loudly abused the nobles, all of them talked at the top of their voices, and " perorated " upon everything that was likely to cause a general upheaval of society. They frightened Madame Lebrun by the things they said, and after dinner, on Sieyès expressing an opinion " that they would go too far," she remarked to another woman present : " They will go so far that they will lose themselves on the road."

CHAPTER XIV

FLIGHT FROM FRANCE

The artist's house threatened by the mob—Brimstone thrown into her cellar—She takes refuge with the Brongniarts—Mercenary rioters—Pamela and the mob—Madame Lebrun moves to the Saxon envoy's—She decides to leave France—Drunken national guards invade her room—Secret friends—Money for her journey—She and Julie leave in disguise—The Lyons diligence and its passengers—Incidents of the road—Friends at Lyons—Recognised by a postillion—Arrival in Italy

THE revolutionary mob, who had been taught by scurrilous lampoonists to believe that the new house in the Rue du Gros-Chenet, where the Lebruns were by this time living, had been paid for by Calonne, began to make themselves exceedingly unpleasant to the artist. They threw brimstone into her cellars, they shook their fists at her when she showed herself at the windows; rumours of ill-intent reached her every day from various quarters. The natural result of all this was that her nerves were seriously shaken, and she began to feel and look wretchedly thin and ill.

Her old friends M. and Madame Brongniart were much distressed to see her in this state, and earnestly begged her to stay with them at the Invalides, where this distinguished architect had a residence. She accepted with gratitude, and with the help of a doctor attached to the Palais-Royal, whose servant wore the livery of the Duc d'Orléans ("the only one then respected"), she got to the Invalides in safety. "I was given the best bed," she says in one of the letters; "as I could not eat, they fed me with beef-tea and excellent red wine, and Madame Brongniart never left me." But in spite of all this kindness, she felt hopeless as to the future.

She and her hostess were walking one day close to the Invalides, and sat down against the wall of a cottage. Presently they heard from within the voice of a workman saying to one of his mates: "If you want to earn ten francs, come and shout with us. All there is to do is to cry, 'Down with this man! Down with that!' And above all to cry out very loudly

against *Cayonne*." "Ten francs is worth having," was the reply; "but shan't we get knocked on the head ? " "Go on ! " said the one who had first spoken—" it is we who give the knocks on the head."

The day after this incident Madame Brongniart and Madame Lebrun found a crowd of ruffianly-looking people outside the railings of the Invalides. Madame Lebrun, who, as she readily admits, had less courage than her companion, was so frightened that she began to make for the house, when they saw coming up on horseback a girl wearing a riding-habit and a hat with black feathers. In a moment the crowd lined the way on either side to let this rider pass, followed by her two grooms in that "respected" livery of Philippe Duc d'Orléans, the spendthrift preacher of equality whom the ragamuffins desired for their King. The girl on the horse was none other than Pamela, whom Madame de Genlis had once brought to Madame Lebrun's house. At the outbreak of the Revolution the future Lady Edward Fitzgerald was in all the freshness of youth, and was "truly ravishing" in the eyes of a woman who had a highly trained eye for a pretty face. The crowd also were struck by Pamela's appearance, and, influenced no doubt also by the Orleans liveries, they cried, "Look there, that is the one we ought to have for Queen ! " The girl came and went again and again amid that "disgusting populace," and by so doing gave Madame Lebrun material for some sad reflections.

The immediate danger having apparently passed for herself, Vigée-Lebrun went back to her own house, where her husband, it is to be supposed, was living all the while, though we hear nothing about him. She could not find rest, however, in the Rue du Gros-Chenet, and she went off again to stay in the Rue de la Chaussée d'Antin with M. de Rivière, the Saxon Chargé d'Affaires, whose daughter was her sister-in-law. One day the mob came to that street, burnt the barrier at the end of it, tore up the paving-stones and built barricades, lightening their labour with cries of "The enemy is coming." The enemy, as Madame Lebrun says, was not " coming," it was already in the place.

M. de Rivière's house was technically a part of Saxony, being the Ministry of that state in France, but the populace of Paris was beginning to care very little about anybody's rights or status, and Madame Lebrun finally decided to move out of her native land as soon as possible. She had a number of unfinished pictures on hand, but in her then state of mind she could not paint. She refused at that time to make the portrait of a charming girl of sixteen, Mademoiselle de Laborde (afterwards Duchesse

de Noailles), although the commission was one which in other days would
have greatly pleased her. Success and fortune had no power to attract
in that terrible hour of her life; her only thought was to save her head,
and to get away with her child while there was time and chance. She had
her carriage packed, and procured a passport; she raised what money she
could by obtaining payment herself for a small sum due to her from the
Bailli de Crussol, and was on the eve of departing, when a number of National
Guards, most of whom were drunk, forced their way into her rooms, to
which she had returned to prepare for departure. These alarming visitors
declared, in highly unpleasant language, that she could not leave Paris.
It was useless for her to talk of the new liberty, and her wish to enjoy her
share of it.

 But there was a surprise to follow. Soon after these dirty soldiers had
gone away, two of them came back, and one of the pair said to her, quite
politely: "Madame, we are neighbours of yours; we have come to advise
you to depart, and as soon as you possibly can. You could not stay here;
you look so changed that we are very sorry for you. But don't go in your
own carriage, go by the public coach—it is much safer."

 She thanked them as they deserved to be thanked for such disinterested
advice, the giving of which was a danger to themselves. Three places were
taken in the Lyons diligence, but only for a fortnight afterwards, every place
up till then being already booked, so great was the desire to be away from
Paris. The parting with her mother was a sad one, one may be sure, but
there never seems to have been any fear for the safety of the Le Fèvres, the
retired jeweller presumably having no Royalist sympathies. The day of
departure was a fateful one in the history of the Revolution. It was that
October day on which, after terrible scenes, and with horrible accompani-
ments, the unhappy King and Queen were brought from Versailles to the
Tuileries at a pace of two miles an hour. Etienne Vigée had been in front
of the Hôtel de Ville when the King and Queen were received there by
M. Bailly, Mayor of Paris. He told his sister, when he came to see her off,
how Marie Antoinette had said to the Mayor, "I have seen everything,
I have known everything, and I have forgotten everything."

 Justifiable anxiety for the Royal Family and for polite society in
general made Madame Lebrun so ill that when, at midnight, the time for
departure came, she was scarcely in a state to go. However, disguised as a
poor workwoman, with a thick veil over her eyes, she reached the diligence,
and her brother, her old friend Hubert Robert, and her husband—whom

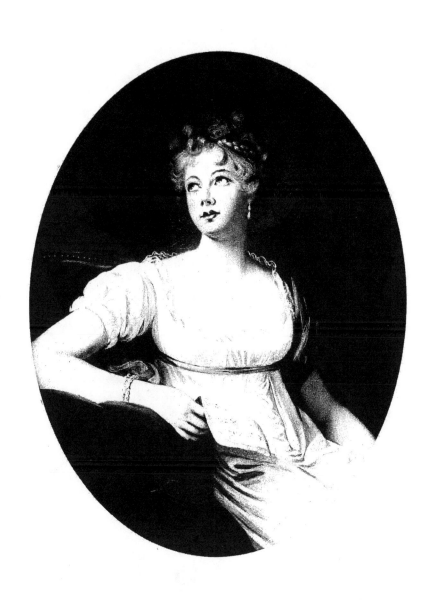

she mentions last—walked at the side of the vehicle until the horses broke into a trot at the barrière du Trône. It is probable that she would not have got out of Paris without some dreadful alarms in the Saint Antoine quarter but for the fact that nearly all the inhabitants had walked to Versailles and back during the day, and had gone to bed dog-tired.

She started on her travels with her daughter of nine years old and a nursery-governess, both dressed in keeping with her own disguise. They could have very little luggage, even had there been no need for affecting poverty. At that moment, when every possible place in the public coach was occupied by a passenger, it would have been impossible to take several trunks and bags. In ordinary circumstances, travellers in the eighteenth century, unless they went in post-chaises or their own carriages, were very badly off as compared with their descendants of our own time. One of the most puzzling things about the pictures of loaded coaches is to discern where enough luggage was stowed away to enable the passengers to pass even one week-end in the country. The principal explanation is that people changed their clothes much less in those days, and we may be sure that Madame Lebrun in the quietest of times would have started for St. Petersburg with less luggage than a Parisienne of her class would now regard as indispensable for a flying-visit to Trouville. As for money, her husband had left her to raise what she could by asking, as we have seen, to be paid for a portrait she had recently done. The coach fares having been settled, she had eighty louis (about two hundred and thirty pounds in present value) with her. Her jewels she left behind.

The company in the diligence was anything but agreeable. On the same seat with Madame Lebrun was, as she believed, " an ultra-Jacobin " from Grenoble, about fifty years old, ugly and bilious-looking, who, whenever they stopped to change horses or to get a meal, made revolutionary speeches at the inns. In every town a crowd surrounded the diligence to hear the latest news from the capital. On such occasions this man from Grenoble would shout, " Don't worry yourselves, my children ; we have the baker and the baker's wife in safe keeping in Paris. A constitution will be made for them, which they will be obliged to accept, and all will be finished." It is not improbable that this person who frightened his Royalist fellow-travellers so much was a Royalist himself, for the only words which we know him to have uttered agreed more with the idea that he was pretending to be a kind of man whose ideas he detested and would

not fully express, than that he was a violent partisan of revolution. Anyhow, it seemed a good thing that Madame Lebrun and her child were disguised—for this person, as a change from his revolutionary perorations, talked about art, and actually praised Madame Lebrun's pictures to herself and her child!

The seat opposite to Madame was occupied by a filthily dirty man, who candidly admitted that he had stolen watches and other property. Not content with describing his achievements in larceny, he began to talk incessantly of hanging this one and that on the lamp-post, his list including many people well known to Madame Lebrun. His horrid talk so frightened little Julie that her mother said to him, " I beg of you, Monsieur, not to talk of murder before this child." He acceded to her request, and ended by playing " beggar-my-neighbour " with Julie! Very often, as the diligence lumbered along, men on horseback came up beside it, declaring that Paris was in flames, and that the King and Queen had been assassinated. Poor little Julie trembled with fear, believing that her father also had been killed and her home burnt down.

At length our fugitives arrived at Lyons, and went to the house of a merchant named Artaut (a Royalist sympathiser), who, with his wife, had several times been Madame Lebrun's guest. Here they were kindly received, and were at once reassured about the immediate fate of the King and Queen.

After three days' rest with the Artauts, in strict seclusion, the little party, still disguised, started again, in a hired carriage driven by a man in whom M. Artaut had a well-justified confidence. Madame Lebrun's emotions on crossing the famous Beauvoisin bridge, and entering Savoy, were naturally rather mixed, but on the whole agreeable to her. " There only I began to breathe again. I was outside France, that France which, all the same, was my native land, and which I reproached myself for quitting with joy."

It is suggestive to compare these words of a Frenchwoman leaving France with those of an Englishman who, on Christmas day of the same year, entered that country from Savoy in crossing the same bridge. " Arrive at Pont Beauvoisin," writes Arthur Young in his journal, " once more entering this noble kingdom, and meeting with the cockades of liberty, and those arms in the hands of the People which, it is to be wished, may be used only for their own and Europe's peace." Had this Suffolk squire met the Paris portrait-painter at a wayside tavern, and talked as he wrote

of the Revolution, he would have been classed by her with the man from Grenoble !

When, in crossing the Alps, Madame Lebrun got out of the carriage to see the glorious view more easily, she had two strange experiences. The first was that, without any warning, a mass of rock was blasted out with gunpowder, making a deafening noise which, echoing from rock to rock, seemed to her " truly infernal." Later on, when, with some other travellers, she was on the Mont Cenis road, a postillion came up to her and said, " Madame ought to take a mule. Walking here is too fatiguing for a lady like yourself." She answered that she was a workwoman, and quite accustomed to walk. The man laughed at this, saying, " Ah ! Madame is not a workwoman; one knows who she is." " Well, and who am I, then ? " " You are Madame Lebrun, who paints to perfection, and we are very glad to know that you are far from those wicked people." It is possible the Lyons coachman may have discovered the identity of his fare. If not, the Paris Jacobins would appear to have known all along that a " workwoman" who had started a few minutes after midnight on the 6th October was a distinguished woman whose chief work was painting the portraits of the ladies of a now disbanded Court.

The first night at Turin was spent in a wretched inn, where there was little or nothing for supper. However, the travellers were very tired, and made up by sleep for want of food. Early the next morning Madame Lebrun sent a note to Porporati, the engraver, who soon replied in person, and insisted on her going with her child and governess to his house, where he and his daughter of eighteen did everything possible to make them comfortable. They also showed her the art galleries of the city, and took her to the theatre, where she had the delight of seeing the Duc de Bourbon and the Duc d'Enghien in one of the boxes. After a week's stay at Turin she went on, by way of Parma and Modena, to Bologna, at which place she was, for a moment, thrown into despair. At the inn where she intended to stop for a week or ten days, she was unpacking her scanty luggage when the landlord saw her, and said, " You are taking a useless trouble, Madame, for, being French, you cannot stay more than one night here." Just then a tall man, of very serious aspect and sombre costume, came into the inn, bearing a paper which she supposed to be an order to quit the town within twenty-four hours. Happily her fears were more than groundless, for the paper was a permit to stay in Bologna as long as she pleased.

At last she felt that she was really among a friendly people, and could move about freely without the help of personal acquaintances. The glories of Italian art were before her to study and enjoy, and the terrors of the last few months in her own abandoned country seemed like a horrid dream from which she was now awaking.

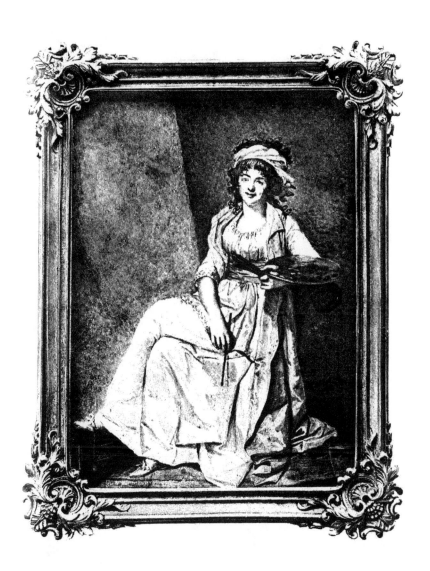

The environment of Vigée-Lebrun—Her religious sense—Her charity—Her easy view of moral obligations—The influence of Voltaire and Rousseau—The Comte d'Artois—The *Mariage de Figaro*—An insult to the Queen—The Bourbons for ever—The loyalty of Madame Lebrun —Her qualities of mind and of person

HAVING followed the career of Madame Vigée-Lebrun up to the time when she has sought safety from the Revolution by carrying out the long-cherished plan of a visit to Italy, we may break off the narrative of her life while we consider a little more closely the character both of the artist herself and of her art. The one and the other may have been seen with some degree of clearness in the manner of her life, the nature of her friendships, and the ideas expressed by herself in some of the passages quoted from her own *Souvenirs*. But somewhere in a book attempting to recall a life-story a more or less definite account of the individual must be essayed, with some kind of analysis of the special qualities of his, or of her work.

Madame Lebrun was a mixture of bourgeois and peasant, with the "artistic temperament" added. Her father was of a bourgeois family, her mother was of peasant origin. He was careless in his morals and his religious duties, while his wife was a strict Catholic and a woman of austere virtue. The influence of both appeared curiously combined in their daughter. She was a Catholic, but the services of the Church wearied her. She avowed to her niece that she was incapable of consecutive thought on serious subjects of faith and conduct. "I enter the church with the firm intention of praying, but as soon as I am seated I cannot help looking about me to right and left. It may be a ray of sunshine which lights up the choir, or it may be a pretty woman who kneels down, gracefully bending over her *prie-dieu*. Involuntarily I think of the pretty portrait I could make of the woman, or the charming picture I could make of the other subject." If this was her usual experience in her later

days, we may, for anything we know, be fairly sure that as a young woman, on the occasions when she went to church, her devotion to the purposes of the place was not much more assiduous. Going to church and religion are not necessarily connected, but Vigée-Lebrun was not a religious woman in any widely-recognised sense of the word. She was not selfish ; indeed, she delighted in giving pleasure to her friends. In Paris, up to the time of her flight, she never had any money to give away in charity, beyond a franc or two at a time. She treated her servants kindly, and with them, as with all the world, she never lost her temper over trifles—unless her nerves happened to be unusually disturbed. Her mind was not that of the typical pretty woman of the time, because it was not so languorously sentimental, so full of nonsense about men. She had something else to occupy her thoughts. Yet she had a great appetite for admiration of her person as well as for praise of her work, and she was not afraid to blow her own silver trumpet to the tunes—whatever they be—proper to conscious loveliness and conscious wit. It was cruelly said of her influential acquaintance Madame de Genlis that she " *mettait les vices en actes et les vertus en préceptes.*" Madame Lebrun was not at all given to preaching morality, and as for her practice we know nothing serious against her (apart from the Calonne libel already discussed) which has any degree of force.

How much liberty she allowed herself in gallantry we have few means of judging. She owed as little fidelity to her husband as a woman of her worldly circle and time could owe, and he played a very small part in her life. They did not " cherish and comfort " one another much in any other way than by his acting as her " manager " and spending her earnings. They shared a home, but he is rarely heard of in any part of it except the *magasin* which he had built in the courtyard for his stock of pictures. She certainly was not a prude, but she as certainly was " respectable " according to the conventions of her time, or she would not have been received so readily by the *grandes dames* of all the foreign capitals she visited. Many *grandes dames* may have been light in their private behaviour, but they have usually been particular about those of a lower social stratum whom they welcomed to their houses. It is evident that whatever tales hack-poets and secret letter-writers might tell of Madame Lebrun, " exalted persons " in every great court in Europe knew of nothing that made her an undesirable acquaintance, and of very much that made her desirable.

That she was broad-minded is shown by the high opinion she expresses on the conduct of a young widow, who continued a large allowance made by her late husband to a woman by whom he had had a child, and whose power over him had been the cause of poignant distress to the wife.

We may know little of the private affairs of Madame Lebrun, but we do know the kind of company she affected. She constantly associated with, and felt a warm admiration for people almost devoid of morals, who belonged to a set among which, in the opinion of Edmund Burke, vice lost half its evil because it was deprived of its grossness, or, in other words, because of the refinement of those who practised it, or the elegance of its environment. When notorious card-sharpers could carry on their business at the faro-table of the Queen, there was not likely to be any serious obstacle to vice in any form among the general company of worldlings either at Versailles or in Paris, so long as it was decently dressed. The works of Voltaire had influenced the Court in general in so far as they had laughed it out of any lingering reverence for the dogmas of the Roman Church, so that the practice of religion was quite perfunctory in the Chapel of Versailles for the bulk of the congregation. But while the destructive teachings of the irreverent philosopher of Ferney were followed, the constructive side of his work—his large, practical sympathy for those who suffered from unmerited wretchedness, his burning and powerful indignation against legal injustice and absolutist tyranny— found but small response from the most powerful party in the state. While Voltaire had scoffed at creeds and poured indignant scorn on the abuse of legal procedure, Rousseau had preached the joys and virtues of the simple life, of rural peace, and the wholesomeness of fresh air. Few more than Vigée-Lebrun appreciated the philosophy of Rousseau in its external forms. She loved the country *au naturel*, or when it was prettily arranged by ingenious gardeners, as in the fanciful Anglo-Chinese grounds of Marie Antoinette at Trianon. She abominated all the absurd artificialities of personal adornment in vogue in her youth, and, as we have seen before, she helped to bring about the partial triumph of reason and taste in the costume of the women of her generation.

Her time was almost wholly devoted to painting and pleasure, and, whether at work or at "play," she was most often in the company of some member or members of the nobility, in the old French sense of that word. Her social ideas and interests centred in the class for whom invitations to Versailles were ordinary incidents of life. She had, as we know, many

friends among leading artists and actors and musicians, and also among
poets and critics, but there is no reason to suppose that she often supped
or spent her Sundays in houses where friendship alone, without " illustra-
tion," was the reigning spirit.

To judge her own character by the men and women of whom she
herself speaks with the greatest kindness would, in many cases, be detri-
mental to her fame. For example, she can never find a word of blame,
and readily finds many of praise, for that " excellent Prince " the Comte
d'Artois, the future Charles X, of whom it was to be said after the
Restoration, in a phrase now commonly applied to all the Bourbons, that
" he had learnt nothing, and forgotten nothing." Whatever he may have
learnt or forgotten by 1825, there is no doubt that, before the Revolution,
he was a *mauvais sujet*. We need not (and should not) believe a tithe of
the stories told about him by the enemies of his family ; but his life at
Bagatelle was that of a sensualist of very loose principles, and he was one
of the worst of the Queen's advisers. The first fact was notorious, and
must have been known to Madame Lebrun; the second, in the days before
the fall of the Monarchy, was perhaps still a matter of opinion. Another
member of the Bourbon world of whom she always speaks kindly, so far
as her personal knowledge goes, is Madame du Barry ; yet, putting all
questions of morals aside, she must have been aware that no one had been
a worse enemy to Marie Antoinette in those early years of extravagance
which the Queen could never live down. Madame Lebrun's mental attitude
towards persons who, wilfully or not, did serious harm to her beloved
patroness, both in her peace of mind and reputation, is again exemplified
by her eulogistic references to the Comte de Vaudreuil. His share in
damaging the Queen's cause was seen, incidentally, in the production of
Beaumarchais' *Mariage de Figaro* in the Comte's country-house at Gene-
villiers. In that play a deliberate insult to Marie Antoinette was conveyed
in the character of the Comtesse Almaviva ; at least nearly every one who
saw the play seems to have so thought.

The truth is, that a Bourbon prince or a favourite courtier of a Bourbon,
or of the Queen (a Bourbon by marriage who held the chief place among
Madame Lebrun's divinities) could hardly do wrong in her eyes, even when
they wronged one another. She never seems to have thought it possible
that there was another side to the conflict between the Bourbon admini-
stration and the French people than that on which she herself, by all her
interests and associations, stood, up to the opening of the year 1789.

Indeed, she stood there always. Her rival, Madame Labille-Guiard (who had been the favourite artist of the King's sisters) stayed in France throughout the Terror, and painted portraits of Robespierre and several other members of the National Convention. Vigée-Lebrun's association —whatever its extent—with the detested Minister Calonne would almost certainly have made it impossible for her to keep her head on her shoulders in Paris. In any case, she had the merit of consistency, and never wavered in her adherence to the Queen and the Bourbons, from her first meeting with Marie Antoinette in the park at Marly to her death in the reign of the last of the Bourbons who have sat on the French throne.

Her chief virtue, we may fully believe, was loyalty, not merely in the narrower sense of fidelity to a Prince, but in the nobler sense of fidelity to her friends. It was only when they turned bitter against her or her Queen that she would give up her belief in them, and even then she could never find it in her heart to be altogether unkind. Her conduct with respect to David, the painter, is a case in point. He was a Jacobin by instinct as well as interest. It is true that, after being imprisoned in the days following the 9th Thermidor, he was less violently Jacobin, but he never got nearer to Bourbon sentiments than in painting huge pictures of the glorious exploits of Napoleon, who paved the way, without intending it, for the return of the Bourbon monarchy.

David could not forgive his old friend Madame Lebrun for having been so loyal to the King and Queen whose ruin he had cordially helped to complete. He retailed, as she was assured by acquaintances common to both of them, the old scandal about her connection with Calonne, and that was an unpardonable offence. Equally unpardonable, perhaps more hopelessly so, was the fact that he was a regicide. Yet she could still in her old age bear witness to the fact that no personal or political dislike had prevented David from being just to her talent as a painter. She admits the probability that, but for his atrocious conduct during the Terror —when, among his many offences, he got Hubert Robert arrested and kept in harsh confinement—she might have forgotten, " sooner or later," his attacks on her own character.

Madame Lebrun's constant association with members of the nobility, and courtiers in particular, did not make her (in the sense in which she can never have heard the word, even in London) a snob. She was too simple-hearted for that. When she declares that for her " titles are perfectly indifferent," there is no reason to suppose that this assertion, superficially

paradoxical, is far from the truth. Circumstances, especially professional, threw her almost from childhood among those who bore titles and wore orders ; and as in their houses almost all the most entertaining people in France were to be met, there is no reason to be surprised if a charming young woman who worked very hard all day, chose to spend her hours of relaxation in that society where she was most certain to be amused.

She was of a bright and kindly disposition, as ready to give pleasure as to receive it, and she was asked again and again, year after year and in some cases week after week, to houses which she had first entered merely as a professional painter.

Vigée-Lebrun had several accomplishments besides painting. She could converse intelligently and with spirit ; she was well supplied with anecdote and gossip, of the more harmless sort. She was not malicious. Her worst way of hurting the reputation of any one who may have stood in her light was to say nothing about that person. It was only when venomous things were said about herself or her friends that she used strong adjectives. She could act, she could sing pleasantly, though her voice was untrained, and she could appreciate literary talent. In her old age her memory often betrayed her in recalling the incidents of her youth and middle-age, but it was far better than most, and in her prime it must have been excellent. At all times she was a favourite with both women and men, and this fact alone would show that she was no ordinary being.

If her qualities of mind and person are to be put in a string of words, let us say that she was graceful, pretty, attractive, lively, good-tempered, loyal, sane, and clever—in a time when cleverness was not nearly so common as it has since become.

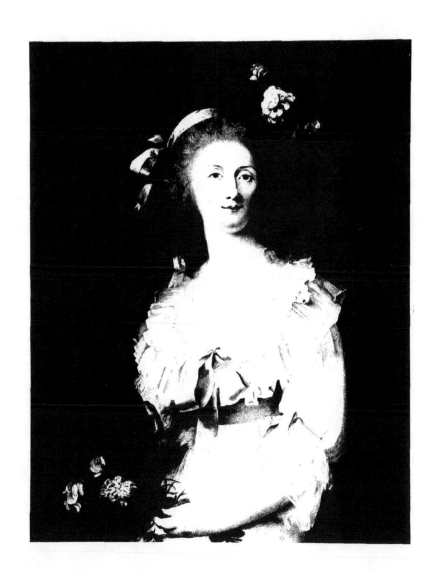

CHAPTER XVI

THE ART OF VIGÉE-LEBRUN

Her methods briefly considered—Dressing her sitters to please herself—Could she paint character ?—Her portraits of women—And of men—Her advice to young artists—Dr. Johnson's test of portrait painting

THE materials for appreciation of Madame Vigée-Lebrun's qualities as an artist are happily abundant. Her colour-sense was well trained, and she rarely forced a note. There is nothing in her work comparable with the blue so dominant in Nattier's work, or the pinky tone that spreads over Boucher's. Her harmonies are simple, she was specially " nice " in her treatment of quiet half-tones, and she had a notable dislike of impasto. She laid on her paint evenly—so much so that there is sometimes a certain hardness and flatness, even in the faces, in the painting whereof she strove with particular care to produce softness of surface and delicacy of tone. If we need special examples of her success in this respect we may find them in the portrait of the Duchesse d'Orléans at Versailles and in that of the Bishop of Derry in the collection of the Marquis of Bristol. In the composition of her pictures, which is almost equivalent to the posing of her subjects, she may often seem rather artificial to a generation that, apart from its acquaintance with the master portrait-painters of the seventeenth and eighteenth centuries, has known Carolus Duran and Robert Brough and Sargent. But compare her portraits with those with which she herself could compare them, and you will admit that she was a leader in the return to " Nature " in the posing as in the dressing of her figures. They loll on couches or in fauteuils, on rocks or grassy banks ; they may hold music, or flowers, or pitchers, or books ; they nearly always seem comfortable, and as they might look if some one near by had spoken a pleasant word to them.

Such portraits as those of the Baronne de Crussol, sitting with her back towards us, but her face looking at us over her right shoulder with

languorous eyes, of the Duchesse de Gramont-Caderousse, standing, with
her basket of flowers beside her, and of Julie Lebrun hurrying along with
the wind ruffling her hair and her dress, show how naturally, seated at
rest, standing at ease, or in active exercise, the living subjects of Madame
Lebrun's pictures were rendered on her canvas.

As for their dress, that, as already seen, was a question on which
the artist had a great deal to say. In some of her works, notably in the
" panier " portrait of the Queen, we see the powdered hair, and even the
monstrous hooped skirts of a lingering mode, but the greater number of her
portraits of women represent them in garments which would not appear
very much out of place in a quiet town of France or of England at the
present day ; though they would be usually wearing too many clothes in
any resort of fashion. As for their hats, they wore simple straws and felts
as pretty as were ever seen before or since—picture hats far more charming
than that of the long-lost " Duchess of Devonshire." It is not to be sup-
posed that all of these ladies who look so dainty in Vigée-Lebrun's pictures
were so nicely dressed when they entered and left her studio as they were
while they sat upon her dais. She had a large collection of robes and
scarves and hats in her *armoires*, and the careful observer of her work will
sometimes come upon old friends in the way of bodices and shawls and
scarves, and hats also, or wreaths, when he gazes newly upon some portrait
by her hand. The scarf was a great help to her in producing her " effects."
Wound round the head, lightly thrown across shoulders or arms, floating
in the breeze, or knotted loosely round the neck, scarves were employed
in more than half of the women's portraits that she painted. The idea
was given to her by the draperies of Italian " old masters," and she turned
it to excellent account. As I have suggested on an earlier page, the artist
may sometimes not only have provided clothing, but a pretty figure, arms
and hands also for her " subjects."

It is a common charge against her that she could not paint character.
Were we to judge her only by her portraits of women, we might agree that,
in general, temperament and feeling of any great depth remained unrealised
by her art. When she was painting women, both she and they—as a
rule—were chiefly bent on the presentation of feminine charm, though
probably neither artist nor sitter ever realised when they looked at the
picture that it would appear wanting in other personal qualities to a later
generation.

" We start, for soul is wanting there,"

was said of the Greece of a century ago by a poet whose portrait, according to her own honest but probably erroneous account, Madame Lebrun painted in his boyhood, and the line expresses what is often felt in front of some of her own pictures of women. Was this a defect of her art, or of her time? Of both, is the answer. Most of the women whom she painted had sentiment, but many of them had little " soul." They lived on the surface of life, and their minds were no more suited to high thinking or strong emotion than their bodies to plain living and active exertion. They may not have been quite so nice to look at as the artist usually makes them, but in most cases to have given them depth of feeling would have been to misrepresent them. Had they possessed it, they could not have passed their lives as they did, like pretty insects hovering round the flowers in the gardens of Versailles or Florence.

Her power of penetrating and depicting character has, however, been judged too exclusively by her portraits of women, including those of herself. The circumstances of her life were not such as to foster individuality. She loved to please and to be pleased ; she was attracted chiefly by the water-lilies of life, the beautiful things that float on the surface, the roots of which might be nourished in clean, sandy soil, or in slimy mud, but which to the eye were charming in either case. The ladies of Versailles prattled happily to her, of balls and *fêtes galantes*, of water-parties and other amusements of their days and nights. She, a busy woman, delighting in her work, delighted also in such pursuits as pleased her sitters, and during the many days of the year that she spent as a guest in other people's luxurious houses, she was as lively a creature as any of them. But when she came to paint men, she did not make them beautiful. Sometimes she left them vapid enough. Even her favourite Comte de Vaudreuil is shown on one of her canvases as a person of commonplace intelligence. As a rule, however, she did get farther into the characters of men than of women when she was painting their portraits—or rather, perhaps, she allowed herself to show more of what she saw in their faces. For the time she could forget the velvety skins, the delicate tints of her usual sitters, and concentrate her talent on the portrayal of something more in accordance with ordinary experience. Her portrait of Hubert Robert, in the Louvre, which, as we have seen, she began on a lovely island in the Seine, is so different from the general run of her work that it scarcely seems to have come from the same easel. Here at least is a man of strong temperament shown to the life. The powerful body well illustrates Madame Lebrun's account of Robert's

physical activity and strength late in middle life, and the noble head and keen eyes, with the whole expression of the face, show force of will and intelligence. The portraits of Vernet (Louvre) and Grétry (Versailles) also suggest character as well as merely personal appearance; and the face of the "boy in red," at the Wallace Gallery, indicates, with an understanding that would be a valuable possession to any artist, the mingling of mischief, impudence, and curiosity in a lively child. These are but examples, of which a good many more could be found, of Vigée-Lebrun's capacity for something deeper than mere beauty of features and eyes and complexion. In the case of her women's portraits, those in which she strove to paint a mind of keen intelligence are certainly in the minority, though by no means few. Look, for examples, at the portraits of Madame Albrizzi, Madame Vestris, and Madame Dugazon, reproduced in this book. The pictures of herself suggest, in most instances, just the sort of nature that we know to have been hers—bright, agreeable, and rather worldly.

We know her ideas on the practice of art rather better than those of most painters. It may be said that we can tell from pictures what their painters have thought about painting, but this test is far from conclusive. Artists are as much subject to self-deception and illusion as any other workers, and such a candidly written account of practical, businesslike aims and methods in portraiture as Madame Lebrun prepared for the instruction of her niece, Madame Tripier Lefranc is specially helpful to the understanding of intentions and beliefs.

"Always be ready half an hour before the sitter arrives," she says, "so that you will not be hurried, or worried about other business." "Before beginning, converse with your sitter; try several poses, and choose not merely the most pleasing, but that which is suitable to the sitter's age and character, as that may increase the resemblance."

"Try to do the head, the face especially, in three or four sittings of an hour and a half each—two hours at the longest—for if the sitter gets tired and impatient the expression changes."

With women sitters "you must flatter them, tell them they are pretty, that they have a fresh complexion, etc., etc. That puts them in a good humour, and makes them sit with more pleasure. . . . You must also tell them that they pose admirably. . . . You will do well to ask them not to bring their friends, who will all want to express their views, and will spoil everything. As to artists and people of taste, you can ask their opinions. Do not be cast down if some people fail to find any

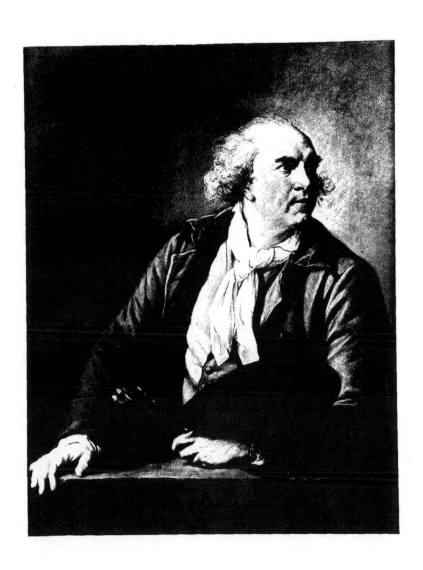

likeness in your portraits ; there are many people who do not know how to see."

" Look at Greuze's heads, and notice particularly the usual arrangement of the hair of your sitter. That adds to the likeness and the truth. You must carefully observe the ' passages ' where the hair is seen with the flesh, so as to render them as faithfully as possible, that there may be no hardness, and that the hair may blend well with the flesh, as much by contour as by colour, in order that it may not look like a wig, which it assuredly will do otherwise."

In describing her own methods she writes : " I tried my best to give to the women whom I painted their natural expression ; those who had no expression (*physionomie*), and one sees such people, I painted pensive, and negligently reclining."

It will be seen that in theory Vigée-Lebrun held the same opinion as an English contemporary of her youth, Dr. Samuel Johnson. " Sir, their chief excellence is being like," said that eminent talker when some question of portraits was being discussed. But she held it with a broad difference, in that in her case the likeness had to be " pleasing." That was the keynote of her success. It is true that the patronage of Marie Antoinette was chiefly responsible for the artist's immense vogue, and it is no less true that this patronage would not have lasted beyond the first " commands " if the Queen's personal appearance had been represented with no other object in view than the exactly realistic reproduction on canvas of the features and colouring of the sitter.

CHAPTER XVII

THE TOUR IN ITALY, 1789-92

Vigée-Lebrun in Italy—The sights of Florence—Rome and its art treasures—Michelangelo and Raphael—A visit to Angelica Kauffmann—Search for a quiet lodging—Varieties of nightly disturbances—Noisy worms in the rafters—Vigée-Lebrun's work in Rome—Some of her sitters—A prima donna with a chest like a pair of bellows—The passions of the Duchesse de Fleury—Napoleon's question and its answer—The Comtesse de Boigne's view of Madame Lebrun—Sir William and Lady Hamilton at Naples—Madame Lebrun's unfortunate choice of a bank for her savings—Disappointed of returning to France, she sets out for Vienna

IT is now time to rejoin the artist in Italy. From Turin she journeyed, by way of Parma and Bologna, to Florence. The first thing she did there, after having taken possession of her rooms at the hotel that had been recommended to her, was to go with her child and friendly M. de Lespignière for a walk on the hills in the environs, whence such beautiful views of Florence can be enjoyed. Julie, looking at a group of cypresses, said, "Those trees invite us to be silent." Such a remark from a little girl of seven surprised even her own mother, who never forgot it.

Vigée-Lebrun visited the Medici Gallery, where the Venus, the Niobe, and the pictures of Salvator Rosa impressed her greatly; and the Pitti Palace, where she was specially attracted by works of Guido and Rembrandt, as well as by a picture "at once very fine and very strong, by Carlo Dolci, a Holy Family by Ludovico Carachi, and the 'Vision of Ezekiel,' an admirable little picture by Raphael. I also saw there the portrait of a woman dressed in crimson satin, painted by Titian with as much of vigour as of truth." She saw, in fact, most that there was to see of pictures and palaces in Florence—including, of course, the Uffizzi Gallery, which, by its collection of portraits of painters of all nations, from their own hands, provides so valuable a record of the personal side of art during several centuries. She too was asked to contribute to that famous gallery, and she naturally felt honoured by the request. She was on the point of leaving for Rome,

and she promised to send a portrait of herself from that city. The promise was duly fulfilled, and the picture, familiar from a thousand photographs, hangs in its place among those of so many other painters, of greater or less consequence in art. Speaking of the Uffizzi collection, she says, " I noticed, with a certain pride, the portrait of Angelica Kauffmann, one of the glories of our sex."

In November 1789 Madame Lebrun had arrived in Rome, whence, on the 1st of December, she wrote to her old friend Hubert Robert a long letter in which she gave him her impressions of the city whose " eternity " had not, in those days, been so furiously assaulted by utilitarian urban authorities as it has been in the last twenty years. In Saint Peter's she had remarked to Ménageot, who acted as cicerone, that she wished the columns had been left in their simple roundness, and he had answered that originally they were so designed, but that as they did not appear solid enough, they had been surrounded by pilasters. Of the " Last Judgment " by Michelangelo she writes : " There is grandeur both in the composition and the execution. As to the disorder that reigns there, it is, in my opinion, entirely justified by the subject." She was very angry with those who repeated the story that Raphael's death was due to his loose living. " The proof that nothing is more false is that we know him to have been passionately in love with that beautiful *boulangère*, without whom he could not live, to whom he remained so faithful that for her sake he refused honours, riches, and the hand of Cardinal Bibiena's niece—so faithful that when at last the Pope wavered and allowed the Fornarina to return to Rome, the joyful emotion of Raphael, the happiness of once more seeing that adored woman, contributed greatly to hasten his end. . . . No, Raphael was not a libertine ; it is only necessary to look at his heads of the Virgin to be certain of the contrary."

It is almost impossible to doubt that in writing so warmly in defence of the personal character of one of the greatest members of her own profession in any age, Madame Lebrun was thinking also of the attacks that had been made on her own character, and the logic with which she defends Raphael from his calumniators is at least as strong as some of that with which she had replied to the aspersions of her jealous detractors in Paris.

Naturally, being in the same city with Angelica Kauffmann, Elisabeth Vigée-Lebrun went to see a sister-artist who not only shared with her the highest honours in woman's art at that time, but had known also,

and perhaps in a more poignant degree, the sorrow that usually results from an imprudent marriage, with the scattering of her earnings by a rascally husband.

"I found her," writes the French artist to Hubert Robert, "very interesting, apart from her talent, on account of her intelligence and her knowledge. She is a woman of about fifty (Angelica Kauffman was, in fact, forty-eight at that time), very delicate, her health having suffered in consequence of her unhappiness in marrying, in the first instance, an adventurer who had ruined her. She has since been married again, to an architect who acts as her man of business. She has talked with me a great deal and very well, during the two evenings I have spent with her. Her conversation is agreeable : *elle a prodigieusement d'instruction, mais aucun enthousiasme, ce qui, vu mon peu de savoir, ne m'a point électrisée.*"

At Rome, as in most other places—it is hard to remember an exception —Madame Lebrun was dreadfully worried by noises, and found much difficulty in settling comfortably in any house commended to her. Throughout her travels she was pursued by noises at night : now it was horses in some neighbouring stable, now market-carts in an adjoining street ; now it was people singing, and now washerwomen pumping water ; now rats in a wainscot, and now a bird in an opposite window. But it was at Rome that the strangest of all such disturbing influences spoilt her rest, and compelled her to leave a lodging in which she had hoped, from its retired situation, to pass her nights in refreshing sleep. In spite of such hopes, she had been wise enough to arrange for a trial-night in the place before signing an agreement with her landlord. That agreement was never signed, and the reason for the breakdown in the negotiations shall be given in her own narrative.

"Scarcely had I got into bed, when I heard over my head an absolutely intolerable noise ; it was caused by an innumerable quantity of worms which gnawed the rafters. As soon as I opened the shutters the noise stopped, but it was none the less necessary to abandon that house, to my great regret. . . . I am convinced that the most difficult thing to do in Rome is to house oneself."

At length, however, the harassed artist did get some lodgings where worms gnawed not the beams, and horses champed not in their stalls, and where there were no absolutely intolerable noises of any kind to make her nights hideous. There having set up her easel, she speedily found herself in the full tide of portrait-painting. The first sitter she mentions was

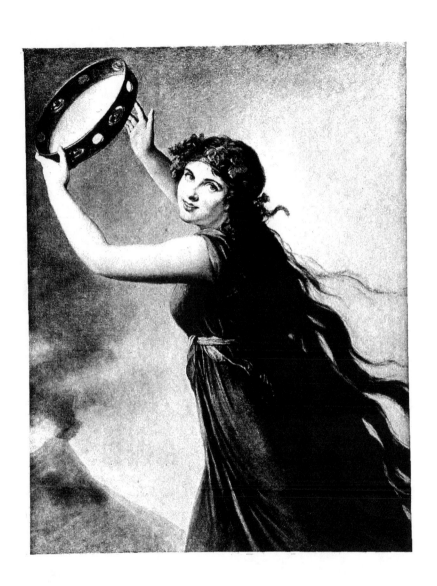

a very pretty child of sixteen, Miss Pitt, a daughter of Lord Camelford, whom she represents as Hebe, sitting in a cloud, and holding a drinking-cup to an eagle. The eagle which "sat" for this picture, and which belonged to Cardinal de Bernis, gave the artist a great fright. "The cursed animal, which was accustomed to be always in the open air, chained in a courtyard, was so furious at finding itself in my room, that it wanted to dash upon me."

The Comtesse Potocka, who is shown in her portrait seated on a mossy rock beside a cascade, astonished the artist by her *sang-froid*. The Comte brought her to the studio, and, as soon as he had left the house, she said : "That is my third husband ; but I think I shall take back the first, who suits me better, although he drinks."

Mademoiselle Roland, the mistress, and shortly afterwards the wife of an English nobleman, was the subject of a portrait which (though the name has been given in an exhibition catalogue at the London Guildhall to one of Madame Lebrun's other portraits of ladies) it seems almost impossible to identify. Among the distinguished women whom Madame did not paint at Rome was the prima donna Banti, whose wonderful voice was apparently due to a physical organisation which, as described by Vigée-Lebrun, was assuredly unusual, if not unique. "This admirable singer was shaped in a very peculiar manner : her chest was high, and constructed exactly like a pair of bellows, as she showed to me and some other ladies in a dressing-room, after the concert, and I thought that this strange organisation accounted for the power and flexibility of her voice."

The most eminent personage whom Madame Lebrun failed to paint at Rome was the Pope himself. The Abbé Maury, an old acquaintance of the artist, came to tell her that His Holiness wished to sit to her. "But it was necessary that I should be veiled while I painted the Holy Father, and the fear that I could not under such conditions accomplish anything to my satisfaction obliged me to decline this honour. I did so with much regret, for Pius VI was still one of the handsomest men that could be found."

Her chief friend in Rome was the lovely and fascinating Duchesse de Fleury. "We were naturally drawn to one another; she loved the arts, and, like me, had a passion for the beauties of nature. I found in her a companion such as I had often desired." The Duchess's passion had other objects than scenery and flowers. She was at that time carrying on a correspondence with the Duc de Lauzun, a man as immoral as he was

attractive, and Madame feared that, however innocent, such a correspond-
ence was dangerous for her friend. However, so far as Lauzun was a
source of anxiety, the danger was removed by his being sent to the guillotine.
Madame's friendship with the Duchesse de Fleury would of itself prove
the easiness of her own moral prejudices. That charming young woman
was not so much a *grande* as a *perpétuelle amoureuse*. On her return to
Paris after the Revolution she and her husband obtained a divorce, and
she married a young man whom she loved passionately, until they got
tired of each other, and she was again divorced. Then she took another
lover. One day during the Empire, Napoleon said to her : "Aimez-
vous toujours les hommes ? " " Oui, Sire," she replied, "quand ils
sont polis."

Of Vigée-Lebrun at Rome we get a not over-friendly glimpse from
the Comtesse de Boigne, who, in her *Mémoires*, recalls that Julie Lebrun
was one of her play-fellows in that city, and of Julie's mamma writes :
"Madame Lebrun, a very good person, was still pretty, always very foolish ;
she had a distinguished talent, and possessed in excess all the little affecta-
tions to which her double rôle of artist and pretty woman entitled her.
If the term *petite maîtresse* had not become as bad taste as the fashions
that are nowadays implied by it, it could fairly be applied to her."

After eight months at Rome, Madame Lebrun set out for Naples,
travelling in the rather depressing company of M. Duvivier, who in that
same year (1790) lost his wife, formerly the " Madame Denis " so familiar
to readers in the life of her uncle, Voltaire. M. Duvivier had no sense
of natural beauty : the sheep in a flowery meadow near the sea depressed
him because they were not as clean as those he had seen in England ; and
the great clouds casting shadows on the Apennines caused him no emotion
except the fear that it would rain the next day ! He thought nothing of
the views on the way to Naples, preferring, he said, the scenery of Burgundy,
" which promised good wine."

By some extraordinary freak of fortune, the Hôtel de Maroc at Chiaja,
on the sea coast opposite Capri, left no memory of noise or discomfort in
Madame's mind. Her satisfaction with the house was increased by its
being next door to that of the Russian ambassador at Naples, the Comte
Skavronski, who was so polite as to send her in an excellent dinner on the
evening of her arrival, and whose wife very soon arranged to sit for a
portrait. This beautiful noodle—for such she evidently was—had been
richly endowed with money and jewels by her uncle, the famous Potemkin,

but she made a poor use of her wealth. Her favourite way of passing the time was to lie at full length on a sofa, wrapped in a big black pelisse, and " without her stays." Boxes full of the " latest creations " came to her from Mademoiselle Rose Bertin, the principal dressmaker in Paris, but she scarcely troubled to look at them, nor did she wear the wondrous diamonds that she possessed. " A quoi bon ? Pour qui ? pour quoi ? " she asked, when any one suggested that she should put on her fine dresses or her jewels. She told Madame Lebrun that, in Russia, she had a woman serf under her bed every night, whose duty it was to send her to sleep by telling her a story. Unlike Scheherazade of the *Arabian Nights*, this serf told the same story every time, no doubt a more efficacious method of inducing sleep.

After this indolent Russian beauty, Madame's next sitter was a woman more accustomed to posing than any other who had ever been shown on a Vigée-Lebrun canvas. This was Emma Hart, or Lyon, soon to be Lady Hamilton. The artist painted four portraits of the " professional beauty." The first was a " Bacchante " lying beneath an arched rock near the sea. Sir William Hamilton paid £96 for it, and sold it for £315, thus making a big profit out of his wife's portrait, according to his habit. Another of the four pictures, composed somewhat in the Romney manner, showed the lovely Emma again as a " Bacchante," running, with bare arms outstretched to play a tambourine held high before her, vine-leaves in her flowing chestnut hair, and Vesuvius in eruption in the distance. Yet another was the " Sibyl," which the artist took about Europe with her, rolled up in transit, as a specimen of her best work ; and the fourth was another " Sibyl " painted for the Duc de Brissac. Sir William Hamilton and his mistress were pleased with Madame Lebrun's society, and the undignified British ambassador endeavoured to entertain her with stories of the most prominent ladies of the Neapolitan Court, so scandalous that she could not repeat them. He declared that some of these ladies could not read, that a good many " did not know there was any other country than Naples," and that their only occupation was " *l'amour*," with frequent change of the objects of their affection.

Assuredly the King of Naples gave little encouragement to learning or virtue. He left the trouble of government—such as it was—to the Queen, and generally resided at Caserta, much interested with a factory there, the work-girls of which, as Madame was told (perhaps by Sir William Hamilton), made his seraglio.

8

One of her notable sitters at this period was the Earl of Bristol, Bishop of Derry. This handsome prelate was as well known in Italy for his love of the arts as he was for the generosity and tolerance with which he fulfilled his episcopal functions. At his country seat in County Londonderry he kept a great state, and in Dublin his big carriage, drawn by four horses, was a familiar sight in College Green during the sittings of the Irish Parliament. Towards the end of his life he spent some of his vacations in Paris, where the splendour of his private house suggested the name of an hotel which opened in the Place Vendôme in those days, and through imitation of which many another Hôtel Bristol has puzzled the curious as to why Bristol, more than any other English port, should have caught the fancy of hotel-builders.

Not only did Madame Lebrun paint several portraits of the Bishop of Derry in Italy, but she also copied for him—with some variations—her portrait of herself that she gave to the Uffizi Gallery at Florence.

After a long visit to Naples, Vigée-Lebrun, still of course accompanied by Julie and the governess, went on by way of Siena and Mantua to Venice, where the artist-diplomatist Denon did all he could to make her stay enjoyable. Among other things, he exhibited her " Sibyl " in his studio, and thereby brought her much acceptable praise and attention. She saw the spectacle of the Doge throwing the ring into the sea, and the splendid *Bucentaur* galley that comes out of dock on those occasions ; as for pictures, she spent many happy hours in contemplating the masterpieces of Tintoretto, Veronese, and Titian. Of her own work done in Venice, the most notable example is the portrait of the handsome Greek woman, Isabella Marini, afterwards Comtesse Albrizzi.

One of the familiar sights of Venice at that time was the ancient burial-ground, adjoining the " English " Cemetery, and containing the tombs of some of the earliest Venetians. Madame Lebrun, being anxious to see it, went there in a gondola one moonlight night with a friend of M. Denon. As they might have expected, they found the gate locked. However, by mounting on some stones fallen from a breach in the top of the wall, they got inside through that breach. When they wished to return, it was " nearly an hour " before they could find this place of entry. Having got outside, they met with two sentinels, who let them pass without any questions. " They no doubt took us for a pair of lovers," says Madame, " people who are always highly respected in Italy." One only of her memories of Venice was really very unpleasant—she lost there

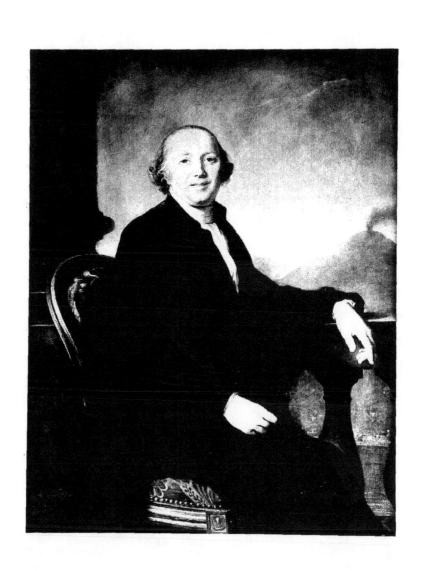

over thirty thousand francs, part of the money she had earned in Rome and Naples. She had been warned by a member of the French Embassy at Naples that the Venetian Government might shortly be attacked by the French army. "Surely," she had said, "republicans will not attack a republic!"

The warning was too well justified. Bonaparte, when he captured Venice and removed so many of its treasures, gave orders that Madame Lebrun's money in Haler's bank should be kept safely, and interest paid to her; but the order was not properly carried out, and she says that she never received more than two hundred and fifty francs interest on the large sum she had sent to the bank.

From Venice she passed to Turin, where she was delighted with her reception by the Queen of Sardinia and by her former "sitter" the Comtesse de Provence, wife of the prince who, some twenty years later, was to be King of France as Louis XVIII.

Madame Lebrun had come to Turin with the intention of returning to France, under the impression, then generally prevalent, that the time of massacres and executions was over, and vainly supposing that the exception from the law against *émigrés* of artists abroad for the purposes of their profession would be held to cover her case. Meanwhile she accepted an invitation from Porparati, her host on her former passage through Turin, to stay at his farm, about four miles from that city. It was a delightful spot, and Vigée-Lebrun and her child were very happy there until, one evening, the post brought a letter from M. de Rivière (her sister-in-law's brother) telling her of the awful events of August 10, and asking her to await his arrival at Turin. When he came, a fortnight behind time, he was able to reassure her as to the safety of her mother, her brother, and her husband—who about that period was arranging a divorce from her—but the state of affairs in Paris destroyed her hope of returning there. Before leaving the neighbourhood of Turin, she repaid her host for his kindness by painting his pretty daughter's portrait. On her way from Turin to Milan, the three French travellers—Vigée-Lebrun, her daughter, and the governess—were stopped as French "enemies," but there was not much difficulty in obtaining a permit to go on. Madame thought that Milan Cathedral was *fort belle* (few indeed are the travellers who can contain their admiration of that famous example of ornate architecture in two words), and she was charmed with Lake Maggiore. She even lived for a time on Isola Bella, with the permission of its proprietor, Prince

Borromeo. Of course she went to see Leonardo's " Last Supper," already
in a sadly decaying state. " Since then," says Madame, in mourning
over its fate, " I have learnt that that *chef d'œuvre* has been otherwise
degraded. I have been told that, during the last wars of Bonaparte
in Italy, the soldiers amused themselves by firing bullets from their
muskets at the 'Cena' of Leonardo da Vinci! Cursed be these
barbarians."

At length, by the advice of the Austrian envoy at Milan, the Comte
de Wilscheck, who promised her a warm welcome from his many friends in
Vienna, she set out for the Austrian capital, travelling by way of Tyrol
and Styria, and finding the scenery very pleasant from the beginning to
the end of her long journey.

Madame's little party did not travel alone. There was a Polish
beauty, the Comtesse de Bystry, whose acquaintance Vigée-Lebrun had
made in sitting next to her at a concert, and as both the stranger and her
husband took a fancy to Madame, they advanced their own departure
for Vienna so that she might travel in their company.

CHAPTER XVIII

LIFE IN VIENNA, 1792–3

Social life at Vienna—Extraordinary number of pretty women—A romantic wedding—" Nor spinster, nor wife, nor widow "—The octogenarian Prince de Kaunitz—He exhibits Vigée-Lebrun's " Sibyl " portrait of Lady Hamilton—News of the execution of Marie Antoinette —Death of the Duchesse de Polignac—Madame Lebrun's feelings—The happy relations of rich and poor in Vienna—A court ball—Untiring dancers—A week in Dresden—Triumph of the " Sibyl " picture—Delightful Prince Henry of Prussia—Provisions for the journey to Russia—The start—Weary travellers

THAT year, 1792, in which the artist-exile arrived in the city whence her Queen had come more than twenty years before, was the most terrible of the Revolution, but in the early days of her long sojourn in Austria she was happy enough. She and the Bystrys had become so easy together that they decided not yet to separate. As they could not find comfortable rooms in Vienna to hold them all, they lived in one of the suburbs until these Poles returned to their own country, when Madame Lebrun moved inside the walls, among those *grandes dames* to whom the Comte de Wilscheck had given her introductions, and by whom, no doubt, she would in any case have been well received, if with more formal courtesy. Chief among them, it would seem, was the Comtesse de Thoun, whose " evenings " were attended by " all the high society of the town," and by many French *émigrés* of social distinction, including the Polignacs, that family whose fortunes had been bound up so closely with those of Marie Antoinette. The artist had, as we know, always a keen eye for feminine beauty, and she found much of it here. " I have never," she says, " seen in any drawing-room so many pretty women as were to be found in that of Madame de Thoun." Most of these ladies brought their work, settled themselves at a large table, and went on with their embroidery. " Sometimes," as Madame Lebrun recalled over forty years afterwards, " I was asked to give my advice upon effects and shades of colour ; but as nothing hurts my eyes more than to look at bright colours by the light

of lamps or candles, I admit that I often expressed an opinion without looking. As a rule, I have taken great care of my eyesight, and I have been well repaid, since, even now, I can paint without being obliged to use glasses."

Several of the ladies whose crudely-coloured needlework distressed Madame Lebrun's eyes, repaid her by sitting to her for their portraits. Of these were the Comtesse de Sabran and the Comtesse Kinska (*née* Diedrichstein), whose position was peculiar, she being, as Madame writes, "nor spinster, nor wife, nor widow." She had "every possible charm; her figure, her face, in fact all her person was perfection; and I was greatly surprised when I heard her story, which was truly like a romance. The parents of Comte Kinski, and her own, had agreed together "—like the mothers of Jane Austen's Darcy and Miss de Burgh—" that the young people, who had never met, should marry one another. The Comte lived in some German town, and only arrived at the bride's home for the wedding. As soon as the service was over, he said to his young and charming wife, ' Madame, we have obliged our parents; I regret to have to leave you, but I cannot hide from you the fact that I am already attached to a woman without whom I cannot live, and I go to rejoin her.' His post-chaise was waiting at the church door, and, that adieu having been uttered, the Comte entered the carriage, and returned towards his Dulcinea."

According to her custom, Vigée-Lebrun, as soon as she had settled in Vienna, called on the leading members of her own profession. One of these artists, but little regarded now, was François Casanova, brother of the notorious boaster Jacques Casanova " de Seingalt." François, apparently, had much the same nature as Jacques. He made a great deal of money by his battle-pieces and pictures in glorification of the deeds of princes, but his life was so disorderly that, at sixty years of age, he was no better off than when he began. He was a capital story-teller, mixing up personal experience and invention just as either came handy for his purpose; and he was prompt at repartee. It is true that the only example of his repartee which Madame Lebrun gives is not specially brilliant. An old German baroness, when she heard some one say that Rubens was an ambassador as well as a painter, remarked, " What! a painter ambassador! Surely he was an ambassador who amused himself by painting." " No," answered Casanova, " he was a painter who amused himself by being an ambassador."

One of Madame's friends in Vienna was the celebrated Prince de

Kaunitz, then considerably over eighty, but still one of the finest horse-men that could be seen. It was in his drawing-room that "the Sibyl" portrait of Lady Hamilton was exhibited for a fortnight, during which the Prince "did the honours of that picture to the town and to the court with a grace that was all kindness for me."

The death of this kindly old man, whilst she was still at Vienna, afforded an object-lesson in the shallowness of popular esteem to Madame Lebrun, who had received many such lessons before she left Paris. "Up to the time of his death, the glory that he had gained as Minister still remained to him ; on New Year's Day, and on his birthday, a huge crowd came to his house to congratulate him, no one kept away, one might have supposed he was Emperor on those occasions. I was therefore greatly astonished, at the moment of his death, by the indifference of the Viennese at the loss of their celebrated countryman."

Vigée-Lebrun, as we know, had always been fond of theatricals, and at the houses of the Strogonoffs and the Fries (both of which families provided her with several subjects for portraits) she saw some amateur performances entirely to her taste.

For a time the social delights of Vienna were saddened, if not stopped, for the French exiles by the news from Paris, first of the execution of Louis XVI, and then of that of Marie Antoinette. This last tragedy does actually appear to have killed the Duchesse de Polignac, who, however unhappy her personal influence over the Queen may have been, really loved her deeply. Madame Lebrun did not read the news of either event. Having one day seen in a gazette a list of persons who had been guillotined, wherein were the names of nine of her own acquaintances, she never—so she tells us—looked again at newspapers (which she calls *papiers-nouvelles*) until those troubled days were over. She heard from her brother in Paris that the King and Queen had died on the scaffold. It would seem that the horror which she felt at the Paris events of 1793 was little allied with grief. It is difficult to discover, at any point in her memoirs, that she gave up any particular pleasure in consequence of bad news. Hers was one of those buoyant natures which, so long as the immediate evidence of anguish and death can be kept away from them, are not very deeply affected. The knowledge that a dead body was in the same house with her always caused her intense distress, even when she had never seen the dead person in life or in death. But the gloom cast on her mind by the tragedies of the Revolution was never of long duration. In speaking of

the grief of the Duchesse de Polignac on hearing of Marie Antoinette's death, Madame Lebrun says : " It is certain that I can judge how frightful the events of France must have been for her, by the sorrow they caused to me." The news of all the worst of those events, so far as her own life was concerned, came while she was living in Vienna. Yet she tells us, " I was as happy at Vienna as it is possible to be, away from one's relatives and one's country." She was not ungenerous, she was even exceptionally free from envy or malice, but she was so far an egoist of the common sort that, so long as the world went well for herself she asked little more from the world.

Madame Lebrun's account of Vienna at the time of her sojourn there might convince a trustful reader that not only was the old and rigid class system of society perfectly represented in and around that city, but that it existed to the advantage and happiness of the whole community. As a succinct statement of the " Lady Bountiful " ideal of " social position " her simple page on this subject could scarcely be bettered. She begins by remarking that as far as the ways of people *comme il faut* were in question, there was no perceptible difference between Paris and Vienna. But as to the people who were not *comme il faut*, " Nowhere else have I seen that air of happiness and easy circumstances, which never ceased to rejoice my eyes during my stay in that great city. Whether in Vienna itself, or in the surrounding country, I have never met with a beggar ; the labourers, the peasants, the waggoners, all were well-dressed. One saw at once that they lived under a paternal government, and one may truly call it so. Moreover, the rich Viennese families, some of which have enormous fortunes, spend their incomes in the way most honourable to themselves and most useful to the poor. They provide an immense amount of work, and benevolence is a virtue common to all the well-to-do classes. One of the things that most astonished me was, the first time I went to the theatre, to see many ladies, among them the beautiful Comtesse Kinska, knitting thick stockings in their boxes. I thought this very strange ; but since I was told that these stockings were for the poor, I was pleased to see the youngest and prettiest women working like this—all the more so because they knitted while attending to other things, without even looking at their work, and with a prodigious speed." They were as good knitters, apparently, as the Scotch herring-lasses—óne could not put it higher than that.

Rich and poor alike kept their happiness alive by dancing. No

A

CATALOGUE

OF ALL THAT

NOBLE & SUPERLATIVELY CAPITAL ASSEMBLAGE

OF

VALUABLE PICTURES,

DRAWINGS, MINIATURES, AND PRINTS,

THE PROPERTY OF THE

Right Hon. *Charles Alexander De Calonne,*

LATE PRIME MINISTER OF FRANCE;

SELECTED WITH EQUAL TASTE, JUDGMENT, AND LIBERALITY,

During his Refidence in FRANCE, and his Travels through ITALY, GERMANY, FLANDERS, and HOLLAND, and while in ENGLAND;

AT THE

IMMENSE EXPENCE OF ABOVE

SIXTY THOUSAND GUINEAS,

THERE IS ALSO INCLUDED

A SMALL ELEGANT, COLLECTION OF CABINET PICTURES,

BEQUEATHED TO HIM BY THE LATE

MONSIEUR D'ARVELEY,

HIGH TREASURER OF FRANCE;

Forming together the moft fplendid COLLECTION in EUROPE, which were intended for a magnificent Gallery at his late Houfe in PICCADILLY.

COMPRISING

The INESTIMABLE WORKS of the moft admired MASTERS of the ROMAN, FLORENTINE, BOLOGNESE, VENETIAN, SPANISH, FRENCH, DUTCH, and ENGLISH SCHOOLS.

Which will be SOLD by AUCTION,

BY

Meffrs. *Skinner* and *Dyke,*

On MONDAY the 23d of MARCH, 1795, and FIVE following Days,

PUNCTUALLY AT TWELVE O'CLOCK,

AT THE

GREAT ROOMS, in SPRING GARDENS,

BY ORDER OF THE NOW MORTGAGEES.

———————

To be publicly viewed Four Days preceding the Sale, (Sunday excepted.)

Catalogues may be had, at Two Shillings and Six-pence each, in Spring Gardens, alfo of Meff. SKINNER and DYKE, Alderfgate Street.

TITLE PAGE OF THE CALONNE SALE CATALOGUE, MARCH 1795

Lancashire operatives at Blackpool or Southport, no Ragtime or Tango enthusiasts in London drawing-rooms or Margate saloons, ever threw themselves into the ecstasy of motion with more tireless zest than the Viennese of those days, to say nothing of to-day. Madame Lebrun was invited to a court ball, on the occasion of the marriage of the Emperor Francis II to his second wife the Princess Marie-Thérèse of Naples, whose portrait she had painted in 1792. At that ball the dancing was, of course, after the manner of courts; but at a ball given by the Russian ambassador " the waltz was danced so furiously that I could not conceive how all these people, in turning round and round in that fashion, could help making themselves so giddy that they would fall down. Both men and women, however, are so well accustomed to this violent exercise, that they do not leave off for a single moment, so long as the ball lasts." Here, as often elsewhere, the reader of Madame Lebrun's own accounts of her experiences must find a grain or two of salt to help him to swallow easily.

Her old acquaintance the Prince de Ligne, still as lively, if not quite so sprightly as when he showed the Lebruns round his house near Brussels in 1782, gave her such a flattering account of the Empress Catherine of Russia, whom he had accompanied during the famous journey in the Crimea, that when some of the most influential Russians in Vienna urged her to go to St. Petersburg, and assured her that the Empress would be delighted to see her, she succumbed to the temptation.

Leaving Vienna on a Sunday in April, 1795, she went, " by a very pretty route," to Prague, where she arrived four days later. One day was devoted to seeing Prague and its art treasures, and on the next she went on towards Dresden, where she was moved to " adoration " by Raphael's " Virgin and Child," which made all the other masterpieces in the gallery appear to be lacking in dignity.

One need scarcely say that, in such a centre of the arts as Dresden, her own " Sibyl " was once more unrolled, framed, and exhibited, this time by the express wish of the Elector of Saxony, who ordered that it should be shown in that same gallery where Raphael's great work had enthralled her. " During a week all the court came there to see my picture. I went there myself on the first day, in order to show the Elector how much I was touched and how grateful I was for that high favour, which I was far from expecting or desiring." What a naïve soul was hers, and how innocently she enjoyed her triumphs !

After this week of triumph, " being in a great hurry to reach St.

Petersburg," she went straight to Berlin, where she devoted five days to sight-seeing in that city, which at the time was, as it seemed to her, too big for its population, so that the streets were a little dull.

Then, on May 28, 1795, she set out on a drive of some forty or fifty miles, along a road which was mostly of sand, to visit Prince Henry of Prussia at Reinsberg, where that former acquaintance of the artist received her with "une bonté sans égale." Indeed, there is no record in her *Souvenirs* that she was ever treated more handsomely. Her taste for the theatre was gratified by the Prince's own company of French comedians, and there was plenty of music, of which he was still as fond as in the times when he joined in the quartette at her house in the Rue de Cléry. " I cannot tell how sad I felt in leaving this excellent prince, whom, alas! I was never to see again, and whom I shall regret all my life. The welcome he had given me, the kindness with which he had overwhelmed me during my stay with him, all seemed to render that separation painful. His attentions for me did not relax for a moment, and, immediately after I had left Reinsberg, I was touched to the last degree on discovering the quantity of provisions, both eatables and wines, that he had had placed in my carriage, knowing that I should find nothing until I got to Riga. There was enough to feed a Prussian regiment, and the good prince could feel quite certain that I should not die of hunger on the road."

But if the little party of travellers—"Madame, Mademoiselle et la gouvernante "—had plenty to eat and drink, they would willingly have changed some of their provisions for pneumatic tires had such accessories then been invented. The sandy roads were so bad that two miles an hour was exceptionally good progress in many places. However, travelling by day and night, they at length reached Riga, where they were obliged and glad to rest for a few days, awaiting their passports for St. Petersburg.

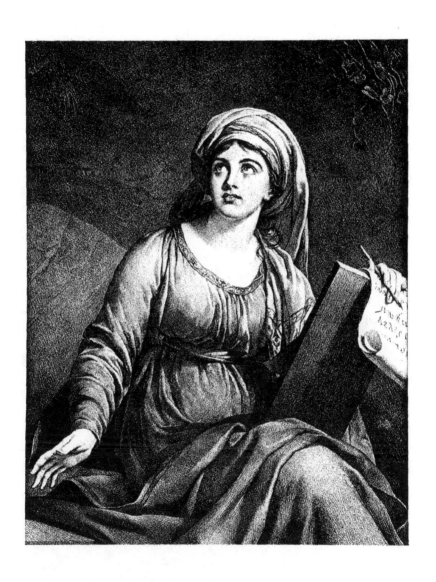

CHAPTER XIX

ST. PETERSBURG, 1795–1800

Commanded to Court—No time to get a dress made—Kindly reception from Catherine II—Comte Esterhazy reproaches Madame Lebrun for her forgetfulness of etiquette—Her supposed enemies at the Court—Extravagant hospitality of the Russian nobles—The Princesse Dolgorouky and her hopelessly devoted lover—How Potemkin had stormed a fortress to amuse her—Tableaux vivants at the Princesse Dolgorouky's—Madame Lebrun is robbed by a servant, and loses £1800 through the failure of a Russian bank—The " Greek supper " story—A lie exposed—The artist paints the grandchildren of Catherine II—Trouble about the costumes—The grand-duchess Elisabeth—Stanislas Poniatowsky.

TOWARDS the end of July 1795 Madame Lebrun arrived in the " new capital " of Russia, having been three months on her much interrupted way from Vienna. She was in great need of rest. If the sandy roads of Central Germany had been wearisome, the roads from Riga to St. Petersburg had been dangerous. They were in many places simply tracks of loose stones, like the beds of mountain rivers in summer, and the shocks were all the more violent because the carriage was of the roughest description. The inns being so bad on that route that it was impossible to stop in them, the travellers had gone on " from jolt to jolt " without any rest until they reached their destination. Twenty-four hours after her arrival, whilst Madame was still reposing after that horrid bone-shaking, the Bourbons' "Ambassador" to Russia, Comte Esterhazy, came to welcome her, and, on the same evening, returned to tell her that the Empress Catherine would receive her the next afternoon at Tsarko-Selo.

This promptitude on the part of the Empress was as disturbing as it was flattering to Madame Lebrun. Most readers of her own sex will sympathise with her distress that there was no time to get a suitable dress made, and that she must either go in a simple muslin gown, such as she usually wore in the evenings, or disobey the Imperial command. The second alternative was, of course, not to be cogitated; such behaviour would have started her very badly on her professional and social route in Russia. When, the next morning, she went to lunch with the Esterhazys

before the presentation to the Empress, her hostess could not carry her
politeness so far as not to ask: "Haven't you brought another dress?"
No wonder that Vigée-Lebrun "became crimson" at this question. "I
explained to her that I had not had time to get a more suitable dress made.
Her dissatisfied air so much increased my anxiety, that I had need to arm
myself with all my courage when the time came to go to the Palace."

However, M. Esterhazy, to Madame's astonishment, had assured her
that the Empress was "really a good sort of woman." She was somewhat
reassured, too, by an encounter, on the way through the gardens of the
Palace, with the Grand Duchess Elisabeth (the wife of the future Alexander I),
a pretty girl of seventeen or thereabouts, who was watering some carnations
at a window, and who spoke to the artist, ending her remarks with the
flattering statement : "We have long waited to have you here, Madame,
so much so that I have often dreamt that you had come." To the French
painter her reception by the Empress of All the Russias—and of Poland
by that time—was naturally one of the great events of her life.

Accustomed though she was to courts and princesses, she made a
mistake at the outset which would have earned her the grave displeasure
of some monarchs even in our own enlightened times. Let us have her
account of this reception.

"I was trembling a little when I came into the presence of the Empress,
and a few seconds later I was in a *tête-à-tête* conversation with the Autocrat
of All the Russias. M. d'Esterhazy had told me that it was necessary to
kiss the Empress's hand, and in accord with that usage she had taken off
one of her gloves, which ought to have reminded me of the rule, but I entirely
forgot it. Truly the aspect of that famous woman made such an impression
on me, that I could think of nothing else except to look at her. I was at
first exceedingly surprised to find her very short : I had imagined her to
be of prodigious tallness, as high as her renown. She was very fat, but
she had still a handsome face, which her white hair, brushed high off the
brow, framed to perfection. Genius seemed to rest upon her wide and
lofty forehead. Her eyes were soft and well-shaped, her nose the true
Grecian, her complexion highly coloured (*fort animé*), and her countenance
very mobile. She said to me at once, in a gentle voice, a little thick for
all that, 'I am charmed, Madame, to receive you here; your reputation
has arrived ahead of you. I am very fond of the arts, and especially of
painting. I am not a connoisseur, but an amateur.' Everything she
said during that conversation, which was rather lengthy, about her wish

that I should like Russia well enough to stay there for a long time, was so kindly that my timidity disappeared, and when I took leave of her Majesty I was completely at ease. Only I did not forgive myself for not having kissed her hand, which was very pretty and very white, and I regretted that forgetfulness all the more because M. d'Esterhazy reproached me for it. As to my costume, the Empress did not appear to have noticed it, or perhaps she was less fastidious than our ambassadress."

According to Madame Lebrun, she became at once a subject of petty intrigue at the court. She tells us that the Empress ordered her chamberlains to give her a suite of rooms in the palace, as she wished to be able to see her painting portraits, and that the chamberlains, believing her to be an adherent of the Comte d'Artois, and fearing that she came to intrigue against M. Esterhazy in the interests of that Prince, assured the Empress that there were no suitable rooms vacant. Madame thought it probable that the Bourbon envoy himself was in accord with the chamberlains in this matter. "But truly," she says, "one could know very little of me not to be aware that I was too much taken up with my art to be able to give my time to politics, even apart from the aversion I have always felt from all that has any resemblance to intrigue." In any case, she felt that she would have been far less free at the palace than in her own lodgings, and the kindness with which she was treated by the great ladies of St. Petersburg made up for any little unkindness she received from the immediate entourage of the Empress.

The hospitality of the wealthy Russian nobles at that period was displayed on a highly generous scale. No foreigner, if he had a satisfactory introduction, ever needed to take his meals at an hotel or a restaurant. "I remember," writes Vigée-Lebrun, "that during the last month I was in St. Petersburg the Prince Narischkin, Grand Equerry, kept an open table of twenty-five to thirty covers for strangers who were recommended to him." Wherever foreigners of "good position" travelled in Russia they could lodge and feed free of expense at the country-houses of nobles, merchants, or landed proprietors, who were surprised at the warmth with which their guests thanked them for their generous treatment. "If we were in your country," said these lavish hosts, "you would certainly do as much for us." Madame Lebrun's comment on such a confident opinion was fully justified, so far as Western Europe was in question. It is expressed in the one word—"Alas!"

It was not long after her arrival in Russia that Madame Lebrun made

two friends who were to remain in her friendship for many a year to come: the beautiful Princesse Dolgorouky, and the "amiable" Princesse Kourakin. She also became acquainted with the Austrian ambassador, Comte Cobentzl. The two ladies, indeed, and the Comte, "kept house together." Let not the reader of modern French novels suppose that there was anything wrong with this arrangement. Madame Lebrun stayed in the house for a week, and her report is as follows: "The Comte de Cobentzl was passionately in love with the Princess Dolgorouky, who made not the slightest response to his affection; but the indifference with which she received his attentions could not drive him away, and, as some song says, he preferred her severities to the favours of other women. Hopeless of any other happiness than that of seeing her, he was determined at least to enjoy that to its full extent; whether in the country or in the town, he never left her. As soon as his despatches, which he wrote with great ease, were sent off, he flew to her house, and made himself completely her slave. One would see him run at the least word, the least gesture of his divinity." All of which goes to suggest that "cherchez la femme," if we regard the object sought as a passive influence, must have been applicable to many little difficulties of diplomacy between the Austrian and Russian Governments at that time.

Apropos of ambassadors, Madame Lebrun tells the following little story of a dinner at which she was present, given by a Princess Galitzin to Duroc and Chateaugiron, envoys to Russia of the French Republican Government. The cook, knowing nothing of the French Revolution, and supposing the principal guests to be the ambassadors of the King of France, decorated his filets, and moulded his pâtés, "en fleurs-de-lis." The effect of this misplaced compliment was so unpleasant that the hostess, fearing she might be supposed guilty of a bad practical joke, sent for the cook and questioned him about this display of fleurs-de-lis. "The good man replied, with a self-satisfied air, 'I wished to show to Her Excellency that I know what is the correct thing to do on grand occasions.'"

To return to the Princesse Dolgorouky and her slave. Entertaining and obliging as the ugly and middle-aged Cobentzl seems to have been, he was always eclipsed by more brilliant and more lavish admirers of his *belle dame sans merci.* Among them had been Potemkin, who had not only showered diamonds upon her, and, on one occasion, sent a courier to Paris, travelling night and day, to get her some shoes to wear at a ball, but had actually (as was commonly asserted) ordered an assault on a hostile

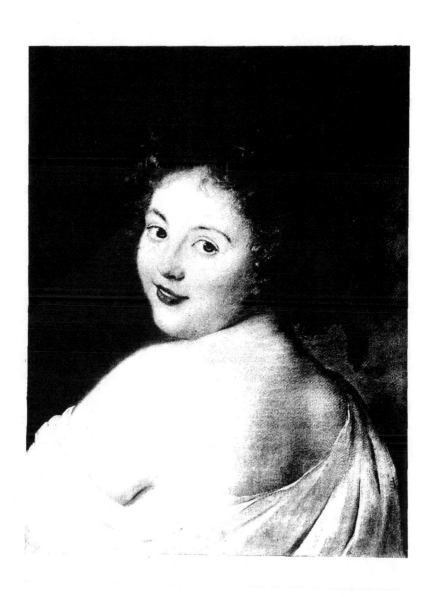

fortress before the time previously fixed, because she had ·expressed a desire to see this " spectacle." Madame Lebrun gives some remarkable anecdotes in illustration of the extravagance and autocratic behaviour of Potemkin, but she adds nothing to what the Comte de Ségur, the Prince de Ligne, and others have recorded concerning him. His costly stage-management of the tour of Catherine II through her empire is one of the best known, the most absurd, and the most melancholy facts in Russian history—melancholy, because he managed to prevent the sovereign from learning anything of the real state of her people, and spent on it vast sums wrung from the toil of those patient slaves.

The Comtesse Skavronska; who, as has already been stated, was Potemkin's niece, said to Madame Lebrun, " If my uncle had known you he would have overwhelmed you with honours and with wealth." Possibly he might have done so, but in any case the artist had no desire again to go through the humiliation she had endured after receiving a bonbonnière with some bank-notes from a Minister whose portrait she had painted. As a fact, she had few Russian men among her sitters, the three artists, Borovikofsky, Chtchoukin, and Lampi dividing the vogue as painters of Russian noblemen at that time. At Alexandrovsky, where the curious *ménage à trois*—the two Russian princesses and the Austrian ambassador —spent the summer months, Vigée-Lebrun stayed for a week, enjoying the moonlight water-parties, and still more pleased by the amateur theatricals. To these, at her suggestion, tableaux vivants succeeded, the figures for which she dressed and arranged, preferring serious subjects, " or those from the Bible," as she quaintly says. She also arranged, from memory, several pictures in the " grand style," such as " The Family of Darius " (possibly after the Veronese now in the National Gallery). The greatest success was with " Achilles at the Court of Lycomedes." Her idea of the correct dress of a Homeric warrior seems to have been as remote from probability, in a different direction, as that of the Comédie Française of her youth. She took the part of Achilles herself, in the tableau, " because I was generally dressed in such a way that a helmet and a shield šufficed to make up a very accurate costume." Happily for Madame Lebrun's modesty, she had forgotten the statues of Greek warriors in the Louvre collection ; happily also, she did not have the idea of painting a portrait of herself as Achilles. Her " classical " mother-and-child portrait is charming. What would her classical warrior portrait have been, in the eyes of those to whom subject has some relation to art ?

It will be remembered that, after leaving Italy, Madame had the misfortune, in spite of the order of Napoleon in her favour, to lose a great part of her savings in a Venetian bank during the French invasion. Twice afterwards, in St. Petersburg, she lost a good deal of her money. First, she was the poorer by fifteen thousand francs through the dishonesty of a young man-servant, whom she managed, on his conviction for the robbery, to save from the gallows. This loss was due, one would naturally say, to the folly of keeping so large a sum in her house. But in the other case, the loss occurred precisely because she kept her money in a bank. During the first month of her residence in St. Petersburg she earned £1800. Under friendly, but unfortunate advice, she placed this money in a bank which suspended payment shortly afterwards, with a total loss to her. Up to this time, she wrote to her sister-in-law, she had saved nothing out of her earnings. This was not strictly true, as the house in the Rue du Gros-Chenet at Paris, which her enemies described as a gift from Calonne, had been built, according to her husband and herself, out of the fruits of her painting as well as of Lebrun's business. The old calumny was still pursuing her. In the letter in which she tells of the failure of her banker at St. Petersburg, she also tells how a certain Monsieur de L—— (whose name she does not give) had told the Baronne Strogonoff that he was present at the famous "Supper after the manner of the Greeks," and that to his knowledge it cost sixty thousand francs. He had also intimated that he was on very friendly terms with the giver of that feast.

One day, when Madame was in the bedroom of the Baronne Strogonoff, who was indisposed, this Monsieur L—— was announced. Madame hid herself behind the curtains. When the visitor—in the conventional manner which would now be so unconventional in England—was shown into the room, the lady in the bed said to him : " 'Well, you ought to be very happy, for Madame Lebrun has arrived.' Then she tried slily to draw him on as to his liaisons with me, and the Greek supper. My man began to get confused, the Baronne still putting questions, when at length I showed myself. I went up to him, and said, 'Monsieur, you know Madame Lebrun very well, it seems?' He was obliged to answer 'Yes.' 'That is very strange!' I replied, 'for I, Monsieur, am Madame Lebrun, whom you have calumniated, and I meet you to-day for the first time in my life.' At these words he was so much overcome that his legs trembled under him. He took his hat, and since then has not been seen again, for

the doors of the best houses have been shut in his face." This letter to Suzette Vigée ends with the following reflection: " It is sad to remark, as I have too often had to do, that in a foreign country it is only French people who are capable of trying to injure their compatriots, even in employing calumny. Everywhere, on the other hand, one sees the English, the Germans, and the Italians, mutually sustaining and supporting one another."

Vigée-Lebrun would not have been herself if she had not changed her abode whilst at St. Petersburg. She moved from her first lodgings into a house in the big square of which one side was formed by the Palace of Catherine II. She had the pleasure, every morning, of seeing the Empress open a French window and throw bread-crumbs to the birds, which came regularly to receive their rations. In the evenings, through the windows of the brightly-lit rooms of the Palace, the Empress could be seen playing at hide-and-seek with her grandchildren and their attendants.

Two of these grandchildren, Alexandrina and Helena, both between twelve and fifteen years old, sat for their portraits, by command of the Empress, to the French artist, being painted together on the same canvas. This picture, which is now at Gatschina, is signed, and dated 1796. The two girls are dressed in their own costumes, but, as first represented, they were dressed by the artist in costumes which, she says, were " a little Greek, but very simple and very modest." The reason for the alteration was that Zuboff, the favourite who had succeeded Potemkin in Catherine's affections, told Madame Lebrun that the Empress was scandalised. In the artist's own opinion the effect of the picture was spoilt by the alteration, apart from the fact that " the pretty arms, with which I had done my very best, could no longer be seen." She declares that the Empress herself denied that she had made any complaint, and she charges Zuboff, who does not seem to have liked her, with inventing the criticism. His enmity, she suggests, was due to her neglect, during six months, to seek his good offices by means of a letter of introduction to his sister, which the artist had with her.

It seems certain, however, that the Empress did not care for the picture, and she never sat to Madame herself, though she gave her some other commissions.

The second " command " portrait was of the Grand Duchess Elisabeth, whom we have seen watering her carnations. She was a nice-looking girl,

9

if we may trust that portrait. Indeed, the artist assures us that at a ball at the Palace, where she was unable to keep count of the multitude of lovely women who passed before her as she sat watching the *polonaises*, the four young princesses of the Imperial family were the most beautiful. They were all four dressed *à la Grecque*, their tunics being fastened on the shoulders by diamond hooks, so that they seem to have shown their pretty arms on this occasion, and to give the lie to Zuboff. Madame herself assisted at the toilette of the Grand Duchess Elisabeth, " so that her costume was the most correct "—a conclusion that, remembering her idea of the correct costume for Achilles, we may find it difficult to endorse. We know from the Comtesse Golovine, who was in St. Petersburg at that time, that the Empress was much displeased with the Grand Duchess for appearing in this dress, which, in her eyes, was far from being "correct."

After the death of Catherine, who, as Vigée-Lebrun believed, had been a very fountain of happiness for her subjects, the brief and unhappy reign of the eccentric Paul I was in no way inimical to the interests of the French portrait-painter. The new Empress, Marie Feodorovna, had happy memories of her visit to Paris. Madame Lebrun had there been presented to her ; and now, in 1799, she painted a great portrait of the new Empress, with all the usual accessories of Royal portraiture—crown, columns, sumptuous curtain and the rest.

Her vogue as a painter was also maintained by the exhibition of her last portrait from life of Marie Antoinette, and the favour shown to her by that involuntary *roi fainéant*, Stanislas Poniatowsky, whose portrait she painted twice, helped to keep her busy. Her charge seems to have been about £300 for a portrait of ordinary size, a large price in those days. In addition to her portraits of others, she painted for the Academy of St. Petersburg, into which she had just been received with the usual honours, the picture of herself, with her palette in her hand, which, from prints and photographs, is familiar to the admirers of her work.

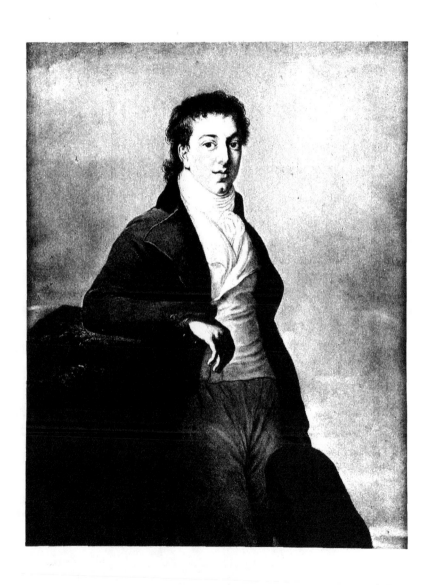

CHAPTER XX

THE MARRIAGE OF JULIE

A heavy blow—The marriage of Julie Lebrun to M. Nigris—Madame Lebrun's description of her daughter—A spoilt child—An unfaithful governess—The artist leaves for Moscow—The change does her no good, and she returns to St. Petersburg—Favour shown by the Emperor Alexander and his wife (The Grand-Duchess Elisabeth) to Vigée-Lebrun—She leaves Russia—Visit to Queen Louise at Potsdam—Sketches the Queen's portrait—The Queen's candour about her plain children—Madame Lebrun detained in Frankfort by the rumour of Bonaparte's assassination.

IT was now, when her fortune seemed to be in the full tide of success, that she received a blow which hurt her more than any that she had yet felt. The news of her mother's death, in April 1800, must have distressed her, though she does not refer to it in the text of her *Souvenirs*, but the marriage of her daughter in the same year gave her far more sorrow. Julie—" Brunette " her mother and her friends called her more often—was not, perhaps, quite as pretty as that mother describes her : " My daughter was now seventeen. She was charming in every respect. Her large blue eyes, wherein so much intelligence was shown, her nose a little *retroussé,* her pretty mouth with its beautiful teeth, a dazzling freshness of complexion, all formed one of the prettiest faces you could see. Her figure was not very tall, but she was *svelte* without being devoid of *embonpoint.* A natural grace reigned in all her person. There was as much vivacity in her manners as in her wit. Her memory was prodigious—everything she had learnt in her various lessons or by reading she remembered. She had a charming voice, and sang in Italian to a marvel, for at Naples and at St. Petersburg I had given her the best music masters, as well as masters for English and German. Moreover she accompanied herself on the piano and the guitar. But that which charmed me most was her happy promise in painting, so that I could not say how happy and proud I was of all the advantages she combined."

"Brunette " was pretty and accomplished, but for all that she was a

131

spoilt child. She was invited wherever her mother went, and her mother's delight was to satisfy the girl's fancies. Unfortunately, Julie did not fully return the maternal affection, and while Madame Lebrun was easily influenced by Mademoiselle, Mademoiselle was just as easily influenced by Madame Charrot, the governess who had come with them from Paris, and had been with them ever since. One of the friends who showed a fondness for Julie was the Comtesse Tchernycheff, at whose house the girl was allowed to spend many hours when her mother was elsewhere. There she met M. Nigris, a young man of about thirty, who was secretary to Comte Tchernycheff. He had an attractive manner and a rather romantic appearance, and Julie fell in love with him. The Tchernycheffs, helped by Madame Charrot, intrigued so well to bring about a marriage between the pair that at length, attacked on all sides, Madame Lebrun consented, but not until Julie had become really ill from dread of a refusal. The father's consent was received, after a long delay, which Julie attributed to her mother—unjustly, as Madame Lebrun declares. The fact was, M. Lebrun in Paris had a more promising husband in his mind for his daughter, and did not readily agree to her marrying a penniless foreigner. There is reason to believe, from some remarks of Madame Lebrun herself, and from a letter of Comte Tchernycheff which she gives, that the ancient calumnies against her had been raked up to prejudice her daughter's mind.

The wedding-day arrived, a sad festival for Madame Lebrun. She had given Brunette a beautiful trousseau, jewels (including a diamond bracelet bearing a miniature of M. Lebrun), and a handsome dowry.

People did not go off for honeymoons in those days, and on the morrow of the wedding the mother went to see her daughter, finding her " calm, and without exaltation over her happiness." A fortnight later she found her less calm, but no more happy. The bridegroom, who was talking to some other visitor, had a bad cold, and had a furred wrap round his neck and shoulders. " I hope you are very happy," said the mother, " now that you have him for a husband ? " The bride's reply was not very encouraging : "I confess that the furred wrap disenchants me ; how do you suppose one can be in love with such a get-up ? " Madame Lebrun took these words very seriously, and regarded them as marking the end of the romance. She adds, however, in one of those footnotes wherein her natural sense of justice sometimes finds expression, that " M. Nigris had a gentle nature and a taking wit " (*esprit insinuant*). " They lived very well together during some years."

The coldness with which Madame Lebrun regarded her son-in-law might conceivably be gauged from one simple fact. She merely calls him "M. Nigris." The "nobiliary particle" (de), which she so freely prefixed to the names of untitled persons of any nationality, without any better warrant than her own fancy for it, was not given to him.

The marriage of her daughter almost destroyed Madame's fondness for St. Petersburg, and she sought change for mind and body by a journey to Moscow, where she spent five months, having a fresh triumph, both professional and social, in the old capital of the Empire.

It seems almost superfluous to say that she had to leave her first residence in Moscow on account of an "infernal noise," the trouble on this occasion proceeding from a band of trumpeters, who practised their pieces in the adjoining room !

In the house to which she removed, which was lent to her by the Comtesse Stroganoff, she had an awful night, being nearly suffocated by smoke from a stove of which the chimney was stopped. It may be noted, as showing how lightly her husband regarded his divorce from Vigée-Lebrun, that in this house at Moscow she held an exhibition of pictures by various masters which he had sent to her for that purpose from Paris.

Before a fortnight was over she had begun half a dozen portraits, and she was certainly not idle during her stay, but she left no special list of her Moscow works, including them in the St. Petersburg list.

The change to Moscow did her no good, and though she was probably never in quite the state of despair and weakness which she described in writing to her son-in-law, declaring that she was so melancholy that the greatest of misanthropes would seem too lively for her, yet she undoubtedly was feeling very poorly at that time.

A few days after she had written to M. Nigris about her health, she found herself much better, and in spite of many kindly attempts to keep her at Moscow, and offers to pay her higher prices for her portraits than she received elsewhere, she set out at the beginning of March 1801, learning, when she was half way to St. Petersburg, of the assassination of the Emperor Paul, and finding the capital, when she reached it some days afterwards, " delirious with joy, people singing, dancing, and embracing in the streets."

Her stay in this happy capital was not long, but she was able, in spite of her health, which was by no means re-established yet, to make pastel studies from life of the Emperor Alexander and his wife, whose portraits she had already painted. The favour with which these sovereigns treated

her would, as she says, have ensured her fortune had she been well enough
to profit by it. As it was, she was determined to get away from Russia
as soon as she could, and with her maid (a married woman) and an old
man whom she kindly took as a servant because he wanted to go to Prussia,
she set out, "accompanied" by old M. de Rivière, who travelled in another
carriage, and who was of very little assistance to her, being so little able
to enforce his will over his postillions that they took him nearly all the
time by cross roads, zigzagging across the main road to which her own
carriage kept. Curiously, the zigzag method seems really to have been
the best, for Madame herself says of the route, "I saw from a distance
some wolves on the hills, but apparently they were afraid of us, as they
always fled on our approach; so did the poor stags, frightened by M. de
Rivière's carriage, which I often saw crossing the road." Passing through
Riga again, she hurried on to Mittau, hoping to find there the young
Duchesse d'Angoulême, the "Madame Royale" of the picture at
Versailles, from whom she had lately received a kindly letter concerning
a portrait of Marie Antoinette; but the Princess had left when the
artist arrived.

Again she suffered badly from the state of the route, and once the
jolting affected her so much that she fainted. But as she approached
Berlin the trouble was lessened, and when, near the end of July (1801),
she arrived in the Prussian capital, she was so much better that, in spite
of irritating troubles with the customs over her luggage, and the theft by
a drunken official of some of the Indian muslin which Madame du Barry
had given her, she was well enough a few days after her arrival to go to
Potsdam, at the request of Queen Louise, to paint the portrait of that
Princess of pathetic history. The Queen showed every possible attention
to the artist, and was pleased to be satisfied with the "Sibyl," which was
again unrolled. She was not so complimentary to her own offspring as to
Madame Lebrun's work. "During one of her sittings the Queen sent for
her children, whom, to my great surprise, I found ugly; in showing them
to me, she said, 'They are not good-looking.' I admit I had not the face
to contradict her—I contented myself with answering that their faces were
very expressive (qu'ils avaient beaucoup de physionomie)." Thirty-five
years later, by the by, when Madame Lebrun was preparing her reminis-
cences, she felt that this anecdote might hurt the feelings of the "children,"
who were now middle-aged, and therefore she added this footnote: "These
children, since that time, have much changed to their advantage. The

Princess, who is now Empress of Russia, has greatly improved in appearance."

Having made two pastel studies of Queen Louise, and some of other members of the Prussian Royal Family, and having been made a member of the Berlin Academy of Arts, Madame Lebrun, full of foreign honours and enriched by much foreign money well and honourably earned, went on her way to France. She stayed a short time in Dresden to make several copies, already commissioned, of the portrait of the Emperor Alexander of Russia. At Weimar, though she had letters of introduction to the Saxon from the Prussian Court, she was again so upset (figuratively) by bad roads that she was too modest, too timid, and too weary to use them.

At Gotha she called on Grimm, who was of much service to her with regard to changing her money and arranging for the rest of her journey ; at Frankfort she was robbed by a servant, and moreover was delayed for six days by the rumour that Bonaparte had been assassinated, which, if true, would have made her stay abroad still longer. She employed these days of waiting in mending her underlinen, work at which she was so unskilled that a new maid whom she engaged after she reached Paris, on seeing the garments thus " mended," exclaimed, " Any one can see that Madame has come from a barbarous country, for these things are cobbled diabolically."

Considering that M. Lebrun had secured an act of divorce during the Terror, his conduct on the return of his former wife to Paris was not without comedy. He had the house in the Rue du Gros-Chenet done up for the occasion. Her bedroom was draped with green cashmere, bordered with golden silk embroidery, and the bed was surmounted by a crown of golden stars. There were plenty of flowers about, and all that was possible had been done to please her. It was all very nice ; and although, she says, " M. Lebrun certainly made me pay very dearly for all that, I was none the less sensible of the trouble he had taken to make my home agreeable." From that day onward, except on the occasion of his death, we hear scarcely anything more about this light-hearted and light-principled man.

CHAPTER XXI

The artist's return to Paris—Lost friends, but many left—A ball at Madame Récamier's—The desolation of Marly—The fate of Rosalie Bocquet—How M. de Verdun escaped the guillotine —Madame Lebrun resumes her old life—Beautiful women of the Revolution—Madame Tallien described

WIDE as were the gaps that the Terror had made in Madame Lebrun's world in Paris, there were still many of her best friends to cheer her—the Brongniarts, the Verduns, Greuze, and Ménageot among them. Josephine Bonaparte came to visit her, and reminded her of dances at which they had met before the Revolution, but of which Madame Lebrun had no recollection. "Madame Bonaparte was very pleasant, and asked me to lunch at the house of the First Consul. As, however, I did not show any great eagerness in the matter, the date of that luncheon was never fixed."

The brothers of Bonaparte also came to see Madame Lebrun's pictures, and Lucien was delighted with the famous "Sibyl." The Comédie Française put her upon the free list. The leading actors, furthermore, asked to be allowed to perform a comedy in the gallery in her courtyard, the management of the Opera House proposing to provide a ballet on the occasion. These last offers she declined, sensible though she was of the honour of such a festival, because she did not wish to be "placed in evidence."

A ball to which she went at Madame Récamier's (whose acquaintance she had just made) delighted her, all the more as she was with her St. Petersburg friend and patron, the Princess Dolgorouky. "There was a large company, without any confusion; a great number of pretty women, a very fine house—nothing was wanting. As the peace of Amiens had been arranged, one found again in that reunion I know not what air of propriety and of magnificence that the young generation had not known

before. It was the first time that young people of twenty years old saw at Paris liveries in the ante-chambers, ambassadors in the drawing-rooms, as well as other distinguished foreigners, richly dressed, and all wearing brilliant orders. Whatever one may say, that sort of luxury is more in keeping with a ball than short jackets and trousers."

In fact, the Revolution was over, and there was soon to be a Court again. Gaiety had resumed its sway, but melancholy indeed were the changes that met the sight of the returning exile. The fire of the Revolution had passed, and burnt up a great part of that which, animate or inanimate, had been most pleasant to her eyes.

She went again to Marly, where first the Queen of France had taken notice of the artist, both being then in their teens ; and Marly, all but its park, its watering-place for horses, and its farm, had disappeared. The palace, the cascades, the fountains were as if they had never been. " I found but a single stone, which seemed to me to mark the middle of the salon." Marly was but a type of the changes in the world that she had left behind on that dreadful October night, thirteen years before.

Among the many old friends who had, to use the awful slang of the Revolution, " looked through the National window " (the guillotine), was her fellow-student in girlhood, Rosalie Bocquet, who might have rivalled Elisabeth Vigée as a portrait-painter had she not almost entirely given up painting after her marriage to M. Filleul. The Bocquets had possessed some influence at Court, and the Queen had appointed this young Madame Filleul concierge of the Château of La Muette, a post which gave a home to the newly married pair, a certain income, and various rights and privileges. M. Filleul died in 1788. When Madame Lebrun had told the young widow, the year after, that she was going to leave France, Rosalie had said, " You are wrong to go away ; I shall stay here, for I believe the Revolution will be the cause of happiness." At the beginning of the Terror, Madame Chalgrin, daughter of Joseph Vernet and an intimate friend of Rosalie Filleul, came to the Château of La Muette, at the invitation of the " concierge," to celebrate very quietly the marriage of her own daughter. On the day after, the revolutionaries came to arrest Madame Filleul and Madame Chalgrin, who, they said, had been guilty of " burning the wax-candles of the nation," and both were guillotined a few days later, the formal charge against Madame Filleul being that she was " a servant of the Court, a friend of the Messalina Antoinette," and that " the ci-devant crapulous Comte d'Artois had shaken hands with her."

Another of Madame Lebrun's friends who had said " Why should I have any anxiety ? what harm have I done to any one ? " was M. Boutin, her host of so many pleasant dinners at his house in Montmartre. He stayed in France, and he too " looked through the National window." His crime was that he was rich, and that the new power wanted his money.

Of those who had stayed behind at the emigration, and survived to welcome her, none was more pleasant to her heart than Madame de Verdun, her hostess at Colombes, and friend of almost a lifetime. M. de Verdun, like M. Boutin, was guilty of being rich, and was speedily arrested and sent to prison under the Revolution. He owed his survival to the fact that he was not merely a financier, but a landed proprietor who had been kind to his labourers and poor neighbours. They were sufficiently grateful to stick by their employer and helper. As soon as the news of his imprisonment reached Colombes, the peasants gathered together and marched to Paris to demand his release. This prompt action by so many people saved his life, but he was kept in prison until the peasants came again, and showed themselves so absolutely determined, that he was at length set free. His wife, on hearing the good news, was so overcome with joy that she sent for two hackney coaches to fetch her husband from prison, thinking she would get there more quickly with two than with one.

Of all the old acquaintances whom Madame found alive in Paris under the Consulate, none was more in the state of finding his " occupation gone " than the Comte d'Espinchal, whose extraordinary capacity for knowing everybody by sight, and everything that anybody was doing before it was done, formed the subject of an earlier page. Vigée-Lebrun, when she first met him again in 1802, said to him, " You must be frightfully ' disoriented'—you know nobody any more in the boxes at the Opera and the Comédie Française." He made no answer, but " raised his eyes to heaven." This strange person died soon after, probably of ennui, for he was not very old. It was said that, before his death, he burned an enormous quantity of notes that he had been accustomed to make every night before going to bed. " I had," says Madame Lebrun, " heard several people talk of these notes, which perhaps made them anxious. It is certain that they would have furnished enough material for a book which would have been very piquant, but quite as certainly would have been very scandalous."

It is a good thing for the reputations of many of the Parisiennes of the days of Louis XVI that those papers were burnt, no doubt, as it is a good thing for the ladies of Versailles that Madame Lebrun herself was

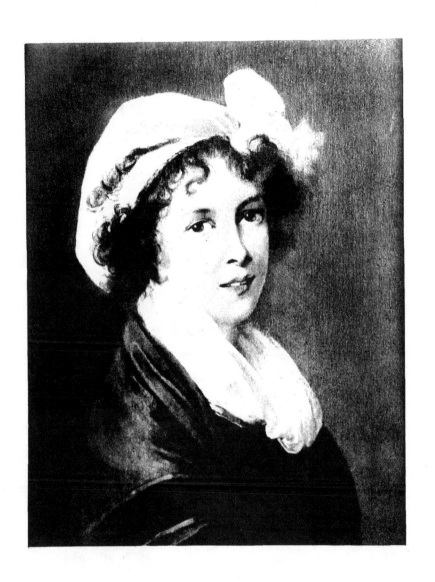

not a scandal-monger. She knew all the gossip of Baron de Breteuil, for example, who was at the head of the Government when the Bastille fell.

Recalling the last sitting that Marie Antoinette gave her for the big picture at Versailles, Madame says: "I remember that the Baron de Breteuil, then Minister, was present, and that, during the whole time of the sitting, he never ceased to talk scandal about all the women of the Court. He must have supposed that I was rather deaf or a particularly good person, if he did not fear that I should repeat some of his wicked stories to the people most concerned. As a matter of fact, I have never repeated a single one, although I have not forgotten any of them."

Here we have the chief reason for the "dullness" of which many readers of Vigée-Lebrun's *Souvenirs* complain. The Baron de Breteuil himself must have omitted most of these scandals from his memoirs, but she left them all out of hers. There is nothing more creditable in her history than that she kept for ever locked in her memory nearly every tale that could have damaged the reputation of any one of her contemporaries. This fact alone would be sufficient to establish that, whatever her merits or defects, she was a woman of admirable instincts. When we think of the reminiscences she could have written, and those she did produce, we can measure the detestation in which scandal was held by one who herself had suffered so much from its poison.

As soon as she had recovered from the immediate shock of finding the Paris of her youth so changed, she began to resume her old way of life. She went out to evening parties, she gave suppers herself, with music as of old. Still looking out with an artist's eye for lovely women, she enjoyed the sight of such beauties as Madame de Canisy, who was "made like a model," Madame de Bassano, who was very proud but very pretty, and Madame Tallien, in whose appearance the artist sought vainly for a single defect. "She was at once beautiful and pretty; for the regularity of her features did not detract from that which is called the physiognomy. Her smile, her look, had something ravishing in them, and her figure, her arms, her shoulders, were admirable." Madame Lebrun goes on to say that this new acquaintance of hers "joined to her beauty an excellent heart; it is well known that during the Revolution a crowd of victims, condemned to death, owed their safety to the empire that she had over Tallien, and that such unfortunate people called her *notre dame de bon secours.*"

This account of Madame Tallien would alone show how over-favourable

is the impression often given by Madame Lebrun through her habit of suppressing all the evil and telling only the good of those who were amiable to herself. Nearly all that she tells us of Madame Tallien is true, for it is certain from many contemporary accounts that this much-married woman was at least as lovely as ever was Lady Hamilton, and far more cultivated in her manners and movements. It is also certain that Madame Tallien secured the release of various prisoners, but it has been lately shown, in a new account of her life and character, that she probably sold her interest at a high price.

CHAPTER XXII

IN ENGLAND, 1802–5

BEING still depressed, and hoping to cheer herself up again by fresh changes of scene and life, Madame Lebrun determined, in the early spring of 1802, to cross the Channel. Some years before, whilst she was in Rome, just after the outbreak of the Revolution, the Paris papers had given as news that she had gone to London, in order, as she says, "to make people think that I had followed M. de Calonne," just as, a year or two earlier still, it had been put about that she had gone to Italy " to rejoin M. de Vaudreuil," her enemies never allowing her to go anywhere unless one of her alleged lovers had led the way. She had never seen London, and curiosity, coupled with the desire for fresh conquests in her profession, was enough to draw her thither. " I did not know a word of English. It is true I took with me an English maid, but this girl had not been much use to me before, and I was obliged to discharge her soon after I reached London, because she did nothing all day but eat bread-and-butter. Happily I also took with me a charming person, to whom misfortune rendered the security of my house, where she lived as my friend, very welcome. This was my good Adelaide, whose attention and advice have always been so useful to me." After crossing the Channel for the first time, Madame was rather frightened, on landing at Dover, to see a crowd of people on the pier. She was set at rest on this matter by

141

some more experienced seafarer, who informed her that these people were there merely out of curiosity, to see the passengers land from the packet-boats. That crowd still frequents the harbour at Dover, but the spectacle which attracts it is perhaps less remarkable in our days of turbine steamers and lightning passages than it was in the years when the sailing-boats, with their stuffy and comfortless cabins, frequently took seven or eight hours to buffet and tack their way across the narrow strait. Madame does not tell us whether or not she was a good sailor. Probably she was, or more probably she had a calm and pleasant voyage, or else she would have recorded the disagreeable incidents. It is surprising that the smells of the bilge-water, the tarry cordage, and the strong tobacco chewed by the crew did not draw from her one single paragraph of disgust.

Evening was drawing in when, on an April day, the artist set foot on Kentish ground. She hired a three-horse chaise, and set off as soon as possible, having been warned by some person, kindly or otherwise, that she might very possibly be stopped by highwaymen on that famous Dover road. She had taken the precaution of putting her diamonds in her stockings, and was glad of it when she saw two horsemen approach at a gallop and come up one on each side of the chaise. But they went on without saying or doing anything more alarming !

On arriving that night in London, she went to the Hôtel Brunet, in Leicester Square, the position of which hostelry seems to be lost to remembrance.

(In passing, it may be noted that the Hôtel de Provence, formerly known as Hôtel de Sablonnière et de Provence, at the Bear Street corner of the Square, was used by French émigrés during the Revolution, and it was there that Jean Gabriel Peltier, the author or editor of the *Dernier Tableau de Paris*, published that work in 1792.)

Of course Madame Lebrun had a bad night ; it was impossible for her to sleep well in a strange house, noise always attending on her rest in such cases. On this occasion she owed her wakefulness to an old acquaintance, " M. de Parseval de Grandmaison," as she characteristically names him, inserting before the Parseval a " particle " to which he had no title. He had the room above hers, and spent a great part of the night in walking about reciting his own verses in a very penetrating voice.

As at Rome, Florence, Moscow, and almost everywhere else, she went from lodging to lodging for some time before she got settled in London. From the hotel in Leicester Square she moved to Beak Street, where the

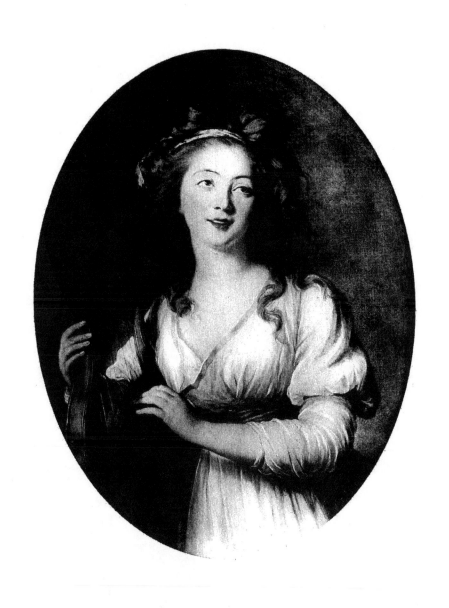

badly-played cornets of some cavalry, whose barracks were thereabouts, awoke her whenever she got to sleep. She moved next to a house in Portman Square, whence annoyances both of sound and imagination soon drove her away. These annoyances are so typical of the peculiar kinds of troubles that kept her moving on, that her own description of them must be given. On the first night in Portman Square, she went to bed in a room at the back of the house, where she expected to be free from all disturbing influences of sound or sight. She slept till daybreak, it would seem ; but when the light came there came also screechings which pierced her ears. "I got up, and looked out of the window, when, at the next window to mine, I saw the biggest bird I had ever seen. It was fastened to a large perch. Its look was furious, its beak and tail were of enormous length; indeed, I can affirm, without any exaggeration, that a big eagle would have looked like a little canary beside it. According to what was told, this horrible creature came from the East Indies. But whatever may have been its original home, I none the less wrote to its mistress to ask her to shift the bird over to the front of the house. That lady replied that it had been put there in the first instance, but that the police had ordered her to remove it because it frightened the passers-by.

"Being unable to get rid of the bird, I should perhaps have endured that torment ; but the house had been occupied before me by some Indian envoys, and I was told that these diplomatists had buried two of their slaves in the cellar. These corpses and the bird together were too much for me ; I left Portman Square, and went to live in Maddox Street, in some rooms which were frightfully damp. I stayed on there all the same, being weary of packing and unpacking."

This story of why the French artist left Portman Square may help the reader to understand some of the difficulties of writing her biography. However much of her *Souvenirs* may have been compiled by her friends, from notes of her spoken reminiscences, the passage quoted was surely either penned or dictated by herself. When she tells us, quite seriously, "affirming" the fact, "without any exaggeration," that on a perch in the next window to hers there was a bird beside which a great eagle would have looked like a small canary, we may ask ourselves whether the roc encountered by Sindbad the Sailor had been captured and sold to a lady in London, or, if not, whether Madame Lebrun may have been exaggerating a little, in spite of her affirmation to the contrary. The probability would seem to be that this "monstrous" bird which cried so loudly was a large

parrot. An ostrich, a rhea, or an emu sitting on a perch in a window off
Portman Square would be an almost incredible phenomenon. Yet what
other bird would even remotely comply with Madame's specifications as
to size ? Then, as to the buried slaves, it may be that the unnamed
person who came and told her the story of the envoys and their use of
the cellar as a sepulchre was, to speak metaphorically, " pulling her leg."

However large and fine a town London might be, Madame found it
less attractive than Paris, Rome, or Florence, " offering," as she puts it,
"less pasture for the curiosity of an artist." In those days there was no
National Gallery, no South Kensington Museum, or Tate Gallery, or Wallace
Collection, and the British Museum had not got beyond its early Montagu
House stage, when the archæological value of its treasures was out of all
proportion to the artistic. As soon as she was settled in Maddox Street,
she began to explore the sights of the town. Until she had made her
presence felt among the possessors of private collections there were few
pictures to be seen, so she went again and again to Westminster Abbey,
lingering often and long in the Poets' Corner. There, the memorial to
Chatterton made her reflect that the money spent on it would have been
better employed in relieving his necessities and saving him from suicide.

After the narrow and dirty streets of Paris, few of which in those days
had any " side-walks," she admired the comparatively wide and clean
thoroughfares of London, with their raised pavements. But she did not
admire—save in the older sense of the word—the spectacle, not infrequently
to be witnessed, of men fighting till the blood flowed from their faces.
Far from this sight seeming repugnant to those who watched it, they
treated the combatants to gin in order to encourage them to further
conflict, and to Madame Lebrun, who had travelled so far in Europe, it
was a frightful exhibition : " one might believe oneself in an age of barbarism
and extermination."

When the arrival of the painter of Marie Antoinette had become known
in the world of fashion, invitations came in plenty, and she had the melan-
choly satisfaction of seeing for herself what a " rout " was like. At one
of those evening parties an Englishman whom she had known in Italy
came up to her, and, " in the midst of the deep silence which always reigns
in these assemblies," asked her if such gatherings were not amusing.
" What is amusement to you would be boredom to us," was her reply.
She could not imagine what pleasure could be derived from stifling in a
crowd which was so congested that few of the guests were able to get near

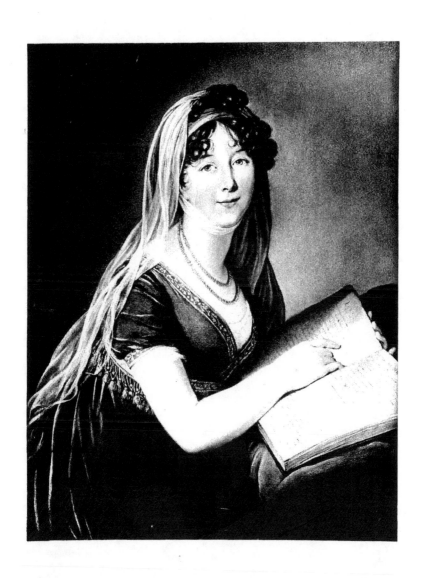

the hostess. Silence seems to have been as much the fashion in those days as is talk at the present time. In the Park the women walked together on one side, " all dressed in white, and their silence, their perfect calm, would make one think they were walking ghosts." The men on the other side were just as solemn. When, now and then, Vigée-Lebrun came behind a lady who, in rare instances, walked arm-in-arm with a man, she amused herself in listening whether they spoke to each other, and she declares that she never heard a word between such a pair. " Never," in common with all such words of unreserved generalisation, is specially to be mistrusted when used by Madame Lebrun. We are not, therefore, to suppose that white was the only wear among the ladies of Mayfair or Bloomsbury in the first years of the nineteenth century, or that, at evening parties or in afternoon promenades, no word was ever spoken except to or by the lady who thus records her impressions of London society.

In any case, she took care that silence did not reign at her own *soirées*. Although her rooms in Maddox Street were damp, they were commodious, and she recalls one specially successful evening, when those famous *prime donne*, the English soprano Madame Billington and the Italian contralto Madame Grassini, sang duets ; Viotti played the violin ; and the Prince of Wales (afterwards George IV) said to his hostess, " Je voltige dans toutes les soirées, mais, ici, je reste." Such a compliment was highly appreciated, we may be sure, by the lady to whom it was uttered. We are not told whether on these occasions Madame Billington tried to sing contralto and Madame Grassini soprano, as they sometimes did to the despair of the director of the Opera-house !

At that time the leader of fashion in London was the Duchess of Devonshire (*née* Spencer)—who, by the way, was almost certainly not the model for the portrait attributed to Gainsborough and probably painted by Lawrence, which attained so much notoriety some years ago, and which has given a name to a particular variety of the " Matinée hat." Madame's account of this famous beauty may be rather distressing to those who admire her from report or from portraits, but her reputation dates, of course, from the days when the Duke fell in love with her youthful figure, rosy cheeks, and the pair of soft eyes of which, in her middle age, one had lost its sight. Her features, says Madame, were very regular, but " she had too high a colour, and though she partly hid her blind eye under a bunch of curls, they could not dissimulate so serious a blemish." She was

10

rather tall, of a stoutness which in those times suited well with her age
(of forty-five), and "her easy manners were extremely gracious."

We get a glimpse of the Duchess as Whig politician, when she points
out Sir Francis Burdett to Madame Lebrun at a concert at Devonshire
House, and we hear of her support of Fox at the famous Westminster
Election. The public clamour in favour of Burdett made the French-
woman think that the Revolution had spread from France to England,
and the conduct and popularity of the Duchess of Devonshire suggested
to her that this social queen was a female equivalent, more or less, of
Philippe Egalité. "Not being a politician," she says, "I could not well
understand how this great lady, who seemed to be of the popular party,
was at the same time in the Prince of Wales' set. The fact is they were
closely allied—so much so that she allowed herself to give him lessons.
Finding myself one evening, at a party, with the Prince and the Duchess,
I reproached the Prince for having made me waste my time by his failure
to keep an appointment for a sitting. The Duchess seemed very pleased
by my freedom of speech, saying 'You are quite right—princes ought never
to break their promises.'"

The portrait on Vigée-Lebrun's easel when the Prince of Wales kept
her waiting in vain—like so many other ladies who were not painters—was
that which is reproduced in this volume. It was done about the beginning
of 1805, shortly before she returned to Paris. "I painted him," she records,
"nearly full length and in uniform. Several English painters were very
angry with me, when they heard that I had begun this portrait, and that
the Prince of Wales gave me as much time as I needed to finish it, because
for some years past they had in vain waited for such a favour. I knew
that the Queen said her son paid court to me, and came often to lunch
at my house. She repeated a lie, for the Prince never came in the morning
except for his sittings." Perhaps he came to the *soirées* for conversation
with a lady who was still handsome, and whose talk, after so much
experience of society in so many cities of Europe, was certainly worth
listening to. If the Prince "sat" in the mornings, and "paid court"
in the evenings, Queen Charlotte's second-hand "lie" was nearly as
white as the dresses of the women in Hyde Park.

George Prince of Wales was then about forty, but looked older, chiefly,
as the painter thought, because he was already too fat, or rather, in more
elegant French, *avait déjà pris trop d'embonpoint*. Thackeray would have
enjoyed her description of the Prince, of whom twenty years later he spoke

in his famous lecture on George IV. " Tall and well made," she writes,
" he had a handsome face; all his features were noble and regular. He
wore a wig most artfully arranged, the hair of which was separated upon
the forehead, like that of the Apollo Belvedere, a fashion which suited him
admirably. He was good in all bodily exercises, he spoke French very
well, and with perfect ease. He was fastidiously elegant, and his magnifi-
cence was prodigal, so that at one time, it was said, he owed three hundred
thousand pounds, which his father and Parliament at length paid for him.
As he was for a long time one of the handsomest men in the United
Kingdom, he was idolised by women." As soon as the portrait of the
Prince was finished, he gave it to Mrs. Fitzherbert. That lady had it
mounted in a frame on wheels, like the big mirrors in milliners' show-
rooms, so that she could have it moved from one room to another.

The anger of the courtly painters of England at the favour accorded
to a French artist by " Prince Florizel" did not stop at talk. One of
them published a book in which he attacked French art in general, and
Madame Lebrun's in particular. The nasty bits were, of course, translated
to her by friends, and she wrote to the author a long letter in which, not
unskilfully or unwisely, she defended her country's painters, who, on the
whole, understood the arrangement of draperies, if perhaps nothing else,
better than the English did. She also, while admitting her own deficiencies,
refused to admit the merit which her English critic declared to be her only
one,—patience. That, she said, was unhappily a virtue foreign to her
character. At the same time she admitted that she could not easily leave
her works, "thinking them never sufficiently finished." Her pictures
were not of that sort of which Whistler declared that " a work of art is
always finished."

Madame Lebrun's portrait of the Prince, who shared with the Comte
d'Artois the title " First Gentleman in Europe," was not painted till near
the end of the artist's stay in England, and a chance reference to its pro-
duction has led us rather far out of the chronological path. She herself,
in her *Souvenirs*, may show an agreeable disregard for the proper sequence
of incidents, but one who tries to tell her story, with more regard for
accuracy, must not mix up the years quite so freely as she, in old age,
naturally and pardonably mixed them.

Like so many foreign visitors, up to the present day, Madame Lebrun
found the London Sunday " as *triste* as the climate." She declares that
one could not sing or play the piano without running the risk of having

the windows broken by the indignant populace. Probably she had not tried the effect of playing and singing the hymns of Dr. Watts, which might have softened the resentment of the people in the street. She turned Sunday to account by making it the only day on which she allowed visitors to see her pictures. Other days, when she was in London, were given up to work.

Not all her time, of course, even on weekdays, was spent at the easel. She went to see new friends, and she saw the pictures of many painters of the day, the first whom she visited being Benjamin West, whose powers of composition appeared to her to be very considerable. Of Reynolds, already dead ten years when she went to London, she tells an anecdote in her own praise. " When my portrait of M. de Calonne arrived at the London Custom-house, Reynolds, having heard in advance of its coming, went to see it, and this is what I was told by some one who was present. After the packing-case had been opened, he looked at the picture for some time, and spoke highly of it, upon which a silly fellow, repeating the stupid calumny about it, said, ' This portrait ought to be good, for Madame Lebrun received eighty thousand francs for it.' ' Well,' answered Reynolds, ' if any one would give me a hundred thousand, I could not do as good a one.' " Possibly such an incident really happened. Anyhow it is quite in accord with many similar stories about portrait-painters.

One of the persons with whom Madame renewed acquaintance in London was Lady Hamilton, whose portrait as a Sibyl had been so useful (as a sample of the artist's work) at Vienna and other European cities. In the year after Vigée-Lebrun's arrival in England Sir William Hamilton died, and we have in the *Souvenirs* an account of his widow which is so much in keeping with other contemporary evidence that we may accept it as being true in general, if, like others of Madame's reminiscences, not over-precise in its observance of " the unities." Lady Hamilton came one day to Maddox Street, " wearing the deepest mourning. An immense black veil surrounded her, and she had had her beautiful hair cut short in order to have her head dressed *à la Titus*, according to the fashion of the day. I found this Andromache huge, for she had become dreadfully stout. She said to me, with tears in her eyes, that she was deeply to be pitied ; that she had lost in Sir William a friend, a father, and that she would never be able to console herself. I admit that her grief made little impression on me ; for I fancied I could see that she was acting a part. How little I deceived myself was shown a few minutes later when, having seen some

GEORGE, PRINCE OF WALES, AFTERWARDS GEORGE IV.
(The Dowager Countess of Portarlington)

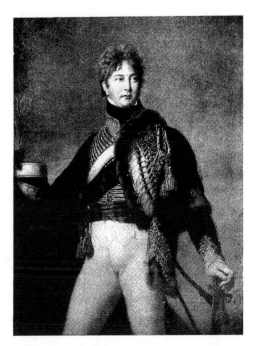

THE PRINCE OF WALES, AFTERWARDS GEORGE IV, 1805

pieces of music on my piano, she began to sing one of the airs which she found there.

"It is well known that Lord Nelson, when at Naples, had become very much in love with her ; she had continued a very tender correspondence with him ; when I went to see her one morning in London, I found her radiant with happiness ; more than that, she had put a rose in her hair, like Nina [in the French play of that name: *v.* picture at page 57]. I could not help asking her what this rose implied. ' It means that I have just had a letter from Lord Nelson,' she answered."

Most readers will have heard of the " attitudes " of Lady Hamilton, and perhaps have seen the prints illustrating these famous poses. Some may have seen a remarkable work by Gainsborough at Windsor, or his preliminary sketch for the picture, representing a number of nymphs bathing in a stream, each in a different attitude, but for all of which, there is reason to believe, Emma Hart " sat " in those days of her greatest beauty, when she was a chief delight of the eyes of two of the greatest of English painters. The " attitudes " shown in this picture, however, are of physical grace, those shown in Madame Lebrun's drawing-room represented moral emotions.

Two of Madame Lebrun's princely acquaintances—the Duc de Berry and the Duc de Bourbon—were very anxious to see the famous beauty display these "attitudes," which she was rather shy of doing in London. However, at the earnest solicitation of the French artist, Lady Hamilton consented to give her " show " in the Maddox Street drawing-room, and a small party of French people was invited to meet the Princes and to see the performance.

" The appointed evening having arrived, I placed in the middle of the room a very large frame, with a screen on either side of it. I had ordered a huge wax candle, which gave a very strong light, and I put it so that, while it could not be seen, its rays fell on Lady Hamilton as one lights up a picture. All the guests having arrived, she took in the frame various attitudes, with truly admirable expressiveness. She had brought with her a little girl of seven or eight years old, who bore a strong resemblance to her. I was even told the child was a daughter of Madame Nelson. She posed this child with her, and reminded me of the fleeing women in Poussin's picture of the ' Rape of the Sabines.' She passed from misery to joy, from joy to terror, so well and so quickly that we were all delighted with her.

"I had asked her to stay to supper, and the Duc de Bourbon, who sat next to me, drew my attention to the quantity of porter she drank. She was evidently quite accustomed to it, for she was not intoxicated after two or three bottles."

Readers who have seen Gillray's satirical drawing (1801) called "Dido in Despair" will be reminded of the enormous bulk that that ruthless caricaturist gives to Lady Hamilton, the flask of maraschino on the dressing-table, and the book called *Studies of Academic Attitudes*, which lies near the window.

The *triste* climate of London so little suited Madame Lebrun's health that she accepted many invitations to pass weeks and fortnights in the country. One of the first of such visits was at Gillwell, the home of the Chinnery family. Certainly her reception there was flattering to her vanity—more flattering than that prepared by her husband on her return to Paris after the Revolution. The classical porch was adorned with garlands of flowers twined round the columns, garlands were hung on the staircase, and the little marble cupids, which presumably formed part of the permanent decoration, carried their vases full of roses. When the French visitor entered the drawing-room, "two little angels," the son and daughter of Mrs. Chinnery, sang a pretty little song which Viotti, who was staying in the house, had composed for the occasion of his friend's coming. She enjoyed herself greatly at Gillwell, and her love of music was gratified in the evenings by the violin-playing of Viotti, and the amateur but capable performances on the piano of Mrs. Chinnery and her daughter of fourteen. The mother herself was good-looking, as may be seen by her portrait.

Another of the country visits was to Knole, where the Duchess of Dorset (widow of John Frederick Sackville, the fourth Duke, and wife of Lord Whitworth) was her hostess. She did not come to Knole quite a stranger, for she had known Lord Whitworth in St. Petersburg, where, during much of the time of her residence in Russia, he had represented his country at the Court of Catherine II. The atmosphere of Knole, so delightful to lovers of the past, did not appeal very strongly to her. Except in a fancy for simplicity of dress, and for her notorious "supper after the manner of the ancients," she was not much addicted to the study of antiquity outside the immediate range of her art.

She declares that she should think it unkind to compel anybody to live in so gloomy a house ("*on se ferait conscience d'y placer quelqu'un*"),

a remark which suggests how much the taciturnity of the châtelaine of those days must have affected the spirits of a lively visitor. When the Duchess warned her that there was never any conversation at the dinner-table, Madame Lebrun replied that it was so at her own table, as she had dined alone for years past! But at Knole this imitation of the monks of the Grande Chartreuse was evidently carried too far for their countrywoman. The Duchess of Dorset maintained almost absolute silence at table, and even when her son, then a boy of about ten, came in for dessert, she scarcely said a word to him—which seemed strange conduct to her guest, who found in it a proof of a saying that the English women only loved their little children, and hardly cared for them when they grew big. The portrait of the Duchess which Madame Lebrun painted, and which hangs to-day in the ball-room at Knole, is a very pleasing example of her work, and the fact that Hoppner's fine portrait of the same lady hangs in the same house helps us to test its value as a likeness. We may still believe in her general veracity as a portrait-painter after making the comparison thus offered.

Knole, both within and without, was in many ways much as it is to-day in the time when, at the beginning of the last century, Vigée-Lebrun stayed there. The " very beautiful pictures," the " furniture of the Elizabethan age," and the " dressing-table of solid silver," of which she writes, are still there; and outside in the park the two great trees which " they told me were more than a thousand years old " are yet alive. It is true that one is a beech and the other an oak, whereas Madame calls them both elms, but such is her way. Knole itself she calls " Knowles"; and to Lord Whitworth's name she can get no nearer than " Wilfort." Small blame attaches to her for such inaccuracies. We laugh sometimes at the forms in which English names appear in French books and newspapers, but it is doubtful whether there is much to choose between ourselves and our neighbours in such little errors.

A good deal of her spare time was passed in and about Twickenham, then, as for nearly a century after, the English Bourbonnais, where exiled princes of the royal family of France found homes amid the leafy gardens of the Thames valley. Her friend of so many years, the charming Comte de Vaudreuil, had found there, near to his beloved Comte d'Artois, a home for the young wife whom he had married in England. Madame Lebrun says that this wife was also the niece of the Comte. As a fact, she was the daughter of his first cousin, the Marquis de Vaudreuil.

Whilst staying at Twickenham with Madame de Vaudreuil (who had

" very beautiful blue eyes, a charming face, and the greatest freshness of complexion "), Vigée-Lebrun painted the portraits of her two little boys.

The Comte de Vaudreuil took her to pay a visit to the Duc d'Orléans, who, with his two brothers, the Ducs de Montpensier and de Beaujolais, was living close by. The Duc d'Orléans was Louis Philippe, later on to be the "Bourgeois King" of the French; and the father of these three young men was Philippe Egalité, who, after assisting to start the Revolution, had himself fallen a victim to the Revolutionary Tribunal in 1793. Their unhappy and admirable mother was wandering in the south of Europe. The Duc de Montpensier (then just under thirty, and destined to die at Twickenham in his thirty-second year) had become familiar with all the walks in the neighbourhood, and he was fond of going out to sketch with Madame Lebrun. He it was who took her up Richmond Hill, and showed her the famous view which, not many summers later, when the inhabitants celebrated a birthday of the Prince of Wales, was the subject of a big picture by Turner. In the very year of Vigée-Lebrun's arrival in London Turner became a Royal Academician. She does not mention him in her *Souvenirs*, and it is very likely the two artists never met, for Turner's was not at all a familiar figure in the wealthy homes where the French portrait-painter was most likely to be encountered.

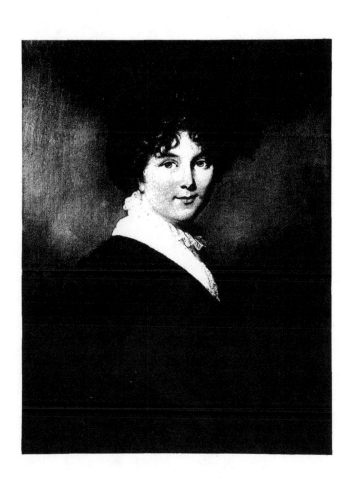

CHAPTER XXIII

ENGLISH FRIENDS

Lady Craven, Margravine of Anspach—Evil effects of "cookery and coaches" on the nobility —A trip to the Isle of Wight—Visits to Stowe and Donnington—No talking after dinner at Lord Moira's house—Windsor Park—Hampton Court—Bath and its amusements— Vigée-Lebrun might have painted Jane Austen—A visit to the Herschells—Recalled to Paris—Difficulties of getting there—Madame Grassini's forethought

A S we have seen, and as is usually the case with portrait-painters, many of Madame Lebrun's sitters became her friends, in whatever country she happened to be. Such an one in England was the Margravine of Anspach, better known, perhaps, to English readers as Lady Craven, one of the most freely "talked-about" women of her period. Born in 1750, a daughter of the fourth Earl of Berkeley, married at seventeen to Mr. (afterwards Lord) Craven, she had separated from her husband (after fourteen years, when seven children had been born of the marriage), taking away with her the third of her sons, Keppel, then an infant. She wandered about Europe, living for some years at the little court of Anspach as the intimate friend of the Margrave, and at length, after the deaths of his wife and of her own husband, married His Serene Highness, who proceeded to sell his territorial rights to the King of Prussia, and came with his new wife to live in England till his death in 1806. She had been in Paris in 1785, and probably met Madame Lebrun at that time. These two women had several qualities and tastes in common. Both were attractive and quick-witted, both were very fond of acting themselves and of seeing others act, and both stored up memories of remarkable people and incidents, for publication in books in the closing years of their lives. They had some strong contrasts in character also. While Madame Lebrun objected greatly to discomfort and to "roughing it" in general, and was not averse from excellent dinners, the Margravine was of opinion that "cookery and coaches" had "reduced the English nobility to a languid state," and held that "too great indulgence in the Fine Arts" was

responsible for the waste of "time which ought to be employed in the important duties of life." She was much given to reflection, and in 1790 had published *La Philosophe Moderne*, having already, four years before, brought out an account of her travels through the Crimea to Constantinople, a book which was very popular in its time. It may be mentioned here that, according to her statement, a more famous book on European travel to Constantinople and elsewhere, issued twenty-three years before her own, Lady Mary Wortley Montagu's *Letters*, was not really the work of the avowed author. The Margravine declared that Lady Bute (Lady Mary's daughter) told her "that Horace Walpole and two other wits joined to divert themselves at the expense of the credulity of the public by composing these letters." The value of this statement may be judged from the fact that it has never been regarded seriously, or as anything but an example of the Margravine's strong imagination, in spite of her defiance of her most bitter enemies to say that she was "ever guilty of a falsehood."

Madame Lebrun's first visit to this imaginative lady was at a country-house near London which she calls "Armesmott." It has not required any very exhausting research to discover that this curious-looking word is the nearest that Madame Lebrun could get, relying on her memory after thirty years, to Hammersmith! At that riverside village, then quite out of town, the Margrave had bought a place which he called "Brandenburgh House," and there many parties for theatricals were given. Such an entertainment was announced for May 23, 1804, in the "Fashionable Arrangements" column of the *Morning Post*, and Madame Lebrun was no doubt invited on that occasion.

Another seat of the Margrave's was Benham House, not far from Newbury, which had been purchased from the Margravine's eldest son, Lord Craven. It was a much finer and more attractive property than that at "Armesmott," and the guests were entertained there in much more spirited fashion than in most English country houses in those days. Madame Lebrun enjoyed herself so much that, going for one week, she remained three.

The Margravine's reputation for eccentricity made the artist hesitate about accepting her first invitation to paint her portrait at Brandenburgh House. It was said that she was so excitable that her visitors were roused up at five in the morning, and could scarcely get a minute's peace all day. Madame Lebrun made her visit conditional on being allowed to finish her sleep, and to go for quiet walks alone when so disposed. "The

excellent woman consented to all, and religiously kept faith with me, to such a point that if, by chance, I encountered her in her grounds, where she often used to work as hard as any gardener, she pretended not to see me, and let me pass without saying a word." The Margravine spent part of the year somewhere on the South Coast, and on one occasion she took her friend across to the Isle of Wight, which Madame Lebrun describes as " elevated upon a rock, and reminding one of Switzerland." The island, she was told, was renowned for the pleasant and quiet manners of its inhabitants, who lived like one family, enjoying perfect peace and happiness. She noticed that all these happy islanders were well dressed, had a kindly appearance, and " did not seem to be tainted by the immoral contagion of the great towns." Apart from the human amenities of the Isle of Wight, Madame found its hills and valleys and shores so ravishing, that she wished she could live there always. It, and Ischia, in the Bay of Naples, were the only islands, she says, that ever gave her such a desire. Having merely landed for a few hours at Ryde or Cowes, as it would seem, Madame had not time or opportunity to observe that a principal industry of the people on the far side of the Isle of Wight in those days was smuggling, or she might have supposed that the gentle manners of these happy islanders were partly due to the frequent intercourse of the men-folk with her own compatriots.

It is evident that, whatever may have been the Margravine's eccentricities, Madame Lebrun enjoyed herself more at Hammersmith and at Benham than in most of the great houses to which she was invited in this country. She stayed at Stowe with the Marquis and Marchioness of Buckingham, who had shown such generous hospitality to the French aristocrats of the emigration, and she duly admired the temples, statues and other works of art within and without that famous house.

We have heard how at Knole conversation was prohibited during dinner. At Donnington Castle, the country-house of that highly distinguished and adventurous soldier Lord Moira, Madame found that no talking was allowed after dinner, which she evidently regarded as a much more severe regulation. The company, when they met together to finish the evening, were collected in a fine gallery, where the ladies sat apart, doing fancy needlework, embroidery or tapestry, without speaking a word. The men, on their side of the room, took up books, and were equally silent. The splendid library contained collections of prints, and Madame's only resource was to fetch portfolios of these prints and to look through them,

taking care to hold her tongue like the rest of the company. One evening, in the midst of this perfect silence, she forgot that there were other people present, and made an exclamation of delight at the sight of a beautiful engraving. Such a breach of propriety "surprised them to the last degree."

In spite of this love of holding their tongues, so strange to a lady whose life had been passed in the more lively social circles of the Continent, she did not regard the English as being wanting in conversational charm, and goes so far as to say that she had not met a single dolt during her three years' sojourn in England! We must remember, in estimating the value of this astonishing tribute, that the lady who offers it could not understand our language, and that in those days nearly all the people who spoke French with facility were well educated according to the standard of the age, and possessed at least the outward graces of social life.

At Windsor, the park was the only thing that pleased her eyes; she does not say whether she saw the inside of the castle, which in those days was perhaps not much less *triste* than Knole had seemed to her. Fanny Burney had certainly found life dull enough there ten years earlier. Vigée-Lebrun was greatly interested in the Raphael cartoons, then at Hampton Court, and also in the great vine. She visited "Tumbridge-Well," where the "assemblies" bored her terribly, and Matlock, whose scenery, according to her favourite comparison, reminded her of Switzerland, of the character of which country she had seen something on her way from France into Italy, though she had not as yet been within its borders.

At Brighton she proved that her powers of vision were unusually strong, for she assures us that "you can see the French coast" from there. Her visit to that favourite watering-place (the Prince of Wales had already built his soul an oriental dwelling-house there) was at a time when the Martello towers were being erected along the south coast to keep Napoleon out of England, and she recalls that "the (English) generals never ceased reviewing the national guard, which was continually in movement, beating the drum, and making an infernal noise" (*bruit d'enfer*).

At that period the most fashionable place in England, outside the capital, was Bath, and thither, in February 1803, Madame Lebrun went. She had been assured by habitués of the Bath season that there was nowhere in our country where one could have a better time—that it was indeed the very *monde où l'on s'amuse* if ever such a world existed. On the strength of such assurances, she expected, as she wrote to her brother

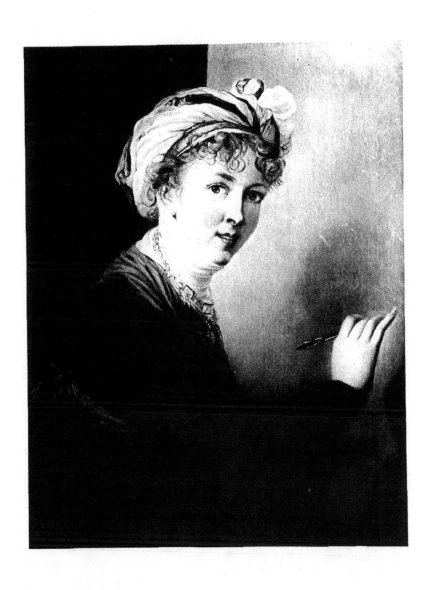

in Paris, "to find there the delights of Capua." Alas ! she found nothing
much to her taste in the amusements procurable at that famous city,
except on the "mountains" surrounding it, which she liked to climb in
the mornings. Even that "delight" was usually denied to her, as it was
nearly always raining. She thought the principal architectural features
of Bath in rather poor taste, but admired the general appearance of the
town from a distance, whence, she declares, "the effect is immense."
Even in the streets and squares she "fancied herself in a town of the
ancient Romans," and whatever the "taste" of the buildings that cover
the slopes of Lansdown Hill, she admits that Bath is "undoubtedly the
most beautiful town in the kingdom." The air was delicious to her, if the
people pleased her not. For the public entertainments the "Upper Room"
and the Pump Room were either crowded to suffocation or nearly empty,
and the behaviour of some of the company seemed very disagreeable.
Of one of the suppers after a concert, for instance, to which Madame
went with her friend Madame de Beaurepaire, she writes to Etienne Vigée :
"We took our places next to some very old and very ugly Englishwomen.
I reasonably supposed that they were of the number of those who never
leave their own provincial district, where they preserve *la morgue gothique* ;
for the *grandes dames* of London and the Englishwomen who have travelled
are agreeable and well-mannered, whilst our neighbours on this occasion,
as soon as we were seated, turned their backs on us with a certain air of
contempt. We had resigned ourselves to support the disdain of these
old women, when an Englishman who knew them came up, and said
something very quietly to them, which made them turn towards us at once
and show us more civility." It is not difficult to imagine what the magic
words were. "That French lady next you is Madame Vigée-Lebrun, the
famous portrait-painter," was probably very nearly the remark that turned
those heads from one side to another.

It must again and always be remembered, in hearing Madame Lebrun's
criticisms on her experiences in this country, that she did not know the
language. Of course the plays, and routs, and Pump-room life of Bath
were dull to her, after her first curiosity of vision had been satisfied. She
stayed for three weeks in the town, mostly occupied indoors, waiting for
the rain to stop ! The air was autumnal, she never felt cold, and there was
foliage on many of the trees, "which prolongs the *belle saison*, and gives
us the illusion of fine weather."

In that year, 1803, Jane Austen was at Bath, living with her family

in Sydney Place, gathering material for those descriptions of the town and its life which add so much to the attractions of *Northanger Abbey* and *Persuasion*. There is no evidence of her absence from Bath in that year, except in the summer, when she seems to have been at Ramsgate; and we may be fairly confident that at one or more of the public gatherings at which the French artist with difficulty restrained her yawns, the English novelist was taking mental notes of the ways of some of the very people who gave so poor an impression of English manners to their foreign observer.

Few people in those days knew that Miss Austen was writing fiction, and none of her novels had been published, so that she was not a " celebrity " in any way. Had she been one, she would probably have declined to be introduced to this distinguished Frenchwoman for the same reason that, years later, she refused an invitation to meet and converse with another distinguished Frenchwoman, a friend of Vigée-Lebrun, Madame de Staël. "To her truly delicate mind," says Miss Austen's brother, "such a display would have given pain instead of pleasure." But what a chance was missed by the guardian angels of literature and of painting when they allowed Elisabeth Vigée-Lebrun and Jane Austen to be in the same town together without the French artist painting a portrait of the English novelist! Such a picture, if as well painted as any of the known works done by Madame Lebrun in England, would have been, for many people, the most valuable production of her brushes and palette. As it is, it does not seem that there was any pictorial result of Vigée-Lebrun's three weeks in the city of Bladud.

During a short visit to Warwick Castle, where of course Lord Warwick showed her the famous vase, Madame Lebrun saw upon the piano two little drawings which had a curious history. During her acquaintanceship at Naples with Sir William Hamilton and his beautiful companion she had made some charcoal sketches on the doors of a summer-house which they used. These it was that she now recognised in a drawing-room at Warwick Castle. Her host explained to her that he had bought them at a very high price from Sir William, to whom they had not been sold by the artist. This was quite in accord with Hamilton's conduct, as described several times by Madame Lebrun. He made money by the sale of portraits of his wife whenever a good opportunity occurred. So notorious were his money-making ways that the son of the French ambassador at Naples (a member of the Talleyrand family), hearing Hamilton described as a

protector of the arts, remarked, "Say, rather, that the arts protect him."

During her stay in London, Madame went one day, with Prince Bariatinsky and some other friends, to see the elder Herschell. "The doctor received us with the most obliging cordiality; he was good enough to show us the sun through a smoked glass, pointing out to us the two spots that had been discovered on it, one of which was of considerable extent. Then, in the evening, he showed us the planet which he had discovered, and which bears his name; we also saw in his house a large map of the moon full of detail, whereon mountains, ravines, and rivers, which make this planet resemble our own world, are shown. Indeed, there was not a moment of ennui all the time we were there;" and therefore Madame avoided for so many hours that which she dreaded above all else in human experience—being bored! Probably it really was the "Georgium Sidus" that the astronomer showed through his telescope, and not, as related in a well-known anecdote about a visit of Queen Charlotte to that telescope, an ingenious arrangement of a lamp and a piece of cardboard!

The general sympathy for the Bourbons and their adherents felt by those classes of English society in which she lived during her stay on this side of the Channel was naturally very agreeable to "the painter of Marie Antoinette." It was never more strongly exhibited than on the receipt in London of the news of the killing of the Duc d'Enghien, in March 1804. She was at the theatre when this news arrived; it was soon passed round the house. "All the women who filled the boxes turned their backs to the stage, and the play would not have been finished if immediately after some one had not come to say that the report was unfounded. Every one went back to his seat, and the play was continued to the end; but on our leaving the theatre, all, alas! was found to be true. . . . I can bear witness to the effect which this assassination produced upon all the English people; the horror which it inspired was general."

Many of the French exiles made part of Madame's social existence whilst she was here, and from English acquaintances, who often became friends, she received more invitations than she could possibly accept. Altogether, in spite of our fogs, which, she says, prevented her from ever having a good view of London from Hampstead or Richmond Hills, she enjoyed herself so much that she would have stayed longer but for letters which told her that her daughter had arrived in Paris, and had been

allowed by M. Lebrun to become intimate with some persons whose society was not at all suitable for a young woman. From the little we know of Julie Nigris she was capable of choosing her friends without any help from her father or mother, and it is possible that Madame's long cessation of all relations with Monsieur may have made her a little unjust to his paternal sensibility and prudence in this particular.

Napoleon had shown himself so disagreeable with regard to the release of English travellers unfortunate enough to be in France when the Peace of Amiens was broken, in 1803, that one of Madame's English acquaintances, perhaps half seriously, declared that she ought now to be retained as a hostage! As it was, she had some trouble about her passport, though the French Foreign Office, of which Talleyrand was then the chief, does not seem to have been as much against her return as she supposed. At length, in the summer of 1805, she took her passage in a Rotterdam packet, the Channel routes being practically closed to travellers at that time, when the long war between England and France was already two years old. The hours of departure for the Continental packets in those days were so uncertain, owing to dependence on wind as well as tide, that it was needful to stay somewhere close to the vessel, if not to go aboard of it, hours, and sometimes days, before the voyage began. Madame Grassini, who had made several voyages between England and the Continent, showed herself thoughtful for her French friend at this time. When Madame Lebrun was to leave Maddox Street for wherever below London Bridge the ship lay, and the post-chaise was actually at the door, the young Italian prima donna arrived. Madame Lebrun supposed that her friend had come to wish her good-bye, but it was really to see her comfortably on her way. Madame Grassini made the departing traveller come in her own carriage, which was half-filled with pillows and packages of provisions. When Madame Lebrun expressed her surprise at these accessories, her friend said, out of the fullness of experience, " You do not know, then, that you are going to the most detestable inn in the world, where you may have to stay for a whole week or more if the wind is unfavourable, and I am going to stay there with you."

We need not wonder when Madame says: " I cannot express how much I was touched by this mark of interest. This lovely woman left the pleasures of London, and her friends (to say nothing of the crowd of adorers always about her there), simply to keep me company."

The Signora Grassini had been reaping one of her many fine harvests

during that season of Opera at the King's Theatre in London. Her chief triumphs had been on successive Saturday nights in the once popular opera of *Gl' Orrazzi e Curiazzi*. The chief feature of the performance was a duet between Grassini and Braham, in which these two young singers (they were both thirty-two) " brought down the house." Grassini's exceptional charm, both physical and social, made her, apart from her beautiful voice and dramatic ability, welcome wherever she appeared, and Madame Lebrun might fairly regard the incident recalled above as a notable example of real friendship towards a fellow artist in a different field.

The London which Madame Lebrun (the only French artist of distinction who visited England during the Revolution) now left, never to return, was, so far as she was concerned, a well-to-do, busy place, whose inhabitants were mainly occupied with routs, balls, concerts, plays, and operas. The "West End" spread far into Bloomsbury then, and Belgravia was still in the country. The " talk of the town " in that season had been the performances of Master Betty, " the Infant Roscius," that remarkable boy of thirteen who was for a time a formidable rival to the full-grown actors, headed by Mrs. Siddons, whose work that year was much interfered with by the rheumatism from which she suffered so severely. Mrs. Siddons had been friendly to Madame Lebrun, who recalls the beauty of her voice, as well as her splendid talent as an actress. The two women, by the way, were born in the same year.

Of the English friends whom Vigée-Lebrun now left behind her, Lady Mary Bentinck (who at her house in Piccadilly risked the stones of the Puritans by giving Sunday evening concerts and supper parties) seems to have been one of the most intimate, and an Irish friend, whom Madame was frequently to meet later in Paris, was Lord Trimlestown, a connoisseur in art and literature.

II

CHAPTER XXIV

PARIS AGAIN, 1805

MADAME LEBRUN had left Paris under the Consulate ; she returned under the Empire. Bonaparte, as Baron de Frénilly said, had " set out by way of the Rue Saint Honoré as First Consul, and returned as Emperor by the Boulevards, the side-walks of which were very prettily illuminated. . . . The procession was a mere masquerade, in which all the participants had donned their costumes for trial, and for which no one had yet studied a *rôle*. . . . This saturnalia was a subject for either laughter or tears, according to individual taste and character." We may be sure that in the eyes of Madame Lebrun, the spectacle of any one but a Bourbon wearing an Imperial Crown in France would have been but a sorry farce.

The pleasure of meeting Julie again, after several years' separation, was very great for Madame Lebrun, in spite of all that had happened to estrange the mother and child, and there was no longer any cause to be jealous of M. Nigris. He had brought his young wife to Paris at this time, where he had been entrusted with the task of engaging artistes for the Imperial Theatre at St. Petersburg. When he returned home, a few months later, he left her behind, to her mother's great satisfaction, for there had long ceased to be any question of love between the married pair—if, indeed, it had survived the honeymoon.

If the last friend to say adieu to Madame Lebrun in London had been the young and lovely Italian singer Grassini, the first new acquaintance that she made in Paris on her return from England was the younger and not much less beautiful Italian singer Catalani, then only twenty years

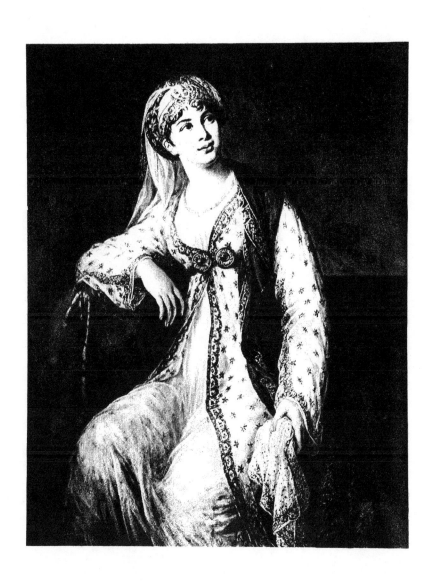

old, and destined to make a rather deeper mark in musical history than Grassini, although, according to Madame Lebrun, "she had not the expression which charmed in Madame Grassini ; she delighted after the manner of the nightingale."

True to her instincts of hostess and music-lover, Madame Lebrun seized so good an opportunity for re-starting her musical evenings, and Madame Catalani was ready to fall in with her new friend's wishes, and to sing at these pleasant *soirées*, thereby ensuring their success. In the old days of the Rue du Gros-Chenet the music had been chiefly instrumental, but Viotti, the first violin of Madame Lebrun's concerts before the Revolution, had not yet settled again in Paris, and Lafont (a distinguished pupil of Kreutzer), who came to the "evenings" later on, was not available at the start. So for the time being vocal music held the field, with Catalani as the principal singer. But Madame Lebrun and her friends, old or new, could not sing or listen to singing all the time, and so, to vary the pleasure, she remembered the success of the tableaux-vivants at St. Petersburg. Having provided a transparent gauze curtain, she brought out her box of costumes and, with the help of some of her guests, presented various charming pictures to the rest of the company. She tells us that she took care that only "handsome men and pretty women" should take part in these tableaux. If she managed to draw so fine a line between the plain and the beautiful without offending some of the spectators she must indeed have been endowed with a rare discretion.

Another evening was enlivened in a manner that is not unknown in Paris or London in our own days. Madame drew upon a screen several heads of historic personages, men or women, cutting holes where the faces ought to be, and leaving who would among her guests to fill the gaps with their own faces. Hubert Robert, who still, at seventy-two, was as keen on such games as any schoolboy, made everybody laugh consumedly by appearing as Ninon de l'Enclos.

In recalling these innocent diversions Madame feels that serious people will regard them as puerile in the age of Louis Philippe and William IV, when "people pass their evenings in talking politics or playing cards." "The fact is," she adds, with a touch of pity for the degenerates of those later days, "that some of us had not yet lost the habit of amusing ourselves, and that we amused ourselves very well ; after all, such pleasures were quite as enjoyable as the cards in the salons of Paris and the stuffy routs in the drawing-rooms of London."

We know of one young lady at least who, if she took part in those tableaux-vivants, was the exception who tried the rule as to beauty. It was Mademoiselle Duchesnois. This young woman, who, in spite of the rivalry of Mademoiselle Georges, achieved high rank as a tragic actress, was a pupil in declamation of Etienne Vigée, and he used to bring her to his sister's house to recite in the evenings. Madame gives a circumstantial account of the début of Mademoiselle Duchesnois at the Théâtre Français, the general accuracy of which may be accepted, though she places the event after her own return from England, whereas it took place in the year that she went there. Both Mademoiselle Duchesnois, then twenty-five, and Mademoiselle Georges, who was about nine years younger, came out at the Comédie Française in the same year (1802), the elder débutante as Phèdre, the younger as Clytemnestra. Mademoiselle Duchesnois had the greater talent and was very plain, Mademoiselle Georges had beauty and less ability as an actress. Madame Lebrun describes her own efforts, crowned with success, to make influence for her brother's pupil through the aid of Madame de Montessor, who was in favour with Bonaparte. By these means an official " order " was procured for the appearance of the young actress at the State Theatre. Madame's reference to the personal appearance of the two young actresses is as follows : " The fact is that Mademoiselle Duchesnois lacked a good deal on the score of prettiness. . . . On the day of her début I advised her, as an artist, how to be dressed, and how to have her hair done, for it was her face especially that was unattractive." As for her rival, Mademoiselle Georges was " the loveliest creature that has ever been seen on the stage."

Although Madame's memory failed her when she supposed that the first appearance of her protégée Catherine Rafin (Duchesnois) took place after the return of the painter from England, there is no reason to doubt that it was very soon after that return that Napoleon said at the Tuileries to the Comte de Ségur, whose wife repeated the words to the subject thereof, " Madame Lebrun went to England to see her friends." The point of the remark was, of course, that " her friends " were the nobles of the emigration, the enemies of the " Corsican upstart."

Not long after Bonaparte had made this remark about a woman who, unlike her friend Madame de Staël, was not of sufficient political importance to be worried by the new power in France, she was commanded by the Emperor to paint a portrait of his sister Caroline, the wife of Joachim

Murat. The price she was promised was only eighteen hundred francs—less than half her usual charge for portraits of the same size. Rather naïvely, the artist says: " This sum of money was all the more moderate from the fact that, in order to satisfy myself in the composition of the picture, I painted at the side of Madame Murat her little girl, who was very pretty, and that without raising the price." The production of this picture was attended by many difficulties. " It would be impossible to describe all the little annoyances, all the worries I had to endure whilst I made that portrait. To begin with, at the first sitting I saw Madame Murat arrive with two maids, who were to dress her hair whilst I painted. However, on my saying that I could not possibly catch her likeness under such conditions, she consented to send her two women away. Afterwards, she invariably failed to keep the appointments she gave me, so that, in my anxiety to complete the picture, she obliged me to spend almost all the summer in Paris, more often than not waiting for her in vain, which put me out of patience to a degree I could not describe. Moreover, the intervals between the sittings were so long, that she changed her way of doing her hair between one sitting and the next. During the earlier days, for example, she wore curls hanging on her cheeks, and I painted her as I saw her before me; but some while after, that style having ceased to be the fashion, she came with her hair arranged entirely differently, so that I had to scratch out the curls I had painted upon the side of the face; and I also had to efface the string of pearls which she had worn as a fillet, in order to replace them by cameos. It was just the same sort of thing with her clothes. The dress in which I had painted her at first was rather open, as they were worn just then, and ornamented with a spreading embroidery. That fashion having changed, I was obliged to narrow the opening of the dress and begin the embroidery over again, as it was much too extensive. At length, all the trouble that Madame Murat gave me ended by ruffling my temper so much that one day, when she was in my studio, I said to M. Denon [then Director-General of Museums and Art-galleries] loud enough to be heard by her: ' I have painted real princesses who have never worried me, and have never kept me waiting.' The truth is that Madame Murat was quite unaware that punctuality is the politeness of kings, as was so well said by Louis XIV. who, surely, was not a parvenu."

When at length she had got rid of Madame Murat, Vigée-Lebrun resumed the peaceful life which, she declares, had become her pleasant

habit in these years of middle age (she was just fifty), though it is true she was not long content to live quietly at home. " My taste for travelling was not yet satisfied : I had not yet seen Switzerland, and I was burning with the desire to contemplate that grand and beautiful country," of which, as we know, various places had already " reminded her."

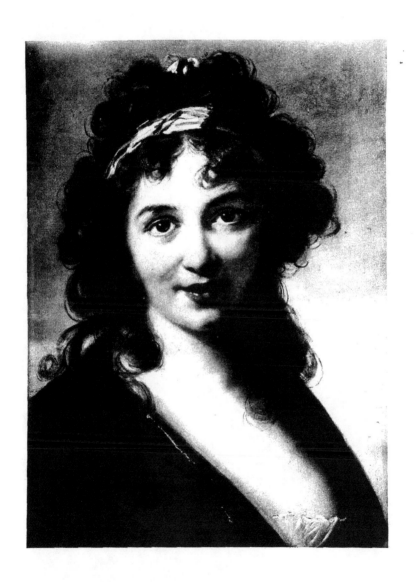

CHAPTER XXV

VISIT TO SWITZERLAND, 1808

A tour in Switzerland—Rousseau's Island—Madame Lebrun's trouble with foreign names—
Descriptions of Swiss scenery—" A thousand piquant anecdotes," and none recalled—
Climbing the Wunschenstein—A dog which wept at the sunrise—A visit to Coppet—Madame
de Staël at home—Amateur theatricals—Portrait of Madame de Staël as " Corinne "—The
shepherds' festival

HER yearning to see Switzerland was at length to be gratified. In 1808 Madame Lebrun set out, with her faithful Adelaide, for Basle, and spent many months in the gratification of her eyes among Swiss mountains and valleys and lakes, producing about one hundred drawings in pastel, with no great artistic success, but with considerable personal pleasure. The record of this agreeable time is contained in nine letters addressed to the Comtesse Vincent Potocka, of which the writer had kept copies. Shortly after leaving Basle, on the road along the side of a precipice, the horse which drew her carriage became violently excited, his harness being too tightly buckled, and but for the help of a passing peasant the vehicle and its occupants would have been in imminent danger of going over the precipice. This experience so frightened the travellers that they walked most of the way to Bienne. From Bienne they made a trip to the Isle Saint-Pierre, famous by its association with Rousseau, for whose writings, in spite of her fidelity to the Bourbons, Vigée-Lebrun had a considerable admiration—so much so that she was rather disgusted to find that the house he had occupied on the island had been turned into a tavern. The gentle reveries over Jean-Jacques and Julie (from whom, maybe, Julie Lebrun derived one of her names) afford one of several proofs of the inconsistency—it was that rather than catholicity—of Madame Lebrun's political ideas. It is true she was not a politician, in that she knew very little about the past, or of contemporary politics, outside her own personal experience. But such political faith as she possessed was centred in a conviction, which was never shaken, that the Bourbons were the only fit rulers of her country, and that all who did or said anything

against their characters or interests were scoundrels. Yet, holding such
prejudices, she nevertheless feels it a profanation that a home of Rousseau,
who had done so much to undermine the Bourbon constitution, should be
used as a wine-shop. The explanation probably is, that she was unaware
how much his writings had contributed to the adversities of her dear
Princes of the Bourbon blood.

Madame went on to Berne, where the French Ambassador, General
Vial, showed her much courtesy, and took her for delightful drives in the
environs.

In the course of her wanderings in Switzerland she saw Thun, Lauter-
brunnen and the Staubbach Cascade (which, ignoring the derivation, she
calls Schaubach, making a " dust-stream," as this fall is named on account
of the cloud of spray into which it is beaten as it dashes on the rock, into
a " show-stream "). Her account of the valley of Lauterbrunnen (here
also she makes the name absurd by lopping off the final syllable) is charm-
ing, the contrast she draws between the place and some of its occupants
being in her best vein as a descriptive artist. " The valley of Lauterbrun
is so rugged and so sombre that I could not bring myself to believe it was
inhabited. It is shut in on all sides by mountains so high that the sun
only lights it up completely at midday, so that the mornings are gloomy,
and, as soon as the sun sets, the night comes there. This valley, therefore,
is the realm of black shadows for three-parts of the time. Judge, then, what
a delightful surprise it was for us to come upon a group of young girls as
pretty as angels ; their complexions were of milk and roses ; an air of
innocence added to their beauty. They brought us some fine and excellent
cherries. In a place so *triste*, so wild, how could we doubt that these
young shepherdesses, with the fruit that they carried, had come down to
us from the heavens ? The scene was for me as some fantasy of the
Arabian Nights." So while Wordsworth regarded the Staubbach as "sky-
born," and Byron saw " the many hues of heaven " in its waters, Vigée-
Lebrun felt that the children of the valley were sky-born also, and that
the hues of heaven were in the colours of their cheeks and of the cherries
that they bore.

At Schaffhausen (the Schaffouse of our traveller) Madame made a
mistake as to descriptive nouns which she actually discovered and acknow-
ledged ! Seeing some vines on the slopes near the falls of the Rhine, she
asked the burgomaster, to whom she had an introduction, and who was
showing her the glories of his domain, to send her some of the wine pro-

duced in his own vineyard. "He replied, with a little embarrassment, that the carriage of the wine would cost more than the wine itself was worth. I assured him that I had drunk some of it at the inn, and that it was excellent. 'Monsieur is right, however,' said Adelaide; 'the wine you drank at the inn is of the *côte* of the Rhine.' I saw my mistake: I had confused the *côte* and the *chute* (fall), and I was ashamed of my mistake."

In the neighbourhood of Zurich, Madame Lebrun took a furnished villa, and found in her landlord another agreeable general, whom she had previously known in Paris before, and in Naples during the Revolution—the General Baron de Salis, who, with his family, lived in another house near the lake. His kindness added considerably to her enjoyment. She was treated by this old soldier (he was eighty-one) and by the family as if she were one of their near relatives. In spite of the infirmities of age, the Baron de Salis was always lively and witty. "He told me a thousand piquant anecdotes." Unfortunately, out of all the thousand she does not recall one for the entertainment either of the Comtesse Potocka, to whom she was writing, or of ourselves. It is most disappointing, and reminds us of the many novels and plays in which we are told how brilliant is the conversation of Mr. This or Mrs. That, without ever hearing them utter a word that could be cited in evidence of their wit. We must hope, for the credit of the old General and of the lady who enjoyed his conversation, that the anecdotes were not too "piquant" for reproduction, as those told by such old compaigners occasionally are.

"I pay little attention to the towns, it is nature to which I give all my thoughts," wrote Madame from Solothurn, and most of her letters from Switzerland bear out her claim to be fonder of scenery than of streets.

One long walk up the Wunschenstein she made, starting from her inn at Solothurn with a carriage and four horses, a driver, a guide, and Adelaide—the object to be reached being a châlet on a grassy slope, where a herd of cows were having their summer pasture. The landlord of her inn had assured her, and she was innocent enough to believe him, that there was a splendid road all the way; but after three-quarters of an hour's drive the road became a mere bed of rough stones, and she preferred to walk.

"My guide could not help talking of my courage; he was immensely surprised at my long walk, which lasted from four o'clock in the afternoon till half-past eight; I had climbed three and a half leagues. During the

first two hours the heat was terrific, but the ardours of the sun once over, the more I climbed the stronger I felt. The truth is, that the views which I was enjoying were so charming as to make me forget my fatigue. I saw five or six huge forests, one after the other, descending before my eyes; the Canton of Solothurn appeared no more than a plain, the town and the villages were like little dots. The beautiful line of glaciers which bounded the horizon became more and more brilliant in colour in the glow of the setting sun; the other mountains were iridescent, golden lines and rainbow hues spread over the left of the mountain on which I was moving; the sun went down behind the summit. . . . At my feet I saw wild valleys surrounded by dark pine-trees. As the light failed, and the shadows extended, the different sights took a severe character, as much by their forms as by the long silence which harmonises so well with the fall of the day. I can tell you that I have rejoiced with all my soul at that scene at once so solemn and so melancholy."

It is clear that Madame, in spite of her long climb, was able to reap her reward; and when a radiant moon came up, and lighted her to the hut for which she had set out, and where she was to pass the night, nothing was wanting, for the moment, to her perfect enjoyment. "The delicious air, the scent of the grass on which I trod, gave me true happiness; if I had had some friends, I think that I should never have descended. The cows remain on those heights during the whole summer; the sweet grass is their food, and gives its perfume to their milk." Alas! some of this very milk brings us from the heavenly joys of our mountaineer to some very earthly sorrows. "The milk formed my only supper, for the chicken they gave me at the châlet was hard and dry. I was to get up before three in the morning to go one more league in order to see the sunrise from the top of a mountain. I could not sleep on account of the fleas, and I sat on a chair waiting impatiently for the signal to start."

Madame's description of sunrise is as enthusiastic as of the sunset of the previous evening, and a fellow spectator was a dog of such rare sensibility to the wonders of nature that "motionless upon his feet, he watched the rising sun, and wept in face of that glorious scene."

Do not let us smile too freely at this picture of *Le chien qui pleure*. According to a high authority on metaphysics, a dog might feel a certain pleasure in such a lovely view. "It is through sight and hearing," says Lord Haldane, in his Gifford Lectures of 1903–4, "that we perceive beautiful objects, and through these senses almost exclusively. This fact seems to

indicate that it is only for a reflecting mind that what is beautiful exists. For a dog or a horse it is there, at the most, only in a very slight degree." So that even so modern a philosopher as Lord Haldane, while he would probably demur to the conclusion that the tears of the dog on the Jura were caused by sentimental emotion, would not deny that, " in a very slight degree," the animal from which Madame Lebrun parted with so much regret did appreciate the beauty of that Alpine sunrise. It may be that the cause of his tears was the intensity of the sun's rays, which, according to Madame, are "a thousand times more radiant upon the mountains than in the plains."

Alpinists may laugh at Madame Lebrun's " highest peaks of the Jura," whereon cows browse tranquilly on the rich herbage, but a hundred years ago mountains were still more provocative of dread than of pleasure to most travellers, and her ascent of the slopes of the Wunschenstein was really, for the period, no bad performance for a middle-aged woman. " That excursion," she wrote to her friend, " will always remain in my memory. Why were you not with me, my dear Comtesse ! That is always my refrain."

The next letter from Switzerland leaves Madame at Vevey, thinking again of Rousseau and of Julie. Both that author and his creations were in her mind as she enjoyed a moonlight tour on the lake. " My Adelaide being too tired to go with me, I set off alone with the fat innkeeper ; he was not Saint-Preux, I was not Julie, none the less I was happy. My boat was the only one to be seen ; the vast silence all around me was not disturbed except by the light noise made by the oars."

From Vevey at one end of Lake Leman to Coppet at the other was an inevitable voyage for Madame Lebrun, seeing that at Coppet, in that autumn of 1808, was established the irrepressible and brilliant Madame de Staël, then recently exiled from France by Napoleon on account of the political allusions in her novel *Corinne*, which had appeared in the previous year. The Emperor himself, by the way, was supposed to have written the review of the novel for the *Moniteur*.

The week which the artist spent at Coppet was a memorable one in the life even of a woman who had enjoyed such exceptional opportunities for meeting with notable people. The house was always full of guests, and among those who were there during her visit were Benjamin Constant, whose close friendship with Madame de Staël is historic, and Madame Récamier. Napoleon's *bête noire* was no ordinary hostess. The visitors

were left to amuse themselves as they liked best till the evening, when, after dinner, she made her first appearance in the general company. " You could see her thus walking about the drawing-room, holding a sprig of foliage. While she talked, she shook that little branch, and spoke with an animation which was peculiar to herself. It was impossible to interrupt her ; at such moments she gave me the impression of an improvisatrice." On one evening at least Madame de Staël had to abandon this kind of " conversation." Some amateur theatricals were given, and *Sémiramis* was the drama boldly selected. Madame de Staël herself took the part of Azéma, in which " she had some fine moments, but her playing was very uneven," while Madame Récamier was overcome by stage-fright in the title-rôle ! The men were no better. " I have always observed," says Madame Lebrun, " that amateurs ought only to try comedies and pro- verbs, never tragedies," and her observation will be generally endorsed. The mornings of that week at Coppet were partly taken up with the earlier stages of the portrait of Madame de Staël, whom Vigée-Lebrun chose to represent as Corinne, seated, with a lyre in her hands, upon a rock, as Corinne sat when she sang her improvised verses at Cape Miseno. The sittings for the portrait were of a remarkable character. " Madame de Staël," says the artist, " was not pretty, but the animation of her face took the place of beauty. In order that she might sustain the expression that I wished to give to her face, I begged her to recite to me some tragic verses, to which I hardly listened, so much was I occupied in trying to represent her with an inspired air. When she had finished her tirades, I said to her, ' Go on reciting ' ; she replied, ' But you don't listen to me,' and I responded, ' Go on, all the same.' Understanding at length my intention, she continued to declaim passages from Corneille and from Racine."

It may be added here that it was ten months before the completed portrait arrived from Paris, where it was finished without sittings, and that Madame de Staël seems to have been pleased with what was undoubtedly a flattering representation of a plain woman. She at once sent a cheque, apparently for a thousand écus (about £200) ; but her affairs at that moment requiring, as she had previously written to the artist's daughter " des ménagements de fortune," the cheque was made payable for a date more than six weeks later than its despatch.

After leaving Coppet, Madame Lebrun paid a visit to Ferney, and here, as at the Isle Saint-Pierre, found how little reverence was yet paid

were left to amuse themselves as they liked best till the evening, when, after dinner, she made her first appearance in the general company. " You could see her thus walking about the drawing-room, holding a sprig of foliage. While she talked, she shook that little branch, and spoke with an animation which was peculiar to herself. It was impossible to interrupt her ; at such moments she gave me the impression of an improvisatrice." On one evening at least Madame de Staël had to abandon this kind of " conversation." Some amateur theatricals were given, and *Sémiramis* was the drama boldly selected. Madame de Staël herself took the part of Azéma, in which " she had some fine moments, but her playing was very uneven," while Madame Récamier was overcome by stage-fright in the title-rôle ! The men were no better. " I have always observed," says Madame Lebrun, " that amateurs ought only to try comedies and proverbs never tragedies," and her observation will be generally endorsed. The mornings of that week at Coppet were partly taken up with the earlier stages of the portrait of Madame de Staël, whom Vigée-Lebrun chose to represent as Corinne, seated, with a lyre in her hands, upon a rock, as Corinne when she improvised verses at Cape Misena. The sittings for the *Musing Vesuvius (M. Charles Sedelmeyer).* " Madame de Staël," says the artist, " was not pretty, but the animation of her face took the place of beauty. In order that she might sustain the expression that I wished to give to her face, I begged her to recite to me some tragic verses, to which I hardly listened, so much was I occupied in trying to represent her with an inspired air. When she had finished her tirade, I said to her, ' Go on reciting ' ; she replied, ' But you don't listen to me,' and I responded, ' Go on, all the same.' Understanding at length my intention, she continued to declaim passages from Corneille and from Racine."

It may be added here that it was ten months before the completed portrait arrived from Paris, where it was finished without sittings, and that Madame de Staël seems to have been pleased with what was undoubtedly a flattering representation of a plain woman. She at once sent a cheque apparently for a thousand écus (about £200) ; but her affairs at that moment requiring, as she had previously written to the artist's daughter " des ménagements de fortune," the cheque was made payable for a date more than six weeks later than its despatch.

After leaving Coppet, Madame Lebrun paid a visit to Ferney, and here, as at the Isle Saint-Pierre, found how little reverence was yet paid

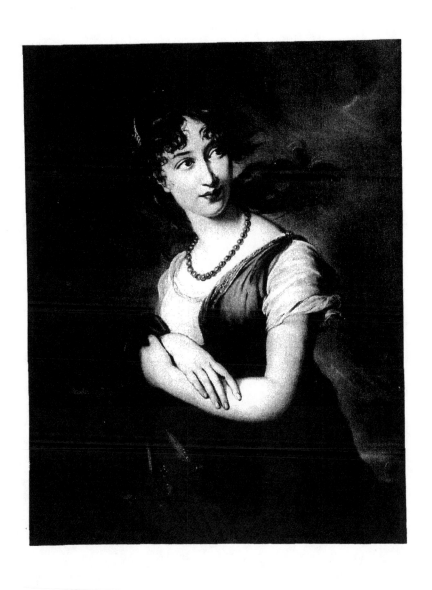

to the scenes associated with the prophets of the Revolution. While Rousseau's island house was now a cabaret, Voltaire's house was in such a filthy state that she could not believe it had been swept out since he had left it on his last journey to triumph and death in Paris.

Taking everywhere her box of pastels, the painter now revisited many of the lovely scenes she had lately enjoyed in Switzerland. The drawings she made were not very successful, and are for the most part lost to the world of art, which puts a very small price on them when they come to light in sale-rooms. For example, two sketches representing the Lakes of Thun and Lucerne were sold together in 1898 for ten francs.

In one instance she herself admits a complete failure. Mont Blanc at sunset, bathed in gold and opal, was her conqueror. " I seized my pastels ; but alas ! impossible : there was never palette or colours that could render those glorious tints." There is, however, one of her Swiss pictures which, as late as 1899, fetched a thousand francs in Paris. It is a " View from Interlaken during a cantonal fête," is of considerable size, and is painted in oil colours. The origin of this work—which has been in several famous collections—is fully described by the artist in the last of the letters to Madame Potocka. The actual spot was Unterseen (Undersée, as she calls it), and the spectacle represented was the annual fête of the shepherds. The artist, when she took her seat upon one of the benches set out for spectators, was glad to find herself next to Madame de Staël, who had come from Coppet. Hardly were they settled in their places than " We heard some sacred music perfectly chanted by young shepherd-esses. It was followed by the famous song of the Swiss herdsmen. The shepherdesses were preceded by the Bailie and the magistrates. Then came peasants of the various cantons, all in different costumes ; white-haired men carried the banners and the halberds of each valley. They were dressed in the costumes of five centuries ago, of the days of the Conjuration of Rutti [Declaration of Swiss Independence, 1307]. Those old times were represented by the venerable old men. Madame de Staël and I were so moved, so overcome by that solemn procession, that rustic music, that we pressed each others' hands without being able to utter a single word, but our eyes were filled with tears. Never shall I forget that moment of reciprocal emotion. After that procession, the sports began. Twelve mountaineers and men of the valley hurled enormous stones, weighing eighty pounds, from above their shoulders with in-credible force. The wrestling followed, in which the competitors showed

astonishing strength and agility. When the sports were over, the Bailie gave away the prizes. Patriotic hymns were again chanted, and the song of the herdsmen was sung. Then the crowd broke up, and on every side there were to be seen groups of people who sang, or danced, or waltzed, or ate. Several marquees had been set up, with tables, where many visitors had sat down to dinner. The peasants did their cooking in the open air. It was the most varied, the most lively *coup d'œil* that I have ever seen."

In a footnote to her letter, as printed, the writer adds : " After the fête Madame de Staël strolled about with the Duc de Montmorency; as for me, I stayed on the meadow to paint the place, with the groups of people. The Comte de Gramont held my box of pastels. The general view of that fête is painted in oil-colours. The Prince de Talleyrand is now the owner of the picture."

CHAPTER XXVI

THE RESTORATION

Madame Lebrun buys a house at Louveciennes—Death of her husband—His debts—The Prussians at Louveciennes—Alarming experience of Madame Lebrun—The two returns of the Bourbons —Louis XVIII is gracious to the painter of Marie Antoinette—Princesse Natalie Kourakin in Paris—Her friendship with Madame Lebrun—Death of Julie Nigris—Mother and daughter.

AFTER her delightful tour in Switzerland, Vigée-Lebrun found that Paris in summer was no longer pleasant to her, and in 1810 she bought at Louveciennes, near the Pavillon du Barry, the house wherein so much of her remaining life was to be spent. The panorama of the Seine, the woods of Marly, the " delicious market-gardens, so well cultivated that one might fancy oneself in the Land of Promise," these attractions which decided her to fix a home on that spot, are to be found there now.

The death of her husband—or ex-husband—in 1813 did not greatly trouble her repose ; how should it ? He had for many years been almost a cipher in her life, but it is not surprising to find that he died greatly in debt to her, for she was generous in helping him even after he had divorced her in 1794.

The list of his debts filed after his death includes an " obligation " to his one-time wife of 104,000 francs and a few centimes. He died owing also 10,038 francs to another picture dealer, and 10,360 francs to an architect.

During the year after her husband's death Madame suffered a very distressing experience. On the last night of March, 1814, after the surrender of Paris to the Allies, Louveciennes was pillaged by the Prussian soldiers, who had come into France to restore the Bourbons to the throne of their ancestors.

" It was eleven o'clock at night, and I had just gone to bed, when

Joseph, my servant, who was a Swiss, and spoke German, came into my room, followed by three soldiers of horrible appearance, who, sword in hand, came up to my bed. Joseph shrieked to them that I was Swiss and ill; but, without answering him, they began by taking my gold snuff-box, which was on a table near my pillow. Then they felt to ascertain if I had not hidden any money under my blanket, from which one of them coolly cut a piece with his sword. Another of them, who seemed to be French, or at any rate who spoke our language perfectly, said to him, 'Give her back her box,' but, far from obeying that invitation, they went to my writing-table, took everything they could find there, and pillaged my wardrobes also. At last, after having made me pass four hours in the most frightful terror, these dreadful people left my house."

She herself also left it next morning, and went to lodge in one of the houses just above the Seine, where she found that some other ladies had already sought a refuge. The place was a mere cottage. The lodgers dined together, and lay at night six in a room, where sleep was almost impossible.

However, all must have been forgiven to the pillaging Prussians when, on April 12, she had the immense pleasure of seeing the Comte d'Artois enter Paris, the precursor of his brother Louis XVIII. "It is impossible," she says, "for me to describe the delightful sensations that I experienced on that day; I wept tears of joy, of happiness."

Life in Paris was also made happier for Madame Lebrun now by the return of the Comte de Vaudreuil, who had followed the Comte d'Artois from England. He had lost nearly all his property, but the Bourbons did not leave him without means of subsistence, and gave him rooms in the Louvre, where he entertained his friends. The Comtesse Potocka, in describing a party she had attended at Vigée-Lebrun's house in those days, says: "Every one is amused to see M. de Vaudreuil doing the honours as if we were back twenty-five years ago. They appear to be very happy together, in spite of the lapse of time; they have found each other again like the handsome Cleon and the beautiful Javotte."

The happiness was soon to be broken, when, just a year later, the Bourbons went off again at the beginning of the Hundred Days. July 1815 came, and with it the Bourbons once more, and all the returned emigrants, many of them old friends and acquaintances of Madame Lebrun, resumed, as far as their finances allowed, the social pleasures that they had first left behind them at the Revolution.

The " painter of Marie Antoinette " was received at the Tuileries with marked distinction by Louis XVIII, and painted several new portraits of members of the Royal Family. The big picture of Marie Antoinette and her children was once more hung on the wall at Versailles, from which it had been taken down by Napoleon's orders, though the custodians had made a good many francs by showing it unofficially to visitors who cared to see it.

During her residence in St. Petersburg Madame Lebrun had, as we have seen already, been on very friendly terms with the Princess Natalie Kourakin, to whom many letters quoted in earlier chapters were addressed. When, in 1816, the Russian lady came to Paris, the friendship was speedily renewed.

" What pleasure have I not felt this morning," wrote the Princess in her diary on October 26, " at seeing Madame Lebrun again! When she came into my drawing-room she pressed my hand and, at the same time, showed me my letters and a flower I had sent her years ago from Russia. How one's heart rejoices in finding again a heart which cherishes it!"

Almost every day these two women, the Russian and the French, were together, often several times. They would " drop in " on each other for a few minutes, in going or coming on the business of social pleasure; they treated each other to theatres and concerts, and went to parties together. The only cloud of which we hear, in this private Franco-Russian alliance, was caused by the failure of the Princess to visit her friend at Louveciennes in the summer of 1817. For this omission " Madame Lebrun was furious." But the fury soon changed into forgiveness.

In the following year it seemed for a moment as if Madame Lebrun might have a dangerous rival in the affections of her dear Natalie. Some time in June the Princess met Madame Récamier, who had returned to Paris from the exile to which Napoleon had condemned her on account of her friendship with Madame de Staël. " Madame Récamier and I were like sisters together," writes the Princess, concerning that particular afternoon, " and we promised ourselves to see one another often." Nothing came, apparently, of this sudden discovery of sisterly love, and the more substantially founded friendship with the much older Frenchwoman was in no way disturbed.

If the death of M. Lebrun had not been more than a temporary grief to the woman who had been his wife, the death of their daughter, in 1819,

12

gave her intense sorrow—none the less, perhaps even the more, because of the coldness that had existed between them since Julie's marriage in St. Petersburg, about twenty years before.

The mother and daughter had never again been on quite the old footing of perfect confidence and affection, but they had seen each other constantly in Paris and elsewhere after Julie, separated in her turn from her husband, had settled there in 1805 ; and Madame Lebrun found a good deal of new happiness in the presence and society of her daughter. " Whether it was my fault or not," writes the mother, " if her empire over my heart was great, I had none over hers, and at times she made me shed some bitter tears. . . . I had the disappointment of not being able to persuade her to live with me, because she persisted in associating with several people whom I could not have in the house," people more after the taste of the father who had gone than of the mother who remained. That mother was not with Julie at the last hour. " The moment I heard that she was suffering I hurried to her ; but her disease advanced quickly ; I cannot express what I felt when I lost all hope of saving her. When I went to see her, for the last time, alas ! and my eyes fixed themselves upon that pretty face, so terribly changed, I became ill. Madame de Noisville, my old friend, who had come with me, came to drag me away from that bed of sorrow ; she held me up, for my legs would no longer support me, and she took me home. Next day, I had no longer a child ! Madame de Verdun came to tell me, and strove in vain to appease my despair, for the faults of the poor child towards me were wiped out, and I saw her again, I see her now, as she was in her childhood. . . . Alas, she was so young ! Ought she not to have survived me ? "

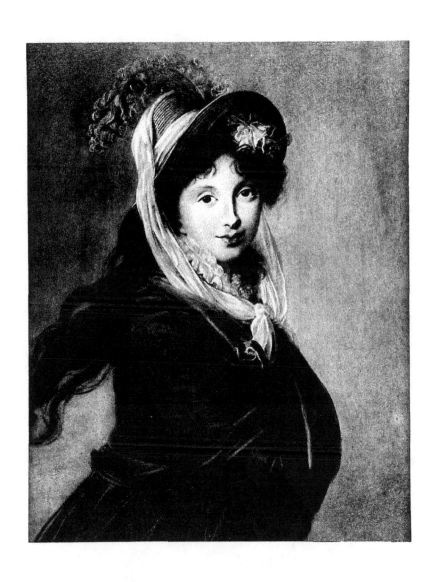

CHAPTER XXVII

AUTUMN AND WINTER

A visit to Bordeaux—Château of Méréville—Sham rocks and other "embellishments" of the gardens—Tours—The monastery of Marmoutier—Vandalic iron-founders—The hotel at Bordeaux—Disadvantages and advantages of a top-room—The fascination of the harbour —Madame Lebrun at sixty-five—"Settles down" in country and town for the rest of her life—The rivalry of her devoted nieces—A happy and uneventful old age—She prepares her souvenirs—Death of Madame Lebrun—Her will—Where her ashes lie—The sentinel above her grave

THE deaths of her daughter and also of her brother Etienne, within the year, upset Madame Lebrun's health so much that her friends advised her to try once more her usual remedy—travel and change of scene. She took the advice, and chose Bordeaux for an object, the town itself being unknown to her, and most of the route also. Very early on the journey she left her carriage in order to visit the château of Méréville, the seat of M. de Laborde, son of a great financier, and brother of the rather eccentric and very beautiful Madame d'Angiviller. Madame Lebrun's account of the place affords sufficient evidence that, however simple her taste in costume, some of her ideas of the embellishment of Nature were not at all superior, or inferior, to those of the landscape-gardeners who laid out the grounds of the Trianon. Millions of francs had been spent on this "truly enchanting resort of Méréville, where there was not a corner in which art had not come to add to the beauties of nature." Even the rocks were sham, or at least brought from elsewhere. These rocks, "which are immense and must have cost a fortune, the cascades, the temples, the pavilions, all is in its place and contributes to the charm of the view . . . One of the temples, called the Temple of the Sibyl, is an exact copy of that at Tivoli, but restored throughout with perfect taste and care. On another spot, close to the river, is a mill and several little houses like Swiss châlets. . . . Indeed, it would take too long to enumerate all the things that make the park at Méréville so delightful a place, which in my opinion

179

surpasses anything of the kind that one can find in England. This park was designed in great part by Hubert Robert."

But Madame Lebrun had a real love for the picturesque, and the "nobles débris" of castles along the banks of the Loire delighted her eyes, to which Chambord appeared " a fairy-castle so romantic, that one could never see anything which so much impresses the imagination."

Tours has happily changed in one respect—it has changed in many,—since she was there in 1820. She declares that there was a disgusting smell in every street, and that in " the best hotel," where she stayed,—the trees of the present Boulevard Béranger were young in those days—sweet-smelling herbs and toilet vinegar could not overcome the unpleasantness, which drove her away after two days, during which she found time to visit the cathedral, the picture gallery, and the ruins of that great monastery of Marmoütier, familiar to readers of Balzac's early work. She found this famous relic of the middle ages in process of demolition ! " An infernal band of iron-founders was destroying all these beautiful things. A Dutch mercantile company wanted to buy the monastery to make it into a factory. They offered 300,000 francs, which was refused ; and later on the villainous iron-founders had it for 20,000, on condition that this noble building should be entirely pulled down ! The Vandals themselves could not have done worse ! Ah well, all along my route I heard things of that sort."

By Poitiers and Angoulême, the traveller arrived at Bordeaux. She does not forget to record that from the suburbs of Paris to the suburbs of Bordeaux the road is " like an alley in a garden, and it is so well made that one feels no fatigue." The road is good enough now, perhaps, but the motor-cars, over a considerable part of it, would interfere sadly with Madame Lebrun's pleasure in her gently-rolling carriage, could she make the journey again in the same manner.

At Bordeaux, this staunch adherent of the aristocracy benefited by its overthrow, for she stayed at a charming hotel which, before the Revolution, had been the residence of a noble. It was on the quay, and, she writes: " I cannot express my ecstasy, my ravishment at the sight of the magnificent picture which met my eyes when I opened my window ; I believed I was in a beautiful dream. So many vessels in harbour, a thousand boats and lighters which come and go in every direction, while the ships lie motionless ; the silence which reigns over that immense mass of water, all concurs to give the idea of a fairy-picture. Although I stayed

nearly a week, and by night and day enjoyed that sight, I could never get tired of it, above all by moonlight ; you see there upon the hills some little lights in the houses, and all becomes magical. The pleasure that I tasted at my window would alone have repaid me for the trouble of coming to Bordeaux.''

She had only one acquaintance in the town—the Comte de Tournon-Simiane, préfet of the department of the Gironde, who was himself a bit of an artist. But she went out little, it seems; and one reason why she spent so much time at her window was that her room was very high up, in days when the advertised merits of a provincial hotel never included " lift to every floor ",—in spite of the fact that lifts were known before the Revolution, much as railways were known in the days of George III. It would need no more than the above account of the view from a hotel window at Bordeaux to prove that Madame Lebrun did not belong to the *nil admirari* class, and was not afraid to express her feelings for the beautiful.

A curious phonetic error in her account of her visit to Bordeaux might be adduced as evidence that she dictated this part of her *Souvenirs* to an absent-minded amanuensis. The hostelry where she stayed is there called " *l'autel Fumel* " (Fumel was the name of its former owner, the nobleman). It is remarkable that such an obvious slip of somebody's should have persisted in editions published in our own days.

After this visit to Bordeaux, Madame Lebrun, being now sixty-five years old, felt disposed for a permanently settled life, and determined that henceforth her painting, always her favourite occupation, should be her principal relaxation. She was no longer able to produce the charming portraits of five-and-twenty years before, but she enjoyed painting pictures, generally pastels or water-colours, which had little value for sale, but much for her own pleasure. She also found a grateful occupation in the instruction of her niece Eugénie Lebrun, who under the aunt's eye made quite a success as a portrait-painter on her own account. Madame had saved enough money during her progress through Europe, notably in Russia, to enable her to live in great comfort at Louveciennes, and to spend several months of each year in Paris.

This niece, Eugénie, who was soon to marry Monsieur Tripier Lefranc, and Caroline, "Madame" de Rivière, her other niece, were, one or both, her almost constant companions. The last twenty years of her life passed in the quiet enjoyment of good health, agreeable society, and keen pleasure

in art and nature. She went to see her friends, and they came to her "evenings" still in Paris, or to stay with her in her pleasant country-house. When she was verging on eighty she followed the mode among survivors of the Revolution by preparing (at the suggestion of some literary friends, among whom Aimé Martin seems to have been the chief instigator) her reminiscences for publication. In part the volumes which appeared in 1836-7 are filled—as already mentioned—with letters to the Princesse Natalie Kourakin and the Comtesse Vincent Potocka, and for the rest they were mostly dictated, or compiled by others from notes of her talk.

Happily she seems to have had no idea of the jealousy with which Caroline de Rivière regarded Eugénie Lefranc, especially with reference to her (Madame Lebrun's) inheritance. An intimate friend of Eugénie's was Madame de Joinville, who, writing on February 26, 1842 (about a month before Madame Lebrun's death), says to Madame Lefranc: "I hope that your little boy at least, if he has a good heart, will give you a little more consolation than you have had from your aunt, whose age, and the efforts of memory that her literary work has necessitated, have drained her energy and her intellectual resources. I have always supposed that her fortune amounted to much more than 300,000 francs (£12,000); apparently she had considerable life-annuities, for her ex-penditure, and her manner of living, especially during (the past) six months, gave the impression that she had an income of 25 or 30 thousand livres (£1,000 to £1,400) a year. I had some apprehensions also on the subject of Madame de Rivière. Observer, by character, of the moral inductions which a study of the inward disposition presents, I have noticed in her the manifestation of love of money, carried to a passion. I saw her, in the first days of the Revolution of 1830, arrive at her aunt's house, crimson with anger, and uttering cries of despair . . . because she had heard that her pension had been stopped by the new Government." Referring afterwards to this same incident, this profound detective of the human heart, Madame de Joinville, writes to Eugénie Lefranc: "An incident that I have told you about in an earlier letter had shown me the kernel of the character of that mild and pleasant face. Lavater himself would have been deceived; but for me, steeped in the physiology of Dr. Gall—that is to say, of his theory of the plurality of the organs, or of the theory of conductors, in the brain, of innate dispositions—it was only necessary to see her enter her aunt's

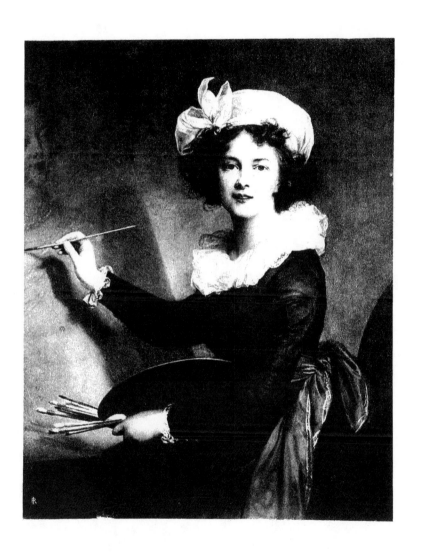

house, crimson with anger, as a lioness from whom one has taken her cubs." One can imagine the works of Lavater and Gall lying handy for reference on Madame de Joinville's writing-table.

Whatever the personal relations of her nieces, who ultimately went to law over her money, no fear of such a calamity troubled Madame Lebrun's last days.

Her death was a quiet and happy close to a life which, in spite of the mistake of her marriage, the miseries of the Revolution and her daughter's estrangement, had been as happy as is vouchsafed to more than a small proportion of humanity. On March 29, 1842, she had a few friends to dinner at her rooms in the Rue Saint-Lazare in Paris. After they had gone she went to bed, looking forward to seeing other friends on the morrow, and in the early hours of that morrow she died, as such old people commonly do, from the stopping of a heart which is tired of its work.

"I desire to be buried in the Calvary," she had said in her will of 1829. But the Calvary was closed soon after, and in 1831 she said in a new will (specially addressing her niece Eugénie, the residuary legatee), " As it is no longer possible for me to be buried in the Calvary, I desire that she will choose a place for me in the cemetery at Lucienne, and that my only monument may be a column with a pedestal on which she will have engraved in bas-relief a palette with paint-brushes, and the words ' Here at last I rest' (Ici enfin je repose), and below that my names, Elisabeth Louise Vigée-Lebrun. The little monument will be surrounded with green trees, and guarded by a bronze railing. I wish to have a very simple funeral, and that the poor of the neighbourhood shall be given a sum of two hundred francs, to be divided among them by my niece and the Curé of Lucienne."

The "new" cemetery at Louveciennes (where Elisabeth Vigée-Lebrun's dust lies, beneath a memorial not precisely in accordance with her wish, even as to her names), is, in one respect, unlike any other burial-place I know. It is inside a fortification, earthworks having been thrown up round its walls, not to protect the bones of departed villagers, but to command the valley of the Seine. On the green embankment of the fort a sentry in blue and scarlet, leaning upon his rifle, looks out over the fields and hills, the market gardens, and the graves. There are woods, and many scattered trees in the immediate neighbourhood, but in that tiny cemetery the " green trees " that she desired are but shrubs as yet, and the sun beats down upon the stones and the grass.

In spite of the adjoining battery, there is at most times little of sound there but for the hum of insects in summer or the twittering of birds. The greatest disturbance of the peace in which "the painter of Marie Antoinette" rests among her peasant neighbours is at those regular intervals when a word of command, followed by a clatter of arms, comes from the other side of the rampart, whereon the silent sentry awaits the changing of the guard.

CATALOGUE OF MADAME LEBRUN'S WORKS

(Unless otherwise stated, the sales mentioned took place in Paris.)

ADELAIDE, Madame. Daughter of Louis XV. Painted at Rome, 1791.
 Born in 1732, Madame Adelaide, like her sister Victoire, lived a life little remarkable until the Revolution, except that she was largely instrumental in the recall of Maurepas to Court and influence in 1774. During their flight from France to Italy in 1791, the two sisters were several times stopped, and were only able to leave the country by the express consent of the National Assembly. They lived first in Rome and then in Naples, fleeing to Trieste when the French invaded Italy, and dying in that city, Adelaide in 1800 and Victoire in the previous year.

AGUESSEAU, Madame. With her dog. 1768–1772. ? Christie's, 1887: "A Lady with a Dog." 36 × 28. Bought in at £168.
 ? Wife of Henri, Comte d'Aguesseau, Avocat, Academician, Deputy of the nobles to the States-General, Judge and Senator under Napoleon, Peer of France under Louis XVIII. *See* "LADY WITH A DOG."

AGUESSEAU, Madame de Fresne d'. 1789.

AILLY. *See* DAILLY.

ALBAN, Madame de Saint. 1781.

——, The same. 1789.

ALBRIZZI, Signora Isabella Marini, *née* Teotochi, afterwards Contessa Albrizzi. Venice, 1792. Bust. Red dress, cut low. Dark hair, bound with red and white fillet. 18½ × 13. (It has apparently been cut down since 1826, when it was measured as 19¾ × 13¼.) Signed and dated, with the addition " pour son ami Denon," who engraved the portrait. The writing was scratched on the dress in the left-hand bottom corner after the paint was set. Denon sale, 1826, 260 fr. Bardini sale, Christie's, June 1899, £620, (Hodgkins). 1913, Hodgkins.

ALEXANDER I, Tsar of Russia. Pastel. St. Petersburg, ? 1801. Paris, Exhibition of French Art under Louis XIV and Louis XV, 1888, Collection of M. Moreau-Chaslon.
 Madame Lebrun says she painted a pastel (head and shoulders) in 1801, on which the Dresden pictures (see below) were based.

—— Presumed portrait of the same. Pastel. Paris, Exposition Rétrospective Féminine, 1908, Collection of Monsieur G. Camentron.

—— Three portraits of the same. Bust (after the pastel portrait). Dresden.

ALEXANDRINA, The Grand-Duchess. *See* HELENA AND ALEXANDRINA.

AMERICAN, An (A little boy). 1779.

AMERICAN LADY. *See* LADY, AN AMERICAN.

AMPHION. *See* LUBOMIRSKI.

ANDLAU, Geneviève Adelaide, *née* Helvetius, Comtesse d'. Bust. Kerchief round head and tied under chin. Paris, Exhibition des Alsaciens-Lorrains, Palais Bourbon, 1874. Exhibition of National Portraits, Trocadero, 1878, Collection of Marquis de Mun. Comte Albert de Mun, 1913.

> ? Daughter of the celebrated Femier-Greneral Helvetius, the friend of many eminent authors and the author of the book *De l'Esprit* (1758), which was condemned by the Sorbonne.

—— The same. "Avec les mains." Paris, 1802–1805.

—— Son of the above. Paris, 1802–1805.

—— Another son of the Comtesse d'Andlau. Paris, 1802–1805.

ANDLAU, Stanislas d'. Paris, Exhibition of Portraits of Women and Children. Ecole des Beaux-Arts, 1897, Collection of Comtesse de Chanaleilles. Probably one of the above sons of Comtesse d'Andlau.

ANGELEY, Comtesse de Saint-Jean d'. Sale, Paris, Jan. 21, 1884. 1,950 fr.

ANGERVILLE, Mlle. de. Couteaux Sale, 1863. 127 fr.

> An actress of the Théâtre Français.

ANGIVILLER, Charles Claude la Billarderie, Comte d'. 1788.

> Director-general of buildings, gardens, manufactures and Academies under Louis XVI. A friend and protector of men of letters. His property was confiscated in 1791. He emigrated, and died in 1810 at Altona.

ANGOULÊME, Marie Thérèse Charlotte de France, Duchesse d'. Known as "Madame Royale." Dressed as a milk-girl. Low-necked dress. Roses and lilac in lap. Wearing a hat. Jules Duclos Sale, Paris, 1878, 2,420 frs.

> "Madame Royale," born in 1778, was the eldest child of Louis XVI and Marie Antoinette. Imprisoned with her parents in the Temple, she was exchanged, in 1795, by the Convention, for the Republican Commissaries whom Dumouriez had given up to Austria. In 1799 she married her cousin, the Duc d'Angoulême. She died in 1851, at Frohsdorf, in Austria.

——, The same. (For the Duchesse de Polignac.) 1787.

> One of these pictures (possibly they are identical) was in the Exhibition of National Portraits, Paris, 1878, being lent by Monsieur J. B. Chazaud.

——, The same, with her brother the Dauphin Louis-Joseph (*q.v.*).

ANNE, The Grand-Duchess. ½-length. St. Petersburg, 1795–1801.

—— The same. ¼-length. St. Petersburg, 1795–1801.

ANSPACH, The Margravine of. ¾-length. London, 1802–1805.

> Elizabeth, born in 1750, daughter of the 4th Earl of Berkeley, married at seventeen to Mr. Craven, who soon afterwards succeeded to the Peerage as 6th Baron Craven ; separated from him in 1781, after bearing seven children in fourteen years. After his death she married, in 1791, the Margrave of Anspach, who sold his territories to Prussia and settled with his wife in England. She was the author of some plays, some satires, and of a volume of Travels, as well as of Memoirs, published in 1826, two years before her death. In this last work she refers to the above portrait, saying: "Even Madame Lebrun, who painted a three-quarter length of me, has made an arm and hand out of all proportion to the chest and shoulders."

? ANTRAIGUES, Comte d'. Drawing. J. B. Lebrun. Sale, 1814. 30 fr. 50. (Entered in catalogue of that sale as "Comte d'Entrague.")

> If, as seems probable, this was Emmanuel de Launay, Comte d'Antraigues, it represents a notable figure of the revolutionary period. Born in 1755 (the same year as the artist herself) he declared for the Revolution in 1788. Then he was

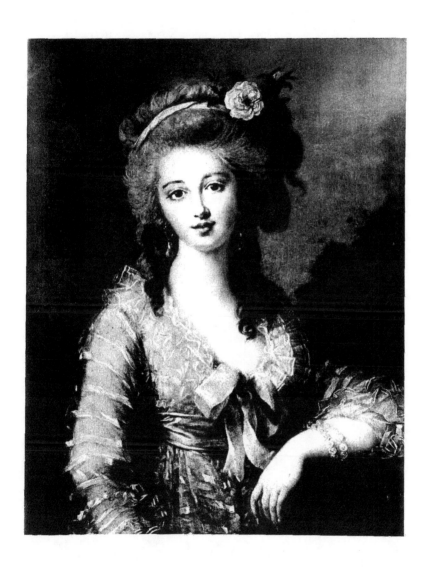

elected to the States-General, and in 1790, having become Royalist, he emigrated, and devoted himself to the Royalist propaganda. He was successful in gaining the support of Pichegru for the Bourbons. In 1812 he and his wife, the former Madame Saint-Huberti of the Opera (*see* Index) were assassinated in London by a servant, who is supposed to have sold his master's political secrets.

APRAXINE, Catherine Vladimirovna, *née* Princesse Galitzin. Head and shoulders. Signed 1796, St. Petersburg, Exposition Artistique et Historique de Portraits Russes, 1905, Collection of Alexandrina Mikhaïlovna Apraxine.

AREMBERG, Princesse d'. 1776.
 Wife of Louis, Prince d'Aremberg, Grand Bailly of Hainault.

ARMAILLE, Marquis d'. 1778.

ARTOIS, Marie-Thérèse de Savoie, Comtesse d'. 1783. White muslin dress, blue sash. Oval, 27¼ × 21¼. Christie's, Feb. 1913. 200 gns.
 Wife of the Comte d'Artois, afterwards Charles X.

——, The same, probably a twin picture. 1783.

ASSISTANT, An (Commis) of Mademoiselle Pigale, Marchande de Modes to the Queen. 1768–1772.

AUGEARD, Madame d'. 1775. Oval, 29¼ × 23⅝. Looking up to right, open corsage, bunch of roses in bodice; right hand placed below left breast. Collections of M. Louis de Silvestre and the Comte de Raffignac. Wildenstein, 1914.

AUMONT, Madame d'. *See* PIENNES, Duchesse de.

B——, La Comtesse de. Oval, 30¾ × 23⅝. Gasquet Sale, Paris, 1888. 2,200 fr.

BACCHANTE, A. Sitting, life-size, ¾-length. Salon, 1785.

BAILLOT, Mademoiselle. 1773.

BANDELAIRE, Monsieur. 1768–1772.

—— The same. Bust. Pastel. 1768–1772.

BANDELAIRE, Madame. 1768–1772.
 Wife of the above.

BANDELAIRE, Mademoiselle. 1768–1772.
 Daughter of the above M. and Madame Bandelaire.

BANKER, A. 1776.

BARIATINSKY, Prince. London, 1802–1805.

BARIATINSKY, Prince Ivan Ivanovitch. Signed. St. Petersburg, Exposition Artistique et Historique de Portraits Russes, 1905, Collection of Prince Alexandre Vladomirovitch Bariatinsky.

—— The same. Same exhibition. Same collection.

BARRY, Comte Jean du. 1773.
 The brother-in-law of the mistress of Louis XV.

BARRY, Marie Jeanne Gomard Vaubernier, Comtesse du. ¾-length. White peignoir bound at waist by mauve ribbon, straw hat trimmed with flowers and a grey feather. 1787. Painted for the Duc de Brissac. Belonged (1793) to the Duc de Rohan-Chabot. Rohan-Chabot Sale, 1807. 400 livres. Paris, Exhibition of Marie Antoinette and her Time, Galerie Sedelmeyer, 1894, Collection of Duc de Rohan. Exhibition Rétrospective Féminine, 1908, same collection. Exhibition of One Hundred Portraits of Women, 1909, same collection.
 1746–1793. Daughter of a clerk of the Octroi service. Married, 1769, to Comte Guillaume du Barry and presented at Court in that year, becoming about that time mistress of Louis XV, over whom she exercised immense influence until his death in 1774, after which she retired to Louveciennes, and lived there as the mistress of

the Duc de Brissac, Governor of Paris. She escaped to England in 1792, but foolishly returned, and, being betrayed by her Asiatic servant, Zamar, was guillotined, Dec. 8, 1793.

BARRY, Comtesse du. The same. Morning dress, straw hat with flowers. Hubert Robert sale, 1809. 302 fr.

—— The same. 1787. Standing. White satin dress. Holds a coronet, and is leaning on a pedestal. Painted for the Duc de Brissac.

Madame Lebrun, after the Revolution, was vexed to find that the face in this portrait had been tinted, as if rouged, since she had last seen the picture. Madame du Barry, says the artist, did not use rouge.

—— The same. Commenced Sept. 1789. Finished after the painter's return in 1802. Madame du Barry is shown seated under a tree, her head resting on her left hand, while the right hand holds a lily and a rose. Simply-made yellow dress, with open neck and sleeves fastened by gold buttons from shoulder to wrist. A white veil on her head. Curly hair. Eyes half closed. Tripier Le Franc sale, 1883. 3,520 fr. Collection of the Baron Fould-Springer, 1912.

—— The same. 1789. Another version of the last ; same pose and similar head-dress, but dark sleeveless dress with short-sleeved white under-bodice. The right hand holding a limp-backed book instead of flowers. Bibliothèque de la Ville de Versailles. This picture is not well authenticated as the work of Madame Lebrun.

—— The same (?). Holding a lily and a rose. Talleyrand sale, 1847. 300 fr.

BEAUGOIN, Madame de. 1777.

BEAUJON, Nicholas. Banker to the Court, Receiver-General at Rouen. 1784.

1718–1799. His later life is illustrated in the painter's *Souvenirs*. He founded a hospital in Paris, still existing, and called by his name.

—— The same. 1785.

—— The same. (For his hospital.) 1785.

At present (1914) there is a sculptured bust of M. Beaujon at " his hospital," but this picture is not there.

BEAUMONT, Comtesse de. 1788.

BELGARDE, Madame de. 1774.

BR. (BÉLIER ?), Mademoiselle. Dated 1785. Paris, Exhibition des Alsaciens-Lorrains, Palais Bourbon, 1874, Collection of M. Rothan.

BELOZERSKY, Anna Grigorievna Kozitzky, Princesse Belosselsky—.signed. St. Petersburg, Exposition Artistique et Historique de Portraits Russes, 1905, Collection of Comte A. V. Orloff-Davidoff.

BENEVENTO. *See* TALLEYRAND, CHARLES MAURICE.

BÉON, Comtesse de. Salon, 1787. ¾-length. Oval. Claret-coloured dress with slashed sleeves, over white muslin bodice, cut low ; yellow sash, hair bound with mauve ribbon. Gold chain with small Maltese cross. 35 × 27½. Sale, Christie's, June 7, 1912. £1,627 10s. (Thrift). Mr. William McKay, 1913.

Wife of François, Comte de Béon, an officer of the King's body-guard. She herself was a lady-in-waiting to Madame Adelaide, aunt of Louis XVI.

—— The same. 1787. Probably a twin picture with the above.

? BERING, Mrs. London, 1802–1805.

BERKELEY, Lady. 1776.

BERRY, Charles Ferdinand d'Artois, Duc de. As a child. Paris, Exhibition des Alsaciens-Lorrains, Palais Bourbon, 1874. Collection of M. Rondeau.

1778–1820. 2nd son of the Comte d'Artois (afterwards Charles X). Married

in England, during the emigration, a Miss Brown, by whom he had two daughters. Louis XVIII insisted on this marriage being annulled, and in 1816 the Duc married the Princess Caroline of Naples, by whom he had one daughter. He was assassinated on leaving the Opera in Paris, Feb. 13, 1820, by Louvel.

BERRY, Princess Caroline of Naples, Duchesse de. Wife of the last named. Salon, 1824. Red velvet dress.

—— The same. Blue velvet dress.

Of these two portraits Madame Lebrun says in her *Souvenirs*, " I do not know what has become of them."

BIBIKOFF, Alexandre Alexandrovitch. St. Petersburg, Exposition Artistique et Historique de Portraits Russes, 1905, Collection of M. Ivan Apollonovitch Bibikoff.

BISTRI. *See* BYSTRY.

BLACHE, Comtesse de la. Paris, Exhibition des Alsaciens-Lorrains, Palais-Bourbon, 1874, and Exhibition of National Portraits, Trocadéro, 1878, Collection of Comte d'Haussonville.

BLACHE, Vicomte de la. 1768–1772.

BLACHE, Vicomtesse de la. 1768–1772.

BOISJELIN, Vicomte de. 1774.

BONNEUIL, Madame de. 1773.

—— The same. 1773

—— The same. 1773.

The beauty of this lady was very attractive to Elizabeth Vigée's eye, and, as we see, she painted three portraits of her in one year.

BORELLY, Monsieur de. 1774.

BOY. *See* AMERICAN.

" BOY IN RED." 25 × 20¼. Wallace Gallery.

The Catalogue of the Wallace Collection (1913) says, " This is probably the same picture that was exhibited as ' Young Nobleman ' at the Bethnal Green Loan Exhibition, 1872–1875."

BRAONNE, Comtesse de. ¾-length. Vienna, 1792–1794.

BRENTE, Madame de. 1776.

BRICHE, Madame de la. 1788. Paris, Universal Exhibition. Exhibition (Retrospective) of the Town of Paris, 1900, Collection of Duchesse de Noailles.

BRICHE, Mademoiselle de la. (A child.) 1786. Salon, 1787.

BRIE, Comte de. 1774.

This man, according to the *Souvenirs*, persecuted Vigée with his dishonourable proposals before her marriage, and afterwards by spreading scandalous lies about her, until M. Lebrun complained to the police, and the nuisance was stopped.

BRIE, Mademoiselle de Saint. 1774.

BRISSAC, Louis Hercule Timoléon, Duc de Cossé, afterwards Duc de. 1778.

1734–1792. Captain of the Cent-Suisses and Governor of Paris. He braved the Revolution as Commandant of the King's Constitutional Guard. Accused of treason by the Jacobins, he was arrested at Orleans. Being brought towards Paris, he and some fellow prisoners were murdered by ruffians in the Rue de l'Orangerie at Versailles. (Sept. 1792.)

—— The same. In Court dress (habit de cérémonie). Pastel. Salon de la Correspondance, 1783.

BRISTOL, Frederick Augustus, fourth Earl of, Bishop of Derry. ¾-length. 49⅝ × 39⅞. Seated to right, face to spectator, clean shaven, grey-brown hair, bluish eyes. Black

clergyman's coat, knee breeches and silk stockings. Left elbow rests on a balustrade, over which can be seen Vesuvius in eruption, and through the pillars of which a town is visible. Naples, 1790. Marquis of Bristol. London. *See* Index.

BRISTOL, Earl'of, Bishop of Derry. The same. ¾-length. 50 × 40. Seated, profile to right. Purple coat, black apron, knee-breeches and silk stockings. Left elbow rests on arm of chair, head supported on left hand. Episcopal ring on third finger of right hand. Bust of Mæcenas on pillar to right. View of mountains in background. Italy, 1790. Sir Henry Bruce, Bt., Downhill, Londonderry.

BRONGNIART, Mademoiselle Alexandrine Emilie. Daughter of M. Alexandre Brongniart, "Architect du Roi." At eight years of age. On wood. 25½ × 20⅞. Curly hair bound with silk kerchief knotted over forehead. Spotted gauze fichu. White dress. She is taking balls of wool from a green silk bag on the table. Salon, 1789. Exhibition of Arts " au début du Siècle," Paris, 1891, Collection of Baron J. Pichon. Baron Pichon sale, 1897. 20,000 fr. ? Bought by the Brongniart family.

—— A child of the architect Brongniart. 1778.

—— Another child of the architect. 1778.

—— " Le Petit Brongniart," (presumably one of the architect's family). 1788.

BRUYÈRE, Jean de la. Author of the *Caractères*. 1775. Done from an old engraving, and presented to the Academy, as described on pp. 14, 15 of this book. 1645 ?–1696.

BUQUOI, Comtesse. Sister of the Prince de Paar. Vienna, 1792–1794.

? BYRON, George Gordon Noel, Lord. The poet, as a youth of 14–17. London, 1802–1805. Madame Lebrun gives " Lord Byron " in her English list, but it seems probable that she has confused some other name with that of the poet. Nothing is known by his family at the present day of such a portrait.

BYSTRY, Comte. A Polish nobleman. Vienna, 1792 (*see* Index).

—— Comtesse. Wife of the above. Vienna, 1792.
These two portraits were formerly in the collection of Count Siemontkowsky, Château de Koustyn, Valonie, Russia.

CADEROUSSE, Marie-Gabrielle de Sinéty, Duchesse de Gramont-. Salon, 1785. A brunette. To right, nearly full face. Large straw hat over lawn scarf which falls from back of head over the shoulders. Black velvet bodice with sleeves to elbow; red skirt. She holds a basket of grapes, which stands on a table. Open air. Marquis de Sinéty.
A miniature, taken from this picture by Villers, signed and dated 1795, is in the Pierpont Morgan Collection.

—— The same. (Wildenstein.)

CAILLEAU or CAILLOT, Joseph. To below the knees. 36¼ × 28⅜. In *Les Deux Chasseurs et la Laitière*. Fowling-piece in hand, game bag slung at his side. Salon, 1787. J. B. Lebrun (after death) sale, 1814. Boitelle sale, 1874. Boitelle sale, 1891. 510 fr. (Haro).
1732–1816. Distinguished actor and singer, of the Comédie Italienne and the Opéra Comique. He retired from the stage at forty.

—— A child of Joseph Cailleau. 1787.

—— Another child of Joseph Cailleau. 1787.

CALONNE, Charles Alexandre de, Contrôleur des Finances. ¾-length. Seated at writing-table. Full face. Black satin coat and knee-breeches. He wears a ribbon and order. 1785. An engraving by De Bréa was published in London in 1802.
1734–1802. Minister of Louis XVI (1783–1787). After his fall from office

he lived for some time in London ; there became the agent of the Bourbon party of Coblentz, in whose interests he spent the greater part of his fortune. In 1802 he returned to France, where he died in October of that year.

CALONNE, Charles Alexandre de. The same. Bust, almost a duplicate of the head and shoulders of the above. 1785. Oval. Exhibition of Marie-Antoinette and her time, Galerie Sedelmeyer, Paris, 1894, Collection de M. Jacques Doucet. Doucet sale, 1912, 19,000 fr.

One of the above portraits of Calonne, apparently, was sold at the Baron Charles de Vèze sale in 1855 for 79 fr.

CARIGNAN, Princesse de. 1785.

The Carignans are a branch of the house of Savoy, from which the present Italian dynasty is descended. The Princess de Lamballe (q.v.) was a Carignan.

CARREAU, Mademoiselle Julie. 1775.

Afterwards the wife of Talma, the tragedian.

CASES, Comtesse de Las. Painted from memory.

Probably wife of the Comte de Las Cases, so closely connected with the later career of Napoleon.

CATALANI, Madame (Angélique). Singing, standing by a piano, looking up. Paris, signed, 1806. 47⅜ × 35½. Low-necked white muslin dress. Diadem on curly brown hair. The music of *Sémiramis* is open on the piano. Talleyrand sale, 1847, 100 fr. Muhlbacher sale, 1907, 10,000 fr.

1782-1849. Born at Sinigaglia. Immensely successful as an opera singer in her native Italy, and in Paris, London, and elsewhere. Madame Lebrun writes : " I made the portrait of that charming woman, wishing to keep it in my own house, where it still hangs as a pendant to that of Madame Grassini."

CATHERINE II, Empress of Russia.

1729-1796. The Empress Catherine, who died less than fifteen months after the arrival of the painter in St. Petersburg, received her with distinction, but never gave her a sitting. It would seem that the Empress was not satisfied with Madame Lebrun's picture of her grandchildren, the Archduchesses Alexandrina and Helena, declaring that she had made them "look like ninnies."

CAZE, Monsieur. 1775.

CHALGRIN, Madame. 1789.

Daughter of Joseph Vernet (q.v.) and wife of a distinguished architect, Jean François Chalgrin. Was guillotined during the Terror, with her friend Madame Filleul (q.v.).

CHASTELLUX, François-Jean, Marquis de. 1789. Painted from memory, the year after his death.

1734-1788. Madame Lebrun calls him " Comte de Chastellux," but there can be little doubt of his identity.

CHATENAY, Comtesse de. Oval. Salon, 1785. Paris, Exposition Rétrospective Féminine, 1908, Collection of Monsieur Féral.

—— Madame de (The elder). 1787.

CHÂTRE, Madame de la. 1789.

? Wife of Claude-Louis, Duc de la Châtre, député to the States-General, afterwards Bourbon agent in London, and (under the Restoration) French ambassador there.

CHAULNES, Duchesse de. 1781.

Wife of Marie-Joseph-Louis, Duc de Chaulnes, who left the army in order to devote himself to natural science. It was he who had such a violent quarrel with

Beaumarchais that the two men were shut up in different strong lodgings to cool their tempers, the Duc at Vincennes and the dramatist at Fort l'Evêque.

CHILD, A. Bust. Paris, Exhibition of Portraits of Women and Children, Ecole des Beaux Arts, 1897, Collection of Madame Edouard André.

CHILD, Portrait of a. Sale, May 13, 1892. 655 fr.

CHINNERY, Mrs. Low-necked red dress, edged with gold embroidery. Lawn veil falling over either ear. Necklace of two strings. She is holding open, on a cushion, a volume of the *Letters of Madame de Genlis*. Signed " L. E. Vigée-Lebrun." England, 1802. 35 × 27. Sedelmeyer.

 One of the hostesses of Madame Lebrun in this country. The artist's welcome at Mrs. Chinnery's house is described in her *Souvenirs*, and is mentioned in this volume.

—— A child of. England, 1802–1804.

—— Another child of. England, 1802–1804.

 Probably these two children are the girl and boy the artist speaks of as " two little angels."

CHOISEUL, Marquis de. 1768–1772. (*See* Index.)

CHOISY, Mademoiselle de. Pastel. Vienna, 1793–1794.

—— Mademoiselle de. Sister of the above. Pastel. Vienna, 1793–1794.

CHOUART, Marquis de. 1776.

CHRISTINE DE NAPLES, Princesse. Daughter of Ferdinand IV, King of Naples. Prado, Madrid.

COËTLOSQUET, General Comte de. Salon, 1824.

COLOGAND, Comte de. 1775.

COLOGAND, Comtesse de. 1775.

COMTE, M. Le. Dans son Cabinet. Exhibition of the Académie of Saint-Luc. 1774.

CONSTANS, Madame. Bust. Paris, 1806.

CONTAT, Mademoiselle, of the Comédie Française. ½-length. To right. Oval, on wood. 30¾ × 24¾. Flowing hair, red dress, white kerchief knotted round head. The head only is finished, the hands scarcely indicated. D'Armaillé sale, 1890. 1,750 fr. (Benard).

? CORDAY, Charlotte. Lecurieux sale, 1862. 440 fr.

 1768–1793. If this picture is really intended to represent the girl who killed Marat, it must have been done from other portraits, or from imagination, as Madame Lebrun had left Paris some years before Mademoiselle Corday d'Armont came from Caen.

COSSÉ, Marquis de. 1778.

 ? Either the Duc de Cossé, afterwards Duc de Brissac (*q.v.*), or his son.

—— Comte de. Salon de la Correspondance, 1781.

 ? A son of the Duc de Cossé, afterwards Brissac (*q.v.*).

—— Mademoiselle de. 1775.

 ? A daughter of the Duc de Cossé, afterwards Brissac.

COURLANDE, Prince Biron de. In hunting dress. London, 1802–1805.

COURVILLE, Madame de. 1775.

CRAON, Princesse de. 1776.

CRAVEN, Elizabeth, Lady. *See* ANSPACH.

CRAVEN, the Hon. Keppel Richard. Third son of sixth Baron Craven and his wife (afterwards Margravine of Anspach). Painted in England about 1803.

 1779–1851.

CRÈVECŒUR, Marquis de. 1777.

CROUY, Princesse de. 1781.

 The family of Crouy (or Croy), spread over Western Europe, supplied an extra-ordinary number of Ministers, diplomatists, cardinals, bishops, generals, and other distinguished persons to several of the great Powers.

CRUSSOL, The Bailli de. Paris, Exhibition of Eighteenth-Century Art, Galerie George Petit, 1883–1884, Collection of Duchesse d'Uzès. Exhibition of French Art under Louis XIV and Louis XV, 1888. Exposition Rétrospective Féminine, 1908, Collection of the Duc d'Uzès.

 It was almost certainly this portrait, painted in 1788 or 1789, for which Madame Lebrun received the hundred louis with which to start for Italy in October 1789. The family of Uzès is descended from the " Sires " de Crussol.

—— The same. Head and shoulders. Large. Paris. Painted after the Revolution.

—— Baronne de. Salon, 1785. Seated on couch ; looking over her left shoulder. She wears a big hat ; hair loose down back ; holds a book of music. Now in Museum of Toulouse. Engraved by A. Belzers, whose version was reproduced in colours in the *Connoisseur*, Christmas 1913.

CUPID. Asleep under a rose-bush, watched by two nymphs. 1789. (For M. le Pelletier de Mortfontaine.)

CZARTORYSKA, Princess Isabella, *née* Comtesse Fleming, wife of the Prince Adam Casimir. With dog. She wears a round cap. Reading music at a piano. Vienna, 1792–1794. Galerie Czartoryski.

 1743–1835. Known as an accomplished student of art and literature, and as a collector. Her collection of Polish historical souvenirs, formed at Pulawy, her husband's family seat, was confiscated in 1832 by the Emperor Nicholas I.

—— The same. Attributed to Madame Lebrun.

CZARTORYSKI, Prince. Vienna, 1792–1794.

 ? Adam Casimir, 1734–1823. Polish noble who became Field-Marshal in the Austrian army, or his son, Adam Georges.

—— The same. In a mantle. Vienna, 1792–1794.

DAILLY, Monsieur. 1778.

 ? d'Ailly.

—— Madame. 1778.

 ? d'Ailly.

DAMERVAL, Madame. 1774.

DANCING GIRL. Full-length. White dress, red scarf. Exhibited at Burlington House, 1879, Sir Edward Sullivan's Collection.

DARTOIS, Mademoiselle. 1777.

—— The same. 1777.

DAUDELOT, Madame. 1786.

DAUPHIN, The, Louis Joseph, eldest son of Louis XVI. 1783.

 1781–1789.

—— The (Louis Joseph) and his sister, " Madame Royale," holding a bird's nest, in a garden. Salon, 1785. Now at Versailles. Engraved by Blot.

—— The. Louis Charles, second son of Louis XVI. Salon, 1789. Painted for the Duchesse de Polignac.

 1785–1795. At first known as Duc de Normandie, he became Dauphin on his brother's death in 1789. He is believed to have died in the Temple on June 8, 1795.

13

DAVARAY, Madame. 1786.

DAVIDOFF, Madame *née* de Gramont. Salon, 1824.

DEGÉRAUDOT, Madame. 1778.

DE LA WARR, Lady Elizabeth Sackville, afterwards Countess. 1802–1804.
Daughter of the third Duke of Dorset and his Duchess (*q.v.*).

DELILLE, L'Abbé Jacques. Painted from memory.
1738–1813. His translation of the Georgics (1769) brought him into notice, and five years later he became a member of the Academy. His benefice of Saint-Séverin, given him by the Comte d'Artois, brought him 30,000 fr. per annum. He lost his fortune at the Revolution, and narrowly escaped in the Terror. Refusing to compose a hymn for the fête of the Supreme Being in 1795, he removed to Basle. Returned to Paris under the Consulate, where he resumed work as Professor of Latin Poetry at the Collège de France. Delille was one of the brightest spirits in Paris social life, and was always a general favourite.

DEMIDOFF, Madame, *née* Strogonoff. St. Petersburg, 1795–1801.

DENIS, Madame. 1775.
The niece of Voltaire.

— Monsieur de Saint-. 1776.

DEPLAN, Madame. 1775.

DERVISCH KHAN, Mahomet. Full-length. Standing, in Oriental costume, scimetar in right hand. 88⅝ × 59¼. Ambassador from Tippoo-Sahib, Sultan of Mysore. Salon, 1789. J. B. Lebrun (after his death) sale, 1814. 112 fr. (Constantin). Collection of Lord Trimlestown. Madame Cottin sale, 1872. M. Marnier Lapostolle, 1908.
Sent to France in 1787, with Usman Khan (*q.v.*), to seek the help of Louis XVI against the English. Both envoys were decapitated on their return because their mission had failed.

DESMARETS, Monsieur. 1774.

DEVARON, Mademoiselle. 1781.

DIANA. Bust. Salon de la Correspondance, 1783.

DICBRIE, Madame. 1779.

DIETRICHSTEIN, Comte. St. Petersburg, 1795–1801.

— Comtesse. Wife of above. St. Petersburg, 1795–1801.

DILLON, Miss. London, 1802–1805.

DITTE, Madame. Paris. After the Revolution.

DOAZAN, Madame. Paris, Exhibition of French Art under Louis XIV and Louis XV, 1888, Collection of Baron de Bully.

DOLGOROUKY, Princesse Cathérine-Féodorovna, *née* Princesse Bariatinsky. Signed. St. Petersburg, 1795–1800, Looking up to right. Seated by a table, holding an open music-book. St. Petersburg, Exposition Artistique et Historique de Portraits Russes, 1905, Collection of Comte A V. Orloff-Davidoff. Prince P. Dolgorouky, 1913.
The intimate friend of the Princess Natalie Kourakin, and a friend of the painter also.

— The same. Presumed portrait of. Oval, 32¼ × 25½. Half-length. Full-face, walking in a wind, which blows her hair about. She is wrapped in a shawl under which she keeps her hands. Collection of Prince Lubomirsky. Beurnonville sale, 1881. 4,700 fr.

DOMNIVAL, Monsieur de. 1778.

DOMNIVAL, Madame. 1778.

DORION, Mademoiselle. 1768–1772.

— ? The same. 1789.

DOROTHEA, Princess of Wurtemberg, Empress of Russia, second wife of the Emperor Paul I. ? Painted at Vienna, 1793–1794. Hocedé sale, 1854.

DORSEN, Comte de. (Fils.) 1779.

DORSET, Arabella Diana, third Duchess of. England, 1802–1804. Nearly full face. Velvet dress with high waist and V-shaped bodice, white under-bodice with lace ruffle. Lord Sackville, Knole.

 Daughter of Sir John Cope, Bt. Some time after the Duke's death (1799) she married Sir A. Whitworth, formerly British Ambassador at St. Petersburg, who was given an earldom and became Earl Whitworth.

DUCLUZEL, Monsieur. 1775.

—— Madame. 1779.

—— The same. 1779.

DUCAZON, Jean Baptiste Henri Gourgault, known as. Oval, 8 × 6. Marquise du Plessis Bellière sale, 1897. 995 fr.

 1743–1809. Comedian. During the Revolution he was aide-de-camp to Santerre. The above miniature represents him in the rôle of " Unique," in a burlesque called *Syncope*, given at the Court on Jan. 31, 1786.

—— Louise Rosalie Lefèvre, Madame, actress of the Comédie Française, as Nina, " at the moment when she thinks she hears Germeuil." (The play was *Nina, ou la Folle par Amour*. Salon, 1787. 57½ × 45¾. Seated under a tree ; flowers in right hand, roses in hair. White muslin dress, light violet waistband. De Salverte sale, 1887. 24,000 fr. (C. de Pourtalès.) Paris, Exhibition of One Hundred Portraits of Women, 1909. Collection of the Comtesse E. de Pourtalès. In possession of the family of the Comtesse, 1914.

 1755–1821. Married Jean B. H. Dugazon, the comedian (*q.v.*), but divorced. After years of success in the parts of *jeunes amoureuses* and soubrettes, she had to take the parts of elderly women, on account of her increasing stoutness, and made another lasting success. Several other artists painted her in the same scene.

—— The same. In the same character. 31½ × 25. Dark bodice, crimson skirt, white muslin fichu, blue riband round hair. She is cutting a rose from a plant on a table. Christie's, May 22, 1914, 400 gs. (Coureau).

? —— The same. Marille (2nd) sale. 1857. 93 fr.

DUMESNIL. Recteur de l'Académie de Saint-Luc, Paris. Exhibition of that Society, 1774.

DUMOLEY, Monsieur (Junior). 1781.

—— Mademoiselle de. 1781.

—— Madame. 1788.

DUPETITOIRE, Mademoiselle. 1773.

 ? Dupetit-Thouars. If so, possibly a sister of the brothers Louis and Aristide, who sailed in 1792 on the fruitless search for La Pérouse.

DUTHÉ, Mademoiselle. 1789. One knee rests on a blue sofa, whereon are some books. She has a picture in her hands. 28¾ × 23¾. Sale, 1845, 61 fr. Sale, 1857, 550 fr. Raguse sale, 1857, 587 fr. Boitelle sale, 1891, 3,050 fr. (Brame). Paris, Exhibition of Portraits of Women and Children, École des Beaux-Arts, 1897, Collection of M. Bardac.

 A beautiful courtesan. Madame Lebrun says in one of her letters to Princess Kourakin : " Vous ne sauriez avoir une idée, chère amie, de ce qu'étaient les femmes entretenues à l'époque dont je vous parle. Mademoiselle Duthé, par exemple, a mangé des millions."

Duthé, Mlle. Round picture. She is wearing a straw hat. Tuffiakin sale, 1845. 61 fr.
Duvernais, Madame. 1789.

E——, the Young Comte d'. Comte d'Espignac sale, 1868. 5,100 fr.
Elisabeth Alexievna. Wife of Alexander I, Emperor of Russia. ½-length, standing, arms resting on a cushion. Hair loose over shoulders, curls over ears. Thin necklace three times round neck. Musée, Montpellier.
—— The same. Diadem and veil on head. Talleyrand sale, 1847. 115 fr.
—— The same. To waist. Poppy-coloured dress, trimmed with embroidery, and with gold waistband. Gauze veil over shoulders. Oval, 26 × 21¾. Dubreuil sale, 1821, 280 fr.
—— The same, as Grand Duchess. Pastel. St. Petersburg, Exposition Artistique et Historique de Portraits Russes, 1905. Palace of Gatchina.
—— The same. Same exhibition. Signed. Grand Palais, Tsarko-Selo.
—— The same. Standing. Hermitage. Galerie Romanoff.
—— The same. Full-length. Arranging flowers in a basket. St. Petersburg, 1795–1801.
—— The same. ½-length replica of above.
—— The same. Another ½-length replica.
—— The same. Bust, showing one hand.
—— The same. Bust, showing one hand.
 All painted at St. Petersburg, 1795–1801.
Elisabeth de France, Madame. "En bergère." Straw hat, green bodice laced, red skirt, holding a bunch of flowers, 1782. Paris, Exhibition of Marie-Antoinette and her time, Galerie Sedelmeyer, 1894, Collection of Comte des Cars.
 1764–1794. Philippine Marie Hélène de France, known as "Madame Elizabeth." Sister of Louis XVI. Guillotined.
—— The same. Replica of same.
—— The same. 1783. ½-length. Oval, 31½ × 24½. Low-cut white dress, blue sash, wreath of roses round head. Marquis du Blaisel sale, 1870, 1,560 fr. Marquis de Blaisel sale, 1873, 4,100 fr. Exhibition of National Portraits, Trocadero, Paris, 1878. Portalier sale, Nice, 1880, 6,100 fr. Secretan sale, 1890, ? 6,100 fr. Grafton Fair Women Exhibition, 1894. Price sale, Christie's, 1895 (C. Davis), £525. Sold in June 1895, £620.
—— The same. 1783. To waist. Full face. Straw hat trimmed with flowers. Low-necked dress of violet silk. 29½ × 23¼. Comte J. de Bryas sale, 1898, 14,200 fr. (Lowengard.)
—— The same. ½-length. Cambric cap with blue ribbon, white dress and blue sash. Attributed to Vigée-Lebrun, but of doubtful authenticity both as to artist and subject.
—— See Parme, Duchesse de.
Entrague, Comte d'. See Antraigues.
Escars, Baron d'. (A child.) 1788.
Espagnac, Baron (Fils). A child. 25¼ × 21. Salon, 1787. Comte d'Espignac sale, 1866, 5,350 fr. Exposition Rétrospective de Tableau de Maîtres, May 1866, M. Dugied.
Esterhazy, Princesse d'. Vienna, 1792–1794. Full-length. Seated on rocks at the edge of the sea.
Esthal, La Baronne. 1768–1772.
—— A child of the Baronne. 1768–1772.
—— Another child of the Baronne. 1768–1772.

F——, La Maréchale. 60⅜ × 54⅜. In a wood near a spring. White satin, low-necked dress, with lilac waistband. Straw hat with lilac strings, white feathers. Sale, March 13, 1893.

FARGUE, Madame de la. 1777.

FEISTHAMEL, Baron de. Painting a picture. Paris. After the Revolution.

FERRONNAYS, L. de Lostanges, Marquise de la. 24½ × 20. White dress edged with fur; blue ribbon tying her curled hair. Comtesse de la Ferronnays sale, Paris, 1897, 5,800 fr.

FERTÉ, Mademoiselle de. 1779.

FÈVRE, Monsieur le. The artist's step-father. Wearing dressing-gown and nightcap. 1768–1772.

FEZENSAC, Anne-Pierre, Marquis de Montesquiou-. 1779.

 1739–1798. Equerry to the Comte d'Artois. Soldier, Député of the nobles to the States-General. Commander of the Army of the Midi in 1792, and conquered Savoy. Author of essays on finance, verses, and memoirs.

—— The Marquise. Wife of the above. 1779.

—— Baron de Montesquiou-. 1782.

 ? Son of the Marquis.

—— Baronne de Montesquiou-. 1780.

 Wife of the above. ? Married in 1780, at fifteen years of age.

—— Louise Letellier de Montmirail, Comtesse de Montesquiou-. Governess of the King of Rome. Montesquiou-Fezensac sale, 1872. 12,050 fr. Exhibition of the Alsaciens-Lorrains, 1874, Collection of the Vicomtesse de Cessac.

FILORIER, Madame. 1778.

FINNEL, Monsieur le. 1777.

FLEURY, André Hercule, Cardinal de. 1775. Done from an old engraving, and presented to the Academy.

 1653–1743.

FODI, Madame de, 1785.

FOISSY, Madame de. 1778.

 ? Fossy (q.v.).

FONTAINE, Monsieur de la. 1773.

 ? From an engraving of Jean de la Fontaine (1621–1695), author of the *Fables* and the *Contes*.

FOSSY, Madame de. 1768–1772.

—— (A boy). 1768–1772.

FOUGERAIT, Madame de. 1775.

FOULQUIER, Madame. 1780.

FOURNIER, M. Conseiller de l'Académie de Saint-Luc. 1774.

FOUQUET, Mademoiselle. (A child). 1786.

FRANCIS, Hereditary Prince of Naples. Afterwards King. As a boy. Naples, c. 1790.

FREDERICA CHARLOTTE (H.R.H.), Duchess of York. ½-length. She is wearing a lace collarette on an open bodice. Turban with metal ornament in front, and feather. Engraving by Meyer (published by Fisher, Feb. 24, 1827) in B.M.

FRIES, Maurice, Comte de. Pastel. Vienna, 1792–1794.

 A young man. Engraved by Jean Keller. *See* HAUGWITZ.

—— Mademoiselle la Comtesse de. Oval, ½-length. As Sappho, holding a lyre and singing. Vienna, 1793–1794. Duveen Exhibition, London, 1906. Formerly in the Tatlet Collection. Exhibited at Bagatelle, 1911.

GALITZIN, Princesse Alexandrina Petrovna, *née* Protassof. With her nephew, Prince Vassilt-chikoff. Signed, St. Petersburg. 1795-1801. St. Petersburg, Exposition Artistique et Historique de Portraits Russes, 1905, Collection of Prince Ivan Ilarianovitch Vassiltchikoff.

—— Princesse Anna Alexandrovna, *née* Princesse Grouzinsky. Leaning on a cushion. Aigrette and feather in head-dress. Signed. St. Petersburg, Exposition Artistique et Historique de Portraits Russes, 1905, Collection of Elizabeth Alexievna Narychkine. In same collection, 1913.
 In her first marriage Madame de Litzyne.

—— Princesse Eudoxia Ivanovna, *née* Ismailoff. Signed. St. Petersburg, Exposition Artistique et Historique de Portraits Russes, 1905, Collection of Marie Pavlovna Rodzianko.

—— Princesse Louise. Vienna, 1792-1794.

—— Princesse Michel, Bust. Large. St Petersburg, 1795-1801.

—— Princesse Bauris (? Boris), Nearly full-length. St. Petersburg, 1795-1801.

GANISELOT, Mademoiselle de. 1775.

GENLIS, Félicité Stéphanie, *née* Ducrest, Comtesse de. Marcille sale, 1857.
 1746-1830. The celebrated author, and governess to the children of Philippe Egalité.

GENTY, Madame. 1780.

GEOFFRÉ, Comte de. 1773.

—— The same (?) 4 Replicas of the above portrait. 1773.

GÉRAC, Marquise de. 1775.

GIRL, A, carrying basket of flowers. Sale, Jan. 25, 1878, 1,000 fr.

—— Portrait of a. Pastel. Hulot sale, 1892, 1,000 fr.

—— Head of a. Drawing. Signed. Louvre.

—— A. Drawing in black chalk. Signed and dated 1785. 11¾ × 8⅝. J. B. Lebrun sale, 1814, 14 fr. (Paillet.)

—— A young. Bust. Head on one side, with finger to mouth. A sketch. Oval, 47⅞ × 34½. 1799. Citoyen Cochu sale, 26 livres 5 sols.

—— A peasant. Pembroke sale, 1862, 230 fr.

—— A young, at a piano. Violet dress. White hat with feathers. 1845. De Cypierre sale, 410 fr.

—— A young. Discovered writing.

—— A young. " Effrayée d'être surprise en chemise et se cachant la gorge." ? Sale . . . January 1857, as " La Surprise."

—— A young. " Respirant une rose." ½-length. Pastel. 1781. Salon de la Correspondance, 1781.

—— A young. Preparing to paint a picture. Paris, Exposition Rétrospective Féminine, 1908, Murray Scott Collection.

—— A young. In black shawl. 39½ × 31½. Christie's 1910. £147. (Glen.)

—— A young. Yellow dress, red shawl. " Portrait in an oval." On wood. Comte Vincent Potocki sale, 1820. 9 fr.

—— A young. 21¼ × 17⅞. Powdered hair, Dugléré sale, 1853. 41 fr.

—— A young. Oval, 32¼ × 25½. Beurnonville sale, 1881. 4,700 fr.

—— A young. Directoire period. Meynier Saint-Fal sale, 1860.

—— A young. Oval. Powdered hair. Wagnier de Labarthe sale, 1857.

—— A young. Paris, Exposition des Alsaciens-Lorrains, 1874, Collection de M. Barre.

—— A young. Pencil drawing. Oval, 7½ × 6. ½-length. Full face, head leaning to

left. Hair curled, and hanging over back of neck. Large fichu. Beurdeley sale, 1905. 7,050 fr.

GIRL, A young. Red chalk. 6 × 9½. Standing, seen from behind. Low-necked dress with short sleeves; head turned three-parts to left; small cap. Chennevières sale, 1898. 1,000 fr. (Dubois.) Dubois sale, 1901. 780 fr.

—— A young. A drawing in Indian ink. ½-length. Oval. 9 × 8. Flowers in her light hair. Baron Schwiter sale, 1883.

—— A young. Head. Stump-drawing and red chalk. 14½ × 11. Alfred Sensier sale, 1877.

—— A young. Bust. Stump-drawing and red chalk. Palla sale, 1873.

—— A young. Red chalk. Seen from behind. Peasant dress. Baron V. Denon sale, 1826. 32 fr. " With two pen-and-ink sketches by Watteau " !

—— A young. 9⅞ × 7⅞. Declou sale, 1898. 3,050 fr.

—— A young. 17¼ × 14¼. Blonde. Black mantilla on head, and falling over bosom, which is partly exposed. Duchesse de Berry sale, 1865. 1,800 fr.

—— A young. Oval, 8¼ × 7. Full face. Head and shoulders. Light, curling hair, bound with blue ribbon. White dress edged with gold lace. Bérandière sale, 1885. 620 fr. (Féral.)

—— A young. Oval, 31½ × 24½. To left. ½-length. Seated in armchair. Her arm supported on a ruby velvet cushion. She holds a small book. Nearly full-face. Hair curled and powdered. White dress, muslin fichu edged with lace. De Salverte sale, 1887. 8,000 fr. (Gouin.

—— A young. Oval, 9⅞ × 7⅞. Seated, leaning on a table, with a pencil-holder in her hand. Decloux sale, 1898. 3,050 fr. (Comte de Bari.)

—— A, Picking roses. Gasquet sale, Paris, 1888. 850 fr.

—— A young. Wreath in hair. Oval, 21 × 17¼. Christie's, 1911. £99 15s. (Thorne.)

—— A. Standing. Back view. Sanguine. Marquis de Chennevières sale, 1898. 5⅞ × 9½. 1,000 fr.

GIRLS, Two young. Oval, 30 × 24½. " The Two Sisters." One brunette, the other blonde ; standing, with arms intertwined. ½-lengths. White muslin, low-necked dresses, embroidered. The brunette has a waistband of yellow silk, the blonde a blue drapery with yellow embroidery over her right arm. Christie's (Schwabacher sale), 1906, £63. (McLean.) Sedelmeyer sale, 1907, 11,000 fr.

GIROUX, thé Abbé. 1774.

GIVRIS, Mademoiselle de. 1775.

GOBAN, Monsieur. 1775.

GOLOVKIN, Prince Theodore Gravilovitch. Signed. St. Petersburg, 1797. St. Petersburg, Exposition Artistique et Historique de Portraits Russes, 1905. University of Kieff.

GOLOVIN, Comtesse. Showing one hand. St. Petersburg, 1795–1801.

GONTAULT, Comtesse de. 1774.

GORDON, Lady Georgiana. London, 1802–1805.

GOURBILLON, Madame de. Full face, wearing a bonnet. Canvas, backed with wood, 18½ × 13. Signed and dated, Turin, 1792. Paris, Exhibition of Marie-Antoinette and her time, Galerie Sedelmeyer, 1894, Collection of M. Giacomelli. Giacomelli sale, 1905. 23,000 fr. (Ed. Veil-Picard.)
 Afterwards Lady-in-Waiting to Louise de Savoie, wife of Louis XVIII.

—— A son of the above, c. 1792.

GRAMONT. See CADEROUSSE-GRAMONT.

GRANGE, Madame de la. 1774.

GRASSINI, Giuseppa. London, 1802–1805. As "Zaire," in the title-rôle of Peter von Winter's opera. Red tunic without sleeves, over a dress of muslin flowered with roses; waistband with gold buckles. Paris, Exhibition of National Portraits, Trocadero, 1878. Musée de Rouen. Engraved by S. W. Reynolds.

 1773–1850. One of the most successful prime donne of her time.

—— The same. Small copy of above. London, 1802–1805.

—— The same. ½-length. 31½ × 24¾. Dark yellow dress, red mantle, diadem of pearls and feathers, cameo on waistband. Bequeathed by the painter to the Academy of Vaucluse. Exhibition of National Portraits, 1878. Musée Calvet, Avignon.

—— The same. Bust. London, 1802–1805.

—— The same. ¾-length. Paris, after the Revolution.

—— The same. ¾-length. Paris, after the Revolution.

—— The same. Showing one hand. ¾-length. Paris, after the Revolution.

GREEK WOMAN, A. Pastel. Oval. Bust. Hair falling over breast, half-covered by a white drapery. J. B. Lebrun sale, 1778.

GRÉNONVILLE, Mademoiselle de. Bust. Paris, after the Revolution.

GRÉTRY, André Ernest Modeste. Oval. ½-length. Full face. Salon, 1785. Versailles. Engraved by L. J. Cathelin, 1786.

 1741–1813. Composer and musician.

GROLLIER, Marquis de. 1788.

—— The same. 1789.

—— Marquise de. Painting flowers. Paris, after the Revolution.

GROS, Antoine Jean, Baron. As a child. 1776.

 1771–1835. Painter.

GUICHE, Aglaë de Polignac, Duchesse de. ? Vienna, 1792–1794. Full face. Bust. Loose hair caught up by a blue ribbon. Red dress in antique fashion. Paris, Exhibition of Marie-Antoinette and her Time, Galerie Sedelmeyer, 1894, Collection of Duc de Gramont.

 1768–1803. Daughter of Duc et Duchesse de Polignac (q.v.).

—— The same. Two portraits. 1783.

—— The same. Life size. ½-length. Pastel. Oval. Dated 1784. 31½ × 21¾. Peasant costume Low-necked red bodice, bare arms, hands crossed on bosom, holding gauze fichu. Light hair, curled; lace cap with blue ribbon. Comte de V—— (? Vaudreuil) sale, 1881. 16,000 fr., (Comtesse de Montesquiou). Montesquiou-Fezensac sale, 1872.

—— The same. Holding a garland. 1787.

—— The same. 1789. Pastel. 31½ × 21¾. Comte de Vaudreuil sale, Paris, 1881. 1500 fr.

—— The same. Another pastel. 1789.

—— The same. Salon, 1824.

—— The same. Same period.

GUICHE, Marie Jeanne de Clermont-Montoison, Marquise de la. Salon, 1783. "En jardinière." Paris, Exhibition des Alsaciens-Lorrains, Palais Bourbon, 1874, Collection of Marquis de la Guiche. Exhibition of National Portraits, Trocadero, 1878, same collection. Exhibition of Portraits of Women and Children, École des Beaux-Arts, 1897, Collection of Marquise de la Guiche.

—— The same. "En laitière," 1788. Open air. Seated. Low-necked, laced bodice, plain skirt; blue corn-flowers in right hand, left arm resting on a milk-pitcher. Marquis de la Guiche.

GUISFORD, Lady (? Gaisford). Pastel. Vienna, 1793–1794.

HAMILTON, Lady. As the Persian Sibyl. Rome, 1792. 53⅞ × 39⅜. Seated, face looking up; left hand extended, right hand holds a tablet, stylus, and parchment. Red robe, light green turban, brown drapery over knees. Sale, 1865. 5,000 fr. Paris, Exhibition of one hundred Portraits of Women, 1909, Collection of the Comtesse E. de Pourtalès. Duchesse de Berry sale, 1865. 5,000 fr. (De Pourtalès.)

 1761?-1815. The favourite model of Romney.

—— The same. Head. As a Sibyl, Naples, 1790.

 Study for the head of the last-named picture.

—— The same. As a Bacchante. Naples, 1790. 4 ft. 7 × 5 ft. 3. Reclining beneath a vine, near the sea. Bare arms resting on leopard skin which lies on a rock. Wine-cup in left hand. Very long hair falling over shoulders. Loose white robe. Rock to right. Purchased from Sir William Hamilton by Mr. William Chamberlayne. Grafton Gallery, Romney Exhibition, 1900. Mr. Tankerville Chamberlayne, Cranbury Park.

 This picture was at one time in Romney's studio, and that painter expressed a high opinion of it. After being engraved it was reduced in size. Above are its present dimensions. An enamel by H. Bone, said to represent Vigée-Lebrun's " Portrait of Lady Hamilton as Ariadne " and left by Sir Wm. Hamilton to Nelson, was sold at Lord Northwick's sale, in 1859, for £735 (Marquis of Hertford). Nelson bought a portrait of Lady Hamilton, apparently by Vigée-Lebrun, in 1801 (See Dr. Pettigrews book). Sir William Hamilton grumbled at "Emma" for being covered with a " tiger's " skin in the picture.

—— The same. As a Bacchante, dancing, with a tambourine. 52½ × 41½. Flowing hair, nude arms, vine leaves on head. In background to left, Vesuvius in eruption. Tripier Le Franc sale, Paris, 1883. 1,150 fr. Now in possession of Sir W. H. Lever, in the Hulme Hall at Port Sunlight. There is a mezzotint by J. B. Pratt.

HARCOURT, Comtesse d'. 1774.

HARDIK, Mademoiselle la Comtesse Thérèse de. Pastel. Vienna, 1793-1794.

HARRACH, Comtesse d'. Pastel. Vienna, 1793-1794.

—— The same. Small pastel drawing. Vienna, 1793-1794.

HARVELAY, Madame d'. 1781.

 Wife of the Keeper of the Royal Treasury, and afterwards wife of Calonne (q.v.).

HAUGWITZ, Sophie, Comtesse de, née de Fries. As a Muse, wearing a red robe. Vienna, 1793-1794.

 Engraved by Jean Keller.

HEAD, A. Leaning to one side. Painted for the Duc de Cossé. 1779.

—— Study of a. 1781. For M. le Pelletier de Mortefontaine.

—— For M. Proult. 1781.

—— A small. Bologna, c. 1792. For the Institute of Bologna.

—— A. Painted at Parma, c. 1792. For the Academy of Parma.

—— A. Pastel sketch. Haupmann sale, Paris, 1897. 250 fr.

—— Study of a. 24 × 20. Baron Mourre sale, 1892. 1,250 fr.

HEADS, Three studies of. 1781. For the Duc de Cossé.

HELENA AND ALEXANDRINA PAVLONA, Grand-Duchesses. Holding a medallion of the Empress Catherine, at which they are looking. Signed. St. Petersburg, 1796. St. Petersburg, Exposition Artistique et Historique de Portraits Russes, 1905. Palace of Gatchina. (Engraved 1799.)

HENNET, Madame. 28⅞ × 23. Black hair, blue eyes, light brown low-necked dress, with embroidered edging. Red shawl over right shoulder and left arm. Comte C—— sale, April 30, 1898, 550 fr. Comte A. de Ganay sale, 1903, 4,700 fr.

HERMINE, M. de Saint-. 1785.

HUBERT, Monsieur Saint-. 1777.

INNOCENCE taking refuge in the arms of Justice. Pastel. 1779. Musée d'Angers.
Engraved by Francesco Bartolozzi.

INTERLAKEN, View from, during a Cantonal fête. 33¼ × 44⅞. Talleyrand, Valençay,
Sagan sale, 1899, 1,000 fr.

Fête des Bergers at Unterseen, described in the Artist's *Souvenirs*, and in the
present volume.

ISOUPOFF, Princesse. ¾-length. St. Petersburg, 1795–1801.

—— Prince. Son of the above. St. Petersburg, 1795–1801.

—— Daughter of the Princesse. St. Petersburg, 1795–1801.

JAFFRAY, Marquise de. Standing, playing a harp. ? Christie's, 1874, as " A Lady singing
with a Harp." £50 8s. Exhibited at Guildhall, 1902, as " Madame Roland " (*q.v.*).
David H. King, Jr. sale, New York, 1905. (M. Wildenstein.)

JAUCOURT, Marquise de.

Wife of Arnail François Marquis de Jaucourt, 1757–1852, who served under
Louis XVI, was imprisoned in 1792, and released through the influence of Madame
de Staël. He served also under Napoleon and under Louis XVIII. He was a Pro-
testant.

JEUNE, M. le. 1787.

JOSEPH II, Emperor of Austria. Oval, 28 × 22½. Bust. Full face. Blue coat, white
striped waistcoat and white neckcloth. Cross and ribbon of an order. Beraudière
sale, 1885, 500 fr.

The brother of Marie Antoinette.

JUMILHAC, Madame de. 1775.

JUNO coming to borrow the girdle of Venus. 19 × 14½. Salon, 1783. Bought in that
year by the Comte d'Artois for 15,000 fr.

Venus, crowned with roses, is seated on a cloud. Cupid plays with the girdle
which Venus unlooses ; Juno stands before her.

—— Sketch for the above. 1781.

The picture itself, or the preliminary sketch, was sold for 375 fr. at the E. Vincent
sale in 1872.

KALITCHEFF, Madame. St. Petersburg, 1795–1801.

KAQUENET, Mademoiselle de. Vienna, 1792–1794.

KASISKY, Mademoiselle, Sister of Princesse Belosselsky-Belozersky (*q.v.*). St. Petersburg,
1795–1801.

KINSKA, Comtesse. ¾-length. Vienna, 1792–1794.

—— The same. Bust. Vienna, 1792–1794.

Née Comtesse de Dietrichstein.

KOTCHOUBEY, Princesse Marie Vassilievna, *née* Vassiltchikoff. Engaged in drawing. St.
Petersburg, Exposition Artistique et Historique de Portraits Russes, 1905. Collection
of Marie Alexandrovna Vassiltchikoff.

KOURAKIN, Prince Alexandre Borisovitch. Bust. Signed. St. Petersburg, 1795–1801.
St. Petersburg, Exposition Artistique et Historique de Portraits Russes, 1905,
Collection of Prince Theodore Alexievitch Kourakin. Engraved.

1752–1818. Educated as companion in studies with Paul I, he was his Chief
Minister throughout his reign, and became Vice-Chancellor at the opening of the

reign of Alexander I. He negotiated the Peace of Tilsit (1807), and was Russian Ambassador in Paris 1808–1812.

KOURAKIN (*continued*) The same. Bust. St. Petersburg, 1795–1801.

—— Prince Alexis. St. Petersburg, 1795–1801.

—— Princesse. Wife of the above. St. Petersburg, 1795–1801.

Nathalie, Princesse Kourakin, an intimate friend of the painter. Madame Lebrun addressed to her a series of letters which form the opening part of the *Souvenirs*.

KOUTOUZOFF, Princesse Catherine Ilyinichna Golenitchiff, *née* Bibikoff. St. Petersburg, 1795–1801. St. Petersburg, Exposition Artistique et Historique de Portraits Russes, 1905, Collection of Nicolas Nicolaevitch Toutchkoff.

Wife of the celebrated Field-Marshal Koutousoff, Prince of Smolensk, who pursued the Grand Army of Napoleon so vigorously during the retreat from Moscow, 1812.

LABORDE, Madame de. 1774 or 1775. On wood. 41 × 32. White spotted muslin dress, small claret-coloured jacket. Muslin toque. Her waistband fastened with a medallion as buckle. Seated on a divan, her elbow on a green velvet cushion. Lyne Stephens sale, Christie's, 1895. £2,362 10s. (Agnew.) Exhibited at Burlington House, 1896 (No. 53) as "Portrait of the Painter," and at the Guildhall, 1898, as "Portrait of a Lady," J. P. Morgan Collection.

Rosalie, wife of Jean Joseph, Marquis de Laborde (1724–1794); Banker to the Court; a generous philanthropist. He was guillotined by sentence of the Revolutionary Tribunal.

—— Mademoiselle de. 1781.

Daughter of the Marquis de Laborde and his wife (*q.v.*). ? Afterwards wife of Comte Angiviller (*q.v.*).

—— The same. 1781.

LADY, Portrait of a. Full face, large hat "à la paysanne." Oval. Paris, Exhibition of Marie Antoinette and her Time, Galerie Sedelmeyer, 1894, Collection of Monsieur J. Doucet.

—— Portrait of a (Madame la Baronne de ——). Wife of an Intendant of Louis XVI. Oval, 22⅞ × 18⅞. Gasquet sale, 1888. 2,400 fr.

—— Portrait of a. Bust. 22⅞ × 18½. Gasquet sale. 1888. 950 fr.

—— Portrait of a, of the Court of Louis XVI. Pastel. Painted in 1793. Sale C——, Feb. 2, 1884. 100 fr.

—— Portrait of a. 31⅞ × 24¾. Sale, May 3, 1897. 6,300 fr.

See MAN, same sale, size, and price.

—— Portrait of a, of the time of Louis XVI. Oval, 31½ × 24¾. Marquis du Blaisel sale, 1870. 1,550 fr.

Cf. Oval picture of Madame Elizabeth de France. 1783.

—— An Irish. London, 1802–1805.

—— Portrait of a. In a pink shawl. Oval, 27½ × 22½. Christie's, 1909. £57 15s.

—— Portrait of a. Painting a picture. Paris, Exhibition of Portraits of Women and Children, École des Beaux-Arts, 1897, Collection of Monsieur Gérome.

—— Portrait of a. In crimson cloak. 25 × 21. Christie's, 1906. 440 gns. (Dowdeswell.)

—— Portrait of a. Low-necked dress. Muslin kerchief over shoulders. Flower in bosom. Bows of ribbon at elbows. Sale, Nov. 27, 1906. Print in B.M.

—— Portrait of a. In grey. Oval, 27 × 20½. Christie's, 1907. £131 5s. (S. I. Smith.)

—— Portrait of a. In white muslin dress. 30⅞ × 24. Christie's, 1909. 900 gns. (Sabin.)

LADY, Portrait of a. Full face, curled hair, white peignoir, wide-brimmed hat trimmed with blue ribbon. Paris, Exhibition of Marie Antoinette and her time, Galerie Sedelmeyer, 1894, Collection of Monsieur Mannheim.

—— Portrait of a. A drawing. Comte C—— sale, Dec. 17, 1900. 800 fr.

—— Portrait of a. 23¼ × 18½. Pierard de Valençay sale, Brussels, 1899. 3,200 fr.

—— Portrait of a. Pastel. 20 × 17¾. Madame Gauchez sale, 1892. 280 fr.

—— Portrait of a. Sale, Jan. 21, 1884. 130 fr.

—— Portrait of a. Sale, 1880. 11,000 fr.

—— Portrait of a. Standing. ¼-length. Left arm rests on a table. Pearl earrings. Rose in hair, which is bound by a fillet. Open corsage. Curls over shoulders. Double row of pearls round fore-arm. Collection Edgar de Stern. (Wildenstein.)

—— Portrait of a. Sale, 1878. 2,400 fr.

—— Portrait of a. Blue dress, powdered hair. Oval, 30 × 23½. Christie's, 1906. £100. (Reford.)

—— A German. Dresden.

—— Portrait of a. Seated. ¾-length. 35¾ × 28½. Classical dress, left shoulder, arm, and breast bare. Pearl earrings. Bracelets. Cupid is holding the ends of her girdle, while she holds his bow in her right hand and his quiver in her left. From the Doisteau collection. (See plate facing p. 26.)

—— Portrait of a. Seated. ½-length. 32 × 25¼. Dated 1810. Right elbow resting on the arm of a walnut-wood armchair, upholstered in green velvet. Robe of red velvet with narrow sleeves, trimmed with fur, opening in V-shape on breast. Necklace of three rows of coral beads. Black hair, in which are a coral comb and a long gold pin. Sedelmeyer sale, 1907. 7,500 fr.

—— Portrait of a. 1780. Given to the (French) State by M. Charles Rivière, 1914.

—— Portrait of a. 39¼ × 31½. Seated in an Empire chair. She is seen to below the knees. Costume of white muslin, with low-necked bodice, and short sleeves of accordion pleating; waistband of old gold satin. Light chestnut hair through which is passed a ribbon of dark yellow silk. Cream-coloured scarf. Cornflowers in her hand. Landscape background. Sedelmeyer sale, 1907. 5,900 fr. (Dufayel.)

—— Black and white chalk stump-drawing of a. Seated on a little knoll, receiving the caresses of her children, one of which is at the breast. De Boissieu sale, 1821.

—— Black and white chalk drawing of a. Sitting asleep, with a book in her hand. J. B. Lebrun sale, 1814. 14 fr. (Paillet.)

—— Portrait of a. Thibaudeau sale, 1857. 410 fr.

—— An American. 1773.

—— Portrait of a. 19¾ × 14½. De Torcy sale, 1857. 60 fr.

—— An American. (" Very pretty," writes the artist.) London, 1802–1805.

—— Portrait of a, Dated 1782. Standing in a garden; left arm rests on a balustrade. Powdered hair, some tresses falling over bosom. Flowers and white feathers as head-dress. Dress of white satin and lace, with pink waistband. Pembroke sale, 1862. 2,200 fr. (Lord Hertford.)

—— Portrait of a. (" Whose name I forget," writes the artist.) Berlin, 1801.

—— Portrait of a. With a young girl. Small sketch. White satin dress, straw hat. She is in a garden, with her hand on the shoulder of the girl, who holds some flowers. Villot (1st) sale, 1864. 62 fr.

—— Portrait of a. 18⅝ × 13¾. Alexandre Dumas sale, 1892. 3,200 fr.

—— Portrait of a. On a divan. Salon, 1791. 41 × 32. Sale, May 11, 1895. £2,362 10s.

LADY, Portrait of a. With a dog. Oval, 36 × 28. Sale, June 18, 1887. £168. *See* AGUESSEAU, Madame. ? The same picture.

—— A. With a little boy. Pastel. Signed and dated 1777. 37½ × 43¾. She is seated by a dressing-table, on which are a mirror, scent bottle, powder puff, etc. She wears a white satin low-necked dress; powdered hair with curls falling over shoulders. Boy in light blue silk stands at her knee to left. Hodgkins, 1913. *See* MONTVILLE, Madame.

LAFOND, Madame. Salon, 1824.

? Lafont. Madame Lebrun gives a Madame Lafont (possibly the wife of her friend Charles Lafont, the violinist, 1781–1839) among her sitters after the Revolution.

LAFONTAINE. *See* FONTAINE.

LAGRANGE, Madame de. Salon, 1787.

LAMBALLE, Marie Thérèse Louise, Princesse (and Duchesse) de. 1781.

1748–1792. The friend of Marie Antoinette, brutally murdered Sept. 3, 1792.

—— The same. 2 replicas. 1781.

—— The same. Presumed portrait of. Straw hat. Prince Tuffeakin sale, 1845. 100 fr.

—— The same. De Plinval sale, 1858. 250 fr.

Presumably one of the portraits entered above. But which?

—— Presumed portrait of.

LAMOIGNON, Madame de. 1776.

? Wife of Chrétien François de (1735–1789), Garde des Sceaux, 1787.

LAMOIGNON, Mademoiselle. 1778.

? Daughter of the above.

LANDE, La Baronne de. 1774.

LANDRY, M. de. 1781.

LANGE, M. de. 1777.

LANGE, Mademoiselle. As "Vanity." Meynier Saint-Fal sale. 1860.

LANGEAS, Comte de. 1775.

LANGERON, Comte de. Wearing several orders. Talleyrand sale, 1847. 60 fr.

LASTIC, Monsieur de. 1779.

—— Madame de (wife of the above). 1779.

LAUTERBRUNNEN, The Valley of. Landscape. Cottin sale, 1872.

LAVIGNE, Mademoiselle. 1783.

LEBRUN, Madame Vigée-, the artist herself, in her youth. Bust. Thin dress, her hair escaping from beneath a straw hat trimmed with flowers. Oval drawing. Collection of M. L. Godard.

—— The same as a young girl. 23¼ × 19. White dress, dark mantle. Black hat with feather. Large drop earrings. (Sedelmeyer.)

—— The same at the age of twenty-one. 22¾ × 19¼. Full-length. White muslin dress with a scarf round her body and a cherry-coloured bow at the corsage. Small cape, and black hat with feathers. Exhibition for the "Caisse de Secours des Artistes," Paris, 1860, Collection of M. Jacques Reiset. Jacques Reiset sale, 1870. 28,500 fr. (Comte H. Greffulhe.) Paris, Exhibition des Alsaciens-Lorrains, Palais Bourbon, 1874, Collection of Comte H. Greffulhe. Exhibition of One Hundred Portraits of Women. 1909, same collection.

—— The same. Life size, to waist. Tulle cap, with blue ribbon, black velvet dress, fichu, 25½ × 21. E. Vincent sale, 1872. 710 fr.

—— The same. C. Maralle (2nd) sale. 130 fr. D'Arboville.

—— The same. Aguado, Marquis de Las Marismas sale, 1843.

LEBRUN (*continued*). The same. Challoner sale, London, 1896. 28,000 fr.

—— The same. Holding a palette. Christie's (Fitzherbert), Dec. 12, 1896, £1,134. (Evans.)

—— The same as a girl (? aged 17). Palette in left hand. Scarf wound in curly hair. Hair loose down back and over shoulders. Full face; paint-brush in right hand. Murray Scott collection, 1911.

—— The same, as a young girl painting a picture. ¾-length. 31¼ × 25½. (Sedelmeyer.)

—— The same. Head. 1778.

—— The same. 1781.

—— The same. Looking in a mirror before her easel, with paint-brush in her hand. 31 × 24⅞. Boittelle sale, 1866. 1,000 fr.

—— The same. 1782. Salon de la Correspondance. On wood. The "Chapeau de Paille" portrait, painted after seeing the famous "reflected light" portrait of Rubens (now in the National Gallery, London). ½-length, standing; holding palette and brushes in left hand; straw hat with feather and flowers; open corsage, edged with white muslin frill. High-waisted, pinkish-grey-coloured dress, black scarf over both arms. Open-air background of blue sky and purple clouds. The left elbow rests on a table. Signed and dated, 1782. 37½ × 27¼. (Baron Maurice de Rothschild, Paris.)

—— Replica of above, on canvas. 37¼ × 27¾. National Gallery, London. Purchased from Mr. S. T. Smith, 1897.

The expression of the face perhaps a little less serious than in the above signed portrait.

—— The same. Vienna, 1902. ¾-length to right. Black academical gown with red band edged with gold. White kerchief turban. 21¼ × 16⅝. Painted for Comte and Comtesse Bystry. From the Collection of Count Valentin Siemontkowsky, Château of Koustyn, Volonie, Russia. National Loan Exhibition, London, 1913–1914. (Otto Gutekunst, Esq.)

The artist met the Comte and Comtesse Bystry first at Milan, and accompanied them to Vienna.

—— The same. 1800. Seated to right, working with a crayon in right hand, holding brushes in left. High-waisted dress and high lawn neckcloth close under chin. Exposition Artistique et Historique de Portraits Russes, St. Petersburg, 1905. Council Chamber of the Imperial Academy of Fine Arts, St. Petersburg.

—— The same. Head and shoulders. Nearly full face. Hair lightly powdered, curls on shoulders. Large black hat with black feathers. Black silk "mantelet," white muslin corsage with pleated collarette, bow of red ribbon at waist. Pearl drops in ears. 25¼ × 20⅛. 1907, G. Muhlborcher sale, 23,000 fr. (Wildenstein.)

—— The same. Bust. In left top corner the words "Virginia (*sic*) Lebrun, Pitt." Scarf bound round head and tied above left temple; loose curly hair to shoulder and on forehead. Lawn neckcloth tied with loose bow. Rome, Academy of Saint Luke.

—— The same. Another version of the above portrait. 23¼ × 19⅛. 1907, Charles Sedelmeyer sale, 45,000 fr. (Cognac.)

—— The same. Head. Wearing wreath of roses. Collection Munier-Jolain.

—— The same, with her daughter. 50 × 38. Christie's, Norman Forbes Robertson sale, May 19, 1911, £441, (Gilbert.)

—— The same. Four portraits. Paris, after the Revolution.

These four pictures were painted "for my friends."

—— The same. White dress, red ribbon at neck. Vicomte de S. P—— sale, Jan. 22 1872, 5,550 fr.

LEBRUN (*continued*) The same. Three portraits London, 1802–1805.

—— Herself and her daughter. Sale, Christie's, 1911, 420 gns. Gilbert.

—— The same, with her child on her lap. 39½ × 33½. The mother in white bodice, violet sleeves and sash, yellow satin skirt, muslin scarf twisted in her hair, with effect of a turban. Child in white. Salon, 1787. Louvre. Given by Madame Tripier Lefranc, the artist's niece. Engraved by Avril.

—— The same. Embracing her daughter. 51½ × 37. The mother is seated, the child standing. The former wears a white robe, which leaves the right shoulder and arm bare ; red sash, red fillet in hair. The child is dressed in blue. Painted for the Comte d'Angiviller, 1788. Laborde sale, 1789, sold in one lot with portrait of Hubert Robert (*q.v.*), 18,000 fr. (The Comtesse d'Angiviller was by birth a Laborde.) Louvre.

—— Embracing her daughter. Oval, 8 × 10. Signed and dated, "Elizabeth Le Browne (*sic*), September 1801." The mother seated on a mahogany chair, over which is thrown a salmon-coloured mantle, embroidered in blue. She wears a dress of dark blue. The child, on her mother's knee, is wrapped in a white drapery. To the left a column, from which hangs a green curtain. Pierpont Morgan Collection. Reproduced in Dr. Williamson's catalogue.

—— The same, seated. (Painting a portrait of Marie Antoinette). Palette and brushes in left hand. Dark dress, red sash tied with large bow, white kerchief as turban. Painted at Rome, *c.* 1790, for the Uffizi Gallery of Florence. Engraved by P. Audouin, of Vienna, after a drawing of Wicar. Etched by Denon, with Raphael's head instead of Marie Antoinette's on the easel.

—— Replica of above picture, painted at Naples, 1791, for the Earl of Bristol, Bishop of Derry. Signed and dated. Marquis of Bristol, Ickworth, Bury St. Edmunds.

—— The same. Pastel. ? 1789. Bust. Straw hat with feathers. She holds a palette Paris, Exhibition of Arts, "au début du siècle," 1891, Collection of M. de Saint-Gilles.

—·— The same. Drawing in black chalk. Oval, 11¾ × 9½. Dated 1799. Seated, to left ; arms crossed under black shawl. Sale . . . March 13, 1893. 350 fr.

—— The same. Drawing in black, white, and red chalks. Daigremont sale, 1866. Duc de Feltre sale, 1867.

—— The same. "For the town of Saint-Petersburg. Intended to serve for the making of a medal, on which would be shown my portrait and that of Angelica Kauffmann." Paris, after the Revolution.

—— Ponce Denis Ecouchard, Poet. Black and white chalk on blue paper. J. B. Lebrun sale, 1814. 30 fr. 50.

 1729–1807. *See* Index.

LE COMTE. *See* COMTE.

LENORMAND, Madame (or Mademoiselle). Sitting, elbow resting on a cushion. Holding a pamphlet. Muslin dress, with sash.

 The artist states that in 1774 and 1777 she painted Madame Le Normand.

LESPARE, Mademoiselle. 1768–1772.

LESSOUT, Madame. 1780.

LICHTENSTEIN, Princesse. Full-length. Vienna, 1792–1794.

—— The same. Full-length. As Iris, in the clouds.

 Wife of Jean Népomucène Joseph, Prince de Lichtenstein (1760–1836), distinguished soldier. Lavice (*Revue des Musées d'Allemagne*, 1867) mentions two portraits by the artist as being in the Lichtenstein Gallery at Vienna.

LIÈVRE, Madame la Présidente de. 1778.

LINOWSKA, Princesse de. Pastel. Vienna, 1793-1794.

LITTA, The Bailli. Grand Master of the Order of Malta. Naples, c. 1790. Paris, Exhibition of French Art under Louis XIV and Louis XV, 1888, Collection of her Imperial Highness the Princess Mathilde.

> The Bailli Litta was dispensed from the vows of the Order of Malta by the Pope, in order that he might marry the Comtesse Skavronska, widow of the Russian Ambassador at Naples.

—— The Comte. St. Petersburg, 1795-1801.
 ? The above Bailli.

—— Catherine Vassilevna, *née* Englelhardt. In her first marriage Comtesse Skavronska. ¾-length. To waist. Full face, leaning on a cushion to left. Cream-coloured dress ; beige scarf with black border ; two rows of pearls round neck ; open bodice. Book in right hand, on lap. Naples, 1790. St. Petersburg, Exposition Artistique et Historique de Portraits Russes, 1905, Collection of Prince Felix Felixovitch Youssoupoff. 1912, Collection of Princesse Youssoupoff.

> A niece of Potemkin ; wife of the Russian Ambassador at Naples. After his death she married the Bailli Litta (*v. supra*).

—— The same. ½-length. Arms resting on cushion. Full face. Naples, 1790.

—— The same. Bust. Naples, c. 1790. 21½ × 17¾.

—— The same. Similar to the Naples ¾-length. St. Petersburg. Signed and dated 1798. (Sedelmeyer.)

—— The same. A replica of the Naples ½-length.

—— The same. ¾-length. Naples, c. 1790. Seated. Right hand on knee, left arm resting on cushion. She regards a miniature, held in left hand. Muslin turban, open-necked dress. Pearl necklace of three rows ; pearl drop earrings. Paris, Musée Jacquemart André, 1914. Engraved by Morghen in 1791.

> A portrait of " La Princesse Litta " was exhibited at Bagatelle in 1909.

LIVOY, Monsieur de. 1775.

LORRAINE, Princesse Charles de. 55⅞ × 49⅜. Seated. Full face. Her elbow rests on a rock, near a cascade. Curly hair bound by a blue ribbon. Open corsage, with a fichu. Grey dress with yellow waistband ; red shawl. Comte Mniszech sale, 1902, 14,000 fr. (Gardner.)

LOUIS XVI. Bust. 31½ × 24¾. Purple coat with gold embroidery. Three-cornered hat under left arm. Wearing the Order of the Saint-Esprit, the Cross of St. Louis, and the Order of the Golden Fleece. Exhibition of Marie-Antoinette and her Time, Galerie Sedelmeyer, 1894, Collection of Comtesse G. de Clermont-Tonnerre. Clermont-Tonnerre sale, 1900.

—— The same. 31¼ × 24¾. Comte de C—— sale, Paris, 1900.

—— ? The same. As a child. Prousteau de Montlouis sale, 1851, 275 fr.

—— The same. Bust. From Collection of Duc de Caraman, sold with portrait of Marie Antoinette. Tardieu sale, 1841, 261 fr. the two pictures.

—— XVIII. *See* PROVENCE, Comte de.

LOUIS JOSEPH. *See* DAUPHIN.

LOUISE AUGUSTE WILHELMINE AMÉLIE, Queen of Prussia. Pastel. Berlin, 1801.

—— The same. Pastel. Berlin, 1801.

—— The same. Bust. Large picture from a study made at Berlin. Paris, after the Revolution.

> 1776-1810. Wife of Frederic William III of Prussia. Famous for her share in the struggle with Napoleon.

LUBOMIRSKI, Prince Henri. As Cupid, holding a crown of myrtle and laurel. Salon, 1789.
—— The same. As Amphion, playing a lyre, with naiads listening. Vienna, 1792. Prince
de Talleyrand sale, 1847. 420 fr.
> The naiads were said to be Madame (Duchesse) de Polignac, Madame (Duchesse)
de Guiche, and Mademoiselle Julie Lebrun, the painter's daughter.
LUCERNE, Lake of. G. Mallet sale, 1898; sold in one lot with THUN, Lake of (*q.v.*). 10 fr.

M—— playing on the lyre. Exhibition of the Académie de Saint-Luc. 1774.
MAILLY, Maréchale de. 1783.
MAINGAT, Madame. 1774.
MAINTENON, Madame de. 52 × 40. Christie's, 1911, £54 12s. (Cohen.)
> ? One of Madame Lebrun's studies from old prints and pictures.
MALATESTE, Claudine de. Woman of between forty and fifty. Bow above waist; small
ribbon round neck; hat at back of brushed-up hair. Nearly full face.
MALO, Monsieur de Saint. 1774.
MAN, Portrait of a. 31⅞ × 24¾. Sale, May 3, 1897, 6,300 fr.
> *See* LADY, portrait of a. Same sale, size and price.
MAN, An old, with his grandson, "effet d'incendie."
MAN, Portrait of a. David sale, Brussels, 1898. 2,350 fr.
MARIE ANTOINETTE. Large portrait. 1779. Full length, standing in a room at Versailles.
Light blue satin dress, huge panier, elaborate tucks, frills, gold fringe and tassels. Low
neck. Blue headdress with feathers. Court train of blue velvet with gold fleur-de-lis.
Table with red cloth to right, whereon is a vase of flowers, and a crown on a blue cushion
with gold fleur-de-lis. Pearl necklace.
> Sent to the Empress Maria Theresa. Hofburg, Vienna.
—— The same. Four replicas of above. 1779-1780. (One a present from Marie Antoinette
to the Empress of Russia ; one for the French queen herself, and two for M. and Madame
de Vergennes, he being the Foreign Minister of Louis XVI at that time.) The picture
now at Versailles, and another belonging to the French National Collection, are pre-
sumably two of these four. Neither of these has the necklace shown in the original
painting.
—— The same. Standing. To waist. Curled hair. Velvet toque with white feathers,
Ruby-coloured low-necked dress, edged with fur. Madame Tripier-Lefranc sale,
1883. 3,500 fr.
—— The same. Bust. 1779
> Six "bustes" (two originals and four replicas) of the Queen were done in this
year, according to the artist.
—— The same. Bust. Red velvet corsage trimmed with fur. Red toque with white
feathers and aigrette. 31½ × 24¾. Comtesse de Clermont-Tonnerre sale, 1900, No. 2.
13,300 fr.
—— The same. Bust. (Collection of Duc de Caraman) Tardieu sale, 1841, (with portrait
of Louis XVI.) 261 fr.
—— The same. A portrait, "for Monsieur de Sartines." 1779.
—— The same. Blue dress and hat. 45 × 34½. Christie's, 1900, £152 5s. Bought in.
—— The same. Velvet dress trimmed with fur. Low-cut corsage. Powdered hair. Red
toque with white feathers. Exposition de la Caisse de Secours des Artistes, Paris,
1860, Collection of M. Tripier Lefranc. Tripier Lefranc sale, 1883. 3,500 fr.
—— The same. 1778. ¾-length. Seated, nearly full-face. Waved hair brushed back from
forehead. Ruby velvet coatee edged with fur. Lace fichu. Large white toque,

14

Hands resting on cushion, the right hand holding a book in which the thumb " keeps the place." 36½ × 29½. From the collection of Prince de Bauffremont. (M. Wildenstein.)

A note by the artist to this prince runs thus : " Je vous remercie bien, mon prince, de m'avoir fait voir le portrait que j'ai fait de Sa Majesté la Reine en 1778. J'ai été heureuse de le savoir entre vos mains et de la destination que vous lui donnée. Notre auguste princesse verra ce portrait qui lui retracerait la beauté et la bonté de notre auguste et infortunée Reine. Je suis doublement heureuse, mon prince, puisque cette occasion m'offre de renouveler les bons sentiments que vous savez si bien inspirer sous tous les rapports." This note apparently refers to one of two pictures separately entered as " copy of a portrait of the Queen " in Madame Lebrun's list for 1778, one of them having been painted " for M. Bocquet." In 1783 she enters four portraits of "the Queen in a velvet dress," and "four copies of the same," so that she appears to have produced eight similar portraits, as well as one of the Queen " avec un chapeau," and two " en grand habit."

MARIE ANTOINETTE (*continued*) The same, 1783. Almost the twin picture of the above. Presumably one of the portraits mentioned in the foregoing entry. Collection of Baron Edouard de Rothschild.

—— The same. Dress of ruby velvet, trimmed with gold lace on the breast and with fur. Corsage of white satin. On the head a gauze scarf and white feathers, the end of the scarf falling on the right shoulder. 25¼ × 20¾. De Villars sale, 1868, 940 fr.

—— The same. ½-length. Turning to right. Full face. White peignoir. Paris, Exhibition of Marie-Antoinette and her Time. Galerie Sedelmeyer, 1894, Collection of Comtesse de Biron. Universal Exhibition (Exposition Rétrospective de la Ville de Paris), 1900, same collection.

—— The same. Nearly full face. To waist. Blond hair, powdered, with white feathers Red velvet dress trimmed with fur. Oval, 25½ × 21¼. Beraudière sale, 1882. 1,205 fr.

—— The same, signed and dated. Salon, 1787. With the Duc de Normandie (on her knees), the Dauphin, and Madame Royale. The Queen wears a dress of red velvet, trimmed with fur. Toque of red velvet, with feathers and fur. One of the galleries of Versailles seen through an opening to left. Engraved by Nargeot.

The large picture, showing an empty cradle, now at Versailles. A replica, belonging to the Baronne James de Rothschild, was shown at the Exposition Rétrospective Féminine, 1908.

—— The same. 1788. Life size, seated with elbow resting on a red velvet cushion placed on a table, whereon is a royal crown resting on a blue velvet cushion, a crystal vase containing flowers, and a spray of lilac. A book in left hand. Hair powdered. She is wearing a large toque of blue silk with an aigrette and plumes, and a blue velvet dress edged with brown fur over a skirt of white silk trimmed with fur. 106¼ × 75. Paris, Kraemer sale, May 5, 1913. 198,000 fr. (Hodgkins.)

—— The same. 1788. Almost identical with the above. The Queen is here wearing a necklace of four rows of pearls, and there are slight differences in the toque, etc. Versailles. Engraved by Schinker.

—— The same. Seated. In red dress. 50 × 40. Christie's, 1900, £73 10s. (Grego.) Christie's, 1902, £84. (S. T. Smith.)

—— The same. ½-length. Standing to right. White muslin dress cut low at neck. Straw hat with feathers and blue ribbons. Tying some roses together with a ribbon. Salon, 1783. Grand-Ducal Palace, Darmstadt.

This is almost certainly the portrait " en gaulle," which caused so much excite-

ment by its unconventional costume (for a Queen of France) that it was withdrawn from the Salon.

MARIE ANTOINETTE (*continued*) The same. ? Three replicas of the foregoing picture. 1783. The artist appears to have painted at least half a dozen examples of this picture.

—— The same. "With a rose." 1783. Low-necked dress of blue silk, gauze headdress with feathers. The Queen is walking in a garden, tying some roses with a ribbon. Rose bush (red blooms) to right, tree trunk to left. Versailles.

Same pose and expression as in the above portrait " en gaulle."

—— The same. Paris, Exhibition " des Alsaciens-Lorrains," 1874, Collection of Marquis de Biencourt.

—— The same. A sketch. Paris, Exhibition "des Alsaciens-Lorrains," 1874, Collection of Madame Flûry-Hérard.

—— The same. Medallion portrait reproduced in magazine of Société de Protection des Alsaciens, etc., 1874.

—— The same. · Sketch of head of, with powdered hair, plainly arranged and brushed up high off the forehead.

—— The same. Apotheosis of. The Queen is seen, in a long robe, ascending towards the heavens, where two angels (her children who had died) and Louis XVI (with wings, emerging from the clouds) attend her. Given by the artist to Madame de Chateaubriand's Saint Theresa Home for Infirm Priests.

MARIE CAROLINE, Queen of Naples (wife of Ferdinand IV), sister of Marie-Antoinette, queen of France. Naples, *c.* 1790. Prado, Madrid.

 1752–1814.

MARIE CHRISTINE, Princesse. Daughter of Ferdinand IV of Naples, afterwards queen of Sardinia. Naples, *c.* 1790.

MARIE FEDOROVNA (Dorothea), Princess of Wurtemberg, wife of Paul I, Emperor of Russia. Full-length. St. Petersburg, Exposition Artistique et Historique de Portraits Russes, 1905. Winter Palace, St. Petersburg.

MARIE LOUISE, Princesse (daughter of Ferdinand IV, King of Naples). Afterwards Grand Duchess of Tuscany. Naples, *c.* 1790.

MARIE THÉRÈSE, Princesse (daughter of Ferdinand IV of Naples). Afterwards Empress of Germany (as wife of Francis II). Naples, *c.* 1790. ? Christie's, 1913, as " Marie Thérèse of Savoy."

MARIE THÉRÈSE CHARLOTTE DE FRANCE. *See* ANGOULÊME, Duchesse d'.

MATHEWS, Mrs. Charles. *See* VESTRIS.

MAYER, Madame de. Vienna, 1792–1794.

MAZARIN, Duchesse de. 1780.

MÉNAGEOT, François Guillaume. Painter. A sketch. Oval. ½-length. Silk coat, flowered waistcoat. Tripier-Lefranc sale, 1883. 110 fr. ? Versailles.

 1744–1816. Born in London. Pupil of Boucher and Vien. Director of the French Academy at Rome, 1787–1793. One of his best-known pictures was " The Death of Leonardo da Vinci."

—— Madame. A drawing in black, white, and red chalks. Oval, 8¼ × 6¾. ½-length. Wreath of roses on brown curling hair. Beurdeley sale, 1905. 3,500 fr. (Cognac.)

MENCHIKOFF, Princesse Catherine Nicolaevna, *née* Princesse Galitzin. At the piano, with her little son at her knees. Signed. St. Petersburg, 1795–1801. St. Petersburg, Exposition Artistique et Historique de Portraits Russes, 1905, Collection of Prince Nicolas Nicolaevitch Gagarin.

MÉRAUT, Monsieur. 1774.

MERVEILLEUSE, Une. In Directoire costume. Boyana sale, 1882. 100 fr.
MOMANVILLE, Monsieur de. 1774.
MONGÉ, Madame. 1775.
—— The same. 1778.
—— The same. 1779.
MONTAUDRAN, Madame de. 1780.
MONTBARREY, Alexandre Marie Léonor de Saint-Mauris, Prince de. 1776.
 1732–1796. French Minister of War, 1777–1780. Emigré in 1791. His memoirs were published in 1827.
—— The same. 1779.
MONTBARREY, Princesse de. 1776.
 Wife of the above.
MONTEMEY, Marquise de. 1778.
MONTESQUIOU. See FEZENSAC.
MONTESSON, Charlotte Jeanne Béraud de la Haye de Riou, Marquise de. 1779.
 1737–1806. Married first to the Marquis de Montesson, who died in 1769; secondly (morganatically) in 1773 to the Duc d'Orléans (1725–1785).
MONTLEGIÈTS, Madame de. 1777.
MONTMORIN, Madame de. 1776.
 ? Wife of Armand, Comte de Montmorin-Saint-Hérem, Minister of Foreign Affairs, 1787, and again 1789–1791. He was massacred September 1792.
—— Mademoiselle de. 1776.
 ? Daughter of the above.
MONTOISON, Marie Jeanne de Clermont-.
MONTVILLE, Monsieur de. 1775.
—— Madame de, with her child. 1775.
 Wife of the above. ? Whether this entry may not refer to the pastel of a "Lady with a Little Boy" (q.v.), signed and dated 1777. The artist was so often inaccurate that the entry in her list of pictures might be two years out.
MORETON, Madame de. 1781.
—— Replica of same picture. 1781.
MORTEMART, Mlle. de. Comte de M—— sale, 1875. 1,175 fr.
MOUSAT, Monsieur. 1768–1772.
—— Mademoiselle. 1768–1772.
MURAT, Marie Annonciade Caroline Bonaparte, Queen of Naples. Full length, with her daughter beside her. Paris, after the Revolution.
 1782–1839. Third sister of Napoleon. Married, 1800, Joachim Murat, afterwards King of Naples.
—— The same. Pastel. Sale, March 1895. 80 fr.
MUSIQUE, La. Exhibition of the Académie de Saint-Luc, 1774.

NASSAU, Charles Henri Nicolas Othon, Prince de Nassau-Siegen, generally called Prince de Nassau. 1776.
 1745–1809. Traveller and soldier. Entered the French army, and accompanied Bougainville on his famous voyage.
—— The same. Full length. 1789.
NIGRIS, Jeanne Julie Louise. The painter's daughter, as a child, regarding herself in a mirror. Profile. Salon, 1787. M. Féral.
 Etched in 1787 by the Comte de Paroy "à l'eau-forte et au lavis," and shown

in Martini's engraving of the Salon of 1787. 1780–1819. Accompanied her mother in her travels through Italy and Austria to St. Petersburg. There, in 1800, she married M. Nigris, secretary to Comte Tchernycheff, in circumstances described in the present book.

NIGRIS (*continued*) The same, Jeanne Julie Louise. Profile. 1787.
—— The same. Reading the Bible. 1787.
—— The same. Small oval. 1789.
—— The same. Head of, wearing wreath. Museum of Bologna.
—— The same. As a bather. Vienna. 1792.
 Madame Lebrun says it was painted " pour la Reine," (presumably Marie Antoinette). 1793.
—— The same. St. Petersburg, Exposition Artistique et Historique de Portraits Russes, 1905, Collection Capitoline-Semenovna Klotchkoff.
—— The same. Salon, 1798. ½-length. 31½ × 27½. Open air. Walking from left to right. Arms crossed under a violet scarf which covers her shoulders. Straw hat with purple feathers, held on the head by a scarf of white gauze. A muslin frill round neck. Dress of green silk. Brown hair, hanging loose down the back, and curls on the temples. Kraemer sale, 1913. 47,300 fr. (Hodgkins.)
—— The same. Pastel sketch. Sale, March 11, 1895. 130 fr.
—— The same. Bust. Oval, 17¾ × 14½. Short hair. White dress. Tripier-Lefranc sale, 1883.
—— The same. Pastel. Oval. Tabourier sale, 1898. 3,800 fr. ? 17 × 13. R. Vaile sale, 1903. £99 15s. (Wildenstein.)
—— The same. (Presumed portrait of). Pastel. 17¾ × 13¾. Bust, full-face. Black hair, crimped. Red dress with little white collarette. Hulot sale, 1892. 1,000 fr.
—— The same (Presumed portrait of). Pastel. Bust, 17 × 12⅝. Blue low-necked dress. Light hair, curled over the forehead and ears. E. Warneck sale, 1905. 650 fr.
 One of these two " presumed " portraits giving black hair to its subject and the other light hair, it is unlikely that both presumptions are correct. Julie was rather dark than fair, though her nickname, " Brunette," had as much to do with her parentage as with her colouring.
 See also LEBRUN, Madame, for the "Mother and Child" pictures.

NOLSTEIN, Madame de. 1777.
NORMAND, Madame le. 1774.
—— *See* LENORMAND.
—— The same. 1777.
NORMANDIE, Duc de. Afterwards Louis XVIII. 1787.
—— The same. Standing. 1789. For the Duchesse de Polignac.
NURSE, The (Nourrice), of the Dauphin. Sale, Jan. 22, 1859.

OGLOVI, Monsieur. 1777.
 Perhaps some British visitor to Paris named Ogilvie.
OPOTCHININE, Daria Mikhailovna, *née* Princesse Koutouzoff. Signed. St. Petersburg, 1801. St. Petersburg, Exposition Artistique et Historique de Portraits Russes, 1905, Collection of Nicolas Nicolaevitch Toutchkoff.
ORGLANDE, Comtesse d'. Daughter of Comtesse d'Andlau. "Avec les Mains." Paris, after the Revolution.

ORLÉANS, Louis Philippe, Duc d'. 1779.
> 1725–1785. Distinguished soldier. Noted also as a friend of men of letters, and for his liberality. Secretly married in 1773 to Madame de Montesson (q.v.).
—— Louise Marie Adelaïde de Bourbon-Penthièvre, Duchesse de Chartres, afterwards Duchesse d'. 1778.
> 1753–1821. The wife (1769) of Philippe Egalité, and mother of King Louis Philippe.
—— The same. Salon of 1789. 39⅜ × 32¼. Life size. Seated on red couch. Head supported on left arm, which rests on a red velvet cushion. Right hand lies on right knee. A medallion on the waistband with the word "Amitié." Gauze toque. Pale blue bodice over muslin dress. Her fair hair falls over the left shoulder to below the waist. ? Bought by Brongniart, architect, Didot sale, 1825. ? H. Howard sale, Paris, 1898 725 fr.
—— The same. Two examples of the above (1789) portrait, both now at Versailles.
—— The same. Pastel replica of the same portrait. E. M. Hodgkins.
—— The same. Bagatelle, 1911.

PAISIELLO, Giovanni. Composing music. Naples, c. 1790. Salon, 1791.
> 1741–1816. Composer.
PAIX (La) Ramenant l'Abondance. 1780. Salon, 1783. "Abundance" represented by a blonde, in golden-yellow robe ; the right shoulder, arm, and breast uncovered ; roses in hair ; "horn of plenty" in right hand ; wheat and poppies in left. "Peace" is a brunette, in violet robe bound with gold braid at the neck ; green cloak flying in the wind. She rests her right hand, which holds a sprig of myrtle or bay, on the right shoulder of Abundance. Louvre. Engraved by Pierre Viel, 1789.
> Lucie Hall, daughter of P. A. Hall, the Swedish miniature painter, sat for "Abundance" and her sister Adèle for "Peace."
PALERME, Madame de. 1779.
PALFI, Comtesse de. Vienna, 1792–1794.
PARCEVAL. See PERCIVAL.
PARME, Elisabeth, Duchesse de, eldest daughter of Louis XV. Pastel. 24½ × 20¼. Despinoy sale, 1850 (Madame de Polignac). Dumas fils sale, 1865. 101 fr.
> If authentic, this portrait must have been done from pictorial sources, this Duchesse de Parme having died in 1759. At Versailles there is (or was) a portrait formerly called "Madame Elisabeth de France," and attributed to Madame Lebrun, of which the face (except for the eyes) has considerable resemblance to Nattier's portrait of the Duchesse.
PARIS, Madame. 1773.
PAYS, Madame de Saint-. 1773.
PEINTURE, La. Exhibition of Académie de Saint-Luc, Paris, 1774.
PERCEVAL, Lady. Pastel. 18⅞ × 14½. Dated 1804. Bust. Light hair bound with black velvet ribbon, edged with pearls. Low-necked black dress; lace collarette. Comte de Vaudreuil sale, Paris, 1881. 2,600 fr.
PERREGAUX, Madame. Signed and dated 1789. Panel, 37⅞ × 30½. Leaning on a balustrade. She is drawing back a curtain. Hat with feather. Sale, 1862. 3,720 fr. Bethna Green, 1872–1875. Wallace Gallery.
> Wife of the banker Perregaux.
PERNON, Monsieur. 1773.
PERRIN, Monsieur. 1773.

PERRIN, Madame. 1777.

PEZAY, Caroline de Murat, Marquise de. Paris, Exposition Rétrospective Féminine, 1908, Collection of Madame Charles Fauqueux.

——— The same. With the Marquise de Rougé and the latter's two children. 1787.

PICTURE, A small. Vienna, 1793–1794. For the Comte de Wilscheck.

PIENNES, Mélanie de Rochechoüart, Marquise d'Aumont, Duchesse de. Oval. 28½ × 22½. Signed and dated 1789. White dress, trimmed with gold braid; green and yellow sash; white and gold kerchief binding her curly hair. Collection of Alfred Montgomery. Mrs. Finch sale, Christie's, July 5, 1907. £2,520, (Asher Wertheimer.) National Loan Collection, 1913–14, (Adolph Hirsch, Esq.)

PIGALE, Mademoiselle. 1768–1772.
Marchande de Modes to Queen Marie Antoinette.

PITT, Miss. Daughter of Lord Camelford. Painted at Rome, c. 1790. A young girl, represented as Hebe, upon a cloud, holding a cup from which an eagle is drinking.

POÉSIE, La. Exhibition of the Académie de Saint-Luc, 1774.

POLASTRON, Marie Louise Françoise d'Esparbez de Lussan, Vicomtesse de. London, 1802–1803.
1764–?1816. Wife of Denis, Vicomte de Polastron. Died in England, and was buried in St. Pancras Cemetery.

——— A son of the above. London, 1802–1805.

POLIGNAC, Agénor de. A child. Pastel. Vienna, 1793–1794.
Son of Duc (Jules) et Duchesse (Gabrielle) de Polignac (q.v.).

——— Auguste Jules Armand Marie, Prince de. Brother of above, as a boy. Pastel. Vienna, 1793–1794. Bagatelle, 1911.
1780–1847. Son of Duc (Jules) et Duchesse (Gabrielle) de Polignac (q.v.).

——— Edmond de. Brother of above. Pastel. Vienna, 1792–1794.

——— Gabrielle de Polastron, Duchesse de. Full face, ½-length, in open air, White dress. Black lace mantle over arm. Straw hat with daisies and feather. 1782. Paris, Exhibition of Eighteenth-century Art, 1883–1884, Collection of Duc de Polignac. Exhibition of Marie Antoinette and her Time, Galerie Sedelmeyer, 1894, Same collection. "Exposition Rétrospective Féminine," 1908, same collection. Exhibition of One Hundred Portraits of Women, 1909, same collection. ? Engraved by Comte de Paroy, who was a friend of the painter.
1749 ?–1817. The favourite friend of Marie Antoinette.

——— The same. Much the same composition as the above picture, but the duchess is wearing a thin scarf loosely knotted round her neck. Baron Edmond de Rothschild.

——— The same. With a straw hat. 1787.

——— The same. Replica of above picture. 1787.

——— The same. Standing, holding a song and touching a piano. 1787. Large hat, necklace of three rows of pearls.

——— The same. 1787.

——— The same. (Two pictures.) 1789.

——— The same, with her child. On wood. 18¼ × 15. In an alcove draped with curtains. The mother is dressed in white, and has a white cap with pink ribbons. Seated on a bed, she holds her baby. On a table to the right are a cup and a porringer. Comtesse de Clermont-Tonnerre sale, 1900. 10,000 fr.

——— The same. Water-colour. 82¾ × 68¾. Sale, Paris, April 17, 1899. 7,000 fr.

——— The same. With a child. 18½ × 15. Sale, Dec. 10, 1900. 10,000 fr.

——— The same. Painted from memory after her death. Vienna, 1793–1794. 21¾ × 17½.

Wearing a frilled cap with strings tied under chin and a fichu. Clermont-Tonnerre sale. Engraved, in reduced size, by J. Fisher, 1794. A reproduction of this print was shortly afterwards made in London by J. Smith.

POLIGNAC, Jules, Duc de. 1787.

—— The father of the above. 1788.

—— Comtesse Metzy de. Sister of Duc (Jules) de Polignac, and daughter of the last-mentioned. Pastel. Vienna, 1792–1794.

PONIATOWSKY, Stanislas Auguste, King of Poland. Head and shoulders. Costume of Henri IV. St. Petersburg, 1795–1801.

—— The same. Wearing a velvet mantle trimmed with ermine, cordon of blue moire. St. Petersburg, 1795–1801. Retained by the artist for her own collection and bequeathed by M. Tripier Lefranc to the Louvre. Exhibition for the "Caisse de Secours des Artistes," Paris, 1860.

—— The great-niece of above, playing with a little dog. St. Petersburg, 1795–1801.

PONSE, Mademoiselle de. 1778.

PONTS, Max, Comte de Deux-. Afterwards King of Bavaria. 1776.

Of the Palatine house of Birkenfeld, which came to the Bavarian throne in 1777. There are some anecdotes of this Prince in the *Souvenirs* of Comte Louis-Philippe de Ségur (*q.v.*).

PORPORATI, Mademoiselle. Turin, *c.* 1792.

Born c. 1771. Daughter of Carlo Antonio Porporati (1741–1816) the Piedmontese engraver.

PORTE, Madame de la. 1781.

PORTRAIT, A Small. Vienna, 1793–1794. For Madame de Carpeny.

POTEMSKI, Princesse. A girl. ¾-length. Paris, 1802–1805.

POTOCKI, Comte. St. Petersburg, 1795–1801.

POTOCKA, Comtesse. 1776.

POTOCKA, Mademoiselle. Dresden.

—— Comtesse, *née* Cetner, by her first marriage Princesse de Lambesc. Painted at Rome, 1790. Reclining on a rock, above a ravine. Dress open on chest, curly hair, full face, hands crossed. Comte Charles Lanckoronsky.

—— Comtesse Séverin. Vienna, 1792–1794.

PRINCE, Baron de Crespy le. Seen drawing. Paris, after the Revolution.

PRIEST, Monsieur de Saint-. Ambassador. 1778.

PROUT, Madame de. Niece of Comte de Coëtlosquet. Paris, after the Revolution.

PROVENCE, "Monsieur," Comte de. Afterwards Louis XVIII. Twelve portraits of, 1776.

—— The same. Painted "for M. de Lévis." (Marquis de Lévis, a collector of pictures.) 1778.

One of the above thirteen portraits was sold in 1851 in the Baron de Silvestre sale.

—— The same. 1781.

—— Replica of above. 1781.

—— Oval. Salon, 1783.

—— Louise Marie Joséphine, Comtesse de. 1778. Seated; full face. Flowers on knees. Dressed *en bergère*. Straw hat with wild-flowers on powdered hair. Open-necked white dress, laced with red ribbons; gauze fichu. Sprig of lilac in left hand. 35½ × 28¾. Beurnonville sale, 1881. 6,400 fr.

Daughter of the King of Sardinia; married the Comte de Provence, afterwards Louis XVIII, in 1771.

—— The same. Salon, 1783. 32 × 24¾. Pleated white dress, blue silk band. Oval.

Signed and dated, 1782. Paris, Exhibition of Marie Antoinette and her Time, Galerie Sedelmeyer, 1894, Collection of Comte A. de la Rochefaucauld. On the back of the canvas is this inscription : " Originale de Mde. Le Brun donné par le roi Louis XVIII en 1815 à M. le Marquis de Crux ancien écuyer commandant l'écurie de la reine, Mde. la Comtesse de Provence."

PRUSSIA, Prince Ferdinand of. Paris, after the Revolution.
 Probably from a sketch made in Berlin.
—— Prince Auguste Ferdinand of. Son of the above. Paris, after the Revolution.
 Probably from a sketch made in Berlin.
—— Prince Henry of. 1782.
—— The same. 1782.
—— The same. 1782.
PSYCHE regarding the sleeping Cupid. Drawing. Constantin sale. 1817.
PUDEUR, La. Pastel. Sale, Paris, 1900 (sold in one lot with " Une Vestale "), 1,500 fr
PUYSÉGUR, Comtesse de. 1786. Plain straw hat, bare arms, corsage of red woollen material, brown woollen skirt. Hands crossed on a pitcher placed on the margin of a well.

RADNOR, William Pleydell Bouverie, Viscount Folkestone, afterwards 3rd Earl of. Russia, 1800. 49 × 39. ½-length. Looking at spectator. Right arm leaning on rocks with the hand hanging down ; the left holds a large black hat. Dark hair and eyes, fair complexion. He wears a blue coat, a white cravat, white double-breasted waistcoat and light brown breeches. Earl of Radnor, Longford Castle.
RADZIVILL, Princesse Louise. Daughter of Prince Ferdinand of Prussia. Paris, after the Revolution.
 Probably from a sketch made in Berlin.
RAFFENEAU, Madame. 1768–1772.
RAGANI, Monsieur. Husband of Giuseppa Grassini (q.v.). Bust. Large picture. Paris, after the Revolution.
RANNOMANOSKI, Monsieur de. 1778.
RASOUMOVSKA, Comtesse. Vienna, 1793. Engraved by C. Pfeiffer.
 Elizabeth, daughter of Count Franz Josef Thun-Hohenstein. Married in 1788, Andreas, Count Rasoumovsky, afterwards Russian Ambassador at Vienna. The patron of Beethoven. He was the son of Kyrill Rasum, a peasant of the Ukraine, who was ennobled by the Empress Elisabeth. A beautiful miniature by Füger, representing the Countess Elizabeth with her two sisters (the sisters were known as " The Three Graces "), is in the Pierpont Morgan Collection, and is reproduced in Dr. Williamson's Catalogue.
RASSY, Madame de. 1778.
RED, Boy in. See BOY.
REFLEXION, La. Ou le Souvenir. Nude woman lying on a couch, one hand supporting her head, the other placed on a bouquet. Stevens sale, 1847. 305 fr.
REYMOND, Madame Elisabeth Félicité Molé. 1787 ?. Picture known as " La Femme au Manchon." ½-length. Walking rapidly from right to left. Dark violet silk coat, blue dress, large blue hat turned up, with large rosette, and feathers. Large muff. Louvre. Bequeathed by Mademoiselle Reymond. Engraved by Jules Massard.
 1760–1834. Natural child of the Marquis du Valbelle and Pierrette Claudine Hélène Pinet (known as Mademoiselle d'Epinay), of the Comédie Française. She was legitimated by the marriage of her mother with François René Molé, the comedian, also of the Comédie-Française (1734–1802). She is herself sometimes described as

"of the Comédie Française," but it is very doubtful if she was engaged there, or even if she was ever an actress.

REYMOND, Madame. Oval. Salon, 1787.

—— The same. Holding her child. 1789.

REZZONICO, Prince. Naples, 1790.

RICHARD, Madame la Présidente. 1779.

RICHELIEU, Cardinal de. Lyne-Stephens sale, London, 1895. 270 gns.
> One of the portraits based on old pictures or engravings, of which the artist did a good many in her early life. See for instance, those of La Bruyère and Cardinal de Fleury for the Academy.

RIVIÈRE, Alfred de. Paris, after the Revolution.

—— Charles-François de Riffardeau, Duc de. Pastel. Vienna, 1793–1794.
> 1763–1828. Confidential friend and minister of Charles X of France.

—— The same. Paris, 1824– .
> Painted for Charles X.

—— Jean Baptiste de. Chargé d'Affaires for Saxony in Paris before the Revolution. Pastel. Vienna, 1793–1794.
> Father-in-law of Louis (Étienne) Vigée, the artist's brother.

—— Mademoiselle de. Paris, after the Revolution.
> ? A daughter of the Duc de Rivière, or one of the family into which the artist's brother had married.

—— Caroline de. The artist's niece. Showing both hands. Paris, after the Revolution.
> The only child left by Louis Vigée and his wife Suzanne Marie Françoise, daughter of Jean Baptiste de Rivière (q.v.). She used her mother's maiden name.

ROBERT, Hubert. 1788. Salon, 1789. In Madame Lebrun's own collection. Robert is shown leaning on a balustrade. Louvre, gift of Monsieur and Madame Tripier Lefranc.
> 1733–1808. Painter of landscapes and architecture. Many of his works are in the Louvre.

—— The same. 59⅛ × 33½. Laborde sale, 1789. Sold in one lot with picture of Madame Vigée-Lebrun and her daughter (q.v.) for 18,000 fr.

ROBIN, Mademoiselle. 1774.

ROCHECHOUART, Mélanie de. See PIENNES.

ROCHEFORT, Prince de Rohan-. 1775.

—— Prince Jules de Rohan-. 1775.
> Son of the above.

—— Mademoiselle de Rohan-. 1775.
> Daughter of the Prince de Rohan-Rochefort.

ROCHEFOUCAULD, Duchesse de la. 1789. White dress trimmed with gold braid; green and yellow sash; white and gold band round hair.
> Wife of Louis Alexandre, Duc de la Rochefoucauld. He was massacred at Gisors, September 1794. Arthur Young writes in May 1787, that he was introduced to the Duc, "well known for his attention to natural history." He it was who, in 1789, declared, "If the constitution is not set up, we shall cease to exist."

ROCHETTE, Monsieur Raoul. Bust. Paris, after the Revolution.

ROISY, Monsieur de. 1773.

—— Madame de. 1773.
> Wife of the above.

—— "Le Petit." 1774.
> Son of the above pair.

ROLAND, Mademoiselle, afterwards Lady (?) Wellesley. Painted at Rome c. 1790.
 See JAUCOURT, Marquise de.
ROMBEC, Comtesse de. Bust. Pastel. Vienna, 1793–1794.
—— The same. Bust. Pastel. Vienna, 1793–1794.
RONCHEROL, Chevalier de. 1775.
—— Marquise de. 1775.
RONSY, Madame de. 1775.
ROSAMBEAU, Comtesse de. Daughter of Comtesse d'Andlau (*q.v.*). Showing both hands.
 Paris, after the Revolution.
ROSSIGNOL, Mademoiselle. 1774.
 An American.
—— Mademoiselle. 1774..
 Sister of the above.
ROUGÉ, Nathalie Victurniène de Mortemart, Marquise de. Oval. 25½ × 21¾. Scarf round
 hair. White muslin dress, with gold waistband. Marquise de Plessis-Bellière sale,
 1897. 1,900 fr.
—— The same. *See* PEZAY, Marquise de. With whom the Marquise de Rougé and her
 two sons were painted.
ROUSSEAU, Madame. With her little girl. ¾-length. The child standing on an uncovered
 table, with her left hand in her mother's right. Salon, 1789. Collection of M. Georges
 Heine, 1912.
 The wife and daughter of M. Rousseau, an "architect du Roi."
—— Another portrait. 1789. (? a Replica.)
ROYALE, Madame. *See* ANGOULÊME, Duchesse d'.
RUBEC, Madame de. 1775.
RUSSÉ, Mademoiselle Thérèse Marie Budan de. 1785. Oval. 27¾ × 22⅝. Seated. Dark
 curly hair with roses and leaves in it. Large gold hoop earrings. Light brown satin
 dress with lapels and cape. Hands crossed. Left elbow rests on blue cushion. On cuff
 of her right sleeve is a large button with the letter T. Purchased by Messrs. Trotti
 from Monsieur H. Budan de Russé. Mr. William McKay, 1913.

SABRAN, Marquise de. 1786. Muslin dress, with sash. Arms crossed on a cushion. En-
 graved by D. Berger, 1787.
SALM, Landgravine of. 1783.
 ? Wife of Frederic, Prince of Salm-Kyrbourg, 1746–1794, who was living in Paris
 about this date. He built there a mansion, which is now the Palace of the Legion of
 Honour. He supported the Revolution, but was guillotined as an aristocrat.
SALVERTE, Mademoiselle Baconnière de. Oval. 28¾ × 22⅞.
 The Marquise de Saporta, *née* Thérèse Beatrix de Ginestous, inherited this portrait
 from the Comtesse de Ginestous, maid of honour to the Princesse de Lamballe. E. M.
 Hodgkins, 1914.
SAMOILOFF, Comtesse Catherine Serguievna, *née* Princesse Troubetzkoy. Between her son
 and daughter (afterwards Comtesse Bobrinsky). 88½ × 29⅜. Open air. Signed. St.
 Petersburg, 1795–1801. St. Petersburg, Exposition Artistique et Historique de
 Portraits Russes, 1905, Collection of Comte Alexis Alexandrovitch Bobrinsky. Has
 been engraved.
SAPEY, Monsieur. Bust. Paris, after the Revolution.
SAPIEHA, Princesse. Vienna, 1792–1794.

SAPIEHA (*continued*) The same. ¾-length. Dancing, with a tambourine. St. Petersburg. Signed and dated, 1797.

 Now in America. ? Frick Collection.

SASSENAY, Mademoiselle de. Bust. Paris, after the Revolution.

SAULOT, Madame. 1776.

SAVALETTE, Monsieur de. 1776.

SAVIGNI, Madame. 1789.

SAVIGNY, Madame de. 1779. (Possibly the above Madame " Savigni " ten years younger.)

—— The same. 1779.

—— A son of the above. 1779.

SCHOËN, Mademoiselle de. Pastel. Vienna, 1792–1794.

SCHŒNFELD, Madame de. Wife of the Saxon Minister to Austria, with her child on her lap. Vienna, 1792–1794.

SCHOUVALOFF, Comte Paul Andrievitch. 1775. St. Petersburg, Exposition Artistique et Historique de Portraits Russes, 1905, Collection of Comtesse Elisabeth Vladimirovna Schouvaloff. In Collection of Comte Charles Lanckoronsky, Vienna, 1913.

 1727–1789. Chamberlain of the Empress Elizabeth of Russia, and son of her favourite, Field-Marshal Comte (Pierre Ivanoff) Schouvaloff, dead in 1762.

—— Comtesse. A young woman. Bust. St. Petersburg, 1795–1801. 25¼ × 21½. At about fifteen years old. Powdered hair, tied with a ribbon. Satin dress. Muff and stole of tiger-skin.

SEDAINE, Mademoiselle. La Béraudière sale, 1881. 9,100 fr.

 Daughter of Michel Jean Sedaine, the poet and dramatist (1719–1797).

SÉGUR, Philippe Henri, Marquis de. Maréchal de France. 1789. ¾-length. Standing, to left. Right hand rests on his baton, left hand on sword hilt. Orders, and ribbon across breast. Paris, Exposition des Alsaciens-Lorrains, Palais-Bourbon, 1874, Collection of Marquis dè Ségur.

 1724–1801. Minister of War. 1780.

—— Louis Philippe, Comte de. 1785. Plain coat, with Maltese cross of an order on left breast. Right hand thrust under waistcoat. Periwig.

 1753–1830. Son of the above. Celebrated diplomatist and man of letters. Author (1824) of *Souvenirs et Anecdotes*.

—— The same. Replica of same picture. 1785.

—— Marie d'Aguesseau, Comtesse de. Salon, 1785. Seated, hands crossed and resting on a table, on which some flowers lie. Large hat with ribbon bow and feather. Kerchief of lawn loosely tied round neck. Low-cut velvet bodice; full skirt. 1759 ?–1828.

 Wife of the above Comte (Louis-Philippe) de Ségur.

—— The same. Replica of the above picture. 1785.

—— The same. Bust. Profile. 1789. Light dress cut low. Dark shawl over right shoulder and left arm. Loose curling hair. Veil over back of head. Collection of Marquis de Ségur.

SENCE, Mademoiselle de. 1774.

SERRE, Comtesse de. 1784.

 ? The mother of Pierre François de Serre, a prominent figure in politics and diplomacy during the Restoration.

SIBYL, A. Salon, 1798. 4½ × 3¾. Seated in a grotto. Red robe with a blue drapery; a veil falls over her hair and around her body. J. B. Lebrun sale, 1814. 460 fr.

SICARDI, Madame. Head and shoulders. Robed as a vestal virgin, her eyes looking upwards. Constantin sale, 1816. 61 fr. (Henry.)

SIEGEN. *See* NASSAU.

SILVA, Madame. Rome, *c.* 1790.
 A young Portuguese lady.

SIMIANE, Comtesse de. 1783.

—— The same. 1783.

—— The same. 1789.

—— The same. 1789.

SKAVRONSKA, Countess. *See* LITTA.

SOLTYKOFF, Comte Ivan Petrovitch. St. Petersburg. Signed, 1801. St. Petersburg, Exposition Artistique et Historique de Portraits Russes, 1905, Collection of Varvara Ilyinitchna Miatleff.

SOUZA, Madame de, *née* Canillac. Wife of the former Portuguese Ambassador to France. Berlin, 1801.

SPANISH SCENE, A.

SPANISH LADY, A Young. Salon, 1791.

STAËL, Madame de. As Corinne. Seated on a rock, near a mountain. She is playing on a lyre. Painted at Coppet, 1808. Geneva, Museum of Art and History.

 1766–1817. Gérard also painted Madame de Staël as Corinne, seated on a rock, with a lyre, " at Cape Mycènes."

—— The same, Oval. ½-length. High-waisted, low-necked bodice. Scarf round head, with one end falling over left shoulder. Engraving by Hopwood in B.M.

STAINVILLE, Maréchal Comte de. 1773.

STROGONOFF, Comte Paul. Bust. Vienna, 1792–1794.

 1774–1817.

—— The same, showing the hands. Vienna, 1792–1794.

—— The same. St. Petersburg, 1796–1798. ¾-length. 41 × 36. Seated on a blue velvet chair. He wears a brown " Directoire " frock-coat with a red velvet collar, a white neckcloth, and fawn-coloured breeches. He holds a pair of brown gloves. Prince Galitzin, Marino, Novgorod, Russia.

—— Comtesse Sophie, wife of the above, *née* Princesse Galitzin. St. Petersburg, 1796–1798. ¾-length. 41 × 36. Companion picture to the portrait of her husband. Seated on a blue velvet sofa. She wears an orange-coloured " Empire " (as it would now be called) dress ; green Indian shawl draped from head over a white turban. She holds a baby (her son Comte Alexandre, 1795–1814) dressed in white, with a lilac sash. Prince Galitzin, Marino, Novgorod.

—— Comtesse Nathalie, daughter of the above Comte and Comtesse Paul, as a child. Head and shoulders. Pastel. 11½ × 9½. White frock. Prince Galitzin, Marino, Novgorod.

—— Comtesse Anna Serguievna, *née* Princesse Troubetzkoi. Arranging flowers in a vase. Signed. St. Petersburg, Exposition Artistique et Historique de Portraits Russes, 1905, Collection of Marie Pavlovna Rodzianko.

SUFFREIN. *See* SUFFREN.

SUFFREN, Vicomtesse de. (?) 35½ × 28. Seated, three-quarters to left. ½-length. Low-necked dress of white muslin, with waistband of blue ribbon. Powdered hair, with roses. Black scarf over right arm, bouquet in left hand. Kraemer sale, May 5, 1913. 22,000 fr. (Hodgkins.)

 ? The " Madame de Suffrein " whom the artist painted from memory. Some experts have thought that the picture here described represents Marie Antoinette. The simple white dress is similar to that of the portrait at Darmstadt commonly described as " Marie Antoinette en gaulle."

SUZANNE, Madame. 1768–1772.
> Wife of M. Suzanne, the sculptor.

TABARI, Madame. 1775.

TALARU, Marquise de. Formerly Comtesse de Clermont-Tonnerre. Salon, 1785. Oriental costume. Yellow robe, turban ornamented with pearls, gold necklace.

TALBOT, Lord. Bust. St. Petersburg, 1795–1801.

TALLEYRAND, Charles Maurice de, Prince de Benevento. Sale, 1847. 80 fr.
> 1754–1838. The famous bishop, foreign minister, and diplomatist.

—— Madame Grant, afterwards Princesse de. 1776.
> An English lady. When Talleyrand, after his exile of 1794–1795, returned to France early in 1796, he brought her with him, she having been divorced from her English husband.

—— The same. Looking up to left. Oval, 35½ × 28¾. Square-cut open corsage. Drop earring. Hair arranged close to head. Her right arm rests on a cushion, and holds the music of a song. Exhibition of Portraits of Women and Children, École des Beaux Arts, 1897. No. 137. Bagatelle, 1909, Reproduced in the illustrated catalogue, Bagatelle, 1909, Collection of Madame de Vernhette. (Wildenstein.)

—— The same. 1783. Oval. Seated, looking up to left. Square-cut open corsage. Right hand rests on a cushion, and holds the music of a song. Hair brushed up and out from forehead, curls over shoulders. Ribbon bows on head and on breast. Exhibition of Portraits of Women and Children, École des Beaux Arts, 1897, Collection of M. Vernhette. Doucet sale, 1912. 400,000 fr.

TCHERNYCHEFF, Comte Ivanovitch. Vienna, 1792–1794. In black domino, holding a mask. St. Petersburg, Exposition Artistique et Historique de Portraits Russes, 1905, Collection of Comte Hippolyte Tchernycheff-Klouglikoff.
> M. Nigris (the husband of Julie Lebrun, the painter's daughter) was secretary to Comte Tchernycheff.

TÉTARE, Madame. 1773.

TEUILLY, Madame de. 1778.

THILORIE, Madame. Bust. 1773.

THOMAS, Monsieur. Architect. Pastel. Vienna, 1793–1794.

THOUN, Comtesse de. Pastel. Vienna, 1793–1794.

THUN, The Lake of. Pastel. 7½ × 11. G. Mallet sale, 1898. Sold in one lot with LUCERNE, Lake of. 10 fr.

TIPPOO SAHIB. Sale, 1847.
> ? A fancy portrait. See DERVISCH KHAN and USMAN KHAN.

TOLSTOÏ, Comte. Salon, 1824.

—— Comtesse. ¾-length. Leaning on a rock near a cascade. St. Petersburg, 1795–1801.

TONNERRE, Comtesse de Clermont-. See TALARU.

TOTT, Madame de. 1786.
> ? Baronne de Tott, wife of the distinguished soldier and diplomatist (1733–1793), who, after years of service in Turkey, returned to France in 1776, and in 1786 was appointed governor of Douai.

TOULLIER, Monsieur de. 1776.

—— Madame. 1776.
> Wife of the above.

TOURNON, Comtesse de. 1779.
> ? Mother of Comte de Tournon-Simiane (1778–1833), diplomatist, peer of France 1824.

TRANCHART, Monsieur. 1768–1772.
TUFFIAKIN, Princesse. The head painted at Moscow ; completed in Paris after the Revolution.

USMAN KHAN, Mahomet. Ambassador from Tippoo Sahib, Sultan of Mysore. Salon, 1789. To below the knees, seated on a sofa. J. B. Lebrun (after death) sale, 1814. 151 fr. (Constantin.)
 See DERVISCH KHAN.

VALESQUE, François de. 1776. Oval. 31½ × 26. Sale, Paris, June 14, 1900. 5,900 fr. " Échevin, fermier général, guillotiné à Lyon, 1793."
—— Marguerite de. Oval, 66 × 31½. Sale, Paris, June 14, 1900. 6,400 fr. " Née à Montlong."
VANDERGUST, Monsieur. 1768–1772.
VANNES, Madame de. 1779.
VARONTZOFF, Comtesse Irene Ivanovna, née Ismailoff. Signed, St. Petersburg, 1797. St. Petersburg, Exposition Artistique et Historique de Portraits Russes, 1905, Collection of Comte Ilarion Ivanovitch Varontzoff Dachkoff.
VASSILTCHIKOFF, Prince. See GALITZIN.
VAUBAL, " Le Petit." 1776.
VAUDREUIL, Comtesse de Rigaud de. Pastel. Bust. Yellow open bodice. Light hair in curls. 19¼ × 15. Clermont-Tonnerre sale, Paris, 1900. 2,250 fr.
 Wife of Joseph Hyacinthe François de Paule, Comte de Rigaud de Vaudreuil (q.v.), to whom she was married in England during the emigration.
—— Comte Alfred de. (Child.) Pastel. Bust. To right. Yellow shirt. 14½ × 11½. Painted at Twickenham, 1802–1805. Clermont-Tonnerre sale, Paris, 1900. 5,800 fr.
 Son of Joseph H. F. de P. Comte de Rigaud de Vaudreuil (q.v.)
—— Comte Charles de. (Child.) Pastel. Bust, to left. In red draperies. 14½ × 11. Painted at Twickenham, 1802–1805. Clermont-Tonnerre sale, Paris, 1900. 6,100 fr.
 Another son of Joseph H. F. de P. Comte de Rigaud de Vaudreuil (q.v.),
—— Joseph Hyacinthe François de Paule, Comte de Rigaud de. 1784. 51⅝ × 39¾. 1784. ¾-length. Seated. Court costume of maroon cloth, with gold embroidery. He wears the orders of Saint Louis and the Saint Esprit. Three-cornered hat under left arm. Left hand holds his sword, and right hand rests on a table. He wears a periwig. Exhibition of the Alsaciens-Lorrains, Paris, 1874, Collection of the Vicomtesse de Clermont-Tonnerre. Clermont-Tonnerre sale, 1900. 11,200 fr.
 1749–1817. Born in Saint Dominique. Grand Falconer, Lieutenant-General, and peer of France. Director of the household of Marie Antoinette.
—— The same. 1784. ½-length. Oval. 28½ × 23¼. Full face. Grey coat with broad turned-down collar, brown waistcoat of striped satin. Ribbon and order of the Saint Esprit. Sale, 1908. 6,050 fr. (Monsieur Sortais.) Exposition Rétrospective Féminine, 1908, Collection of M. Sortais.
 The artist says that in 1784 she painted one portrait of the Comte de Vaudreuil, and "five copies of the same."
—— The same. Two portraits. Busts. Paris, after the Revolution.
—— Vicomtesse de, née Riquet de Caraman. 1785. 36⅝ × 26¾. ½-length. Full face. Seated on a little hillock and holding a book. Silk dress, with ruffles, collarette, and fichu of white gauze. White hat. Clermont-Tonnerre sale, 1900. 3,400 fr.
—— Vicomtesse de. Niece of the Comte (J. F.) de Vaudreuil. Paris, after the Revolution.

VENUS, Study of head for. 1781.
—— Binding the wings of Cupid. Salon, 1783. Pastel on glass. 45¼ × 39⅞. For Comte de Vaudreuil. J. B. Lebrun sale, 1814, 241 fr. Mlle. Thevenin sale, 1819, 251 fr. Didot sale, 1825. Line engraving in B. M.
—— The same. *See* JUNO.
VERDUN, Marquis de. 1780.
A Fermier-General.
—— Marquise de. ½-length. 25½ × 20⅞. Low-necked red bodice, laced in front and opening over a white under-bodice. Straw hat with blue ribbon and flowers. Powdered hair. Kraemer sale, 1913. 29,700 fr. (Hodgkins.)
Wife of the above. Madame Lebrun painted portraits of this almost lifelong friend in 1777, 1779, 1780, and 1782.
—— The aunt of the Marquise de. 1787.
—— The mother of the Marquise de. 1780.
—— The sister-in-law of the Marquise de. 1780.
VERNET, Antoine Charles Horace, called " Carle " Vernet, painter, son of Claude Joseph Vernet. Oval drawing. Wanda de Boucza sale, 1902.
—— Claude Joseph. 1789. 36¼ × 28¼. Palette in left and brushes in right hand. Louvre.
1712–1789. Marine painter, who painted, for Louis XV, the fifteen views of French seaports now in the Louvre. It is said that in order to study a storm at sea, he had himself lashed to the mast of a ship which brought him from Italy to France.
VERTU IRRÉSOLUE, LA. An engraving by Dennel, bearing this title (representing a girl sitting up in bed, holding a letter, which has apparently come with a pearl necklace seen on a table at the bedside), is dedicated " à Madame Lebrun Peintre." It has been described as a reproduction of one of her own pictures. If this attribution is correct, the subject and treatment show the influence of Greuze, of whose work she was a keen student in girlhood.
VESELAY, Monsieur de. 1775.
VESTALE, Une. Pastel. Sale, Paris, 1900 (sold in one lot with LA PUDEUR. 1,500 fr.).
VESTRIS, Madame Lucia Elizabeth. English actress. 35½ × 27½. Signed and dated, 1804. Blue dress cut low, coral necklace, red ribbon in hair. She is walking out of doors, with her loose hair blown by the wind, and holds up her skirt by her crossed arms. Paris, Exhibition of Portraits of Women and Children, École des Beaux-Arts, 1897, Collection of M. Charles Sedelmeyer. Formerly in D. H. King, Jr., Collection in America. Christie's, 1908. £157 10s. (Lennie Davis.)
VESUVIUS. Sketch of the volcano. Naples c. 1790.
VIAMINSKI, Princesse. St. Petersburg, 1795–1801.
VICTOIRE, Louise Marie Thérèse de France, known as Madame Victoire. Daughter of Louis XV. Rome, c. 1790.
1733–1799. She nursed her father in his last illness. Emigrated with her sister Adelaide (*q.v.*) in 1791, and died at Trieste.
VIEUVILLE, Comtesse de. 1768–1772.
VIGÉE, Louis Jean Baptiste Etienne. The artist's brother, in schoolboy's dress. 1768–1772.
1758–1820. Author of much light verse and some comedies. Secretary of the Comtesse de Provence (*q.v.*). Imprisoned under the Terror.
—— The same, in schoolboy's dress. Pastel. 1768–1772.
—— Madame. The artist's mother, wearing a turban. Pastel. 1768–1772.
—— The same. Back view. 1768–1772.

Vigée, Madame. In white pelisse. 1768–1772.
—— The same. 1785.
 Jeanne Messain, wife of Louis Vigée (1727–1767). She died in April 1800.
Villiers, ? Mrs. London, 1802–1805.
Viotti, Jean-Baptiste. The violinist. Paris, after the Revolution.
 1753–1824.
Virieu, Claudine de Maleteste, Vicomtesse de. 1779. Paris, Exhibition of the Alsaciens-Lorrains, 1874, Collection of Marquis de Ganay. Exhibition of Eighteenth-century Art, Galerie G. Petit, 1883–1884, same Collection.
 Lady-in-waiting to Madame Sophie de France.
—— The same. 1785.
Vismes, Monsieur de. 1773.
Vombal, Baron de. 1777.
Vorontsoff, Comtesse Irene Ivanovna, née Ismailoff. Bust. St. Petersburg, 1797. Signed and dated. St. Petersburg, Exposition Artistique et Historique de Portraits Russes, 1905, Collection of Comte Ilarion Ivanovitch Vorontzoff-Dachkoff.
Vrague, Marquis de. 1779.

Wales, George, Prince of. Afterwards George IV. ¾-length. Wearing Hussar uniform. Left hand on sword hilt. The plumed hat on table to right.
 Presented by the Prince to Mrs. Fitzherbert. London, 1804–1805. Now at Came House, Dorchester, in the possession of the Dowager Countess of Portarlington
Warr. See De la Warr.
Woina, Comte de. Son of the Polish ambassador to Austria. Pastel. Vienna, 1793–1794.
—— Mlle Caroline de. Sister of the above. Pastel. Vienna, 1793–1794.
—— The same. St. Petersburg, 1795–1801.
Woman holding a dove. ½-length. Desmarets sale, 1778. 175 livres.
—— A, "en lévite," 1779. Painted for the Duc de Cossé.
Wurtemberg, Princesse de. Vienna, 1792–1794.

York. See Frederica Charlotte, Duchess of.
Young, Madame. 1781.
Youssoupoff, Princesse Tatiana Vassilievna, née Engelhardt. Near a rustic altar. She is making a wreath of flowers. Signed. St. Petersburg, Exposition Artistique et Historique de Portraits Russes, 1905, Collection of Prince Felix Felixovitch Youssoupoff. In her first marriage Princesse Potemkine.

Zamoyska, Comtesse. Dancing, with a shawl. Vienna, 1792–1794.
 ? Daughter of André Zamoyski, Grand Chancellor of Poland under Stanislas Poniatowski, 1764.
Zanicourt, Comte de. 1768–1772.
Zouboff, Comtesse Marie Feodorovna, née Lubomirska. Resting on a large couch; pressing a dove to her bosom. St. Petersburg, 1795–1801.

15

APPENDIX

Page 190.

BYSTRY. These portraits of the Comte and Comtesse Siemontkowsky Bystry were exhibited at the Ehrich Galleries, New York, in Jan. 1915. The Comte's portrait measures 32¼ × 24¾. Black cloak over red jacket. Auburn hair; he holds a guitar, on which is the artist's signature. The Comtesse's portrait measures 32 × 24⅜. She wears a draped white chemisette, and orange-red mantle; a yellow scarf, with a wreath of roses on her head. Holds a goblet. Signed and dated (1793) in left-hand corner.

Page 191.

CHATENAY. A " portrait presumé de Madame de Chatenay " was sold at the Kraemer Sale, 1913. 37,100 frs. (Saint.)

Page 196, insert :

ELLIOT, Mrs. Grace (supposed portrait of). Bust. White scarf twisted in hair, white fichu ; striped dress of dull yellow and blue. 20 × 16. (Lord Weardale.)
[Writer of a Journal during the Revolution, friend of Philippe Egalité.]

Page 198, insert :

GENEVIÈVE, Saint. As a young shepherdess, seated with a Bible in her lap. She holds a distaff. Landscape background, with sheep. Painted for Louveciennes Church, where it now hangs.

GIRL, A little, sleeping. Sale, March 1909. 2,625 fr.

Page 199, after line 5, insert :

—— A young. Sale 1912, as " La fillette à la charlotte blanche." 19,000 frs. (Comte Horace de Choiseul.)

Page 202.

KINSKA, Comtesse. The " Bust " portrait mentioned was exhibited at the Ehrich Galleries, New York, in Jan. 1915. Oval, 28½ × 23. White cap and dress, light blue sash. Fair, with blue eyes.

Page 204, after line 19, add :

This picture appears to have been catalogued at the Doisteau Sale, 1909, as " Portrait presumé de Lady Hamilton en Diane." 8,500 frs.

Page 205, insert :

LEBRUN, Jean Baptiste Pierre, husband of the artist (supposed portrait of, by her). Circular, on ivory, 3 inches diameter. Dark green coat, with purple collar; he holds palette and brushes. (Lord Weardale.)

Page 206, after line 11, insert:

——— The same. 1782. ¾-length. 44 × 34. White dress, lace collar and cuffs. Wreath and ostrich feathers on powdered hair, landscape background. Signed and dated. Presented by the Empress Eugénie to Earl Sydney in memory of The Prince Imperial. Sydney Sale, Frognal, Kent, 1915. £6,930. (Mr. George Kessler.)

[This portrait bears little likeness in the face to the following portrait, painted in the same year.]

Page 206, line 43, add:

Sale, Dec. 1910, 13,100 frs.

Page 207, after line 31, insert:

——— The same. Drawing in black, blue, and white chalks, with tinge of red on the cheeks. Nearly full-face. High-waisted light dress, with high collar. 8¼ × 7¼. Pasted at the back of the drawing is the original mount, on which is written: " A card of leave by Madame Vigée le Brun, drawn on the eve of her departure from London, August 1805, for Mr. de Cort." (Frank T. Sabin, Ltd.)

Page 208, Louis XVI. Delete second entry (Line 38).

Page 209. Delete MAINTENON entry.

Page 211, MARIE THÉRÈSE, Princesse, after " 1790," delete remainder of entry.

Page 215, line 27. Before " Gabrielle," insert: " Yolande."

Page 216. PORPORATI, Mademoiselle, insert:

Bust, nearly full-face; abundant dark hair.

Page 219.

SAPIEHA, Princesse. Ehrich Galleries, New York, Jan. 1915. Oval. 31½ × 24½. Seated at a table, hands crossed, left hand holds manuscript. Wreath of ivy on powdered hair. Signed and dated (1795) on table.

NOTE, referring to page 115, last paragraph:

During the Directory, in July 1799 (Thermidor, year VII), an eloquent petition, signed by scores of prominent painters, sculptors, and others (including Robert, David, Greuze, Fragonard, Isabey, Prud'hon ; Houdon, Pajou ; Cuvier, and Lamarck), was vainly presented to Barras, praying for the removal of Madame Lebrun's name from the list of exiles. Madame Tallien had already done her best in the matter. When at last, in June 1800, permission to return was granted, the influence of David, whom the exile so greatly mistrusted, seems to have been successfully exerted on her behalf.

INDEX